uneasy pleasures

uneasy pleasures

the male as erotic object

kenneth mackinnon

cygnus arts

London Cygnus Arts
Madison & Teaneck Fairleigh Dickinson University Press

Published in the United Kingdom by
Cygnus Arts, a division of Golden Cockerel Press
16 Barter Street
London
WC1A 2AH

Published in the United States of America by
Fairleigh Dickinson University Press
440 Forsgate Drive
Cranbury
NJ 08512

First published 1997

ISBN 1 900541 30 0
ISBN 0 8386 3797 3

Cataloguing-in-Publication Data

Catalogue records for this book are available from the British Library and the Library of Congress

Printed by Bookcraft (Bath) Limited in the United Kingdom

contents

illustrations

acknowledgements

IN ALL THE MAJOR PIECES OF RESEARCH WHICH I HAVE UNDERTAKEN, I AM aware that at no stage—other than that of the writing-up of the results of months of study—could the work proceed without the help of library staff. In particular, those University of North London staff who were based in the library at the former Kentish Town site deserve to be singled out. To say that a book would not have been completed without the help of certain other parties can sound trite and only formally polite. Yet, it is literally true in this instance. There would have been no possibility of the present study's completion without the considerable work of the staff in tracking down inter-library loans, chasing up late arrivals of material and double-checking when an item was said, as often happened, to be unavailable anywhere in the UK. It would have been beyond my resources to have spent the time, let alone the money, which the University of North London empowered the Kentish Town site library to expend on this book's behalf. My gratitude was constant throughout the long period of preparation, but it ought now to be put on record.

Another element invaluable for this book's completion has been the Media Services area of the university, and in particular that branch of the service which was based at the Kentish Town site until the summer of 1995. Certain individuals deserve to be singled out for advice about archives in London, for photographing certain items on my behalf and for showing enthusiasm for the project: my thanks to Nick O'Brien and Milton Hussey, and, above all, to Julia Everitt.

To these must be added the name of Steve Blunt, who has been immensely helpful in ensuring the greater longevity of perishable visual materials by making slides of these, and in providing the photograph for the book jacket.

The other help which was valued was of a quite different sort. A first book can excite interest and surprise in friends and colleagues, while a fifth can engender a sense of routine about book production—which may mean that interest dwindles as surprise vanishes. Therefore, because research even in a field as fascinating as this can be a lonely affair, the

unfeigned—or, at worst, skilfully feigned—enthusiasm of certain friends and colleagues was gratefully noted. My immediate academic colleagues in Film Studies—especially Bruce Carson—sometimes passed on what they (rightly) imagined to be relevant articles, essays or cuttings. Others would mention television advertisements that they (again rightly) felt deserved a glance from me in relation to the topic.

Most helpful of all was student interest, since students combined goodwill with experience and insights which they passed on in the modest (and this time incorrect) belief that I would have thought of them for myself. One student, Iain Lawrence, has listened and advised at various stages of the book's revision. Those final-year dissertation students under my supervision who claimed to be amazed that I was undergoing some of the doubts and loss of confidence that they also underwent in the course of their own research may have ended up providing more support than they realised at the time—or more than they received. One student, Elaine Colomberg (whose dissertation, being for Women's Studies, was not under my supervision), was particularly helpful in that she allowed me to consult that work and to make use of it in the book. A former Film Studies student, Emma Lynch, kindly permitted me to consult her collection of comic books for adult readers.

The principal means by which research has been encouraged must be acknowledged to be the disbursement of funds by the recommendation of the Faculty Research Committee, these funds going towards, for example, the provision of part-time hours to allow time to be redirected from a full timetable of teaching to research hours.

With regard to visual material, the help of the Advertising Archives and of the Retna agency is gratefully acknowledged.

uneasy pleasures

introduction

THERE ARE SIGNIFICANT MOMENTS IN TEACHING EXPERIENCE, WHEN A PARticular aspect of a subject not only grabs students' attention but sets up surprising resistances and other evidence of discomfort.

One unit I teach in the film studies subject area of the University of North London's Humanities Scheme is called 'Questions of Visual Pleasure'. It is no great feat to secure and retain the attention of students, since it deals with the ideas in Laura Mulvey's celebrated 'Visual Pleasure and Narrative Cinema' article and the follow-up 'Afterthoughts' essay.[1] Once clarification of her basic position is achieved, and once the more difficult task of explicating the psychoanalytic framework that Mulvey uses for her ideas is attempted, students are introduced to other authors' ideas. (These writers and their ideas complement, critique or correct Mulvey.)

Each year, students seemed to cope more than well with the published writing on masculinity as spectacle. This area of the unit is crucial, in that arguments in support of male spectacle combat Laura Mulvey's virtual denial of its possibility in narrative cinema, under the formula, 'Man is reluctant to gaze at his exhibitionist like'.[2]

Suddenly, a few years ago, there was a change in that rosy pattern. Thankfully, the change was temporary. It did, though, nearly ruin one seminar and the efforts of one student in particular to spur on his group to keep the seminar going.[3] It seemed that the class had no appreciable difficulty in understanding Steve Neale's thinking in relation to the achievement of male objectification in the film *Chariots of Fire* as long as that thinking was consigned to the printed page.[4] It appeared, however, to be another story when a student seminar was organised on that thinking the week after a screening of the film.

The student group of three or four persons responsible for the organisation of this seminar apparently chose to outline the principal ideas in the article and to ask the class in general to consider these ideas in relation to its experience of the screened film. From the start of the seminar, the class seemed ill at ease, more intent on finding the ideas implausible or

even absurd than on examining them. This behaviour was highly atyp-
ical, in that our students generally give a fair hearing to ideas that strike
them at first acquaintance as unlikely or even repugnant and show an
ability and willingness to change their attitudes if they are impressed by
the supportive arguments. On this occasion, though, idea after idea was
dismissed by an increasingly mocking class, usually without any consid-
eration of them but with a shared jokiness at the expense of both the
writer and the group putting forward these items for discussion. The
organising group began to fall apart, at least two of the group defecting to
join in the class ridicule, leaving one beleaguered soul both to present the
themes for consideration and to try to argue for a fair hearing for these.

Class conduct was not uniform. Several members of the class were
totally silent and disconsolate-looking throughout the seminar. One or
two seemed to wish to consider the ideas, even if they did not quite have
the temerity to demand that the class be less destructive. Subject staff are
supposed to relinquish all claims to leadership of a seminar and usually
speak and participate only if invited to by the organisers.[5] The most atyp-
ical part of all in that session may have been my belligerent interruption
of the seminar. The interruption was to berate the most noisily demon-
strative of the speakers, both for behaving in a markedly unacademic
manner and for forgetting loyalty to the one remaining organiser, and in
the process forgetting consideration for those members of the class who
had fallen silent early on and had remained so.

My own bad temper produced a sense of grievance at being misrepre-
sented in those students who had been more vocal on this occasion. It
also, however, produced a willingness to reconsider their attitudes, par-
ticularly on the part of women students. Those who had been silent
seemed particularly grateful for the scene I had played a major part in
creating, since one or two had been on the point of walking out. They
said later that they felt that the ridicule from the majority had been
directed not simply at Neale's argument (that the athletic aspect of the
film permitted a covert eroticisation of the athletes) but also at them.
They felt, rightly or wrongly,[6] that they had been as marginalised and
silenced by laughter as the very suggestion that males under the alibi of
sport could be eroticised.

The incident, even in memory, represents a low point in my teaching
career. I wished at the time that I could have been more 'cool', not letting

my annoyance show, particularly as I understood then a little of what I now believe to be true about the source of the inappropriate conduct. Both men and women who had never thought of themselves as watching an erotic spectacle when they thrilled to sport on television or in actuality, who had never felt that when they chose to watch a sports movie it might be as a turn-on, were suddenly faced with that very possibility. The ideas in the article seemed too close to home. They threatened to rip the covers off uncomfortable potentialities in sports spectatorship when sports fans would have preferred the covers to have stayed firmly on. If sports had any erotic meaning, it was for others, not for them.[7]

Gradually, relevant ideas were explored, very tentatively. One woman came right out and said that she found sportsmen erotic and had been glad that Leni Riefenstahl seemed to share her taste in objects of the gaze. Another student said that he could understand that "to some people" the sight of athletes straining for victory in slow motion or lying on the massage table could, he supposed, be erotic. One of the defectors from the original organising group was adamant, however. Sport had nothing whatsoever to do with eroticism. He was a football fan. He went every Saturday to watch his team. "When I go to watch football, it is to see men who are younger, stronger and fitter than I am play," he explained. "There's nothing erotic about that". At this point, the prosecution rested.

During the 1993–94 presentation of the unit on 'Questions of Visual Pleasure', I chose on one occasion to introduce the section of the course centring on 'masculinity as spectacle' with three video extracts. The first of these was the famous *Gentlemen Prefer Blondes* sequence in which Jane Russell sings 'Ain't There Anyone Here for Love?' During it, the camera focuses on the Olympic team narcissistically going through its exercises, too self-absorbed to notice its female admirers or Russell's claimed erotic need. This extract seemed to produce an unembarrassed amusement. It was the next two videos that elicited curious, and strong, reactions.

I told the class that I was going to show videos of Take That, and immediately slightly derisive giggles and whispered, puzzled remarks began. It was important to the students, apparently, to indicate that Take That did not represent their taste in music.[8]

One video, 'Do What You Like', has the group behaving in a playful version of polymorphous perversity with jelly and ice cream dished out

on to the singers' half-naked bodies by grinning females. At one point, towels are whipped off the otherwise naked group, but only one bare bottom is shown, the rest having an oblong 'censored' notice obscuring their buttocks, until, that is, a woman with a mop, in long shot, proceeds to clean them up at the end of the video. The next video was 'Pray'. The song was so popular that most of the class must surely have seen the video on mainstream television on numerous occasions.[9] In it, female presence is much less. The stars of Take That take up elegant, narcissistic postures on the beach, appearing to enjoy the suppleness of their own bodies and the flow of water on their exposed flesh. Both videos were watched in comparative silence.

The usual break in the three-hour class was taken up with student after student appearing to need to discuss the impact of the Take That videos with me—but in private. Each individual, regardless of gender, claimed that the viewing had been erotic and pleasurable, but all wanted to know who that pleasurable eroticisation was for, and some earnestly wanted to know why I had chosen these extracts for this particular unit. One woman said that she found "the boys" all "lovely" but guessed that they weren't presented like that for her, that she wasn't meant to see them in that way. Gay men and young teenage girls must have been the intended audience, surely. After all, she had heard that the group was gay.[10] A somewhat 'out', self-identifying gay male student took me aside to say that he had found the viewing a terrific turn-on, but that he was sure it wasn't meant for "the likes of him". I asked who it was meant for. "Oh, that's just what I was going to ask you", he grinned. These were just two of many similar sorts of reaction.

The above two very different responses to the same part of the unit had several commononalities, it appeared. Both of them attested to the perceived need for privateness and secrecy surrounding male spectacle. Most notable was the implicit attitude that, if male spectacle had to be acknowledged as there at all, it must be for some other constituency: for women, for female teeny-boppers, for gay men, for any group but the one to which the individual student felt that he or she belonged. There was a feeling, evidenced with particular strength in the case of the *Chariots of Fire* class, that sports heroes cannot be thought of as even potentially erotic except by some conspiracy of deviants determined to foist their peculiar perceptions on a healthy majority. The eroticised male is

impossible to contemplate, it would seem, without what seems to be felt as the spectre of homosexuality being conjured up.

Unexpectedly strong class reactions are always interesting, whatever regrets about the hiatus in one's professionalism or about their possible prejudices seem to be exposed. They break through the polite interest, and even the unfeigned enthusiasm, of film students for controversial, and clearly difficult-seeming discussion, especially in the areas of gender, sexuality and ethnicity. When a subject or area produces hostility or bewilderment in one of this university's film classes, there can be little doubt that a major taboo has been broken or threatened. The taboo in this case seems to be none other than the acknowledgment, at least in public—that is, outside the bedroom, or the closet of some nature or other—that men can be objectified and eroticised for the pleasure of others (or of themselves).

One way of dealing with the breaking of the taboo appears to be energetic disavowal. That disavowal seems to be most effectively achieved when it can be linked with the notions of licensed and unlicensed or illicit viewing, a notion that must surely accompany the idea that particular sights are for or not for certain individuals or groups. It is unlikely to have escaped the attention of anyone who has been aware of advertising on cinema, television or magazines that since roughly the mid-1980s there has been a massive upsurge in the use of erotic male imagery to sell items as various as jeans, aftershave, even lager. This awareness produces certain reactions. One of these is to have more serious doubts than ever about the credibility of Laura Mulvey's claim that the male is not eroticised in mainstream entertainment, even if she may well be right, in another sense, to recognise the intolerable nature of the male gaze at "his exhibitionist like". Another is to question what might be termed the significance of the phenomenon. Does the public erotic objectification of the male mean that his power is diminished, equalised with that of the female who has for so long undergone an erotic objectification that has only since the 1970s been seriously questioned? Can the phenomenon of male eroticisation be thought to make sense in itself, as it were, aside from the conditions of social actuality? Or does social actuality alter because representation itself alters?

These have the appearance of big questions. Now seems the right time to ask them, because now there seems to be less and less disavowal of

male eroticisation, yet the questions raised by it continue to be evaded except for the occasional journalistic foray into this territory. Confrontation with the evidence and the situations that require account to be given of viewing reactions seems still to occasion discomfort.

This study is an attempt both to compile evidence for the claim of erotic objectification of the male subject (into object) and, taking the clue from students' reactions to the Take That videos, also to consider the ramifications of the view that particular eroticisations are intended to be for particular groups of viewers, and therefore not for certain others.

In more detail, a brief foretaste of the chapters and their concerns might be as follows. Chapter 1 offers an introduction to the principal arguments of Laura Mulvey's 'Visual Pleasure' essay, and a critique of its theses under such heads as:

1. the lack of a stable 'masculine' viewing position in certain genres;

2. the possibility that 'feminine' masochism is as important a visual pleasure as Mulvey's 'masculine' sadism;

3. the likelihood or otherwise of the existence of a female gaze, so-called;

4. the feasibility or otherwise of the male as spectacle, and the importance in this relation of disavowal.

Chapter 2 centres on male narcissism, exhibitionism, masochism and relation to feminisation, and follows discussion of these with that of phenomena capable of consideration in these regards—such phenomena as nudism, body-building and male imagery.

Chapter 3 begins with a focus on the search for fixed signs of masculinity in the context of dance. This search is then contrasted with the feminist strategy of reading against the grain, in its application to, in this instance, fine art. The chapter continues with a discussion of the need to recognise multiplicity of spectatorships in different contexts and media, and then with a consideration of male objectification and the greater facilitation of such objectification through racial Otherness, for example.

Chapter 4 considers some of the evidence for there having long been a largely unacknowledged tradition of male objectification: in the fields principally of photography, pop and, above all, cinema. Chapter 5 then deals with the intensification of this already marked trend in the last ten years, with special emphasis on advertising, magazines, comics and the world of fashion.

Chapters 6 and 7 take the question, for whom eroticisation of the male is offered within dominant media, by considering three social categories: 'women', 'gay men' and 'real men'.

The Conclusion attempts to look back on the research of the seven central chapters: to see whether knowledge can be garnered about male erotic objectification; particularly about the groups which it is believed widely in society that certain manifestations of the phenomeon serve to pleasure; and, thus, more crucially, about the effect of those beliefs.

A NOTE ON INVERTED COMMAS

It would be surprising if a culture critic used the term 'real men' without inverted commas. These indicate irony, but also the sense that a social group is constructed around a certain perception fostered both in, and also about, certain men, whereby they are 'regular chaps', 'the lads', 'average blokes' and so on. The category requires other categories to give some shape to it. Not least, it requires the other two categories in this section of the book—women and gay men. By defining 'real men' as what these others are not, the nebulous nature of 'real' manhood seems to be given sharper definition. That process is facilitated by the association of the other categories with such terms and values as 'softness', 'femininity/effeminacy', 'irrationality', 'emotionalism' and so on.

While few readers are expected to quarrel with inverted commas around 'real men', it could seem insulting to appear to place 'women' on the same plane. Yet, it is important, for present as well as other purposes, to bear in mind that 'women' is a social categorisation, one that goes well beyond the evidence of genitality or biology in its claims. The best argument for quotation marks may be that 'women' is a category that helps to define the category 'real men'. The doubts raised about the latter must surely reflect on the way that the former is received.

The existence of a category that serves purposes which may not validate the existence of women as certain feminisms may understand the term, and which excludes lesbian women, is suggested not least by the title of a contemporary British magazine, *For Women*. The title indicates certain assumptions about the nature of women as consumers and in their relation to men as erotic objects. Objections to these assumptions might well be couched in terms of women's nature—that they're not 'like that'—but that response also reminds us that there are rival categorisations of

women within discourse, rather than an authentic and truthful reality in the wings, waiting to oust what may otherwise seem to be fictional categories.

'Women' in this present context, crystallised by the title of the magazine *For Women*, excludes lesbians. Nevertheless, in social actuality, women identifying as lesbians could find considerable interest in the potentiality of the claimed existence of the male object—not least in its subversion of the patriarchal rules that naturalise a certain kind of masculinity, a certain kind of femininity, in perpetual opposition to each other.

The same could be said of 'gay men' as has been said above for 'women' in this context, but, more radically, it could be said in general of the popular categories by which human sexuality is understood. After the words 'heterosexual', 'homosexual' or 'bisexual' are uttered, it is as if our culture has exhausted most of what there is to say of sexuality. The term 'gay' is widely used, either as a euphemism or, less negatively, in the belief that there is a certain sensibility which merits the word. The controversies about nomenclature are, justly, legion. The politics of queerness as opposed to gayness or homosexuality ought in the full context of sexual politics to be addressed. That it is not in the present context is because 'gay men' is a social categorisation which has been created or assumed in the commercial processes of the provision of erotic images of the male. For the present, the justification of the inverted commas is as a reminder that 'gay', like the other words, has a social meaning and is not to be understood as proof of an exclusive, coherent identity which has a particular socially recognised (created?) kind of sexuality as its foundation. Not least, the value of the inverted commas may be as a reminder that the category arises from a social belief about sexuality. This belief is that there are identifiable and separable—largely coherent as well as discrete—sexualities. It is a short, and to me a dangerous, step from this position to the claim that there are fundamental unbridgeable differences not just between these sexualities but between individuals grouped under these headings.

Such arguments indicate that there are specific mediations of the male erotic object made with these categories in mind. Thus, the categories do exist socially, as imagined embodiments of certain kinds of desire, but they exist in just that way, reifying the different sorts of male objectification, just as these objectifications reify the category.

Inverted commas pepper so many writings of media and culture critics that, to the unsympathetic, they can begin to look like a stylistic tic and to be as self-parodic on the page as they certainly are when 'trendy lefties'[11] make quotation-mark signs in the air at every third word. Some of the words so identified on the printed page might conceivably be over-cautiously signalled as quoted. On the other hand, in an area which spends so much time uncovering social constructedness, it is to be expected that there will not be a general wish to authenticate as real (or even as 'real') what has been energetically argued to be socially constructed. Inverted commas are a reminder of that constructedness.

Thus, in the present book, it is rare for 'masculinity' or 'femininity' to be referred to without inverted commas; these are believed to be categorisations that have meaning only within the social formation that chooses to understand the terms in such and such a way. The fear of not using inverted commas for such concepts is that some reader may imagine that the categories are claimed to have an existence and authenticity independent of the social formation's will in the matter.

A NOTE ON THE PORN/EROTICA DICHOTOMY

The point of this second note is to clarify why the term 'pornographic' is not used in this book as an adversative to the term 'erotic'. The distinction between the terms is recognised within American law, in that the Indianapolis ordinance of 1984 attempts to punish the pornographer and to protect the erotic artist, so-called. Not coincidentally, the erotic has been claimed for women by certain feminists. However, the argument that seeks to depict erotica as feminine, by tying the meaning of the pornographic to an essentialist view of male sexuality and by calling that sexuality exploitative and obsessed with power relations, is circular—in that the erotic is defined largely as in opposition to the pornographic. In this way, the best definition for the erotic seems to lie in the minute characterisation of the pornographic, so that it is above all what pornography is not.

Thus, erotica does not objectify women or re-enact male/female power relations, and does not use an exploitative style. Gloria Steinem, in identifying the subject of erotica implicitly as mutual love and yearning for closeness, does not help.[12] She talks here of content, rather than of representation of that content. Representation seems, in the visual

sphere, to involve looking. How then does erotic representation avoid the very problems of objectification that Laura Mulvey finds inevitable in the realm of visual pleasure?

Andrea Dworkin highlights this difficulty when she recognises that the problem with a feminist erotica is with what she sees as masculine habits of reception. She says, 'in the male sexual lexicon, which is the vocabulary of power, erotica is simply high-class pornography; better produced, better conceived, better executed, better packaged, designed for a better class of consumer'.[13]

A still more trenchant observation on the alleged distinction between erotica and pornography is offered by Ellen Willis, who states, 'The erotica-versus-porn approach evades the . . . question of how porn is *used*. It endorses the portrayal of sex as we might like it to be and condemns the portrayal of sex as it too often is, whether in action or only in fantasy.'[14]

Because the present investigation hinges on questions of reception, or readership, and because the claimed distinction of erotica from pornography rests above all on content, not its representation, there will be no attempt to treat the terms and their derivatives in this book as if they were dichotomous.

I · mulvey and after: 'masculine'/'feminine', subject/object

LAURA MULVEY ON SPECULARITY AND VISUAL PLEASURE

All debates concerning the area of erotic looking in cinema (and within other media) must at some point react to the ideas in Laura Mulvey's essay, 'Visual Pleasure and Narrative Cinema'.[1] On empirical evidence (reading, for example, of feminist literature, and about media well beyond cinema), it seems likely that this essay—now over 20 years old— is the most frequently cited and easily the most influential of any published in the groundbreaking periodical *Screen*. While it has in the work of some admirers assumed a position of orthodoxy, it has also sparked off much dissent and a will energetically to revise or refine upon some of its theses. The common ground between those who view its tenets as unassailable and those who question one or more of these is an awareness that the article made such a contribution to the discussion of representation—and not just filmic representation—in terms of gendered spectatorship that without it it is difficult to imagine the state of current debates on media and gender. The discussion below predictably, in view of the book's principal subject, must take issue with an author who encourages inattention to the very possibility of a male object. The present author's admiration for, and heavy dependence in teaching as well as research on 'Visual Pleasure and Narrative Cinema', should not be allowed to be obscured by that necessarily dissenting discussion.

The essay's principal thesis is that in 'dominant', narrative cinema, woman is constituted as image, or the looked-at (spectacle), while man is the bearer of the look (spectator). Already, in that formulation, there is evidence of slippage, whereby the specular position traditionally occupied by the woman of narrative cinema is neatly conflated with 'feminine' and that by the man with 'masculine'.[2] That same slippage occurs in Freud's treatment of the phenomena of masculinity and femininity, which he does sometimes attempt to use metaphorically and to remove from facile identification with maleness and femaleness, in the biological sense of the latter.

Lacanian psychoanalysis permits certitude of the lack of identity

between the penis and the phallus—of the imposture, in other words, whereby biological maleness takes to itself phallic activity and mastery. Nevertheless, the closeness in representation between the penis and the phallus not only clouds clarity on the issue but raises the likelihood that it is not possible within patriarchal culture to retain a sense of neat separation between these, and thus between biological maleness and phallic power.

Since Mulvey's argument is rooted in Freudian and Lacanian psychoanalysis, it is not surprising that the problem reproduces itself in her work. Nevertheless, it is crucial to recognise the slippage in applying her thesis to questions of the relation to gender of spectacle/spectator, of object/subject, comparatively disempowered/ comparatively empowered. It is easy on first readings of her famous essay to believe that the spectator is not only masculine but male only, and that the spectacle is gendered as female, not simply feminine. After all, women in narrative cinema are coded for, in her idiosyncratic formulation, 'to-be-looked-at-ness'. The question, put extremely simply, arises: Do women never look?

Feminist readers of the essay frequently asked Laura Mulvey why therein the spectator is discussed under the pronoun 'he'. Surely, they rightly suspected, she was not using the masculine form as an indicator of common gender. She therefore followed up her original 'Visual Pleasure' article with an 'Afterthoughts' paper.[3] This paper cleared up the questions raised about her excision from consideration of the biologically female spectator. According to it, if the spectator was not, in every case, male, the spectator was still masculine. Thus, the female spectator of narrative cinema is either temporarily a transvestite, enjoying masculine power in fantasy in order to stay under the spell of the film, or else uneasily oscillating between her sense of her femininity and a nostalgia for the masculinity of pre-Oedipal life. Like Pearl, the heroine of *Duel in the Sun*, the female spectator is, in Mulvey's memorable terms, "torn between the deep blue sea of passive femininity and the devil of regressive masculinity".[4]

The follow-up paper strengthens the original's strong suggestion that spectatorship has a number of connotations attached to it, among them being activity and power, while spectacle is connoted as passive and depotentised. Even in a grammatical sense the spectator is the subject

of the seeing transaction, the spectacle the object. Therefore, there is an emphasis upon the mastery enjoyed by the subject and domination undergone and endured by the object. It is a short step from the recognition that patriarchy instils the notion that it is proper and natural for men to be masterful and dominant to describing narrative cinema as a vital prop for patriarchy. If it is so, it is because of the belief that it guarantees his place as looker to the male while the female is left with the 'to-be-looked-at' role. Thus, both within the audience of narrative cinema and on the screen, there is a gender split in specularity (or looking relations). So tenuous is the dividing line between masculinity and maleness on one hand, and between femininity and femaleness on the other, that the female spectator has to be described in transvestite terms in Mulvey's 'Afterthoughts', when she deploys an active look at the screen.

The title of Mulvey's 'Visual Pleasure' essay indicates that she discusses specular relations with an eye primarily to pleasure and the avoidance of unpleasure. Implicit in her argument are the beliefs that being a subject involves power, that sadism is the only erotic pleasure that can thus be invoked in the context of cinematic looking, and that the sadism involved in pleasurable viewing is a masculine, if not indeed a male, pleasure.

Her argument, important in itself and especially important in relation to the political uses it has been made to serve, deserves scrutiny. As far as concerns subject/object relations and the way that these have been unproblematically tied in with differential (gendered) power relations, it could be observed that grammatical subjects do not always and automatically have obvious social power. Thus, the grammatical subject of the waiting/serving transaction familiar from restaurant settings is the waiter/waitress. Although there may be a measure of social power invested in the staff of certain kinds of up-market restaurants by which customers may experience a sense of being intimidated, we would usually locate greater power on the side of the grammatical object, the customer.[5]

The lesson to be drawn from a detour into the byways of linguistic usage is that we should not lightly assume the powerfulness of the spectator and the powerlessness of the spectacle. These may still be provable, but we must draw back from taking as already proved the equation of the subject position with a wider sense of activity, of the object position with a wider sense of passivity.

It may have been possible twenty years ago to claim that there cannot be a male object of the gaze. The fact that male and female spectators of narrative cinema seem to have taken pleasure in looking at males on screen must in itself shake confidence in that claim. However, it could be, and has been, counter-claimed that male objects of the gaze have been heavily disguised and have acted instead as identification points for the masculinised spectator, a means through which the audience's awareness of sadistic spectatorship is diffused. (The thinking here is that the male or masculinised spectator in the cinema audience evades the implication that he is subjecting the eroticised female of the film world to his/her gaze; rather, it is the male on screen who does this. Identification with him means that the spectator is spared knowledge of, and the need to account for, his/her visual pleasure.) In any case, since the position of object is aligned with powerlessness, how can men, whose masculinity is culturally aligned with the pleasurable wielding of power, assent to occupying it? Or, if they do, how can the male in the audience accept this as pleasurable entertainment?

It is extremely difficult today to deny the evidence for the male as object of the erotic gaze. The present study is an attempt to affirm that the male object has been there, for an awfully long time, and is now much more evident and in far less need of outing than he was when Mulvey wrote her accounts of visual pleasure. It is also—and perhaps this is more crucial—an attempt to consider how the outing of the male object affects assumptions and convictions about the gendered identities of viewing subjects and viewed objects, particularly in relation to access to power.

One aspect of Mulvey's argument that has been passed over until now concerns the impulse to fetishisation to avoid unpleasure. Mulvey recognises that the female object of the gaze represents a potential castration threat to the male spectator. One method of reducing her threat is through voyeurism, an activity that is in the essay aligned with sadism. By this means, distance is created between female spectacle and male spectator; on investigation, she turns out to be a guilty object, an object that is either rescuable through recuperation or deserving of lethal punishment, as at the end of many film noir thrillers. However, just as the potential to overwhelm the male, disoriented by desire, is kept at bay by the investigative, controlling gaze of voyeurism, another means of reducing

the castration threat is to make the female more phallic, more powerful and in that peculiar sense more masculine, through the process of fetishisation. The female star's beauty may be, in Mulvey's term, 'over-valued' and herself be deified, placed on a pedestal, and thus kept at a distance. This time, that distance seems to be in another direction.[6]

The logic of Mulvey's position would appear to be that the female object of the gaze, in being invested with the trappings of greater power through fetishisation, becomes more like the spectator (masculinised and thus, in fantasy at least, powerful). Given this logic, it is surely at least interesting to note in passing that the male object of the gaze is *already* like the masculine spectator.

A recap of the positions that are either explicitly argued or assumed by Mulvey's work in relation to the visual pleasure promoted by narrative cinema would include the following:

1. that the spectator, or subject of the gaze, is either male or mas-culinised;
2. that the spectacle, or object of the gaze, is female (or, implicitly, femi-nised, though there is no 'Afterthoughts' paper to substantiate this possibility);
3. that the spectator's pleasure is thus a 'masculine' one of mastery and control;
4. that it is therefore akin to sadism.

 Noticeably omitted are these logical corollaries:

1. the possibility of a feminised male object;
2. the possibility of (masochistic) pleasure on the part of the spectacle— the female or feminised object of the gaze;

AFTER MULVEY: THE SPECTATOR AS MALE/'MASCULINISED'?

One of Hollywood cinema's most long-lived genres is the so-called woman's picture or, perhaps more insultingly, weepie. The critical neglect it endured was in part compensated by film studies' passionate interest in the genre in the 1970s and particularly the 1980s, during which period the umbrella term 'melodrama' was applied to it. A principal enthusiast for it, and particularly for Douglas Sirk, one of its most cele-brated directors, was Laura Mulvey. At first sight, melodrama presents a formidable obstacle to Mulvey's own understanding of movie-watching as a male or masculinised erotic activity. The putative audience for

melodrama, as redefined by film scholars, is usually taken to be women; the identificatory patterns set up by most of the genre must be seen as of particular relevance and appeal to women.

Because spectatorship of narrative movies is closely allied with experience (albeit experience in fantasy) of power, questions arise as to the female spectator's—and also the female characters'—relation to spectacle, and thus to the disempowerment that being the object of the gaze seems elsewhere to imply. Are the on-screen women of this genre eroticised spectacle? And, since protagonists are often female and since female–female identification seems to be ensured in the viewing, is the spectator's relation to that spectacle, even if it should turn out to be eroticised spectacle, voyeuristic, fetishistic or of some other sort?

It may be conceded that the model of erotic viewing that Mulvey believes to obtain in other genres may not fit easily. Indeed, if erotic objectification does not immediately suggest itself, a different kind of objectification may well produce the same effect of depotentisation of the object of the gaze. If part of the point of erotic gazing is to enhance the power of the male gazer and to keep the female gazer in her place, as it were, then that effect can be achieved by other specular routes. Mary Ann Doane, for example, believes that the gaze in the woman's film is medicalised, converted from erotic to that of the caring male professional. "The female body," she says, "is located not so much as spectacle but as an element in the discourse of medicine, a manuscript to be read for the symptoms which betray her story, her identity. Hence the need, in these films, for the figure of the doctor as reader or interpreter, as the site of a knowledge which dominates and controls female subjectivity".[7]

If the gaze of melodrama only ostensibly, but not ultimately, vests a greater power in women through an apparently non-erotic spectatorship, there is another important genre within Hollywood cinema that modifies the picture of an essentially male spectator.

The horror genre works largely by destabilising a viewing position which can easily be co-opted into masculine spectatorship. In an analysis of *Halloween*, Steve Neale clarifies the splitting of the audience's viewing position between its traditional omniscience and a lack of knowledge, so that the spectator's enjoyment in the context of horror and some thrillers oscillates between a sadistic awareness superior to the characters' and a masochistic pleasure in paranoia, as being the

object of the film's aggression.[8] If spectatorial pleasure is termed mascu-
line in Mulvey's account, what are we to make of Neale's persuasive sug-
gestion that one side of the experience of horror is that the spectator
occupies 'a passive position as object of aggression and control, a posi-
tion articulated across the diegesis as identification with those charac-
ters marked also as objects of an omnipotent violence and threat'?[9]
What else than that, at least on one side of the split in horror's spec-
tating, the spectator is feminised, both in loss of control and power and
in terms of identification? By this explanation, horror films at least
unseat confidence in the unfailing masculinity of the spectator in dom-
inant cinema. Even if he should be male, his loss of control, his subjec-
tion to paranoia and the pleasures of masochism, suggest that there are
genres where an insistence on the masculinity of spectatorship is
wrongheaded.[10]

AFTER MULVEY: MASOCHISM, NOT JUST SADISM, AS VISUAL PLEASURE

If, then, recognised genres within Hollywood cinema regularly unseat
the apparent securities of masculine viewing, the stress in Mulvey's work
on spectatorship as involving sadistic control may result in overstate-
ment.[11]Those spectators who appear to enjoy the viewing of horror films
experience an enjoyment which must involve their subjection to sus-
pense and aggression (and to the aggression of suspense). In so doing,
they must become feminised spectators, to extend the logic of Mulvey's
arguments.

Kaja Silverman takes issue with Freud, and with his account of the
male subject, for his curious and partial explanation of the *fort/da* game
which he observed his infant grandson playing and which he troubled
to explain as 'binding' the potential unpleasure of loss (in the *fort* phase
of the game) through mastery of it by repetition.[12] She feels that his
grandson's delight in the experience of loss counts for too little in Freud's
explanation, which foregrounds the alleged pleasure of mastery as key
to the apparent rehearsal of loss and absence, just as the compulsive
repetition of trauma receives too little attention from the psychoanalyst
in relation to his study of the experience of war wounded.

What he misses, she suggests, is a quite different sort of pleasure for
the male subject—not that of mastery, but that of being mastered, plea-
sure in subjection rather than subjecthood. In other words, Freud fails to

give proper weight to the evidence for the attractions of masochism to the male subject. Pleasure in the context of novel-reading or in that of listening to music seems to be articulated in terms of the novels' power to move, the music's overwhelming of the listener.

By means of Liliana Cavani's *The Night Porter*, Silverman illustrates her thesis that the male gaze is always exceeded by the Gaze, from the place of the Other.[13] She highlights the hero's fascination with the sufferings inflicted on the female victim in her concentration-camp past and in the wilfully reconstructed present of the movie, which seeks to reactivate the past. Although this reactivation must reanimate his cruelties and her sufferings, the key to understanding him resides, she argues, not in his enjoyment of his cruelty but in his fascination with the suffering heroine, so that his sadism gives him a place from which to indulge his secret masochism. When her exhibitionism within the narrative transforms from involuntary to voluntary, it is experienced as a threat. Silverman argues that it is so experienced because it comes too close both to a revelation of the heroine's inadmissible pleasure in suffering, her masochism, and, more significantly, to a revelation of the hero's identification with her and thus his own highly inadmissible masochism.

Her argument, which includes due recognition of the hero's obsession with photographing the victim in humiliating and painful situations in the concentration camp, suggests that the masculine, sadistic position of the spectator serves to mask the true direction of the male subject's identification and pleasure—with the female victim in terms of her suffering and degradation. Thus, Silverman stands Mulvey's account of spectatorship on its head, suggesting that spectatorship jealously guards its outward impression of masculinity and sadism so that the inadmissible pleasures of masochism may be the better veiled. If masochism be aligned with the feminine, then the feminised spectator is an entirely credible and probable phenomenon, but resistance to recognition of this kind of spectator is so fierce as to render that spectator, especially if biologically male, invisible. Using the potential of the Lacanian insistence on the chasm between penis and phallus, she believes that the Cavani movie demonstrates that the so-called male gaze is an imposture, seeking to blind us to the male's subjection to a Gaze from the place of the Other. Taking this insight on to the wider cultural realm, she suggests that

the insistence on spectatorship as properly male activity is a device to divert us from realisation that the male gaze is always exceeded by a transcendental Gaze. By extension, the claim of sadism as an essentially male pleasure works to divert attention from the inadmissible cultural secret of male pleasure in subjection—from, in other words, the identification of the spectator's pleasure in masochism, and from the categorisation, therefore, of the spectator as feminine.

AFTER MULVEY: THE FEMALE GAZE

The collection of essays published under the title, *The Female Gaze*, evades by that title the more difficult question of whether there is a feminine, as well as female, gaze.[14] After all, it comes as no surprise to Laura Mulvey that there are women who gaze—that there is, thus, a female gaze. Yet, she appears to deny the possibility of a consistently or predominantly feminine gaze by calling the spectator masculinised. The principal point of her 'Afterthoughts' paper is to consider what sort of gaze is deployed by women in the audience for a dominant movie.

One particularly useful element in certain of these essays is consideration of those areas within culture where objects are presented for the female subject or gazer. Suzanne Moore's contribution is specially relevant to the present study, in that it centres on the male of dominant cinema and contemporary advertising and the way that he is presented as spectacle for the delectation of women viewers.[15]

Even if Mulvey refuses to consider the likelihood or otherwise of the objectified erotic male, she would presumably argue of the contexts in which Suzanne Moore identifies an invitation to female gazing that the gazing remains masculine, regardless of the gender of the putative viewer. The inversion of the customary gender positioning, which renders the male as object of the gaze, and the female as subject, does not, of itself, subvert the gaze she deems masculine, or, more controversially, male.[16]

To discover even the possibility of a feminine gaze, we have to turn instead to Kaja Silverman's thesis discussed above. What Silverman finally achieves is less an authentication of the feminine gaze than the undermining of the masculine gaze. By her argumentation, the male gaze is always superseded by the Gaze, much as the penis is superseded by the phallus. The near ubiquitous belief in the gaze as male would be

proof, according to her reasoning, of the effectiveness of the imposture by which the male claims the phallus as his. The imposture's effectiveness is in turn proved by the easy blurring of distinctions between penis and phallus by Freud and Mulvey herself.

AFTER MULVEY: THE MALE AS SPECTACLE

We can surmise that the admission of the male as erotic object of the gaze would not result in Mulvey's acceptance of a feminine gaze, but she admits no such thing. Instead, she is on record as saying that 'the male figure cannot bear the burden of sexual objectification'.[17] Thus, when the female is the subject of the gaze, presumably only another female—the woman in the movie—can be the object of that gaze.

The reason for her denial of the possibility of male sexual objectification is that 'man is reluctant to gaze at his exhibitionist like'.[18] This opinion is easily defensible. Yet, the most obvious effect need not follow that credible cause. What she has claimed is the *reluctance* of the male spectator to gaze at the exhibition of another male. Some writers on this area have implicitly accepted the full force of that diagnosis without accepting her final judgment (that there cannot be male erotic objects within dominant representation).

Steve Neale, for example, highlights the importance of disavowal as a strategy by which the male body may be presented as erotic spectacle in mainstream cinema without a direct recognition of the erotic nature of that spectacle.[19] Scenes of fighting and wounding permit the display of the male within what could be termed properly masculine entertainment. The hero who fights half-stripped or who has his shirt ripped off so that bleeding may be bandaged is engaged, in the first place, in the sort of aggressiveness and activity that is culturally accepted to be masculine; in the second place, his wounded body is an object of contemplation because of the exigencies of the narrative, not, apparently, because the male body is rendered an erotic sight.[20]

The importance of disavowal as a mechanism which has long permitted the full-scale exhibition of the male as erotic spectacle cannot be over-estimated. By means of it, 'magnificent' male bodies may be exhibited for scrutiny in art galleries without raising inadmissible questions about erotic gazing that inevitably touch on the taboo of homoeroticism. By means of it, photographed, filmed and videoed male bodies

may masquerade as deserving of the spectator's close attention only when they encounter threat or endure torture in something as 'male' as the action genre, for example. Sportsmen's bodies, likewise, are objects of the gaze only because men love sport, and those who play sport must be in top physical condition. Any erotic gazing can legitimately, as it were, be only from female eyes.[21]

Richard Dyer, while recognising the popularity of the male pin-up, notes key differences in it from the female pin-up.[22] If the men of male pin-ups are there to be looked at, officially, it seems, by women, there is a refusal in the model to acknowledge the viewer, whether or not he looks into the camera. Dyer notices that the male pin-up may look upwards, to emphasise spirituality, or offers the viewer what he terms a 'castrating' stare. Once again, disavowal makes an appearance, although in this account it is the imaged male who disavows the traditional passivity of the photographed object. This sort of disavowal is achieved by the activity of men, either actualised in photographed performance, or with active potential strongly suggested in such corporeal aspects as muscularity.

CONCLUSIONS

Whether or not there is a possibility of feminine gazing, it is demonstrable on commonsense criteria that the female subject of the gaze exists. If she did not, she might well have to be invented, in any case, for the male object of the gaze to exist and to find some sort of legitimacy in a homophobic society. Empirical evidence, particularly in the last ten years, suggests that the latter does exist and has negotiated various forms of legitimation.

The reasons that made Laura Mulvey deny the possibility of his existence have by no means gone away, even if the times seem to have altered between 1973 and now. If there have long been erotic male objects, they have been left relatively undetected for so many centuries because of the cultural habit of massive disavowal. Even now that they are detected, they in part disavow their own status through an emphasis on their activity and thus, it would appear, masculinity, serving to deny the threat of passivity—threatening because this is reckoned within patriarchal culture to be a feminine positionality. In any case, where male objects' objecthood is difficult to deny, a sort of disavowal is permitted whereby

they are objects in answer only to the demands of a female subject of the erotic gaze.

The threat of feminisation within the male pin-up is negotiated by such means as Richard Dyer has suggested. However, the greater threat—of the uncovering of homoerotic potential within the viewing of male objects—is obviated by today's more concerted encouragement towards the genesis of the female subject of the erotic gaze.

II · cultural secrets:
femininity as a male pleasure

LAURA MULVEY, AS HAS BEEN DEMONSTRATED IN CHAPTER 1, GIVES TO THE
female only the place of erotic object of the gaze. In doing so, she reproduces the division between the masculine and feminine as involving, on
one hand, activity/voyeurism/sadism on the masculine side and, on the
other hand, passivity/exhibitionism/masochism on the feminine. Her
attribution of the masculine, in these terms, to the male and the feminine, in these terms, to the female finds a persuasive rationale perhaps in
the world of dominant, narrative cinema. However, even if patriarchal
culture encourages this division and the virtual equation of 'masculine'
with 'male', this should not blind us to the possibility that the psychic
states of male and female may be a lot less neatly ordered.

Exhibitionism, for example, is deemed a mark of femininity. Therefore,
the woman who offers a pleasing appearance for the delectation of men
is treated as somehow natural within patriarchal culture, while the male
who exhibits, makes a show of himself, so to speak, has either to be
explained in less obviously erotic terms, or erotic terms must be found
which are more acceptable. Or else he must run the risk of being considered unnatural, effeminate or even perverted.

Yet, what is *deemed* natural for one gender and unnatural for the other
may be *experienced* quite differently.[1] The aim of the present chapter is to
show that men can never be fully 'masculine' in any case, but also that
exhibitionism, masochism and passivity, while culturally classified as
feminine, can make a strong appeal to the male.

MASCULINITY AS (DIFFICULT) ACHIEVEMENT

The equation of genital maleness with masculinity may be a cultural
habit which perhaps strives to cement the identification between sex
and gender demanded by patriarchy. However, the process must always
be an approximation, if, in Michael Kaufman's words, "masculinity" is "a
figment of our collective, patriarchal, surplus-repressive imaginations".[2]
The account of the psyche offered by Freud and Lacan leaves no possibility that there exists a pure masculinity or femininity. Split subjectivity

in human beings means that all men and women have elements which may be deemed masculine or feminine within a particular culture.

A belief in the close or total fit between maleness and masculinity seems today largely to be held by political conservatives. More oddly, in view of feminism's history of dismantling gender categories and the social beliefs that shore them up, it appears that this view is also held by some radical feminists, particularly within the pornography debate when pornography is taken to expose the truth about the essential nature of man. Yet, the evidence seems to be that 'masculinity' is continually being tested, that its borders are constantly patrolled by inspectors watching out for aberrations from or betrayals of masculine ideals, as held by a particular society. Thus, men endure anxiety that they may not come up to scratch, that their achievement of masculinity is less than perfect—which, to return to the psychoanalysts above, it inevitably must be.

Freud's account of the acquisition of gender identity makes the boy's route to 'masculinity' more tortuous than the girl's to 'femininity'. Her primary identification is with her mother, while the boy has to break identification with his mother[3] so as to transfer his identification to his father. The Freudian picture of differential infantile (post-Oedipal) experience clarifies some of the reasons why masculinity is experienced as defensive and insecure. It is born from the need to manifest a difference from the mother. The early manifestation has its counterpart in the male's adult life with aggressive, overbearing behaviour, often popularly associated with machismo, involving contempt for women, a denial of his own and others' emotional needs, competitiveness, an insistence on what is envisaged as strength in individualism and separation from sentimental ties—which can be translated easily into fear of what is envisaged as weakness and thus, in this process of learning, fear of the 'feminine'.

The male is routed psychologically towards power and away from powerlessness, as they are culturally understood. He is, as it were, trained to interpret the former as masculinity, the latter as femininity. Within Freud's account of the language of the unconscious, the mouth, vagina and anus are taken, because read as primarily receptive (in being capable of pleasurable stimulation by another organ), as primarily passive, while the penis in a male-dominated society is read by the boy

child as active and thus phallic. Threats to activity are understood within this thinking to be castrating. Thus, whatever is culturally associated with the culturally regarded feminine presents a potential castration threat which must be guarded against. In this way are misogyny and homophobia born—and also linked together in the process of the acquisition of gender identity under patriarchy.

One cogent explanation for the apparent compulsiveness in certain men of aggressive, unfeeling behaviour is this: that the male fear that masculinity may not have been safely achieved once for all has repeatedly to be kept at bay by demonstrations of the sort. Thus, even the male who most assiduously demonstrates his masculinity exposes the fact that it is not as natural as he would like to believe it. In this sense, masculinity is a masquerade, an identity worn like a second skin in some cases but never as biologically given as the first skin.

Gender roles within culture are not only distinguished but often polarised. It is important for the analysis of human potential that cultural belief does not itself masquerade as truth. Thus, what are taken to be inbuilt antitheses between male and female behaviour need to be traced to the moment of gender differentiation after what Freud terms a period of polymorphous perversity, when desire for both male and female infants is indistinguishably active.

When masculinity is recognised as a cultural construct, this is not to say that it is a monolith, since cultural conditioning is effective to different degrees and in different ways. It might be fairer to think in terms of 'masculinities' rather than in those of a single 'masculinity'. Constance Penley and Sharon Willis claim that "what we call male sexuality is far more complex than feminist theory has hitherto recognised".[4] It is more complex because it is inflected by class, race and ethnicity. Laura Mulvey's account of the 'male' pleasures of narrative cinema helps to reify masculinity, to suggest that there is a neat fit between the 'male' spectator as constructed on classic cultural lines by the cinematic text and the biologically male spectator in the cinema seat.[5]

The plurality of the masculine is to be anticipated in the sense that there may be an attempt at a hegemonic version but that there are also the non-hegemonic versions that gain currency among, for instance, self-identifying gay and/or black males. Even within terms of hegemony, there are interventions by the media, in which new versions are pro-

moted. Thus, the New Man could be described as an invention through the agency of popular journalism, even if this version has hardly ousted the previous version of media-created masculinity embodied by Rambo.[6] It could be further suggested that the 1980s, the decade in which these identities were created, is a period when postmodernism helps to dismantle the operations of gender (and other) identity construction, when there is, to quote Yvonne Tasker, "a denaturalising of the supposed naturalness of male identity".[7] (Something of this process is detected by Sandy Flitterman in American television's *Magnum p.i.* series, which she believes plays upon the cultural constructions of masculinity. Flitterman claims a parodistic, semi-ironic stance which "functions to problematise the look at the male body".)[8]

These examples offer the possibility that when it no longer, as it were, suits capitalism that there be two antithetical, mutually exclusive genders, the patriarchal demand for belief in them is undermined. If contemporary capitalism needs, in addition to security of production, a technology of consumption together with the legitimation of desire, it is fair comment that the "differentiation of bodies by sex is increasingly irrelevant".[9] If it is irrelevant to consumer capitalism, however, differentiation is a social habit that cannot simply be switched off. Because it cannot be switched off, it carries danger and difficulty when this is downplayed. Thus, in discussing Sonny, the white hero of *Miami Vice*, Lynne Joyrich analyses him in terms of spectacle, but feels that she has to describe his 'feminisation' as 'contagion', on the evidence of the moment where he smooths his hair in the gesture characteristic of his prey.[10] While she recognises the complex and unstable inscription of gender in American television, she states that shows of male spectacle "require the neutralisation or absence of women (while still disavowing any overt homosexual eroticism)".[11] Male power in patriarchy is affirmed largely by power over women, a power which continues or has to be affirmed in different form even when men are accorded 'feminine' qualities as 'New' or as spectacle.

MEN'S FEAR OF FEMINISATION

When Freud claims that every individual "shows a combination of activity and passivity whether or not these last character-traits tally with his biological ones", he seems to imply that there are biological character

traits and thereby to show difficulty in quite relinquishing the notion of maleness as determining masculinity.[12] It may or may not be fair to read a shared male fear of feminisation into his statement.[13] Yet, it is part of maleness in Freud's account of psychological life that, however much that state seeks to distance itself from the feminine, all subjects, male or female, must be feminised in the sense that castration, associated with weakness and the feminine, is a necessary part of what subjectivity entails. Entry into Lacan's Symbolic Order necessitates loss of access to the mother's body but also a splitting away from the Imaginary's whole-ness and complete presence, so that the subject is less than whole and thus must accept castration. Patriarchal culture's stress on women as castrated cannot totally disguise the applicability of the term to the male too. With this awareness, Kaja Silverman calls not for a masculinisation of the female subject in women's interests but for a feminisation of the male subject, since this would constitute "a much more generalised acknowledgment . . . of the necessary terms of cultural identity".[14]

With this understanding of the male's predicament in mind, we can see that 'masculinity' involves not only a rejection of what the male believes to be the feminine weakness inherent in women, but of the 'feminine' within himself.[15] Hence, patriarchy's vision of the human world as made up of binary oppositions may provide a means of warding off the unac-ceptably 'feminine' from the male surrounding himself with 'masculine' charateristics, but, in order to make that imagined gain, dichotomous thought has to exclude "most of experience".[16]

The male caught out, as it were, in a position deemed culturally femi-nine manifests his fear and loathing by energetic disavowal. Thus, the male who is looked at with desire may turn to exaggerated displays of machismo to reassert his precarious sense of masculinity.[17] This would appear to be particularly true of the man who is looked at with desire by another man, since he is rendered 'feminine' in two principal senses: he is made an object of the gaze, and he may be made a receptacle for active male desire.[18]

Means of disavowal are legion, however. Apart from spectator sports as an alibi for looking at male bodies, the presence of women in an oth-erwise homoerotic situation may dispel suggestions of homosexuality.[19] Then too, increasingly, as Susan Jeffords explains, the "aesthetic of tech-nology can divert attention away from the male body as an object of

homoerotic desire".[20] Hence, obviously, the posturing and accou-
trements of Rambo—portrayed as a hero in the 1980s, when *Taxi Driver*'s
Travis Bickle was readable as a misguided psychopath for similar pos-
turing and accoutrements in the previous decade.

Disavowal, by rendering what may otherwise be seen as the desirable
male body as itself technological in appearance—as in the case of Stal-
lone, Schwarzenegger, Dolph Lundgren—has its problems. One of these
is, as Robert Mapplethorpe's photographs of female body-builder Lisa
Lyons show, that male muscles can be made to seem quite arbitrary.
After all, neither male nor female muscles in these instances are the
product of (wage-earning, menial) manual labour. Thus, the signs of
masculinity threaten to become uncoupled from maleness, precisely the
coupling that male body-building may be undertaken to ensure.

Yet another form of disavowal can involve stress on the measurement
of men's 'masculinity' by their social status, intellect or, increasingly in
the 1980s, their material success. Thus, *Arena* magazine's eroticisation of
men's bodies for the pleasure of other men's looking was balanced and to
an extent disavowed by the message of the feature writing which was
that, in Jonathan Rutherford's words, "the conventional male concerns
with money, power and status remained, albeit through the lens of a new
male interest in consumption".[21]

MEN'S WISH FOR FEMINISATION

Laura Mulvey, as has already been noted, offers a place for transgender
identification in fantasy, but for women only and identification with the
active male hero of narrative cinema.[22] Given this concession, it is odd
that she does not take even tentative steps in the direction of male trans-
gender identification possibilities. One possible explanation could be
that she accepts the official version of masculinity, whose public face is
to rejoice in the pleasures of activity and control of others. Yet, since the
woman of the diegesis seems to represent the feminine, to be not simply
a woman, and since the feminine is a component of all biological males'
natures, it is very odd that no possibility for identification with female
characters, even in fantasy, is permitted by Mulvey in her account of nar-
rative cinema's workings. Mary Daly, in her unexceptional attempt to
argue that certain male characters in celebrated novels penned by
females are really transsexed females,opens the door to the suggestion

that male readers responding through identification to even male char-
acters are in actuality sometimes enjoying a transsexed experience.[23]

If men can be taken to enjoy a plethora of subject positions in the world
that patriarchy has constructed, it is surely not unlikely that fantasy invites
men into object positions, not least as receptors to the image, by which
they become psychologically aligned with the object of desire in a species
of identification. As a particular illustration of this general possibility, Gary
Day thinks that pornographic fantasy may well indicate men's desire to
become like women.[24] A measure of corroboration for his surmise is
offered by male stripper Rebel Red, who says of his act, "If women want to
exploit me, that's fine. I enjoy it. I'm just turning things round".[25]

In social actuality, while women continually experience and bitterly
resent sexual harassment in the workplace, it seems to be the case that
there is a cultural expectation that men should enjoy sexual harassment
by a female boss. The man reporting the incidence of such harassment
appears to suffer stigma.[26] If masochism is an inherent part of 'femi-
ninity' as reported by Freud, it is particularly interesting if as a sexual
practice masochism is pursued by more men than women.[27]

Further evidence for men's only half-confessed wish to experience the
'feminine' could be suggested to lie in drag as an element in entertain-
ment. Thus, in *Tootsie*, Dustin Hoffman finds not only that he can pass as
a woman but that he is better at being a woman than the other women in
the film. His assertion that, once his performance of femaleness is
uncovered, he really is still Dorothy echoes Flaubert's similar assertion
about Madame Bovary.[28] It may be too simple, though, to suggest that
the appeal of drag is simply that men temporarily get to be women. The
joke element of much public drag performance may be a means of over-
coming men's fear of women's bodies. Thus, cross-dressing can, in Judith
Williamson's words, "appear to bridge the frightening gap of sexual diff-
erence. After all, if men can do it (be women) there's nothing to it!"[29]

This interpretation helps to raise the idea of male mastering of an oth-
erwise nagging doubt. For at least the last decade, a fear has been
expressed from a number of quarters that men's self-feminisation is a
relatively new means to dominate women, and that most seriously it
damages the chance of "a possible, positive specificity of female iden-
tity"[30] Alternatively, it has been mooted that the evident postmodern
fascination with a subject who is androgynous (Boy George, Laurie

Anderson, Tootsie) could indicate a desire to evade addressing the prob-
lems flowing from patriarchal society's oppressive gender roles, espe-
cially as constructed for women.[31]

Freudian theory notes, but cannot explain, male envy of the female,
except in terms of homoerotic or autoerotic desires. Yet, male desire for
women does not eliminate the possibilities of identification with them.
Much film theory concerned with spectatorship makes the mistake of
assuming an either/or relation between desire and identification, as if
one precluded the other.[32]

MASOCHISM

If the appearance of physical health and the building and maintenance
of musculature are vital components of the masculine image from the
1980s onwards, then contemporary masculinity is shot through with at
least one obvious contradiction. Masculinity may traditionally be active
and thus, sadistic.[33] Yet, at the heart of all the fashionably 'masculine'
leisure pursuits, such as athletics, gymnastics, jogging, aerobics, is the
notion of pain, and of glorying in the triumph over pain.[34] Thus, it may
not be sadism which provides the key to contemporary masculine iden-
tity but masochism.[35] Allied with the working-out ethic of pushing the
body beyond 'the pain barrier' is another feature of masochism, self-
objectification—learning to view the body as object, to be worked on
and studied by the man himself, to attract the attention and, it is hoped,
admiration of others.

According to Phyllis Chesler, part of heterosexual males' fantasy is their
domination by either men or women, although these fantasies cannot be
tolerated or admitted, since the men who have them must thereby face
imagining themselves "in the devalued female sexual role: at the mercy
of other men".[36] Within the masochistic scenario, as interpreted by Gilles
Deleuze on the basis of Leopold von Sacher-Masoch's novels, the patriar-
chal attribution of differential power positions by gender is subverted.
Thus, the male is, at least in role-play, enslaved by the female and surren-
ders power to her. The pleasures of masochism are explicable as being
rooted in infantile fear of loss of the mother. It is this fear which above all
gives her authority. Masochism "obsessively recreates the movement
between concealment and revelation, disappearance and appearance,
seduction and rejection", as Gaylyn Studlar explains.[37]

Such an account of masochism within childhood experience is aug-
mented by Kaja Silverman's drawing of attention to the way that the
superego forbids the son's becoming the father (the desired end of nar-
cissistic libido): "the 'ordinary' male subject oscillates endlessly between
the mutually exclusive commands of the (male) ego-ideal and super-
ego, wanting both to love the father and to be the father, but prevented
from doing either".[38]

So, it is part of the formative psychic experience of male socialisation
that makes masochism not only possible but a likely male pleasure in
later life.[39] The general lack of acknowledgment of the pleasures of pas-
sivity for males is to be understood as part of male flight from 'the femi-
nine' within patriarchy. Silence or repression of knowledge obviously
does not disprove the case. It may, rather, strengthen it. Within our
culture, masochism is acceptable or even admirable in the female
subject and is attributed to her as a component of her normal, natural
psyche, but what is acceptable within the female is rendered patholog-
ical within the male. Clearly, its identification as 'feminine' makes
masochism a threat to the male's retention of his 'masculinity'.

Marilyn French makes a highly relevant point when she suggests that
both men and women identify with the victim in sadomasochistic
pornography. The importance of this is "not just because it challenges
the notion that women are by nature masochistic and men are not", or
because it shows "both sexes as masochistic", but because "it offers
insights into our symbolic experience of sex". Most surprisingly, perhaps,
sadomasochistic experience suggests that it is the masochist, placed in
the socially feminine position regardless of gender, who retains control
of events.[40] The acting-out of masochism as a perversion instead of as a
normal condition of subjectivity, male or female, could be taken to
reflect what it would undermine.[41]

Part of the pleasure of the 'male' genre of the action movie may well be
masochism, the suffering of the wounded or broken body of the male
hero with whom the spectator is invited to identify, but the masochism
must be temporary. Suffering is part of the trial or rite of passage, which
leads to the hero's triumphant reassertion of 'masculinity'. Popular
culture's narratives "in effect enclose and contain male masochism".[42] In
this way, popular culture behaves, not surprisingly, in a manner that pro-
motes popular understanding of masculinity as set over against

masochism. The point of the masochistic moment's inclusion in the narrative may be to defuse the threat from it to 'activity' and to the pleasures of mastery.

Rather than think of the ultimate denial of masochism as *simply* a negation of it as 'masculine' pleasure, it may be possible, however, to liken the progress of the action-movie narrative to that of the melodrama.[43] Melodrama too must end with a closure in favour of the patriarchal status quo, with errant heroine recuperated or punished/eliminated. Yet, the interest of the melodrama may indeed be in the dust it raises on its way to its recuperative closure rather than in that closure. It is equally possible to see the action movie's avowal of male masochism as highly significant, even if it must ultimately be disavowed in a closure recuperative of the hero's 'masculinity'.

The process is similar to that of working out. The jogger or weight trainer may ask that attention be focused exclusively on the result of the exercise rather than on the psychology involved in the progress towards that result. More significantly, the fantasy masochist returns to quotidian reality with power differentials still held in place by culture. Is the fantasy transaction thereby rendered as of no significance, though?

The most influential accounts of looking in narrative cinema play up sadism and downplay masochism or pass it over in silence. It may be unfair to suggest that the reason for Laura Mulvey's silence about masochism could be that discussion of it would water down a delineation of cinematic pleasure as essentially masculine. Even if this account of her motivation were fair, though, that would be to accept cultural notions of masculinity as active and aggressive, whereas work such as Silverman's would suggest that masochism is at least as crucial in the development of the post-Oedipal male psyche as of the female.[44]

MALE EXHIBITIONISM/NARCISSISM

The transition from the previous section to this is eased by Theodore Reik's remark, "denudation and parading . . . play such an important part in masochistic ritual that one feels induced to assume a constant connection between masochism and exhibitionism".[45] In any case, the phenomena are strongly linked by both of them being deemed proper to the female and pathological and perverted in the male in the patriarchal account of the gendered human psyche.

Alternative versions of psychic reality would suggest otherwise—that, for example, exhibitionism is as fundamental to the male as to the female. Lacan's Mirror Stage, through which the passage into subjectivity is effected, must have the presence of an other (standing in, as it were, for the Other) corroborating, for example, that this mirror image is indeed the image of the self before it. Kaja Silverman explains the situation thus: "the subject sees itself being seen, and that visual transaction is always ideologically organised".[46] Therefore, "the male subject is as dependent upon the gaze of the Other as is the female subject, and as solicitous of it— in other words . . . he is as fundamentally exhibitionistic".[47] In historical terms, the fundamentally male pleasure of exhibitionism is suggested by the so-called Great Masculine Renunciation, whereby the exhibitionistic and narcissistic desires given expression through aristocratic sumptu- ouness up to the eighteenth century were thereafter renounced. Thence- forth, such masculine tastes for display had to be dealt with through the processes of sublimation, reversal into scopophilia or male identification with woman-as-spectacle.[48]

Yet, it can be suggested that narcissism, being linked with psychic sur- vival, plays a more important role in the unconscious than Oedipal crisis in its relation to psychic disorder.[49] Narcissism's origins can be traced to the depressive position when the infant begins to perceive itself as sepa- rate from the mother. Libidinal energy is diverted from external objects on to the ego, as a defence against the fear of losing the mother.[50] Voyeurism, which *is* given a place within cultural understanding of mas- culinity, can even be located within the pleasures of narcissism. Charles Henri Ford helps to make the point credible when he states, "The perfect voyeur is a narcissist because he needs no partner and he can be the voyeur of himself".[51]

As has been noted above, masculinity and visibility were not always opposed. Before the so-called Great Masculine Renunciation, when the rise of the European middle class may have ensured that modesty and industry replaced aristocratic values, the most powerful and privileged males between the fifteenth and seventeenth centuries demonstrated a sartorial extravagance that equalled and often surpassed the female variety.[52]

If the narcissism of Western males has had to find oblique expression since the eighteenth century, there are obviously careers which provide

not merely a wage but the chance to express the apparent urge to exhibit and to be admired, in role.[53] Important elements in the choice of dancing as a profession may be narcissism, the desire to seduce an audience and exhibitionism.[54] Some ballets, in turn, partly in recognition of these factors, are created to show off the beauty of the dancer's body.[55] There are opportunities within leisure activity, on the other hand, for those narcissists who might find a career choice based on awareness of this factor in themselves too extreme. Thus, for example, the motivation for a holiday in St Tropez has been claimed as more probably for narcissistic than voyeuristic reasons.[56]

Since the rise of the male pin-up in mainstream magazines 'for women', there has been a good alibi for male narcissism in the claimed desire of women to look at male bodies. The convenience of this alibi could, though, suggest that female desire has been projected by men into a form which manages to stress an imagined ideal of heterosexual complementarity, as well as to provide a screen for male desire to exhibit. Moreover, magazines circulating knowledge of male style among men and including photographs of male models help to open up masculinities and to make them, in Sean Nixon's words, "less armour-plated".[57] Whatever limitations we might want to put on the incautious intepretation of such magazines as advertising what could be termed a freer version of masculinity, they do surely permit male pleasure in self-display to come out, in the modern understanding of the phrase, to some extent, however closely that pleasure is implicated within, or even alibied by, a new species of consumerism.[58]

Far more direct, and unpleasant, evidence of exhibitionism as a powerful component of 'male' sexuality, albeit pathologised as a particular perversion within medical discourse, is the common female experience of what is popularly known as flashing.[59] Significantly, female striptease performance may be responded to by means of male exhibitions.[60]

Despite such evidence of the cruciality of exhibitionism as a 'male' pleasure, the overt admission of its pleasurableness by a man produces punitive reaction in society. Because of the connection forged culturally between visual display and the feminine, virile display, as Lacan sees, itself appears feminine.[61]

The male star who presents his body as object of the cinematic gaze seems to forfeit his reputation for unassailable masculinity.[62] The truth

of this is strongly suggested by the latter part of Rudolph Valentino's career where even the physical culture pin-ups were taken to confirm what Miriam Hansen calls "the masculinist projection of him as 'castrated'".[63] There are, though, clearly loopholes and alibis possible. Otherwise, the reputations of *all* male stars would to some extent be forfeited, since all are at a commonsense level objects of the cinematic gaze, even if not all expose their bodies or pleasure in the exposure of their bodies to the same extent. It is evident too that, in the action genre for instance, certain male stars retain their reputation for hypermasculinity at the same time as they swagger in semi- or even full nudity. It is particularly interesting, in this relation, to have homoeovestism, or the wearing of an athletic article or military uniform during sexual activity—to deny castration—interpreted as in major part a narcissistic act.[64]

Body-building and Olympic-standard athleticism are satirised memorably in *Gentlemen Prefer Blondes* for being so narcissistic as to divert the muscular male beauties from awareness of, let alone interaction with, Jane Russell as she sings 'Ain't There Anyone Here for Love?' The parody is less that of exaggeration than one dependent on what might appear to be shocking revelation of a hidden truth. One description of the objectification involved in body-building stresses that it does to the body-builder's own body what is done in a more general way to bodies in advertising—and that narcissistic self-objectification is literally reflected by the mirrors placed round gymnasium walls.[65]

Male narcissism as the negation of desire is already suggested by the aforementioned musical sequence from *Gentlemen Prefer Blondes*. A similar comedic treatment of perfect male bodies as the sad indicator of lack of attention to female need appears in *Li'l Abner*. Yokumberry Tonic, used by Mammy Yokum on her son, the handsome, muscular young hero, is imbibed by the other men of Dogpatch, with the result that they become beautifully built musclemen of such narcissism that they fail to see, let alone make love to, their spouses. The misery that the movie indicates is caused to the wives by male narcissism is indicated in the song lyrics of 'Put 'Em Back the Way They Was': "He was fat and unattractive / But by golly he was active" and "He was tall and he was lanky / But he knew his hanky panky".[66]

A more straight-faced statement of what could be thought of as body-building's danger of desexualisation is made by Antony Easthope: "If

sexual drive is withdrawn into the 'I' it becomes partly desexualised and can be directed to a non-sexual end", that end being sublimation.[67]

In the context of film-viewing, 'male' pleasure in the contemplation of Tarzan may be narcissistic, but spared the connotations of sexuality when admiration of near-silent strength and identification with it are emphasised in place of audience narcissism. Nakedness or near nakedness is aligned with powerlessness in a number of influential accounts of stars being gazed at in those states. Yet, there seems to be some dispute about the relation between undress and power. On the one hand, for example, we have Alan Hollinghurst saying in his narrator persona for *The Swimming-Pool Library*, "There is a paradoxical strength in display; the naked person always has the social advantage over the clothed one (though the naked person can forget this, as innumerable farces show)".[68] On the other hand, a quite opposite belief is expressed by Jack D. Douglas et al.: "Clothes' crucial property is that they are . . . displays of dominance", and dominance is a "vital social aphrodisiac and provider of access for the male clothes-displayers".[69] Perhaps an answer to this contradiction is to be found in the inscription of gender, since the context of the first statement suggests homosocial if not homosexual space for unclothed/clothed proximity, and the second appears to imply mixed-sex locations such as 'the nude beach' of the book's title. The second view rests also on the notion that power is always sought by males. It is part of the purpose of this chapter to cast doubt on the notion that powerlessness is an antithesis to 'male' pleasure in all circumstances, including those of fantasy. It may be too simple, in any case, to align exhibitionism with powerlessness, pleasurable or not. Male, and other, privilege may transform the social meaning of self-display in certain men. Thus, for example, exhibitionism seems to be conceded as quite legitimate for rock stars.[70]

Until recently, there have been few opportunities in patriarchal culture for male exhibitionism, even to the extent of receiving admiration for physical appearance. The socially sanctioned areas of opportunity have to be carefully negotiated, so that insistent suspicions of anything which could be termed unnatural or unmanly about attention being drawn to the male body can be minimised, if not completely laid to rest.

Sport in general permits—and indeed in some senses is inseparable

from—display of the body, above all display of the male body. In most social entertainment contexts where the male body is scrutinised, there has traditionally been the provision of more and less cogent alibis, where these seem to be needed, for the scrutiny. In the sporting context, the inhibitions attendant on the spectator's gaze at the partially dressed athlete, for example, shelter beneath the explanation, credible but arguably partial, of quasi-scientific inquiry, an assessment of athletic potential and performance with reference to the corporeal data, so far as the data may be revealed by, say, the close attention of the television camera.

Related opportunities for both the display and viewing of the body, male as well as female, were afforded throughout this century particularly by the social activities of nudism and body-building. These may be linked to the ethos of sport through their emphases on health and physical well-being and yet in other respects have a more debatable relationship with it, and therefore with its alibis.

NUDISM

The nudist movement first gained popularity in Germany after the First World War. It has been claimed that the movement provided opportunities for escape, to the countryside and 'nature', from awareness of defeat and the monotony and pollution of increasingly industrialised city life. Presumably, it was for quite other reasons that Hitler closed the nudist parks in 1933 and that there was proscription of the movement itself.[71]

Nudism found a new location, in the United States, after the Second World War and served as inspiration, briefly, from the later 1950s for some feature-length film celebrations of the wholesome healthfulness of full nudity. The nudist body as presented for the cinema spectator, however, had taboo areas, breasts and bottoms being favoured against full frontals. This implicit differential eroticising of the covered and uncovered areas undermined the overt commentary (stressing nudity's naturalness and innocence) in favour of spectatorial pleasure. By the 1960s, the connotations of nudity embraced passive hippy protest against hypocrisy and re-pression.

Although the nudist movements avoid placing more stress on either of the genders, instead representing nakedness as beneficial at a broad human level, it is worth noting that as early as 1933 Dr Maurice Parmelee

claims that women have more to gain from 'gymnosophy', since this gratifies women's "desire to see male nudity".[72] The interest of the statement lies as much in the male author's attribution of spectatorial desire to women as in the truth it purports to convey.

Adherents to nudist philosophy might seek to promote the ethos of a wholesome innocence which precludes eroticisation of the naked body. Yet, there must be complications of this project when viewing of nudists, by largely non-nudists,[73] comes into play, as, for example, in films and magazines. The use of the air brush to obscure genitals on nudist photographs until, in the 1960s, when American and British naturist publications were allowed to print unretouched photographs, suggests as much. Nudist photographs, particularly in 1940s and 1950s America, become one means by which the photographing of naked males and the distribution of these photographs could be legitimised— by the placing of emphasis on the contribution to physical well-being made by the shedding of clothes and by a downplaying of the possibilities of erotic spectacle.

BODY-BUILDING

Cults of the physical can be traced from ancient Greece and China, through the early-nineteenth-century Prussian cult for fitness, to the 'perfect man' exhibit embodied by Eugene Sandow at the 1893 World's Columbian Exposition, in Chicago. The crucial difference between Sandow and the earlier disciples of fitness cults is that the invention of photography allows his physique to be captured and exhibited to those unable to be present at the exposition in person. The photographs of Sandow, a muscleman who found his niche originally in the music hall, took a variety of forms, including those of the cigarette card and the illustrated tin plate. They became, in Alasdair Foster's words, "independent objects in their own right, icons through which Sandow's body, or, more accurately, images of Sandow's body, could be looked at, admired and fantasised over by people who had never seen him in the flesh".[74] The possibility of photography's enabling of wider publicising and pleasurable use of Sandow's muscular physique is underlined by the exploitation, at the turn of the century, of his appeal for advertising ends (Sandow's image promoted a particular brand of beer). In the Sandow photographs, his potential strength is suggested, rather than actualised

through a representation of his performance of heroic feats. Relevant to debates about objectification (principally, that the term has different applications depending on the gender of the object) is the attribution of name and details, an individuation of the man presented to the viewer.

It could be claimed that the zenith of physique photography is reached in 1950s America. This might seem surprising, in view of the fears inspired by McCarthyism. The posture of body-building magazines, however, seems largely to be the celebration of the 'masculine' and the 'all-American' model, despite the Athletic Model Guild's playful sense of camp, both in the style of certain photographs and more consistently in the verbal text included in *Physique Pictorial*.

It was estimated in 1992[75] that roughly five hundred thousand men regularly work out in Britain's gyms. This is not exactly to claim, as another source does, that there were roughly five hundred thousand male body-builders in Britain in 1992[76]—the distinctions between body-building and working out are too easily erased in several non-specialist accounts—but the figures do suggest a permeation of the notion among men that tendance, as well as building, of their physiques is now identifiable as appropriate 'masculine' behaviour. While there are female body-builders, men predominate significantly in this area.

In the latter 1980s, there was observed among young males a tendency to express preference for the mesomorphic body type and a particular preference for the hypermesomorphic (or muscular mesomorphic) body type.[77]

The present absorption of body-building and working out within the repertoire of culturally deemed normal male activities has been read in relation to capitalism. The body-builder has been taken as an image of aspects of a late-capitalist consumer society, especially in so far as that society evinces concern with the outside, "with surface rather than depth", and with visibility.[78] The Sylvester Stallone of *Rambo: First Blood Part II* epitomises those aspects of that version of masculinity.[79]

While the muscular man's sense of masculinity depends on a belief that muscles are natural, that his body is God-given, this belief disavows the obvious implication of attendance at gyms and of the rituals of working out, that the developed body is, in an age when intense physical labour is not required for even blue-collar workers, artifactual, not natural at all. The theatricality of the more summative moments of body-

building, such as the physique contest, where males have to display their
built bodies to best advantage, tells a different story from the account
that sustains the same body-builders' activities: namely, in the latter
case, that muscles belong naturally to masculine men. Another under-
current that sustains the 'masculinity' of men's cultivation of their bodies
is that, at a time when there is an observable narrowing of social gaps
between men and women in occupations and lifestyle, body image
becomes an area where men can feel confident of their ability to differ-
entiate themselves from each other. (The obverse is that men become
less differentiated from women by the same token, in that both genders
thus demonstrate near obsessional concern with appearance. Moreover,
this concern and the loss of self-esteem consequent on daily exposure to
ideal-body representations in advertisements, which were once deemed
traditional for women, have now extended to men.)[80]

Throughout much of this century, up to the early 1980s at least, it has
been broadly possible to divide the visual field between male surveyors
and female surveyed, the latter's bodies being overexposed and thus
minutely scrutinised, while the former's remain out of sight and appear
to be exempted from critical examination. No longer. Whatever rationale
may be clung to in the name of a shifting, but resistant, sense of mas-
culinity, the massive popularity of working out and body-building is
open to readings that may suggest the unsatisfactoriness and partiality
of the more reassuring interpretations. For example, body-building has
been labelled "homoerotic burlesque", in light of awareness that videos
of body-building competitions have been shown on gay bar screens as
erotic entertainment.[81]

The very anxiety to establish the heterosexual credentials of, for
example, the body-builders in the 1977 movie *Pumping Iron* must be evi-
dence pointing to the fear that that anxiety may not be groundless, that
there is something about male concern with physical culture and exhibi-
tion of the cultivated body that sits uneasily with traditional conceptions
of masculinity (aligned by tradition with heterosexuality). The co-option
of female body-builders within an ideal of maleness, so that they are
valued only in proportion to their ability to develop 'male' physiques,
hardly provides full security for an embattled sense of masculinity.
Another sort of reassurance, however, may be provided for cultists by the
bypassing of eroticism and the foregrounding of healthfulness, as with

nudism. This foregrounding is given particular credibility by insistence in the 1980s on self-management of lifestyle as a major health-promoting activity.

The tension between 'masculinity' and 'femininity', with their associated antinomies of activity/passivity, subject/object of the gaze, is perhaps inevitable in relation to the body-builder, and certainly inevitable in the case of the male body-builder as star of the male-action movie genre identified by Yvonne Tasker. Recognising that the muscular male hero is read by some as symbol of a reassertion of traditional masculinity, by others as a hysterical image, "a symptom of the male body (and masculine identity) in crisis", she feels that she cannot choose between these diagnoses.[82] The cinematic body-builder hero is, after all, both posed and in action. If the appeal of body-building rests perhaps on its illusion of power, that illusion has particular appeal to those men who feel powerless in actuality, in particular black and working-class white men, men whose bodies, in display, are already sexualised in the action genre.

Body shaving, long an established procedure to prepare the body for its appearance in a muscle magazine or in a body-building competition, is an apt symbol for the irresoluble tensions discussed. The depilated body may be linked with fine-art marble representations of maleness, and can justly be claimed to imply "a quality of genital maleness (body as superphallus)".[83] At the same time, it clears the displayed body of the hirsuteness of hormonal maleness and renders the body-builder's appearance in some senses as epicene. It displays, particularly with the addition of oil to the body, the muscles, the visible marker of 'masculinity'; yet, at the same time, it exposes the body more to the gaze, renders it more 'to-be-looked-at' and thus feminised, suggests an obsession with appearance which has been traditionally associated with the feminine. These contradictions are outside any individual's conscious control.

MALE IMAGES AND 'MASCULINITY'/'FEMININITY'

The paucity of social opportunities for male display, and the defensiveness with which these are taken, testify to the difficult negotiations that have to be undergone in the effort to keep thoughts of feminisation at bay. They are not, though, evidence that impulses to exhibitionism, passivity and, thus, feminisation are foreign to the male.

There was a time, no more than ten years ago, when self-identifying heterosexual men and also women took as axiomatic the proposition that women's bodies were attractive, while men's manifestly were not. It is, in Rosalind Coward's words, this "strange contradiction at the heart of a culture which in many ways is strictly heterosexual"[84] which has traditionally served the purpose of allowing men to evade scrutiny. It keeps male sexuality every bit as mystified, while it purports to be without guile or subterfuge and pretends to be natural, as male bodies have been. Even when the body is discussed or imaged, there is a stereotypical understanding of masculinity which may well underpin discussion or image. In its striving after hardness, straight lines and flat planes, the stereotyped male body seeks to eliminate the possibility of desire for it. Thus, it fulfils the conditions for what Freud identifies as a cornerstone of society, the suppression of homosexual desire between men. In Antony Easthope's words, the masculine body "would really like to be a cubist painting".[85]

What it would like to be is not, though, how it always seems to be. As the body-builder adds muscle and bulk to his frame, his breasts and buttocks fill out. As the masculine body seeks to exclude curves, it gains them. In any case, the display of the male body (and that is often the masculine body) no longer effects the sublimation of narcissism. Narcissistic elements in male imagery are avowed in ways that would have been little understood in mainstream imagery a short time back.

If male imagery is less inclined traditionally to dismember and fragment than female, favours active over passive, personalises where female imagery universalises, refuses to engage with the viewer's look or else meets it confidently and smilingly, asserting phallic power, if the imaged male connotes independence and self-containment, prefers in fine-art contexts the domain of the public space to that of private fantasy, male imagery still does not exclude the erotic. The eroticism of classical and Renaissance male nudes may be disavowed by art historians, perhaps by the artists themselves. Alternatively, their eroticism may be categorised as homoeroticism, which permits another sort of disavowal. The eagerness with which homoeroticism is attributed by those who want to hive off and ghettoise assumes too much. After all, if in patriarchy viewing is done through male or else masculinised eyes, the eroticism of male imagery becomes, by definition, homoeroticism.[86]

There is another corollary of interpreting patriarchal looking as being effected through only male or masculinised eyes. Since male looking is likely to be aligned with heterosexual-male looking, the effect is probably that the object of the male gaze must be, if not female, feminised.

One of the ways in which 'femininity' is permitted to stay solely proper to the erotic, at the same time as maleness is allowed entry to the field of the erotic, is through the figure of the boy or adolescent.[87] Through the feminised youthful image, artists manage to keep what is culturally identified as beauty as essentially a female quality, while the force and vigour allegedly proper to manhood excludes aesthetic-isation. By this century, Jim French's photographic male (muscular) nudes can be interpreted as a protest against the assumption of beauty as women's exclusive property, while Valentino's appeal emanates from his "alternative form of male identity", one which refused to separate maleness and beauty in the way that American society of the time demanded.[88]

If the body resists feminisation in other ways, it may be rendered masochistic spectacle, as with the male nude in Christian iconography, or the brutalised bodies of mainstream action cinema, which disavow the erotic gaze at them. The crucial factor, according to Paul Smith, is that the masochism is *temporary*. The pierced and bloody body of Christ is resurrected. He returns in glory, however protracted the narrative/visual concern with former degradation and suffering.

Thus, even in its potentially most feminised positions, as object of the photographic gaze, the male body usually promises that it has only temporarily abandoned 'masculinity', that this is waiting to be reasserted.

III · the instability of male imagery: re-reading against the grain

GIVEN THE UBIQUITY OF DISAVOWAL IN THE CONTEXT OF MALE IMAGERY, SO that it has traditionally been other than erotic ('magnificent', 'inspiring', 'heroic', but almost never 'erotic'), it is possible to look at millennia of high art or the last two centuries of more popular arts and believe that there have been no male erotic objects. Where these have been found, they could be thought to belong only in clandestine half worlds which are constantly threatened by legal penalty and official censure.

Certain feminist critics, when faced with dominant traditions of cinema that have been written off as unproductive for women, have refused to be confined within an attitude which would argue that a text's meaning is locked within it.[1] Instead, they find exhilarating political potential in what may be termed 'active reading', in the belief that signification is not a pre-existing matter, already within a text, waiting to be discovered, but that it is a process which vitally concerns readership and reception. Annette Kuhn in particular, throughout her book *Women's Pictures: Feminism and Cinema*, advocates the strategy of reading against the grain as a way out of the apparent impasse in which a more despairing view of narrative film texts and, by extension, of other artefacts within a dominant tradition of patriarchal production leaves women.[2] Reading against the grain can be termed 're-vision'.[3] It involves a second, harder, look at visual and other texts to see whether the preferred reading is the only reading possible or whether an alternative covert—and to many minority groups more persuasive—reading has greater power to illuminate.

Postmodernism, when it is considered as "a conflict of new and old modes . . . and of the interests invested therein", tends also to open up the closed text.[4] The deconstructive strategies of postmodernism could be thought to rewrite closed systems, so that it joins with feminism in at least one regard—the challenging of master narratives.

Counter-readings of male imagery in the context, say of high art, can suggest a persistent eroticisation of power through the use of the male nude. Yet, a culture that has invested, and still invests, so much energy in

disavowal must be strongly resistant to counter-readings which, when subversive of received wisdom and authoritative opinion, must seem false, misleading, downright peculiar.

DANCE AND 'MASCULINITY'

An outstandingly useful example of the determination officially to promote 'masculinity' in art representations of the male is afforded by dance, ballet in particular. The near automatic positive evaluation given to 'masculinity' is well illustrated by the obsessive desire of some dance practitioners to recognise what they would see as effeminacy and then to weed it out, from an art form to which effeminacy is often attributed, as if it were endemic to the form, by the non-specialist public.

In the earlier twentieth century, popular perception of the male dancer seems to find it impossible to unburden him of an imputation of effeminacy.[5] It may be for that very reason that it seemed appropriate that several photographic male nudes should be of dancers, since the male poser is still today reckoned to be feminised by taking his place in front of the camera. The 1969 publication, *The Male Image*, seems nearly obsessional in its concern to establish the masculine credentials of male ballet dancers.[6] The introduction to the book appears to recognise the difficulty of the task. In it, Ray L. Birdwhistell states, "A public, increasingly doubtful of the masculinity of weight-lifters and football players, is probably not going to be swayed by statements about the athletic demands of the ballet".[7] Igor Youskevitch locates a good part of the difficulty in the fashion of negating "the basic performing differences between the sexes" through the mechanisation and depersonalisation of the dancers, which is, he considers, "conducive to effeminacy in the man".[8]

Faced with the general public's annoying habit of insisting that ballet is for women to dance (and thus, by implication, for 'sissies' if men insist on taking male roles in ballet), the contributors to *The Male Image* one by one offer fascinating glimpses into their perceptions of the essentially masculine in dance, putting faith in that to rescue male dancers from social derision. Youskevitch believes, "For a man, the technical or athletic side of dance is a rational challenge".[9] The mastery of it gives the male dancer "the opportunity to display strength, skill and endurance" and also "the vocabulary and means to achieve creativity".[10] Bruce Marks identifies 'weight' as the essential masculine quality in dance. "Women

can't do it the same way, their bodies lack that kind of weight. The man can go after the ground with aggressiveness".[11] In addition to this, he lists "easy assurance", "positiveness" (as opposed to soft, romantic quality) and "restraint" as desirable masculine attributes. Helgi Tomasson seeks weight, strength, simplicity and self-assurance.[12] Simplicity is again chosen by Luis Fuente,[13] restraint by Edward Villella.[14]

The qualities identified by these experts as masculine in the context of dance might well be listed as such in the context of movie westerns, even if 'weight' would require some reinterpretation. The faith put in the fore-grounding of these to certify the masculinity of male dance diverts the reader from a more fundamental problem—whether the display element of ballet and other dance forms raises doubts about the appro-priateness of the male in the overtly to-be-looked-at position, reckoned to be proper to women.

The question is the more acutely raised when dance performance is on film, since musicals more insistently than most other Hollywood genres run the risk of failing to disguise male exhibitionism: dance, whether performed by females or males, is so clearly a display of prowess.[15]

Why do certain male stars whose fame is principally assured by their dancing skills seem to escape the taunt of effeminacy, even when their 'to-be-looked-at-ness' is foregrounded in the musical numbers? Steven Cohan sets himself the task of unravelling this conundrum in relation to Fred Astaire. He locates Astaire's escape (from erotic objectification by his undoubtedly being positioned as spectacle in, for example, *Easter Parade)* in "the theatricality of his musical persona". Thus, the energy of this persona "choreographs a libidinal force that revises conventional masculinity and linear desire".[16] Cohan's emphasis on a theatricalised masculinity could usefully be borne in mind when there are discussions of the *Male Image* sort, attempting to find its answer to the claimed problem of imputed effeminacy in the grafting on to ballet and augmen-tation therein of conventional societal signs of 'masculinity' without attention to the *balletic* conventionalising of masculine signs.[17]

Cohan does not ignore "the static and reductive binarism of traditional gender roles".[18] Rather, he puts faith in the notion of the star's oscillation between these and the theatricalised representation of maleness. This theatricalisation involves a self-consciousness which breaks spectatorial

distance from the image, a distance that is an essential component of voyeurism. Thus, the star is permitted "to acknowledge being looked at by an audience and even, through direct address, to return the look too"[19] In *Funny Face* the way Astaire acknowledges Audrey Hepburn's look of pleasure inspired by his performance for her is daring enough in its reversal of Laura Mulvey's assignation of specular roles between the sexes, but it is, more significantly, a gaze out to the spectator in the cinema.[20]

Male dancers at the time of Rudolph Valentino were popularly believed to have special appeal to women. Whether this belief was a consequence of, or contribution to, the perception of dance as a feminine art form may be of less moment than awareness that Valentino's connections with dance both extra- and intra-cinematically have been taken to be relevant in the explanation of his appeal to women, and thus relevant to discussions of female spectatorship.

THE MALE NUDE IN ART: A RE-READING

In Greco-Roman art, in representations of Christ, in Renaissance statuary and painting, the male nude clearly has greater importance than the female. Thanks to the cruciality of early classical Greece and the early Italian Renaissance, a whole tradition of Western art, lasting for nearly two millennia, is established and reinforced. Renaissance treatises took for granted that the nude body from which inspiration was to be sought must be male. Because activity was associated with the male body, passivity with the female, men were considered to be available for a far wider range of poses than could have been expected from female figures, and, again presumably because of its range of physical activities, the male body was expected in the Renaissance to display its muscles and tendons to the observer far more 'naturally' than could reasonably have been demanded of a female body.[21]

The supremacy of the male nude in Western art traditions, which obtains until the nineteenth century, seems not at all accidental when attention is drawn to the simple point that artistic production for the same period was thought properly to be the province of men. An explanation for that supremacy could be sought in the psychic needs of male artists and male devotees, the rationale for the near ubiquity of the heroic male nude in the derivation of a near-literal worldview from a body image like (but in idealised form) that of the artist's body.[22] (It has

been claimed that, within the context of the avant-garde too, the psychic needs of society as a whole can be identified with those of male artists and their conception of liberation through fantasy, their version of freedom depending, paradoxically, on the subjugation of others.)[23]

Male nudity in the classical tradition of art was offered to be aspired to, revered, worshipped. The point is reinforced by the identification of naked male figures as gods or classical heroes, a means of diverting a directly sexualising tendency. Another means could be taken to be the association of the male nude with suffering, martyrdom, especially in Christian art, although the tendency is also discoverable in representations of Prometheus, for example.

It could be counter-argued that such association sexualises in terms of sadomasochism rather than achieving the imagined end of promoting the 'masculinity' of self-sacrifice for higher ideals. Active reading is not containable within the ostensible desexualising strategies of reference to classical mythology and lofty civic virtues. Yet, it may be essential that the erotic element of male nudity in high art is masked, so that an image seems to transcend sexuality.[24]

The urge to desexualise the nude officially, and by this means to rescue the representation of the naked, thus potentially erotic, male from any suspicions of inspiring a prurient gaze, is indicated by Kenneth Clark's pains at the very start of his celebrated work to differentiate "naked" (with its implications of exposure and embarrassment) from "nude" (which, he claims, "in educated usage" contains "no uncomfortable overtone").[25] By this argument, the body of the early Middle Ages, which connotes shame, is naked rather than nude, but the 'uncomfortable overtone' of such nakedness is coupled with an awareness of sin; humiliation and martyrdom are alibied, as it were, by reference to such biblical episodes as the Expulsion from Eden. Nakedness does not, then, so much invite an erotic reading as one which recognises it as a physical expression of consciousness of sin. (It is only an invitation, though. What it invites is still unable fully to dictate its reading.) Prior to the Renaissance celebration of the nude male as divine or heroic and allegorical— free of fleshliness even as it renders moral strength and power in terms of the physical and fleshly—there is a tendency in Western art to associate torture and death with it.[26]

The supreme example of the attempted deflection of any suspicion of

eroticisation in Christian art is to be found in the representation of the Crucifixion, where the divinity of Christ and the emphasis on Christ's bodily degradation and suffering are jointly reckoned to disallow an erotic reading of the event. However, Madonna's notorious remark about her reverencing the crucifix "because there's a naked man on it" may be less outrageous than it seems to demand to be taken.[27] Leo Steinberg has had the temerity to draw attention to what he terms the *ostentatio genitalium* in devotional imagery, both in relation to the Christ Child and to Christ crucified. He believes that the emphasis on exposed genitalia is such a manifest feature of hundreds of religious works in the period from before 1400 up to the mid-sixteenth century that he has recourse in the explanation of its being overlooked throughout the following centuries to the notion of tactfulness.[28] Even then, though, he bypasses the suggestion of Christian art's sexualisation of Christ, opting instead for the explanation that by being human Christ must be sexual, and thus must be so rendered for his human nature to be illustrated.[29]

When removed from the divine mystery, crucifixion can become commonplace and all too grossly physical, as in Kubrick's film, *Spartacus*. Yet, through its representation in this context, it can be used to render the male body contradictory: both passive, humiliated and eroticised, on one hand, and controlling, self-sacrificial and transcendent, on the other.[30] It may not be stretching credibility to read back such connotations into the more overtly religious-art context of the Crucifixion.

Representations of the masculine in Renaissance art are readily identified in relation to the gods and heroes of Greco-Roman myth (and of mythicised ancient history), and in religious art to the depictions of God-as-Man, and again to those of Adam, Samson and so on. It may be at least as interesting to find evidence that the 'feminine' is discoverable in maleness—not merely in the feminised version of man whereby he is degraded and tortured, but in the figure of the youth, the beardless ephebe.[31]

In view of the history of the supremacy of the male nude in high-art contexts, it ought to be especially noteworthy that, by the nineteenth century, the predominance of the female nude was, as Clark terms it, "absolute".[32] The male nude was retained, according to him at least, in the art schools only out of deference to the classical ideal, although it was drawn and painted "with diminishing enthusiasm".[33]

SPECTATORSHIP: THE FEMALE AS SUBJECT?

So far in this chapter, the emphasis has been on readings that tend to assail the complacency with which the male as erotic object of the gaze has been dismissed from consciousness. It is timely, though, to recall that there are other unsatisfactory or absent areas of spectator-text theory. For there to be reconsideration of the object, there has to be reconsideration of the subject. In Laura Mulvey's accounts of narrative cinema's spectatorship, the subject can only be male or, if biologically female, masculinised. Despite her consideration of oscillation between subject and object positions for the female-gendered spectator, she treats 'active' and 'passive' as fixed not just in opposition but in static opposition.[34]

When narrative cinema and the identifications it permits are considered in terms of fantasy, it is difficult to maintain a rigid separation of subject and object on Mulvey's lines.[35] Then, too, it is worth while to mark a distinction between the spectator (created by the text) and the actual member of the audience, between the cinematic subject and the film viewer, even if arguing the real viewer away completely as merely a discursive category seems unwise. Mulvey appears to leap too easily between the subjectivity of the spectator so dear to narrative–cinematic theory and that of an actual gendered member of the audience, whom she renders implicitly as unified—locked either permanently or for most of the time into a unified gender identity.

Another factor to be borne in mind when Mulvey's signal contribution is used as a basis is that she is explicitly concerned with *cinematic* viewing (and viewing of dominant, narrative cinema). The 'Visual Pleasure' article was originally published some time before the large-scale introduction of VCRs into the home. Its analysis also could not, even at the time, be applied uncritically to, say, television watching.

Some of the more interesting insights into contemporary spectatorship have been offered by Anne Friedberg's *Window Shopping: Cinema and the Postmodern* (1993). [36] In this book, she notes the call by a variety of film scholars for a widening of social and psychic accounts of cinematic spectatorship to include such media as advertising and alternative screen practices. She is particularly impressed by the need for a different account in an age when there are not only VCRs but multiplex cinemas in everyday experience.[37] One of the most crucial changes in spectatorship

is, for her, the time-shifting possibilities opened up by the VCR and mul-tiplex.[38] The availability of movies on video means, she states, that what she calls the "aura" offered by the original moment of cinema exhibition has been replaced. "The VCR . . . becomes a privatised museum of past moments, of different genres, different times all reduced to uniform, interchangeable, equally accessible units".[39] (It has been calculated that in Britain in 1988, 55 per cent of individuals and 69 per cent of people with children had a VCR. More than half of all Japanese households had a video, and three-quarters of all television households in some Arabian Gulf states.)[40]

Then too, Friedberg argues, less persuasively perhaps, that the spatial contiguity of multiplex screens, and the staggering of screening times, makes cinema-going more like television-watching.[41] She completes this analysis of shifts in the experience of movies by remarking that viewers are now remade into *montagistes*. Viewing becomes another form of consumer choice, "with the controls in the hands of a new virtual shopper".[42]

The shopper analogy permits Friedberg to question the view that a one-to-one correspondence between spectator position and gender, race, or sexual identity can be insisted on. She suggests instead that iden-tities can be "worn" and discarded.[43] She traces the origins of the female observer to the mid-nineteenth century, and to such public spaces as the department store or amusement park. This female observer, or *flâneuse*, was both empowered and "kept in her place" by a recognition of her pur-chasing power, with desires created for her by advertising and con-sumerism, but also addressed as a consumer culturally constructed as female. Crucially, for present purposes, Friedberg asserts that both shopping and cinema "relied on the visual register",[44] and also that gender roles could be thrown out of kilter by such experiences as those of the amusement park[45].

The notion of the precinematic female observer makes it very difficult to rest satisfied with an account of spectatorship that forces the female to look steadily through masculinised eyes at narrative cinema, even tem-porarily; the idea of oscillation between subject and object positions, however, can be discovered in the multiple identities tried on and either worn or discarded by Friedberg's *flâneuse*.

Arguably, television-watching is far more significant than cinema-

watching today. The cinematic gaze cannot simply be grafted on to the look at television. 'Voyeurism' may be misleading as a term for television-watching. The glance, with a far less evident relation to power over its object, replaces the gaze as a more accurate term in the context of television. That glance may well be thought feminine, since its close proximity to its object significantly narrows the gap between them, a gap which allows the play of desire on which seems to depend subjectivity.[46] The immediacy of television's presence makes the viewer delegate his/her look to television itself. Thus, events are shared rather than witnessed. Jean Baudrillard thinks of television as no longer playing on the opposition, seeing/being seen. For him, the categories of subject/object, active/passive, have lost their meaning. Television is, for him, postmodern, and postmodernism "seems to disallow the security and mastery of the masculine position"; "as this stable site disappears, we are all left floating in a diffuse, irrational space—a space traditionally coded as feminine".[47] (Further, as the subject–object distinction becomes less meaningful in regard to the female consumer, so it does for the male too, in that consumers of both genders are figured, by the argument just touched on, as feminine.)

If Mulvey's work on spectatorship is unhelpful for television-watching, since that work is linked with the institution of cinema, then films on videocassette may well be watched in a mode that has more to do with television- than cinema-watching. Little work is available on this comparison. (At present, we do not know either what effects zapping between channels or the intervening television commercials might have.) We cannot assume the applicability of a single model of the watching of movies on video, particularly as video technology gives the viewer power over the images, including movie images. The glance at magazines or at publicly displayed posters again implies different relationships between viewer and viewed, such that the neatness of Mulvey's divisions, challengeable in the context of cinema, becomes suspiciously too neat in the different circumstances of viewing that these instances call into question.

OBJECTIFICATION

Now that the neat division of male/subject: female/object has been blurred, it may be time to consider the usage of the term 'objectification'. The term, sometimes qualified with the epithets 'sexual' or 'erotic', has

been vulgarised since its more rigorous use within feminism. Its usage today is sufficiently loose as to be considered appropriate in the context of any gazing transaction in which the gazed-upon, whether or not consciously positioned to attract the gaze, is deemed sexually or erotically attractive. Feminist analyses once suggested that women were particularly likely to experience object rather than subject positions within patriarchal culture; today, however, as part of the recognition that men are liable to be presented as sexually attractive or as, in the obvious sense within representation, erotic objects, it has become easy to talk of male objectification for this reason alone.

Kathy Myers makes the useful observation that there is a kind of objectification which is inseparable from the process of sight and perception, objectification being essential "in order to conceptualise and give meaning to the object of our gaze".[48] She then differentiates this sort from the specific sense in which feminism has understood objectification: borrowing loosely from the Marxist idea of commodity fetishism, feminism refers by the term to that process by which images of women "become commodities from which women are alienated", the commodity status denying women's individuality and humanity.[49] Myers links the popularised use, on the other hand, with Freud's concept of sexual fetishism, whereby "objects or parts of the anatomy are used as symbols for and replacements of the socially valued phallus".[50]

The political importance of the concept of objectification to feminism could be thought of as leading to the rejection of patriarchally imposed definitions of attractiveness and of prescriptions concerning women's proper availability as objects for male subjects, all in the interests of an assertion of women's right to their own version of sexual identity and sexual freedom. The feminist conception involves the identification of women's treatment as not merely sex objects, but also as nurturant, romantic or support objects, and attempts an assault upon societal tendencies to generalise about particular women on the basis of patriarchal stereotypes.

The major question posed by the positioning of the male body in representation as object of the gaze is whether its objectification is of a kind comparable with the term in its more precise, feminist sense, or whether only a looser, almost automatic and tautologous description of the male body as object applies.

It might be helpful to turn here to Paul Smith who, in his study of Clint Eastwood, is firmly of the opinion that the filmic exhibition of the male body involves a specific representation that should not be collapsed into feminisation.[51] He recognises, however, that erotic objectification of the male does entail defensive strategies: principally the sort of masochistic process adumbrated by Paul Willemen and Steve Neale, which is followed by revindication of phallic law and by antihomosexual sentiment. Using the mise en scène of Eastwood's naked walk along the penitentiary corridor in Don Siegel's *Escape from Alcatraz* (1979), Smith locates the effect of the sequence as producing a voyeuristic look at the male body which is still not identified as a look: the disavowal of the voyeurism involved may be characterised as "a quintessential fetishistic process".[52]

Crucial differences between male and female self-display at the more 'social' level of the striptease seem to be indicated in Richard Ballardo's words, "Though exhibiting myself . . . never brought me sexual arousal, it did make me feel good. And powerful. And special . . . I knew the audience was cheering . . . because they liked what they saw . . . I liked being the object of their scrutiny".[53] It is by no means impossible, in post-Madonna days, to imagine these words written by a female stripper. They could be expected, though, to raise eyebrows, to represent a flouting of more conventional thinking on the matter. Men are culturally expected to enjoy being the object of women's desires in a way that has become far more problematic for the sort of woman in Western society who does not see herself as iconoclastic or rebellious in relation to men. The daring involved in Marion Pinto's labelling of one of her exhibitions as 'Man as Sex Object' is the female artist's.

Why is role reversal, attempted by some artists and performers in relation to the male as object of the gaze, difficult or even impossible? Presumably because there is a fundamental asymmetry built into visual representation, via the different significations of the male and female body. While the female body is easily reduced to the meaning of woman's heterosexual function, men's bodies have signified far more than their sexuality throughout many centuries of visual representation.[54]

Perhaps, on second thought, role reversal is easy enough. It is the differential in power relations between the genders that cannot simply be reversed at a stroke. Lisa Steele indicates the different effects of mirror-image photographing of largely undressed males and females in Calvin

Klein's ostensibly egalitarian billboard advertising. Her conclusion is that the male and female images, even read together, are much less androgynous than they might promise to be.[55]

If objectification has different effects for male and female objects, due consideration should be given to the credibility or otherwise of such arguments as those of the activist group New York Women Against Pornography, which holds that (female) objectification in representations must be equated with violence to these objects, since objectification is *the* precondition for violence against oppressed groups. Denial of the full range of humanity need not be straightforwardly sad or dangerous. It may be a component of erotic fantasy which is not acted out, and which the fantasiser does not wish to act out. It seems to be necessary within sport, let alone body-building, to take an objective attitude to the body, for the sportsman/woman to separate it from the self. In conventional medicine, one strong emphasis in training would be on the desirability, if not necessity, of the physician's emotional distance from the patient, so that the objectified body can be the more easily read in terms of its symptoms.

Objectification is a sin for Luce Irigaray, because she believes that women are unable to create a distance from images in the way that men are expected by our culture to do. It is a perversion for Kathleen Barry. Its political ramifications as allegedly naturalising subjection within oppressed groups are highlighted by Richard Dyer.[56] It is not surprising that from the early 1970s any sexual politics which saw itself as progressive or even questioning of the sexual status quo counselled rejection of objectification, or that this hostility was extended into a rejection of both subject and object positions.[57]

There has, however, been a reaction from within feminism against the embargo, a professed willingness to re-examine objectification, and a refusal to accept the belief that in a feminist world there would be no objectification. If men are socialised into habits of objectification, the implication is that women can, as it were, learn that they are not so conditioned by their biology or even their socialisation that the creation of psychological distance in their viewing is predetermined as outside their potential. The question then becomes the point of learning to do so. Part of it may be to lose the automatic distrust or horror which the very word has inspired in the last two decades. As Jennifer Wicke affirms, "'Objectification' need not be in itself a violent act. It may be a sine qua non of desire".[58]

THE RELATION OF ETHNICITIES TO OBJECTIFICATION

In an interesting study of the strategies of *Lethal Weapon* (1987) to "override the potential disruption caused by race", Robyn Wiegman identifies bourgeois culture as "the signifier of racial indifference", enabling the movie to focus exclusively on gender as differentiating factor.[59] Middle-class life represents a solvent of the history of black and white difference. It is the white male, played by Mel Gibson, who is alienated and victimised, while the black family headed by the Danny Glover character represents "the commodified heterosexual norm".[60] This allows the conclusion that "through the discourse of gender, the interracial male bond can seal over the frisson of its own construction, enabling all differences among men to be subsumed in the seemingly natural discourse of gender".[61] That a movie which flatters America and its capitalist system for thus achieving the professed national ideals of democracy should exert so much energy on sidestepping the potential disruption of race underlines, paradoxically, what it seems to ignore. Race *is* potentially disruptive in American entertainment. If the black hero's relation to hegemony seems assured here through his job and his model bourgeois family, that relation has to be demonstrated for it to seem assured. It cannot be assumed.

A separate and sometimes oppositional set of discourses, which could be termed black and white discourses, appears generally to obtain in Western culture. Thus, there are differences in black culture's use and understanding of the star phenomenon, such as in the case of the actor and singer Paul Robeson, who achieved stardom within hegemonically white culture and appeared in postcolonial film narratives.[62] Again, the muscular black hero who parades his torso in the male action genre suggests a markedly different set of connotations from the muscular white hero engaged in similar display. Moreover, the connotations of degrees of blackness in the black male object invite different readings, with light black as the look of the contemporary male model connoting sensuality, and a darker blackness in the model connoting hypermasculinity.[63]

Broadly, in Western white culture, the black athlete's body is an object that inspires reverence and even fear. It is fetishised so that it may be rendered less apparently castrating; and this fetishisation may be performed as efficiently by a white woman (Leni Riefenstahl confronted by the Nuba) as by a white man (the controversies around Robert Mapplethorpe

combining concern about his fetishising of the black body with his puta-
tive homoerotic fetishising of that male body).

Because the black male stereotype within dominant thinking repre-
sents a potentially violent threat to (white) law and order,[64] the image of
the black sportsman or athlete, and hence the black model, may be as
welcome (as an alternative to the more vicious stereotype) to young
black males as to a wider white audience. In each case, physicality is fore-
grounded. This may be taken as a brutish physicality, in the example of
the stereotype of potentially violent lawbreaker, or as an inspiring phys-
icality, as with Linford Christie,[65] the generally 'good' athlete,[66] or as with
Robeson, usually the white-respecting (educated) black man who
stands between enlightened imperial rule and black anarchy. Each pole,
however, has to be understood ultimately in relation to a jungle axis.
There are good men in the jungle of popular entertainment—not only
Tarzan, but natives who accept Tarzan's priorities, It is, however—to put
it mildly—difficult to see the alignment of black males with the sort of
physicality whose apparently natural setting is the jungle as politically
progressive.

The political point of the stereotyping may indeed be to put black men
outside class.[67] A manifestation of the alignment with the physical and
away from class or political power may be found in the common Holly-
wood practice of making black actors play buddies and sidekicks.[68] The
black, by virtue of what are stereotypically connoted as his naturalness,
strength and swiftness in action, seems to complement the white hero,
whose connotations may well include the intellectual and the civilised—
but to complement him in a subsidiary, sidekick, role.

One crucial element in the attribution of physicality is sexual aggres-
siveness.[69] This is precisely the connotation of black physicality that was
played up in 'Blaxploitation' movies of the 1970s, where the hypersexu-
alised black stud stereotype was offered, to black audiences particularly,
as an antidote to the unconfident passivity of another available type in
popular entertainment. The attractions and risks of this particular kind
of stereotyping are epitomised in the celebration of black and Hispanic
men as signifying sexual potency in Madonna's videos and concerts. This
celebration could be labelled racist, all the same. The use of such men to
foreground such connotations is at the very least ambivalent.[70]

While, then, there is ample reason to examine racial otherness as an

important component in analyses of desire and identification in the context of movies, little attention has been paid to ethnicities, most attention going instead to gender as the crucial factor in differential pleasure.[71] Until recently, 'race' seems to have been a blind spot within feminism, although the notion that black women are oppressed by men, especially black men, in a way that is more heinous or more deeply felt than their experience of oppression by whites, men and women, seems ludicrous. Analogously, the notion that all men, black, white, Asian, and so on, have access to the same level of empowerment or access to the curious, controlling gaze seems scarcely likely.

Yet, it may be foolish, too, to assume that stereotyping is all-powerful, that it can do nothing but always achieve the ends for which such stereotyping has proved so useful. One analysis of the artist formerly known as Prince, for example, argues that the pop star uses certain oppressive stereotypes connected with race and gender to force his audience to interrogate its assumptions about him in relation to both areas. According to Joseph Bristow, he takes to extremes what a white audience would expect of a black male pop star.[72] His tactics may be but one example of the methods by which black singers and musicians have parodied stereotypes of black masculinity, thus making these strange, less automatically negative, through the use of charade.

Without energetic intervention of the sort, the black male is already, unlike white men, placed in terms of the visual field on the side of spectacle, the to-be-looked-at. Defined through the body, he is taken to be approximate to a natural spectacle.

Being a spectacle can in turn offer the possibility that inferior social status, even slavery, may be naturalised, since being taken to be a worthy object can suggest the impropriety of being a subject, of having social or political power. Part of the Asian stereotype within Western gay culture may be attributed weakness and passivity as an element additional to the range associated with black male spectacle. Richard Fung declares that (in so-called gay porn) "the white actors are assigned fantasy appeal based on profession, whereas for the Asians, the sexual cachet of race is deemed sufficient".[73] His observation is that the gay Asian is never a sexual subject or even viewer, but always cast in the role of servant.

The consequences of a perception of racial otherness are further illustrated by the contextualisation of Rudolph Valentino's embodiment of

the Latin lover within a culture and period which encouraged xeno-
phobia. Immigrants to the United States after the first World War were
supposed to achieve Americanisation through education. Part of that
Americanisation was conformity with the notion of healthy masculinity,
among whose tenets was resistance to passivity (and thus resistance to
being made spectacle). Valentino's erotic spectacle is containable within
the more acceptable version of racial otherness—exoticism—and,
through the greater part of his career, publicity is manufactured around
his foreignness, his difference, and his consequent availability thereby
for women's fantasy.[74]

As Valentino's example shows, ethnic otherness does not have to be
based on non-European origins. A departure from another form of
stereotype, the WASP, may be all that is required. Italianicity, so-called, in
contemporary male fashion models is sufficient, for example, to permit
narcissistic posing and to provide cover, as it were, for displays of sensu-
ality through pouting, staring and the wearing of daring styles.

Not coincidentally, the codification of male nudes in women's soft-
core magazines as Latin, Middle-Eastern or just exotic helps to natu-
ralise them as erotic spectacle. A man, too, may be European but
readable as a particularly acceptable erotic version of an Arab.[75]

When a real Arab is introduced, as in the case of El Hedi Ben Salem,
who plays Ali in Fassbinder's Fear Eats the Soul (1973), his body is pecu-
liarly open to objectification because of his marked racial otherness.
Kaja Silverman draws attention to the embargo in the shower scene of
that film on looking directly at his naked body. (The film reveals only the
image of Ali's body, reflected from the thighs upwards in a mirror on the
bathroom wall. The revelation happens four times, with only the first
occasion having no diegetic subject of the look, the other three having
his older German loverplayed by Brigitte Mira as diegetic onlooker.) The
effect of this and another scene in which he is exhibited is to re-enact
"that peculiarly non-narcissistic 'narcissism' which Freud associates
with the classic female subject".[76]

It is salutary to be aware that spectator–text theory does not deal with
racial difference.[77] Given, again, that the spectator–text theory that exists
has been of profound importance in such feminist-centred controver-
sies as the pornography debate, the silence about race is peculiarly dam-
aging, both to feminism and to women of colour.[78] But it is not only

feminism's silence that should give us pause. The silence on race is also that of self-identifying gay white males.

Jane Gaines, one of the few to have broken those silences, suspects that the black male gaze is of a low order of privilege, and thus that the workings of the relay of the look at a white female character via the gaze of a black male character need to be questioned.[79] After all, the black male was placed on a level with women in the system of slavery, because the black man's power over a black woman was seen as a threat to the balance of power operating within that system.[80]

Western culture's tendency to sexualise racial Others would encourage low expectations about the transformative potential of the sexual field. By equating the black man with the body, and thus rendering him as spectacle in the visual field, it is tempting to argue that racist culture has placed him, and other racial Others, in the place that patriarchal culture seems to reserve for women. The classic madonna/whore dichotomy that appears in relation to patriarchal concepts of the feminine has its counterpart in the noble savage/black beast dichotomy projected on to the black man.[81] In this relation, it is interesting that Paul Robeson's portraiture could be linked with a notion of passive beauty (something which he possesses, but does not produce),[82] so that patriarchy's treatment of women is reproduced in society's treatment of the black male.[83]

THE POTENTIAL MULTIPLICITY OF THE MALE OBJECT'S IMAGE

The Phallic Image
The male image is often treated as equatable with the masculine image. Masculinity in imagery suggests hardness and toughness. When the body and pose of the male photographed or otherwise rendered is not sufficiently tough-looking, a variety of accoutrements may be used to make the point by proxy. So, Clint Walker in the 1950s was photographed not just as granite-jawed and hairy-chested, but holding a hammer over an anvil. The hardness and straightness (of line and gender confidence) that seek to make a cubist painting of the male body and its images usually rest on symbolisations termed phallic. The penis, which may suggest the possibilities that it is not truly phallic when flaccid, is often left out of phallic pin-ups altogether.[84] The emphasis on the penis in the later 1970s and early 1980s has its bizarre side—for example, that Gérard Depardieu's penis has a part to play in *The Last Woman*, the dark joke at the movie's close being

that the penis is literally separable from the man.[85] The more public place accorded to the penis gives rise to a problem when much of that public arena forbids hardcore imagery, and therefore penile erections, and yet the image of the penis, if it is be 'masculine', must be phallic.[86]

Emphasis on penis size is one way of attempting to ensure the phallic quality of male imagery. One male stripper is confident that size is not of great importance to female watchers.[87] This is beside the point, perhaps. The phallicism of male imagery seems to have far more to do with assuaging men's depotentisation fears than pleasing its (female) spectators.

Counter Images
Barbara Creed states, in relation to the horror film, "Whenever male bodies are represented as monstrous . . . they assume characteristics usually associated with the female body: they . . . become penetrable . . ."[88] This is an extraordinary statement, in that it seems to imply that male bodies are not, usually, penetrable. Masculinity may exclude or do all it can to distance itself from penetration, whether sexual or otherwise, but that is very different from suggesting that male bodies are not normally even *capable of* being penetrated. That a film scholar of the intelligence and perceptiveness of Creed should produce this statement is surely a testament to the power of phallic male imagery to suggest that the male body has no orifices and to obliterate visual evidence that it has.

The masculine body is but one representation of the male, however. The preceding paragraph shows how the masculine body can quickly naturalise itself, so that rival representations are marginalised or even denied. Male imagery does not have to be phallic. That it generally chooses to be is important to observe, all the same.

The persistent hiddenness of the anus, which finds an erotic function in the realm of male homosexual desire, for example, intimates its status as "shameful little secret".[89] Because it is so successfully hidden, formulae such as Creed's which have the effect of putting it out of existence altogether seem commonsensical, objections to her formula overpedantic. It would appear particularly urgent for the male to separate off anality from desire—less so for women in our culture[90]—and thus to deny it, together with its associations with passivity and thus 'femininity' in male body imagery.

The claim that women are "really into butts" is often made, albeit in

different terms.[91] One female personal fitness trainer goes so far as to claim that the raising of the jockey's posterior from his saddle is to be understood less as a means of gaining speed from the horse than as "a ploy to give us all a good rear view".[92] A (male) journalist itemises the components of male physical perfection as "slim hips, small bum, not *too* much musculature", though even he admits that there is another beefcake image of desirability, for what he calls the "dumb broad".[93] Rosalind Coward identifies the reason for the admiration of the small, rounded bottom of a male as sexual surprise. It is valued, she suggests, for being "the sort of bottom which could easily be seen on a woman".[94] (Conversely, it is possible to discern in the attention to the unisex bottom of jeans advertising, in male-fantasy terms, a move away from the ideal woman fantasy to that of the ideal boy.)

Dissent from the view of male buttocks (at least in art contexts) as attractive to women may well be provoked by the feeling that women are thereby shut out. Thus, Sarah Kent takes the view that the message of passivity stipulates too clearly an audience that excludes her.[95] What she conceives of as passive nudes limit fantasy to a specified range and, because they exalt power, offer women a negative identification only.[96] It is also possible to read the display of men's backs as indicating greater capacity for privacy, an interpretation which moves away from passivity as the only legible understanding of male rear display.[97]

The particular point of this last section may be less to achieve consensus, less to arrive at a sort of univocal interpretation of anatomical areas of male imagery, than to underscore the likelihood that the male body is multiple, not singular, however strenuously the phallic body may try to pose as the only possibility.

iv · the (disavowed?) male object: photography/film and pop stars

PHOTOGRAPHY—THE MALE NUDE AND THE MALE PHOTOGRAPHER

In view of photography's invention being dated at 1839, it is noteworthy that nude photographs were first attempted in 1840. The length of exposure time was the chief handicap to the enterprise but that was progressively reduced during the 1840s. Even then, the demand placed on the models to maintain a pose for what was likely to be a minimum of twenty-five seconds, in conjunction with the result of photo plates' sensitivity to only blue light, may have undermined any aspiration to 'life-likeness'.[1] In any case, the fondness for poses after the fashion of Greek statuary, the stylisation of images, the presence of fig leaves, the use of classical references in the naming of photographs, indicate that early photography linked itself to dominant traditions of Western art when the subject was the human figure. A side effect of this is that the attempts at deflection of charges of eroticisation of the male nude in the context of high art are implicitly revived in the photographic versions.

By the 1860s, further reductions in exposure time and the capability of producing multiple prints from a single negative enabled the wider distribution of prints to a public which must have shown little reluctance to buy studies of both female and male nudes, if we are to judge by the claim that a police raid of 1874 resulted in the confiscation of 135,000 nude studies from one dealer.[2]

A brief period, from 1890 to the First World War, has been identified by one commentator as a time that gave the male nude preference and acceptability.[3] Then, after the Great War, the promotion of images of athleticism and good health meant that the male nude was freed from suspicions of eroticisation by the alibi that has proved most effective for this purpose—that of sport. Like nudism, which attempted the desexualisation of the naked body in order to defeat what might be conceived of as false shame, photographic imagery involving the male was used to suggest bodily self-confidence in a way that officially tended to discourage an erotic reading. The method of presenting idealised portraits of athletes, aerialists, sporting types, to celebrate their bodies while attempting

to outlaw readings deemed more prurient, was reharnessed in the 1940s and especially the 1950s to permit subterranean homoerotic possibilities within an unabashedly homophobic culture. Such photographers of male bodies as 'Bruce of Los Angeles' and Jim French could be placed within a tradition stretching from Jean Reutlinger and Paul Emile Pesmé.[4] The alibi of camouflage has been attributed to this tradition by such celebrated photographers of the male, unapologetically aestheticised or eroticised, as Robert Mapplethorpe and Bruce Weber.

The male nude, in the fully frontal sense, has become markedly more commonplace since the beginning of the 1980s, after a more clandestine availability in the 1960s and a more public but self-consciously daring display in the 1970s. It was in the 1980s that the male nude was used to advertise products which had little, if any, overt connection with the erotics of male nudity.

It becomes evident from a perusal of manuals ostensibly on the subject of male photography that the apparent problem already encountered in chapter 3 in relation to dance, of preserving 'masculinity' and banishing feminisation is expected. Once again, the practical suggestions are worth consideration. One is that a male model should be shown in some sort of activity: "men are usually considered to be the more active and assertive sex. Thus an image of a man lounging around doing nothing may be less acceptable conventionally than one which depicts the man's involvement in a job of work".[5] Then, again, the depiction of a man as sensitive and thoughtful carries with it "obvious danger" of its making him look "fey and effeminate".[6] Another tip, this time to outlaw the too obvious impression of voyeurism, is the preservation of the model's anonymity. Or, again, the avoidance of too many props. The female nude, we are told, may grasp anything from an egg whisk to a car's spare parts, but "credibility cannot be stretched so far" when the model is male.[7] One example of a recommended photograph has the male figure tower against the sky. The red of his trunks and socks is said further to emphasise his strong character traits.[8] In another photograph, the effect of the model's lethargic posture is counteracted by the diagonal camera angle and the bright colours of props and setting.[9]

The perceived need to camouflage the eroticism of the photographed male nude, or to preserve it from the sort of gaze that is reserved, it seems, for the female nude, testifies to the discomfort which represen-

tations of male nudity otherwise bring into being. Peter Weiermair calls his study of the photographed male nude *The Hidden Image*[10] precisely in recognition of the camouflage required to ensure social toleration of it, and more literally because certain photographers had to hide away their work in this field for fear of prosecution.[11] The newspaper and periodical reviews of exhibitions of photographed male nudes regularly to the present time betray, or even vaunt, an unwillingness to look at them or else project on to the photographs the prurience that seems to well up in the homophobic spectator.[12] Such photographers as Baron Wilhelm Von Gloeden (1856–1931) who makes little apology for his pleasure in photographing the young males of Taormina run risks of official hostility.[13] One of Von Gloeden's models, Pancrazio Bucini, who kept his negatives in a chest after the photographer's death, was accused of keeping pornography. It is reckoned[14] that only about one-third of Von Gloeden's glass plates of male nudes are extant, and that the rest suffered moralistic destruction.

Despite the alarm that male nude photographs engender in society, probably because of society's unresolved feelings about homosexuality or sexuality in general and its determination to use classical and allegorising references as metaphorical fig leaves, there is no shortage of men who can be identified, proudly or otherwise, with photography of the male nude.

In the nineteenth century, Eugène Durieu was supplied with a persuasive pretext for his photographs, in that they supplied the painter Delacroix with studies of the male form. A less obvious pretext enables Eadweard Muybridge (1830–1904) to explain his many records of nudes of both sexes as scientific data, valuable in the study of motion. Men, functioning naked at work and play, were photographed by a series of synchronised cameras so that their movements (along with those of women and animals) could be studied, as it were, scientifically.

In the twentieth century, appreciation of Minor White's (1908–76) male nudes is facilitated by a different strategy, the bypassing of "homosexual/heterosexual dialectic",[15] in the interests of a generalising tendency, a universal aesthetic, which has been accused of relinquishing the personal, eccentric and unique "in favour of some general majority standard",[16] as if the universal were value-free and without relation to dominant views. Allen Ellenzweig insists on restoring to its full place the

original impetus behind the photographs, so that White's camera may be seen "as a conduit, or surrogate, for personal intercourse, sexual in spirit if not in body".[17] This restoration permits a questioning of the too easily assumed dichotomies photographer/subject/active: model/object/passive, common as assumptions in discussions of the sexual politics of photographing or filming, since a kind of mutuality between photographer and photographed is claimed by White himself.[18]

While the frankness of George Platt Lynes' (1907–55) eroticisation of the male nude evades the generalising tendency stigmatised in White, this considerable area of his photographic work was kept hidden during his lifetime, so that he was associated primarily with his flattering star portraits.

By contrast, Arthur Tress outs himself, not merely in the sense that the male nude has central importance for him but that his images incorporate homosexual, sadomasochistic elements within a kind of theatricality declared by props, settings and poses. The body represented is not so much (nude) male as deviant, that of the Outsider. It has been called "homo-body".[19] The creation of the homosexual body seems to be a crucial part of the work done by Tress and, to a greater extent perhaps, by Robert Mapplethorpe. In both, deviancy is inscribed on the body, so that even when that body sees the light of day secrecy and exclusion are signified. Tress's men perform in Manhattan's disused churches or studios, in settings which are thus both in one sense real and in another theatrical.[20] The reality of the rituals that they perform in these settings with props that occasionally cry out their artifactuality is thus rendered ambiguous. Tress himself claims to be producing a male erotic that centres on the phallus. Lacanians may find it especially interesting that he elides the penis with the phallus. He has been attacked for what can be read as negative images, in that his representation, whether playful or not, of homosexual, sadomasochistic relations could be argued to incorporate oppressive heterosexual stereotyping of masculinity. The argument may be too simple, though. A different hostile opinion of his work, from Tony Benn,[21] that Tress offers a tourist's guide to the New York Homo-Body, could be used to counter the criticism of political incorrectness, in that we are reminded that an excluded deviant's version of stereotypical masculinity does not so much affirm it as hold it up to scrutiny, by making that masculinity in turn strange and deviant.[22]

George Dureau shares with Tress an upfront contempt for canons of good taste and an apparent determination to question social acceptability by showing the hitherto unshowable. A striking example of this is his insistence on the sexuality of the deformed man (particularly, it seems, the dwarf). By celebrating the erotic possibilities of the deformed male nude, he raises questions about the nature of the erotic and of social boundaries that might otherwise not be recognised to exist.

Bruce Weber has made the eroticised male, whether nude or not, a commonplace of popular culture, through advertising—admittedly up-market advertising. With Weber, good taste, with its attendant problems, re-emerges. His photographic models have a generally conceded sensuality, which does not raise the questions that the work of Mapplethorpe, Tress and Dureau forces to the surface. His earlier association with the gloss of the pages of *Gentleman's Quarterly* has not prevented Weber from pretending to the status of artist in the last ten years. His work's marketability as featured in calendars, books and commercials, among other forms, is not explicable in terms only of his wider circulation of the male pin-up. There appears to be a reference in his usual black-and-white images to an art context, though that art in turn may be taken to be most unproblematically that of the world of photographs. The brand of male eroticisation associated with Weber is that of the squeaky-clean male body (possibly epitomised in the shiny white of Calvin Klein underpants). The Weber male is young, athletic, stereotypically American in image, more boy-next-door than city sophisticate, self-advertisingly gym-dependent, cool and controlled, frank in his look out to the viewer via the camera. He lends himself easily to the process of commodification, which such fashion moguls as Klein and Ralph Lauren demand of him.[23] In doing so, he may summon up sexual fantasy in the customer, but somehow remains aloof from his own exploitable erotic potential, perhaps because awkward questions about the gender and sexuality of the work's observer would have to be faced if he evinced greater awareness.

Given the question of the breadth of appeal possessed by the Weber male (and female) and his work's relevance to sexual politics, it is not surprising that while the importance of his mainstream attraction has to be acknowledged, he has been identified as a force of reaction. One of the most uncompromising judgments on him comes from Andrew Sullivan,

who describes him as one of the "parasites on the genuine age of artistic fashion photography", claiming to uncover a fascist whose obelisk picture for Klein objectifies the bodies and excludes minds, motivations, communication from the sextet of models.[24] Elsewhere, he is described—thanks to his book of photographs, *O Rio de Janeiro*—as following a postmodern consumerist trend in locating men before a gaze which is not particularly transgressive, since the viewer is left in commanding place. "Weber's work speaks to sexual fantasy in quite conventional ways; its appeal turns on commodification and the power of money to inform desire; its emphasis is entirely on pleasure".[25]

Today, it is not difficult to command attention for the claim that there are, and have been, many male photographers who eroticise the male, or who at least put on the agenda the question of the possibility and effects of such eroticisation in relation to objectification, to what might be seen as progressive sexual politics, to the division of power between viewer and viewed. Other recent examples than these could be cited: recently, David Lebe indirectly addresses AIDS consciousness and the relevance of visual pornography to a subculture saturated in knowledge of unsafe sex; Herb Ritts walks a tightrope between subversion and reinforcement of the (homo?)erotic with his 'Fred with Tires' photograph; Dino Pedriali foregrounds his own fascination with the males photographed by himself and with the psychological processes attendant on that practice (as do David Hockney and Peter Hujar); Robert Häusser highlights his fragmentation of the eroticised male through his emphasis on the model's buttocks, as does Hiro Sato through his emphasis on pubic hair.

Inevitably, photographers who are increasingly uncloseted in their declaration of passionate interest in the eroticisation of the male must raise questions and anxieties, in those at the cutting edge of sexual politics as well as in the Right, to take two obvious areas of concern. For present purposes, attention can be usefully focused on the bitter controversies raging around Robert Mapplethorpe's work. These controversies offer a crystallisation of attitudes discoverable (but not always at the same time) in the contexts of work by many other photographers; that crystallisation has the added advantage of being well-documented. Another advantage of spending more time on Mapplethorpe is that the controversy embraces questions of 'race'.

Robert Mapplethorpe

According to Janet Kardon, "One cannot avoid the homosexual implications of Mapplethorpe's work. Male nudes of any colour or race when photographed by another male would invite this interpretation"[26] It seems unlikely that Mapplethorpe himself would have wanted the viewer to avoid these implications. Like Arthur Tress, he represents not just the male body, but the homosexual male body, and foregrounds deviancy through such devices as the capturing of sadomasochistic ritual between men. To say of this photographer that he deals in taboo areas is to state the obvious. It may be more interesting to note that he seems little interested in what could be taken to be positive images of deviant sexuality. When his work was described as pornographic, the photographer accepted the definition ("I'd rather call it pornography than call it homoerotic . . .").[27] His inspiration in his earlier career by sadomasochistic images in pornography seems to be on record. Images which he produces under that inspiration could be called transgressive, in the sense that he makes public the private, intimate and socially disapproved and in the sense that his desire calls into question boundaries of gender, race and class. Yet, it is the often-marked element of distanciation—of both photographer and viewer from subject—that seems to allow his work entry into the realm of high art.

Film studies now question the easy assumptions of the more enthusiastic early versions of auteurism, but in the present instance it has become almost impossible to disentangle the heated debates from circulated (claimed) knowledge of the man and of the historical events that marked reaction against him. The knowledge that Mapplethorpe's own sexuality was put on the line in his photographs and that he died of AIDS-related illness seems now as impossible to edit out of the debates as awareness that public exhibition of his work became a focus of attack from the American Right.[28] A less overtly political onslaught upon Mapplethorpe came from critics of his work, some of them writing in the gay press and particularly objecting to his prioritising of form and technique over content, or to the very distance which has been identified above as possibly providing him with a passport to high-art circles.

Objectification of his models' bodies is easily discerned. One of the questions inevitably raised by his work, then, is whether such objectification is automatically reprehensible, for the reasons that feminism has

repeatedly adumbrated. Mapplethorpe's sort of objectification seems to some not only to raise the anxieties that pornographic fragmentation has done in many feminist and a few gay circles for more than two decades, but to intensify the alleged harms of that practice. Tony Benn, for example, writes of "the serialisation of our bodies into the chain-links of a production line" and finds this new version of fragmentation "potentially more disturbing" than that of pornography.[29]

Kay Larson's attempt to defend Mapplethorpe involves recognition of the admission by polite company that the creative imagination depends on Eros but also of its preference that the connection be not made too manifest.[30] The photographer finds the price of repression too high. He rejects the pact with polite society. At the same time, he appears to prove that classicism and eroticism are poles of the same experience.

Alternatively, it is argued that, by this claimed classicism, choice is offered to the viewer, whether to be "voyeur or connoisseur", despite the sitter's direct look at the lens/photographer/viewer.[31] Or else, just as being photographed involves the 'feminine' position of being set up for the gaze, however 'masculine' and aggressive the pose, so it has been argued by David Joselit that Mapplethorpe offers the message that experience of any masculine or feminine identity is "the sensation of an unstable, constantly readjusted succession of poses".[32] Or again, the aggressive version of masculinity in Mapplethorpe has been read as an attempt "to negate the connotations of effeminacy broadly applied to all homosexuals".[33]

Mapplethorpe's favourite models are black males. Therefore, the questions raised by his deviancy are given further dimensions of seriousness by the viewer's awareness that the persons whom he objectifies (or, arguably, does a lot more than merely to objectify) can be taken to be racial Others in apparent service to a privileged, white photographer.[34] Even when the obvious imputation of racism in that relationship is obviated, another, less obvious but equally damaging, imputation of racism can replace it. By virtue of the scrupulous distance already alluded to, Mapplethorpe affects "the studied neutrality of an ethnographer mapping out types—the grid encompassing the 'aesthetic' body as well as race".[35]

Defences on his behalf to ward off charges of racism include the following arguments: (1) His black men are placed on pedestals. (Thus, they are given full dignity and stature in sexual terms whereas his whites tend

to be "a little nerdy by comparison".)[36] (2) These models are endowed by the photographer with enormous power and beauty, so that they confirm the myth of masculine virility.[37] (3) The meaning of his images is equivocal[38] and therefore (4) his work does not so much confirm as challenge racism. (Thus, for example, the viewer is confronted with stereotypes widely discoverable in society, but thereby the stereotype is for once given full and public attention, creating a less comfortable experience of it.)[39] (5) There is a merging of the 'I'/eye of the photographer and the models. (That is, instead of the power distribution held to be the case in more conventional artist/poser arangements, there is an intertwining. This reading is encouraged by extratextual knowledge of the erotic relationships formed between Mapplethorpe and some at least of his black men, and of the willingness of the latter to pose for the former.)[40] (6) Whatever the preferred meanings, his images validate gay black sexual identity. (7) Thus, they have a place in validating female desire.[41]

The arguments against Mapplethorpe are easily anticipated from the items on this list, precisely because his meaning, and therefore inevitably the arguments which assume a more defensible reading of him, are equivocal.

Mapplethorpe's fascination with blackness can suggest a colonialist 'negrophilia', so that his entry into the world of art merely gives a veneer of respectability to his racist fantasies. Whatever readings of his objectification are available, he does still objectify.[42] However his stereotypes (often involving the reduction of the black man to his naked body and 'overvalued' genitalia) may be read, he does stereotype and fetishise.[43] If he objectifies and fetishises, then he is complicit in power structures that reduce the black model to a servicing role.[44]

At the end of the analysis, it would be easy to claim that the jury is still out, that former detractors have become apologists only because Mapplethorpe is targeted after his death by the Right and that the two sorts of judgment balance out; easy to conclude that the only decent thing for this commentator to do is to ask those who have read the evidence to exercise individual judgment. To do so would be to miss a crucial point, however, which is to underline that meaning is not locked in a text, that no text can safely be labelled any one thing, racist or anti-racist. Meaning involves negotiation between reader and text, that negotiation being vitally affected by the reader's social positioning and the context in

which—in this case—the photographs are exhibited.[45] As Gaines reminds us, the objectification-stereotypage critique of Mapplethorpe, as of pornography deemed anti-feminist, runs the risk of implying that sexism (and racism) are in the image rather than in the social relations in which the image is interpreted.[46]

THE MALE AS OBJECT OF DESIRE: FILM STARS

Film stars have been created to appeal to a large variety of admirers in a large number of ways. Male stars' erotic appeal is no less credible than that of female stars, although it may be far more masked and alibied. In a study of this sort, an indication of various kinds of male star appeal is as much as a selection of star names would hope to achieve. In a field as vast as that of stardom, the selection will inevitably look extremely partial. The attempt, though, is not to pick on the male stars whose erotic appeal is most consensually obvious, but rather to choose those male stars whose appeal may help to suggest some wider notions of components of male eroticisation in popular culture.

Rudolph Valentino

Valentino represents a striking element in the history of Hollywood stars. For the present study, possibly the most interesting facet of the Valentino persona is his propensity to be displayed, to play the most to-be-looked-at character in each of his star vehicles. When Valentino is in the military, as in *The Eagle*, he seems to be there so that uniform and deportment can the better set off his physical attractions. His costumes in *Blood and Sand* and *Son of the Sheik* appear to reveal as much as to conceal, his torturing to accentuate his half-naked body and the connotations of masochism which are attendant, as Laura Mulvey's account highlights, on being exhibited in narrative cinema.[47] The parts he is called on to play—such as 'Red Indian', rower, faun—seem to motivate and to naturalise the display of his body.

Alternatively, his costume is sumptuous, attention-grabbing, as relevant to male exhibitionism as his films' emphasis, especially perhaps in *Monsieur Beaucaire*, on disguises. The exoticism of his costuming approximates to the cultural coding of the feminine, because of the materials (silk, satin, lamé) and such accessories as the sarong.

His to-be-looked-at-ness extends to the intensity with which his face

is rendered in close-up, particularly when the narrative has him stricken with passion—an intensity that surpasses that of the photographed heroine's face.

For all these reasons, Valentino has found a place in star history as a supreme sex object. In that his characters' powerful feelings are stirred up only by women for whom they feel desire, he is taken to be created for the pleasure of female fans.[48] It is difficult to deny that he is as fetishised and 'overvalued' as any female star.[49] The question that this must raise is whether Valentino plays to an active female gaze. This gaze is sometimes treated as of improbable existence within patriarchal culture. Perhaps cinema then provides an opportunity for women to violate the cultural taboo; perhaps it panders to, or even helps to create or strengthen, female scopophilia. If it does, Richard Dyer would argue that there is no simple role reversal in Valentino's cinematic objectification. When Valentino is represented in *Son of the Sheik* as an object of desire for the heroine, she is seen first and he is then introduced, so that "he is already located in her dreams, a spiritual realm of desire". Moreover, he is seen in her dreams as *looking at her* with desire![50]

What makes Valentino unique in his time as a star phenomenon is possibly less that he raises the likelihood of a female form of scopophilia than that he is more unequivocally left undisguised as an erotic object than his predecessors were. These men, in extra-cinematic publicity terms, were touted as being uncomfortable with their matinee-idol fame or as encouraging their fans to think of them as actors first. The stories in subsidiary circulation about Valentino's having at first lived off women, and the still teasing questions raised by his reputedly unconsummated marriages to lesbian women, increased what could be thought of as the feminisation of Valentino as sex object. The Pink Powder Puff attack on him by the Chicago *Tribune* of 18 July 1926 crystallised the discomfort that official American discourses of 'masculinity' felt with a male star who was adored by women while being rumoured to be impotent or homosexual in his private life.[51]

In assessing the picture of Valentino as systematically feminised by his movies and the publicity around his star image, we have to take into account two further elements: the emphasis in his screen roles and in subsidiary publicity on his claimed foreignness and the emphasis in his movies on dance.

The xenophobia rife in American culture of the 1920s has been explained as partly a result of the failure after the First World War to achieve the promised Americanisation of new immigrants through education.[52] Popular hostility was specially strong against Italian immigrants. Valentino's eroticisation was, however, particularly enabled by the exoticism associated with ethnic otherness. Popular discourses forged, in Studlar's words, "a contradictory sexual spectacle of male ethnic otherness within a xenophobic and nativist culture".[53] Hollywood's nervous flirtation with the exotic's erotic appeal is exemplified by some of its so-called Latin lovers being WASPs with a suntan or dark make-up, or, curiously, by the Arab hero of *Son of the Sheik* being played by a European.

The instability of Valentino's social positioning, as positively valued exotic or just plain immigrant, could be reckoned to complement his instability of gender positioning, between the 'masculinity' of muscularity and sexual aggression, on one hand, and the 'femininity' of so unabashedly being on screen as object of display, on the other. If he was not 'masculine' enough to gain the approval of a pseudo-official American discourse on gender, the evidence (even of crowd photographs taken at the time of his coffin's public appearance) was still that he made an appeal, called "subterranean" by Miriam Hansen, to male moviegoers.[54]

The feminisation of Valentino's image was much aided also by his being cast as a dancer or a performer of the *torero* variety. His commodification as a dancer identifies him as the ultimate in "woman-made" masculinity, in Studlar's eyes.[55] For all these reasons, it seems likely that Valentino's star appeal rests on his suggesting, especially through his own instability of gender and race, the possibility of mobility to those socially in need of mobility.[56]

Evidence of the difficulties in rigid classification of the star and of his erotic appeal can be found in the attempt to define the sort of scopophilia which his persona engendered. It does not seem to be associated *simply* with the mastery and sadism that Mulvey's version of the look at the female star/object detects. Rather, it involves a reciprocity of the sort suggested above by Dyer in the example from *Son of the Sheik*.[57] The identification promoted by Valentino movies is with the gaze itself, rather than with the gazer, the gaze "as erotic medium which promises to transport the spectator out of the world of means and ends into the realm of passion", to quote Miriam Hansen.[58]

Studio publicity portraits of the star seem to want to eroticise Valentino and yet to find means to make his eroticisation somewhat covert. In one pose, as 'Red Indian', for example, Valentino's bare legs, chest and abdomen are alibied by the (rudimentary) signposting of his racially other persona through such details as feathered headdress, loincloth and moccasins. The connotations of 'pin-up' are modified by the potential for activity suggested by his half-drawn bow.

When he is depicted as relaxing at home, he is once again presented as an object of the gaze, with his bare arms and legs and welcoming submission to the camera's celebration of his physical appeal. Yet, again, his potential for athleticism is strongly suggested, not least by such tactics as his holding a medicine ball in his left hand.

In a still from *Son of the Sheik*, Valentino is made to submit to the hands of less stellar men, who significantly look more foreign (to the WASP ideal) than the victim and thus, possibly, more evil. The bondage of all male stars is, in Hollywood movies, temporary. It is an incident in the narrative which permits play with passivity, feminisation and eroticisation. Yet, its significance in these terms can be denied by the stress on the hero's inevitable escape and triumph over his torturers.

Like many of the publicity photographs of male stars, the bondage sequence from this film presents the hero as object of the gaze at the same time as it deflects that interpretation by the promise of soon to be actualised or potential activity.

Johnny Weissmuller and Tarzan
Weissmuller has been identified as the biggest new star of 1932.[59] As possibly the most famous Tarzan of all, he is associated with body display—to an unusual extent even by Tarzan standards, since his loincloth was cut to maximise the erotic appeal of his Olympic swimmer's legs.[60] If the story about Weissmuller's unexpectedly stripping to his shorts during his interview and then being offered the part of Tarzan without a screen test is to be credited, the star felt that his physical attributes were all that needed to be checked on by the director and producer of his first Tarzan movie.[61] (In this, he might well have been influenced by awareness that it was his body which captured BVD's interest when it offered him a contract to represent their undergear and swimwear.) It was in terms of his physical attributes that he tended to be reviewed.[62] Even today, he is

recalled for having started a trend in the 1930s for frank appreciation of the male physique.[63]

The long series of Tarzan films is itself reckoned to offer, besides the pleasures of the action genre, "a set of visual pleasures focused on the display of the male body".[64] As if to validate this assertion, several other Tarzans have either been assessed in terms of their physical virtues[65] or else have assessed themselves in precisely these terms.[66]

Yet, there is another important element in the Weissmuller persona, his gentleness and suggestions of passivity which had particular sweetness in combination with the suggestion of animality, and of a paradoxical colonialist super-civilised gentleman, in his apeman-of-the-jungle character. Although Weissmuller's portrait has been contrasted with Paul Robeson's, because the former is caught in action and has his body tensed for activity,[67] Cecil Beaton seems to have photographed Weissmuller making use of such conventions as high camera-angle, and emphasising languor and passivity, in ways reserved usually for female subjects.[68]

The most celebrated of Weissmuller's Tarzan publicity portraits could be considered as a counterpart to that of 'Red Indian' Valentino. Weissmuller seems more passive than Valentino, with his faraway, dreamy look and a bow that is noticeably not drawn (its arrows are at rest in a quiver). Perhaps this particular Tarzan's WASP look permits feminisation and passivity to be less compromising than it would have been to the Sicilian, thus ethnically other, Valentino.

In certain pin-up poses, Weissmuller, a BVD model and swimming star before he was celebrated as Tarzan, adopts as broad a smile and as complaisant a pose as Esther Williams would later choose. The suggestion of the gymnasium and rigorous exercise routines in the minimal decor, the look away from the camera, counteract the impression of erotic objectification otherwise obtaining.

In W. S. Van Dyke's *Tarzan the Ape Man* (1932), Johnny Weissmuller, in being contemplated as an enigma by both white hunter and 'natives', is neither one nor the other. Instead, he combines WASP (Aryan?) good looks and frank, but civilised, attraction to Jane (Maureen O'Sullivan) with a remarkably revealing costume that connotes savagery. This costume is at once naturalised by the jungle setting and rendered unthreatening by the star's WASP qualities.

By 1959, Joseph M. Newman's *Tarzan the Ape Man* stars a hero whose

blondness, light skin and all-American good looks considerably soften Denny Miller's quasi-animalistic poses in an untamed-looking environment, as well as the threat of his long-bladed knife. Paradoxically, the inclusion of Cheetah in stills from the 1959 movie further distances this Tarzan from the animal kingdom. What appear today to be artifactual rocks on which they are stood for the hero's display of himself tend to civilise, as it were, the exhibition of bare chest and legs, in a way that is reminiscent of AMG poses for the muscleboys of the 1940s and 1950s. While exhibited for viewing pleasure, this Tarzan has been converted from one understanding of him as jungle savage in favour of another, as clean-cut and clean-living natureboy.

Miles O'Keefe (in the 1981 *Tarzan the Ape Man,* directed by John Derek) suggests with his minuscule loincloth a more passive and even decadent Tarzan. When he is raised unconscious in an elephant's tusks, the noble animal and his valuable tusks are rendered merely as erotic adjunct to the selling of the hero's beauty. O'Keefe's physical development irresistibly brings to mind Groucho Marx's concern about films where the hero's tits are bigger than the heroine's. The focusing, through the lighting of the elephant-tusk still, of attention on the pectoral muscles, rather than face, of O'Keefe, the reduction of Bo Derek to female looker (rather than expected 'looked-at'), speak eloquently of the exposure of male as erotic object in this movie.

The switching of attention from the 1981 Tarzan's pectorals to his exposed right buttock in one particular sequence depends for its effect on the availability of the exhibited male body for fragmentation. Bo Derek's Jane offers in the dialogue verbal recognition of O'Keefe's near silent and feminised pin-up qualities when she tells Tarzan that he is prettier than a girl.

Paul Robeson
It is tempting to discern Valentino's potential for erotic objectification in Paul Robeson too, in that both images embrace otherness and seem to initiate a different kind of gaze, which raises questions about the existence, and nature, of female scopophilia.

A particularly useful example of Robeson's probable objectification onscreen is provided by the sequence of *Body and Soul* considered by Richard Dyer. This sequence, wherein Isabelle undresses and the star's

character moves towards her, at first seems to invite the identification with the male protagonist that Laura Mulvey describes as a sort of fantasy access to the female object of desire. Dyer then takes the spectator's (psychological) positioning differently: "we are invited to place ourselves with Isabelle—it is her flashback—and the final shot, when Isaiah enters and before the discreet fade, is a shot of him smiling at her/the camera, *not* of her cowering or responding to him/the camera".[69] Once again, as in the *Son of the Sheik* sequence with its similar possibilities of female subjectivity in an erotic moment, the technical device of the iris figures.

Portraits of Robeson produce some effects similar to those of Weissmuller-as-Tarzan photographs. In particular, nature and jungle associations are created by tall grass backdrops, and a species of beauty is suggested in each case. However, Dyer has pointed to the greater passivity created for Robeson by his not sharing with the photographed Weissmuller any sense of "properly masculine" striving.[70] What might well be read as his 'ethnic' qualities contrast with Weissmuller's Aryanism to permit greater feminisation and qualities of submissive-

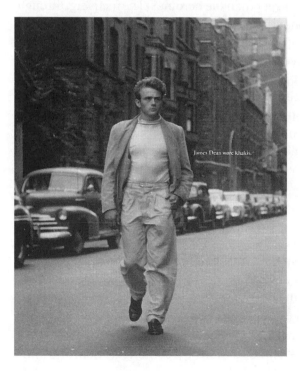

Fig. 1. James Dean's image, already in the 1950s an object of the cinematic gaze, used to sell clothes some four decades later.

ness that not only invite franker eroticisation of his physique but allow him to play, in such colonialist fantasy as *Sanders of the River*, the strong native leader who knows his proper subservient place in the presence of white enlightened rule.

In one of the stills of Robeson in *Sanders of the River* (Zoltan Korda, 1935), he is posed in a way which suggests that he is to be taken as noble savage, the connotation of primitivism reflected in images of African divinity. The additional connotations of racial otherness in the straw hut and wooden floor of the decor, the earring and necklaces and his costuming, help to naturalise the comparative nakedness and impressive tautness of his physique.

By contrast, the suggestions of softness thanks to his submissive, compliant look downwards and particularly to his unflatteringly photographed physique in another publicity portrait offers an unthreatening image of Robeson. He is securely, it would appear, in his place, despite the languidly held spear pointing upwards into the sky.

James Dean

The examples of Valentino, Weissmuller and Robeson combine to suggest that eroticisation of the male body is easiest when there is a feminising component to the star persona, whether that be provided by perceptions of ethnic otherness within a xenophobic or nativist culture, or an unexpected gentleness and passivity in a physically strong man. The example of James Dean suggests another route to feminisation—through the portrayed neuroses of the hero so that even his aggression is explicable at the level of a sensitivity which cannot trust itself to be expressed in verbal language. His bouts of destructiveness in the three movies for which he is remembered are not so much examples of mindless hostility (with which he is attributed by his less understanding observers within the diegeses) as releases of blocked positive and tender impulses whose expression is believed by him to be impossible. The sequence in *East of Eden*, in which after spying on his brother's dalliance with Abra he sends blocks of ice hurtling down the chute from the icehouse, is only one striking illustration of the tendency.[71]

The other significant aspect is that Dean is associated with *young* rebels, being one who has not quite reached physical or psychological maturity.[72] Indeed, the depiction of his personality as neurotic and

hypersensitive is so intimately bound up with his youth that the impor-
tance of the latter for the audience's sympathy with the former may be
missed. If this is fair comment, then youth permits erotic feminisation
in a way that requires less justification than adult male eroticisation
(outside ethnically other and gentle giant stereotypes). Not only James
Dean, but such young male stars of the 1950s as Montgomery Clift, Tab
Hunter and Anthony Perkins have been referred to as "androgynous",
without apparently raising eyebrows or hackles.[73] By his violent death in
1955, Dean managed to stay forever young in ways that were denied to
Clift and Perkins.

There is a curious, but often published, photograph of a bare-chested
James Dean playing a lengthy wind instrument while a male lies, also
bare-chested, under a sheet on a bed in the background. Today, the sym-
bolism seems to approach the parodic. Whether it would have been so
read in its temporal context seems unlikely.

Rock Hudson

Hudson's AIDS-related death in 1985 must play a major part in retroac-
tive reading of his erotic appeal, but the tone of certainty and assump-
tions of superior knowledge which the circumstances of his death and
the revelations of biographies (including his putative autobiography)
allow, falsify the reading of his erotic appeal, especially in his earlier
career.[74] It is not difficult to argue that Hudson was feminised, particu-
larly in his Sirkian melodramas with their women's-film status (whether
accurately labelled or not). If he is, the process should not be made
dependent on an extra-cinematic attribution of homo- or bisexuality to
the man.

One of the most useful attempts to understand the eroticisation of
Rock Hudson and his body is made by Richard Meyer, in an article appro-
priately entitled 'Rock Hudson's Body'.[75] Here, he argues that Hudson's
version of masculinity is less aggressive, more eroticised, in Sirk movies,
and that he becomes the object of "a desiring, *implicitly female* gaze".[76]
Concomitant with his transition to the Sirkian women's film, his publicity
photographs present his body as more relaxed and recumbent, and in
this greater passivity of pose he "invites the look of . . . the viewer".[77] In
this, his relationship to the camera is quite different from that of Alan
Ladd or Kirk Douglas, who retain their brand of masculinity by exhibiting

hostility to the camera's gaze. Hudson does not defy the camera, but gazes beyond it in a manner that permits the reading that he is comfortable with posing for it, that he can easily accommodate the passivity that is regularly part of the pin-up's baggage and puts up no resistance to 'to-be-looked-at-ness'. His body seems not so much adapted to activity as to readiness to be the object of the gaze.

Once again, the question of the nature of the female scopophilia catered to by this phase of Hudson's stardom insists itself. Meyer uses for answer the *Magnificent Obsession* sequence where Hudson, as Dr Merrick, removes his shirt to scrub up, preparatory to surgery. There is no individuated female source of the erotic look at Hudson's bare chest. The Jane Wyman character is, noteworthily, still blind at this point. Even when at the film's end it seems likely that she will have her sight restored, the moment is deferred. She will see tomorrow, she is told by her doctor lover. These curious aspects allow Meyer to conclude, "the spectator will see through her *functional* gaze, will not identify with her restored vision or spectatorial pleasure".[78]

The nature of the gaze is then more tentative, more distanced, than the kind of erotic gazing that Laura Mulvey believes that narrative cinema constantly permits to the male or masculinised spectator. Its pleasure is deferred. Or, rather, its pleasure is in deferment.[79]

If the secrets of Hudson's sexuality were out of reach of informed speculation at the time of the Sirk movies, the impression of his erotic potential—without actualisation of promised sexual potential—may have been precisely what made him so appealing to his fans. Heterosexual culture saw in Hudson many desirable traits, gentlemanliness, understanding, absence of sexual threat, and yet wanted to close its eyes to the possible guarantee of some of these very qualities in the star's sexual deviancy.

In one of his publicity photographs, the juxtaposition of strong, silent, bare-chested male and, it is suggested in the photograph, helpless child brings out the quiet paternalism in an eroticised male. It may be noteworthy that this photographic juxtaposition occurs long before the commercial success of the Athena poster, 'L'Enfant'.

In another publicity portrait, Hudson, in a setting which suggests the snowbound New England of *All That Heaven Allows*, gains the connotations of masculine authority from the rifle and dead birds in evidence of

his skill as hunter. The image of quiet authority ensured by these props, his clothing and his confident look above the camera, may make observation of the lighting—which accentuates the curve of the star's thighs and buttocks—seem a perversely unwarranted intrusion on a reading of the still for its trappings of masculinity. But that is exactly how disavowal works!

Alan Bates/Oliver Reed

The obliquity for which which there has been increasing evidence in this section as a common component of female scopophilia may well be illustrated by the famous nude wrestling sequence of *Women In Love*. The two British stars identified in the subheading could be individually discussed in terms of their erotic appeal.[80] However, it is their shared nudity in the Ken Russell film that most deserves attention.

There has never been such frank disclosure of either star's body. More usefully perhaps, what may fairly be termed the visual pleasure of the sequence can be intimately connected to the men's absorption in each other, so that the threat of audience discomfort (to be so frankly presented with male nakedness) is obviated by the alibi of the wrestling match itself and its emphasis on struggle and the expectation of a properly 'masculine' outcome—victory and defeat.[81] The eroticism of the nude wrestling is bound up with the sense that the two actors seem to be caught up in a struggle of—and also with—the flesh. Thus, although the scene clearly involves male eroticisation, that aspect is not presented in any overt way for the spectator's enjoyment. In that sense, it resembles, unexpectedly perhaps, the bare-chested Rock Hudson sequence from *Magnificent Obsession*. There is no visible diegetic gaze in the Russell sequence, unless it be the gaze of the wrestlers themselves, at each other or even at themselves. The tentative suggestion of homoeroticism serves the purposes of a heterosexual (female?) gaze. As with Hudson, Bates and Reed end up by offering what Meyer would term "a safe date".

Richard Gere

Richard Gere is a star whose movies are likely to require (or to allow!) him to exhibit his body. In *Looking for Mr Goodbar*, he dances wildly in just a jockstrap for the imagined pleasure and eventual alarm of the heroine, played by Diane Keaton. He simulates sexual intercourse in *The*

Honorary Consul, displays his body in *An Officer and a Gentleman*, but is most fully exposed—or would seem to be—in *American Gigolo* (1980). In this last film, he stands fully naked looking out of a window. However, when the logic that a reverse of fantasy (male) objectification (of the female) would require that the spectator look at him through the eyes of Lauren Hutton (the only other person within the sequence and the person who has just enjoyed his sexual favours), Gere is presented instead in extreme long shot, such that the view of his genitals is rendered indistinct. Once again, the female gaze is either refused or mapped on to what appears to be an impossibly distanced gaze.[82] The need for obliquity and alibi (that it is somebody else in some other area who has made the star into an object of the gaze) is exemplified afresh. When, earlier in the movie, Gere exercises half-naked and dresses in near ritual fashion, there is a diegetic gazer: Gere, gazing at himself—in the mirror, for example. He does, after all, play a character who rents his body out for the pleasure of women. Here, the female gaze is imagined only, and by a male, so that the evidence for female scopophilia, as it relates to the objectification of Richard Gere, is significantly skewed by the invocation of the hero's psychology.

The Gere look of the 1970s and early 1980s accentuates the trappings of Italianicity. One of his publicity stills of that period combines connotations of pin-up (the hairstyle, white singlet, subtle nipple protrusion) and machismo (the hairy armpit, the '5 o'clock shadow' on upper lip and chin).

The look culminates in the title role of *American Gigolo*. In the early sequence of the film in which rituals of exercising, choosing garments and dressing are gone through, the mirrors in one sense permit all-round appreciation of Richard Gere, stripped to the waist for much of this segment. The mirrors also, though, work to naturalise his eroticisation. Gere, in the part of gigolo, has his narcissism anchored in the demands of his job, so that the star's exposure is motivated by his character's necessary exhibitionism.

John Travolta

While Judith Williamson candidly declares her enjoyment of the fetishisation of Travolta's body in *Saturday Night Fever* and of being put in the voyeur position,[83] narrative motivation of certain moments of his

objectification are offered, so that the female gazer is not confronted particularly forcefully with evidence of scopophilic desires. As with Gere in *American Gigolo*, Travolta plays a self-cast stud (as well as an exhibitionist dancer), so that the film does not face the spectator directly with claims about her (or his) desires. Like Gere, Travolta watches himself in the mirror, indulges in dressing ritual because that is how he imagines that his (also imagined) female gazers would demand that he be dressed. He may be posed languidly and half-naked on his bed, but there is no diegetic gazer.[84] The concern of the Gere movies and of *Saturday Night Fever* to provide psychological justification, and from within the hero's psyche, for body display, testifies to the difficulties such display occasions and marks it off from the more usual display of the female body.

Disco dancing in *Saturday Night Fever* permits a relatively upfront focusing of erotic attention on the figure of John Travolta, clad in tight-thighed trousers that, it must be said, mirror male fashion of the time. The apparently approving glance of female observers helps to extend the permission that disco seems to grant.

The isolation of the eroticised dancer, who is frankly appraised by a female gazer, while the dancer is spared (by his positioning with, say, his back to her) the need to negotiate that gaze, helps to illustrate one method by which male objectification is effected in a musical.

Burt Reynolds

Although Gere and Travolta continue to be stars of some consequence, who are increasingly treated as actors of some consequence, the tradition of their eroticisation dates from the 1970s.[85] At the beginning of that decade, the reversal, by which what is in the verbal text of captions and articles identified as a 'hunk' becomes a fetishised erotic object of the gaze, seems to be offered as a joke. Burt Reynolds' star image of the earlier 1970s traded on its connotations of machismo.[86] Perhaps for that reason, he seemed a particularly hilarious choice in 1972 for the famous *Cosmopolitan* centrefold where he bared his chest but modestly concealed his genitalia.[87] Whether or not in response to a progressive softening of his image after the centrefold, Reynolds became by the later 1970s a more sophisticated light comedian or romantic ironist. If youth was argued, in the James Dean context, to be relevant to the acceptability of male eroticisation, then the onset of middle age must also require

some adaptation in various male stars' objectification, a greater openness to a sense of the possible ridiculousness of the eroticising enterprise (so that it can the more easily be effected!).[88]

In *Deliverance* (John Boorman, 1972), Jon Voight's half-stripped and homosexually menaced hero, trussed up in the bondage fashion so often included in the male-action genre, is protected by Burt Reynolds. Reynolds in this movie plays the most obviously macho member of his all-male group, his machismo signalled by such devices as his hirsute body and primed crossbow. The passive, even submissive, helplessness of the Voight character, as with that of Valentino in *Son of the Sheik*, is a source of possible erotic titillation which is overtly denied, not only by his rescue but by his being merely threatened with rape—a rape which is not permitted to be actualised. That degradation is reserved for the Ned Beatty character.

A similar deferment of the rape of the star (in that sense, the more conventionally appealing male figure), embodied this time by Bruce Willis—a more contemporary counterpart of Burt Reynolds in the early 1970s—occurs in *Pulp Fiction* (Quentin Tarantino, 1994). Willis's being spared the ordeal of rape may be inevitable, in terms of the star persona—as with Reynolds, who is not threatened with rape in *Deliverance*, and even with the less macho Voight, who is. In narrative terms, it depends only on his good luck. He is spared so that again he may escape. His escape results in his effecting a rescue that augments his reputation for properly masculine activity.

Tom Cruise

Cruise's erotic appeal tends to be that of the younger, less experienced man whose comparative innocence is available to be exploited (or protected) by an older quasi-parental figure. *Top Gun* may be taken to be the most overt example of his eroticisation, because his is one of the several young male bodies made object of the erotic gaze, and also because the heroine is, in the movie's terms, an 'older woman'. If she is not older in other movies, she may be his superior in rank. Thus, the heroine of *Far and Away* is an aristocrat (to his peasant) in Ireland, the movie's Old Country. This may be why her peeking through a hole in her screen at *his* shy undressing in the bedroom they are forced to share seems in context so natural.

In *Risky Business*, when the schoolboy played by Cruise is left alone by his parents, he celebrates his freedom by dancing in his underwear while he mimes to a rock-and-roll disc, in a sequence that seems to have more to do with spectator gratification than narrative cohesion. Even as late as *The Firm*, Cruise, though settled in marriage and what appears to be a good job, inspires parentally protective feelings for him in the Gene Hackman character.

Top Gun offers a particularly useful exemplar of the way that Cruise may be eroticised while the film disavows this aspect of itself in partially operating in the usual way associated with Laura Mulvey's version of visual pleasure. By centring on the looks of the class at the usual, female, object of the gaze, Kelly McGillis, the camera is enabled to offer up Tom Cruise and his fellow actors for erotic contemplation. They look at her, but the spectator looks at them looking—and so looks at them! The process is masked by their being apparently kept, in narrative terms, in place as *subjects* of the gaze.

The device in musicals whereby the male singer or dancer is the centre of pleasurable looking while he performs *to* a female in diegetic terms, is adapted to the demands of *Top Gun*. The female star, who connotes, in

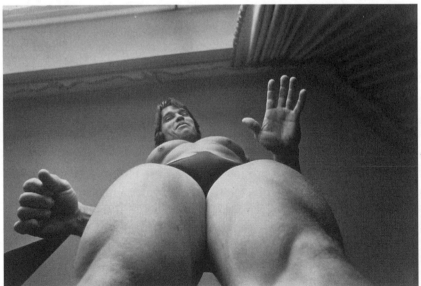

© Susan Gray/RETNA Pictures Ltd.

Fig. 2. Susan Gray's 1979 photograph of Arnold Schwarzenegger.

Mulvey's term, to-be-looked-at-ness, may be reduced to the back of her head and shoulders, when she, together with several male gazers, is captivated by Cruise.

Top Gun's eroticisation of the male threatens to become all-out homoerotic objectification in the changing-room sequences (and perhaps goes all the way in the volleyball sequence, which looks as if it could have been directed by Bruce Weber). The hard stare at each other by Val Kilmer and Cruise, the looks at them by other fetishised males in this sequence, are narratively motivated by rivalry and male competitiveness. Whether that masks erotic objectification, or whether these looks are, rather, signs of how 'masculinity' is eroticised in 'boys-own' contexts, needs fuller consideration.

Arnold Schwarzenegger
When Robert Mapplethorpe photographed Schwarzenegger, the result was "such an exaggeration of manhood that he transcends even most ideal homoerotic physiques".[89] In his earlier days of stardom, the exaggeration of Schwarzenegger's manhood achieved by his hypermuscularity placed him on the cusp of 'masculine' and 'grotesque'. It is probably for this reason that Barbara Creed refers to him (along with Stallone) as "performing the masculine".[90] He is describable as an anthropomorphised phallus. As such, he becomes a parody of a lost ideal, or else a warning of an android future. The highly phallic image, always teetering on the verge of self-parody, presents a problem for Schwarzenegger's eroticisation, because it may be difficult to keep the thought of 'male impersonator' at bay when his (over)developed body is gazed at.

Schwarzenegger's star persona changes, as does his exhibited body, throughout the 1980s and into the 1990s. He is transformed from killing machine as the Terminator in James Cameron's 1984 movie of that name into, a mere four years later, the wide-eyed, inhumanly innocent hero of *Twins*. His transmogrification into the good guy/machine in *Terminator II* (1992) is a more obvious indicator of his absorption within a particular verson of American society. His muscularity is modified to more readily acceptable proportions in these later films and is used to defend family. He is in the process made more amenable to mainstream erotic objectification, by reason of the suggestions of innocence—he has grown up on an island in enforced segregation from most of the human race in *Twins*;

however easily paternal, protective feelings come to him in *Terminator II*, he is a machine only beginning to discover his human side when he sacrifices himself. One achievement of his feminisation is indicated by the commercial success of *Twins*, which contains a sequence where he is seduced (and enjoys it) and another where the heroine surprises him in undress and seems to take pleasure in his predicament.[91] Even when he is parodic super-phallus as the villain of *The Terminator*, his first appearance has him photographed from behind so that his hairless and apparently vulnerable buttocks are eroticised rather than the expected, more phallic attributes.[92]

The deconstruction of the masculinity of Schwarzenegger's image by which he offers himself as object of erotic contemplation at the same time as he denies any such offer is suggested by Susan Gray's depiction in 1979 of him as all pectorals, genital bulge and, especially, thighs. The star's face and hands attempt to deflect what the body parts reveal, it would appear.

Sylvester Stallone

Much that has been said about Schwarzenegger's performance of the masculine could be repeated in relation to Stallone. It might be interesting to compare and contrast the former as Conan the Barbarian or Terminator (I) with Stallone as John Rambo, who as the hypermuscular exhibitionist essence of patriot armed with a rocket launcher could be taken to signal a new cinematic articulation of virility. The political potential for President Reagan in the Rambo image and its apparent message is a matter of history. The relevance of what could be read as a "fascist idealisation of the white male body" to the history of feminism is easily observable.[93]

However, it might be even more interesting to entertain the possibility that the mid-1980s period forms (with the benefit of hindsight) a watershed, after which the 'male impersonator' aspect that was a camp subtext of Schwarzenegger and Stallone action movies is given recognition in their entertainments. Thus, the subterranean humour comes to the surface in *Tango and Cash* (with its shower scene involving a display of Stallone's buttocks and Kurt Russell's disparagement of Stallone's genital size) or elsewhere in the infantilisation of Stallone as mother's boy cop.[94]

Clint Eastwood

Eastwood's image is unlike those of Schwarzenegger and Stallone. The latter's problems with masculinity leak out, as it were, in the mid-1980s and are offered a resolution in some measure by their star vehicles and their (imaged) personality changes. Clint Eastwood, on the other hand, has for long presented himself as a hero whose virility is vulnerable and who exhibits awareness that 'femininity' is not so much, or only, a complement but an area of struggle, both within himself and within females encountered by him in the narratives of his films. This is particularly evidenced by *Play Misty for Me* and *The Beguiled* in 1971, both of which foreground the terrors of male objectification to serve female desire, while not disallowing the attractiveness of that passivity to the hero. In his study of what he terms Eastwood's "cultural production", Paul Smith finds the Leibowitz photograph of the rope-bound star an interesting epitome, which could suggest Eastwood's pleasure in powerlessness as one element of the portrait, the overall effect being to objectify and aestheticise the Eastwood body.[95]

There has already been allusion in chapter 1 to Smith's analysis of the *Escape from Alcatraz* sequence involving Eastwood's naked walk down a prison corridor to his cell. In that analysis, the author draws attention to the lack of correspondence between the direction of the guards' objectifying looks and that of the spectator's gaze. The purpose of this is regarded by him as "to deny or defuse the homoerotic charge of this sequence while still producing a voyeuristic look". He describes as "a quintessential fetishistic process" the joining of looking with not looking.[96] Homoeroticism must be a likelihood within accounts of erotic looking at the male, particularly when Laura Mulvey classifies all looking in narrative cinema as masculine. Nevertheless, the lack of coincidence of looks has already been noted within this chapter. It might therefore be interesting to speculate whether female desirous looking, as well as homoeroticism, is both catered to and denied in the disjuncture between the diegetic spectator's look and the cinema spectator's.

In a still from *Escape from Alcatraz*, Eastwood manages the difficult feat of being offered as a recumbent object of the gaze within a prison setting while denying that status. This is achieved partly by reference to a narrative which has him taking the active part of a prisoner who breaks out, partly by his confident return (the star's face is noticeably well lit) of

the voyeuristic look, even though that look originates with an authority figure within the still who is cloaked in comparative shadow.

Tom Selleck

Although Selleck has achieved crossover stardom of a sort in his several film vehicles, it is as a television star, primarily associated with his playing of "Magnum, p.i." in the 1980s series of that name, that he may still be principally remembered.[97]

Sandy Flitterman, obviously an unabashed fan of series and star, has attempted an analysis of the appeal of Selleck/Magnum. She reckons that pin-up photographs of the male star, which use such traditionally female pin-up conventions as passive, smiling posture, high-angle photography, high-key lighting, are unsuccessful. If this is so, then the programme's claimed fascination may not lie simply in the star's beefcake appeal. Flitterman accepts that Selleck's body is "displayed as libidinal spectacle".[98] Nevertheless, she finds that the look at the male body involves "a parodistic, semi-ironic stance" which problematises that look (43).

The treatment of the hero, she argues, collapses the traditional subject/object distinction based on gender. When Magnum moves from identification figure to desired object, that objectification escapes reification. He offers an impression of availability and at the same time remains "utterly unavailable" (45). (Even within the show, romantic involvement with a female character is prohibited.) Thus, Flitterman concludes, "Thomas Magnum is a highly charged object of the libidinal gaze not only for the idealised image of the male body that he represents, . . . but for his appealing personality as well . . . At a time when questions of sexuality and gender representations are wrought with contradiction, the image of the masculine perfection that Magnum/Selleck embodies . . . provides a potent and enduring icon . . ." (58).

Her account rests on her belief that Selleck/Magnum is "unthreatened about his masculinity, and therefore unaffected by the need to defend it" (45). It is not difficult to concur with this reading of the Magnum character as played by Selleck. The high-pitched giggle, the display of "thighs and whiskers" in eye-catching shirts and shorts, seem unremarkable in the show, undefended because uncriticised. The point at which television series character and actor become separable may be where questions are raised about the actor's masculinity so that he is called on to defend it

where the character is not. Several elements of Selleck's playing of Magnum invite a covert 'gay' reading. Just as it is possible to suggest that Rock Hudson's version of easy, laid-back masculinity suggested a charming masquerade, Magnum's courtesy to women, his lack of threat, what could be read as his unavailability, provide a wish-fulfilment rarely seen in private-eye contexts. This New Man version of virility may be viewed as entirely heterosexual, though different, by the majority of viewers. Flitterman is right, surely, to suggest that the libidinal spectacle made of his body is ironised. Nevertheless, questions were raised some time after the article appeared, effectively 'outing' Selleck. His vigorous denial of the claims undermined the hitherto cool and self-confidently masculine image that Magnum personified, and also, whatever the sincerity or otherwise of the denial, permitted the classic error of confusing what he appeared to think of as unimpeachable heterosexuality with masculinity to be perpetuated.

There may be an alternative to viewing Selleck's status of regular guy as a guarantee for Magnum, so that the character may be read as wholesome and all-American *because of* Selleck's own wholesome, all-American qualities. Thus, perhaps he can be eroticised and made available as libidinal spectacle by the conjoined tactics of irony and feminisation of the Magnum character through Selleck's ambivalence, a process which leaves tantalising questions in the air, unanswered because unverbalised. This process would be akin to the sort of fetishisation invoked by Paul Smith for Eastwood, where a look seems to be allowed by the simultaneous denial that it is a look. An understanding of Selleck's appeal needs the sort of work at last capable of being entered on for a comprehension of Hudson's.[99]

Don Johnson

There are several similarities between Johnson and Selleck, the most obvious being both actors' association with charismatic protagonists of two highly popular television series, the next most obvious being the insistence within the series on those characters as spectacle. Scott Benjamin King's analysis of Johnson/Sonny of *Miami Vice* draws, unlike Flitterman's of Magnum, on the notion of postmodernism as a late-capitalist phenomenon "where all artistic forms are co-opted and transformed into marketable images".[100] Postmodernism as a crisis of

the excess of consumption relates to shifting definitions of masculinity, these in turn relating to a crisis in the concept of work.

King has no doubt that Sonny is fetishised. Nor does he have any doubt that, in large measure through that fetishisation, Sonny is feminised. He then notes that the threat of gender role confusion is defused partly by the fetish's deconstruction.[101] Sonny's feminisation is less by body display than by being a clothes-horse displayed amid consumer products, such as overpriced cars. It is by allusion to the apparent risks of feminisation that King explains Sonny's facial trademark of "masculine stubble"[102] or his glasses, which are his way "of being seen and seeing without being seen seeing" (283). Since Sonny's object status is at some level beyond disguise, however, the series has to recognise and deal with the contradictions thrown up by his having classic masculine attributes (laconicism, for example, or violence and suppression of emotion). Thus, for example, King argues that "Sonny is problematised along the twin poles of capitalism: on the one hand, he is a beautiful consumer image . . . ; on the other, he is in persistent conflict as to what fundamentally defines him as a man, his work" (290).

When he discusses the character's pain in terms of a masochism that can be viewed as concomitant with his feminisation, King widens the discussion of work to include loss in encounters with women.[103] If this masochism sets up a problem of identification in the heterosexual male viewers who are the show's alleged target audience, sadistic pleasure may be offered by Sonny's suffering. According to King, Sonny is "spectacularly destroyed each week for our viewing pleasure" (292).

While the claimed taboo on the selling of the male body as erotic object is easily breakable in late capitalism's voracious quest for new commodities and markets, the problems raised for television mainstream entertainment consequent on the breach are far from negligible. King's emphasis on the series' rehearsal of contradictions in its gender roles and its offer of a range of pleasures, which include masochistic identification with object-display status as well as sadistic separation from that object, helps to make sense of the central place that the objectified male can, since the 1980s, play in popular entertainment.[104]

• • •

THE MALE AS OBJECT OF DESIRE: POP STARS

The peak years of Beatlemania, 1964 and 1965, have been identified as the original period from which dates the most dramatic manifestation of a sexual revolution that centred on women as subjects.[105] Women who pursued the Beatles may be described as representing "the *active*, desiring side of a sexual attraction", since the Beatles "were the objects", the girls "their pursuers": "The Beatles were sexy; the girls were the ones who perceived them as sexy and acknowledged the force of an ungovernable, if somewhat disembodied, lust".[106]

Possible proof of a less disembodied lust inspired in the 1960s by rock musicians—or at the very least of a literal-minded curiosity about their phallic attributes—is discoverable in the Chicago Plaster Casters, who created moulds of the penises of rock stars, such as Jimi Hendrix. It is an acknowledgment of the fantasies that 1960s rock stars incarnated and played to that Jim Morrison was arrested for indecent exposure in public or that P. J. Proby made the splitting of his trousers a pseudo-accidental part of his performance. Earlier than this, though, in the mid-1950s, Elvis Presley was known as 'the Pelvis' because of the excitement that he occasioned by swivelling his hips as he sang and by ending some numbers with what looked like an accurate simulation of uninhibited orgasm. His television appearances involved, in the climate of late-1950s/early-1960s America, an embargo on filming Presley below the waist in certain performances. There was also a distinct watering down of his physical self-expression in the song performances of his debut film, *Love Me Tender*.

The overtness of his body language's sexuality seems not to have resulted in any doubts about the star's masculinity in subsidiary coverage. This could suggest , on one hand, the great openness of rock music to the performance and even foregrounding of male exhibitionism, with only the music itself as alibi. On the other hand, the persistence of suggestions of elements of 'Blackness' in the Memphis star's walk and body movement could indicate an adaptation of the greater ease of objectification which seems to obtain in white culture where black, thus racially other, males put themselves—or are put—on show.

Presley is the most famous of a number of his singing contemporaries—a group that includes Fabian,[107] Frankie Avalon[108] and Bobby Rydell[109]—all of whom owed their fan following to a differentially manifested erotic self-objectification. The images of Fabian, Avalon and

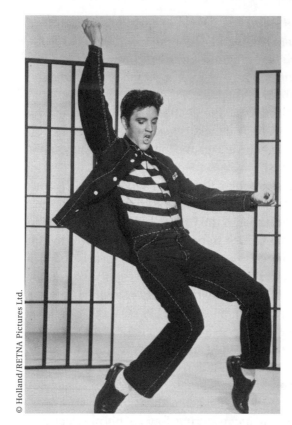

© Holland/RETNA Pictures Ltd.

Fig. 3. Elvis Presley demon-
strates why he was originally
called 'the Pelvis'.

Rydell were undisguisedly feminised. Perhaps the display element of
musical performance began the process, but the crucial elements may
have been sheer youthfulness and adolescent wholesomeness, free
from the taint of experience. Presley took energetic charge of his own
feminisation. The difference may be that in him it was far more success-
fully disguised, partly because of the connotations of aggression and
energy that his erotic exhibitions carried with them.[110] More stellar heirs
to the 'youthful/innocent' tradition include Pat Boone, who gave
expression to wholesomeness through the religiosity that was part of his
packaging and a guarantee of his essential 'decency', and, in the United
Kingdom, Cliff Richard, at least in his *Young Ones* and *Summer Holiday*
roles in the early 1960s.[111]

 The fetishisation of the pop star, in the double sense of making him an
object of the erotic gaze at the same time that the gaze is denied through

such alibis as his connoted innocence or wholesomeness, is demonstrated as occurring in a different mode in the case of the earlier George Michael. Suzanne Moore argues that there is a homoerotic tension between Michael and the other component of Wham, Andrew Ridgeley. Her argument makes Ridgeley's function within the highly marketable Wham image seem a lot less mysterious than his musical contribution. Moore sees Ridgeley as a third term which breaks down the binarism of the choice between voyeurism and control, on one hand, and identification with the image, on the other.[112] If this argument is valid, as it certainly seems to be, dubiety of sexuality can be used positively to grant licence to erotic looking (since the object does not so directly invite the erotic look). It also sets up tensions in the viewer, female or self-identifying male heterosexual. These last are partly defused, though, by the obliqueness of the eroticism.

After rising from Wham—which made no secret of its exhibition of youthful male physical appeal—to solo stardom, George Michael would appear to have felt increasingly restricted by his sex-object status, to judge by his unsuccessful action against his recording company in 1994. Yet, the video images that accompany his 1996 hit 'Fast Love', as well as his Mephistophelean look on the publicity for his album *Older* seems, if anything, to augment his to-be-looked-at-ness.

There is one especially interesting song, 'Do What You Like', in the 1992 BMG video, *Take That and Party*. Its visuals offer a determinedly playful eroticisation of the object position by, particularly, Howard and Gary, of the now defunct all-boy group. With the help of jelly, the boys become "eating stuff" for a long-legged blonde female. Later, platinum-blonded Gary turns his back in further submission, or is poked just above the nipple with an ice lolly by another would-be female tormentor. Male crotch and thigh are served up as party-time treat. It is a party in which the males in the group can enjoy subject or object position indifferently. Take That here 'does what it likes'. And likes what it does. However, awareness of prohibition on male exhibitionism is reawakened by the censorious dark oblong more or less blocking the view of their freely exposed posteriors at one point. Yet, the camera returns almost at the end to a close-up, free of censoring, of the forbidden zone. The track ends with, once again, the playfulness of the tall blonde (literally) mopping up the children's party debris scattered on and around Take That's rumps.

Fig. 4. A rear view of George Michael as sex object.

© Michael Putland/RETNA Pictures Ltd.

A more challenging version of erotic objectification may be provided by the artist formerly known as Prince. Joseph Bristow argues in general that pop is popular because it can commercialise and absorb such a wide range of gender types, from heavy metal's sexually conservative 'cock rock' to the far more challenging deviance that appears to be suggested by (former) Prince.[113] The performer is explicable as immensely successful in commercial terms through "exploiting himself as a sexual spectacle that throws back upon his audience a contradictory interrogation of ideas about race and gender".[114] Partly, he embodies a homophobic misogynistic racist's version of the black pop star, as falsetto-crooning sissy whose glamorous passivity emasculates any threat to the white racist. At the same time, what may be described as the excess elements of his persona carry with them the threat of a prolonged joke at that spectator's expense. His masquerade is readable as bypassing stereotypes precisely by invoking them: "Rather than be construed as gay, Prince uses his contrived mask of femininity to appear to be as close to women as possible, and he does this in a manner that flirts . . . with lesbianism".[115]

It may be hard to remember, because of his much-publicised Calvin

Klein contract and his reputation for exposure of his gym-built body, that Marky Mark is also a rapper. As such, his image is closer to heavy metal's 'cock rock' than to gender-bending.[116] The Marky Mark image seems to be that of the reluctantly used-and-abused body.[117] Watever the discerned truth or artifactuality of this element in the Marky Mark image of forced self-exposure, it enables his overtly erotic exhibition at the same time as it disavows and protests against the feminisation that such exhibition of muscularity entails.[118]

Rap music includes in its repertoire of male body language lead singers' grabbing of their own crotches and the frequent display of elastic waistbands of Klein-type underwear showing above low-slung, baggy pants. Public billboards in the USA featured a self-confidently exhibited Marky Mark with jeans worn in approximation to rapper style or, without apology, taken right down to mid-calf.

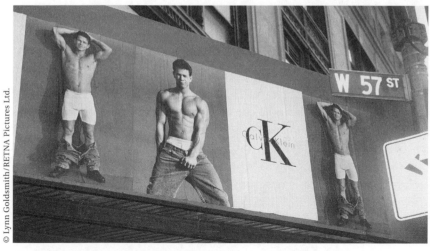

© Lynn Goldsmith/RETNA Pictures Ltd.

Fig. 5. Marky Mark, rapper and underwear model, on public billboards.

• • •

It is appropriate as a transition to the next chapter that this highly selective section ends with Marky Mark, a pop star of sorts who bridges the ever-narrowing gap between pop celebrity and modelling/advertising fame. Today, the bridging move is capable of being made in either direction;

sometimes, advertising fame feeds pop fame, which in turn permits a re-energised re-entry into advertising, and so on.

Nick Kamen may never have become the biggest name in British pop, but when he removed his jeans and stripped to his boxers in the setting of a launderette under the disapproving or prurient gazes of the other customers he seems to have created possibly the most famous of recent British advertising images. That it demonstrates the easy link between advertising and pop celebrity, that it famously allows the erotic objectification of Kamen's body while the exhibitor remains aloof from the implications of voluntary exhibitionism, indicates the usefulness both of seeing pop in terms of its male objects and of ending this section with the promise of an investigation into male imagery as it lends itself to, and is celebrated by, marketing.

V · a decade of outing the male object

MALE IMAGES IN ADVERTISING

Today, the Levi 501s commercial of 1986, in which Nick Kamen stripped to his boxer shorts, coolly disregarding the looks of other launderette clientele (largely female), represents probably the most upfront visualisation, to that point, of the commoditised male body.[1] The desirability of Kamen's body is acknowledged in the looks, indicating variously shock or pleasure; his non-return of the looks can be taken to signify his indifference to public opinion, his (male) power not to acknowledge his body's commodification, or else his confident narcissism.

There is emphasis in the commercial on the 1950s imagery of female hairstyle and dress and, through the launderette window, on the sort of car associated with the period. Customers, of both genders, seem largely, but not exclusively, determined to mind their own business, despite Kamen's display. While it added emphasis to the sense of period with its retro soundtrack, the commercial featured several startled reactions, particularly from females in close-up. These women seemed to be secretly thrilled, while only just maintaining a decorous façade of propriety. Kamen seemed passive, unthreatening, yet quietly confident and, paradoxically perhaps, in control. These qualities can be found in advertising's female subjects and male objects for the decade after the cinema and television exhibition of this commercial.

The commercial, widely shown—and widely parodied—on television and on cinema screens, has been variously identified as marking the emergence of underground 'gay' erotic images into the mainstream and thus a redefinition of male sexuality.[2] It has also been taken as announcing popular culture's ability to absorb the fragmentation and sexualisation of the male body in a way that was once confined to the use of the female body in advertising and other contexts.[3] Significantly, it seems possible to claim from at least this point that the male is eroticised through products (jeans, men's cologne, hair gel), that the male becomes overtly and undisguisedly commodified.

If Levi 501s sales depended increasingly from the mid-1980s on the

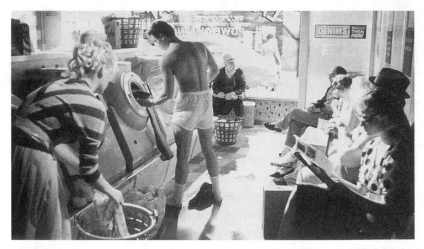

Fig. 6. 1985 commercial for Levi 501 jeans, with Nick Kamen reduced to his boxer shorts in the launderette.

desires created and/or fed by visuals of belts slipping away from jeans, of flies being unbuttoned, jean-clad male bottoms slipping into bath water,[4] possibly the most overtly erotic images of the male can be linked with Calvin Klein. Eroticised male (and female) physiques in Klein advertisements have been most obviously used to promote underwear and those items called 'fragrances'. The process of eroticisation has been much aided by the photographer Bruce Weber, who produces imagery that idealises without any clear invitation to identify.[5] The American Olympic pole-vaulter Tom Hintnaus, photographed by Weber on a Greek island, advertised Calvin Klein underwear from a huge billboard in Times Square. Not only were the advertisement and the model large and impressive but his look made no attempt to engage with the viewer's. Hintnaus was too godlike to hold converse with mortal throngs literally beneath him. The association of athletic achievement with Klein underwear was impressed on the public again by the 1990 image of American football star Roger Craig in Klein briefs.

In the commercial terms which advertisers must take as their chief criterion of success, the association created between sporting virility and the desirability of Calvin Klein wares works. One hardly needs the affirmation of a sales clerk in the Klein section of the Jordan Marsh department store, that women "say they want the muscular male body, as well as the jeans".[6]

The effect, as well as the obvious commercial point, of such commodi-
fication of the male body as Calvin Klein has achieved needs to be consid-
ered in terms of sexual politics, or, less starkly, in terms of the (not
necessarily intended) interaction between these facets. For example, in
order to maximise its customer appeal, advertising must appeal to as
wide a target public as possible, or at the very least attempt not to offend
significant sections of it. Thus, if the claimed appeal to women in the
commodified male body is a positive factor, it would not remain so if it
alienated male interest or made it go underground. Male customers who
would self-identify as heterosexual must not be confronted with too obvi-
ously homoerotic a set of images in the commercials. In relation to the
content of these commercials, 'heterosexuals' appear to be catered for
through the importance of sporting iconography in Klein models partic-
ularly, in the aspirational heroic imagery of Klein males, in their aloofness,
so that they do not acknowledge the desiring look, and also by appeal to
the permeation of an ostensible New Man ideology among middle-class
males.

Fig. 7. Tom Hintnaus, pole-vaulter,
photographed for Klein by Bruce
Weber.

Calvin Klein Underwear

The actuality or demonstrability of this last element may be less important than what might be termed its believability. There is clearly anxiety on the part of Calvin Klein to dispel the miasma of the imputation of sexism. At least, that anxiety appears to lie behind its decision to dispense with the services of Marky Mark. His contract was not renewed in December 1993, because, it is believed, of the evidence of homophobia and racism in his past.[7] Moreover, there seems to be an acknowledgment of feminist critiques of advertising in its 'equal opportunities' billboards where underwear-modelling males and females seem to aim at a mirror-like quality that suggests androgyny.[8]

Bruce Weber's style is connected not only with Calvin Klein but another American giant of fashion, Ralph Lauren. Allen Ellenzweig sees their difference as lying in Lauren's greater conservatism, with emphasis on blond men and women in their country estates, but concludes that the similarity of Klein and Lauren may be located in their offering up of male attractiveness "as a concomitant to the luxury of goods, the frank pleasures of fabrics and scents, and as the proper seasoning for any social encounter".[9] The connection of male physical appeal and the advertising of underwear for men goes back to the early 1930s, to judge by the exploitation of Olympic swimmer Johnny Weissmuller by the BVD company.

Many an underwear advertisement displays the male body beautiful and offers what amounts to a necessary focus (since jockey shorts, for instance, may be what is being sold by this means) on the male crotch. However, distancing devices counteract the possibility of too frank an exhibition. The style of some ads is recognisably Weberian; or the model refuses eye contact, his eyelids closed to indicate a dreamlike state (fascination with his own image?); or the setting may clearly be that of some version of time out from mundane actuality—in the sunshine of a tourist's Greece, for example.

The advertising of underwear for men has gone through seismic changes since the Second World War. In the 1940s, for example, Arrow's advertisement for men's underpants is tucked away near the bottom of the middle column of a three-column magazine page ad for such sundries as shirts, ties and handkerchiefs. It is particularly noticeable that the modelling of clothes is done here by means of joke illustrations, in which women's approval is signalled as the main aim of men's acquisition

of dress sense. The sketch illustrating underwear features a fat, red-headed male with an enormous waistline and shapeless legs in a green-striped pair of shorts, a red devil thrusting a trident at his bottom. The advertising copy reads: "It's a sin for men to wear shorts with seams in the rear end. They chafe. But . . . Arrow Shorts have a *seamless* seat and crotch—never chafe or bind. They're roomier too".

The difference from the mid-1980s may be that the emphasis on practicality, which has throughout this century alibied male interest in their underwear, seems a lesser requirement than before, even if it has not been abandoned. Male underwear may now be sold with designer labels and seems less shamefaced about its claims of being cut to flattering effect.[10]

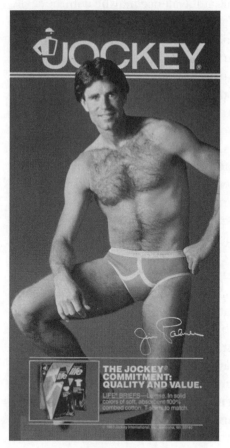

Fig. 8. Jim Palmer offers a reassuringly 'masculine' image of Jockey shorts.

Male sports stars lend themselves to more modern underwear adver-
tising images. For instance, Jim Palmer's signature and his workaday,
unglamorous pose for Jockey in 1983 reassures the spectator that the
underwear has a practical purpose, befitting such a handsome but
evidently square star. In another image—for BVD in 1981—the suggestion
of the Old West, particularly in the stetson, washbowl and resolutely old-
fashioned male grooming equipment, has a double edge. It can straight-
forwardly reassert the unfussy masculinity of the mythical cowboy to
counteract suggestions of fetishisation of the hirsute, largely bared body
of the male model. By using the image, the BVD Company must also
revive the closeted homoeroticisation of the Wild West to which physique
artistry of particularly the 1950s resorted, and to which *Midnight Cowboy*
(John Schlesinger, 1969) refers. This ambivalence may be commercially
useful in its differing appeal to different sorts of potential customers.

In its display of youthful male models revelling in their exhibitionism
on the catwalk, where they are objects of adoring and clearly erotic female
gazes, Marks & Spencer would seem to abandon alibi and come out of the
closet. Yet, the black-and-white photography works to suggest that this is
an image and just an image. The looks of delight and shock on the
women's faces, the near-parodic boldness of the men's display of exhibi-
tionistic pleasure, constantly approximate to the excessive. The distinct
possibility is offered that these men and women are at play, not to be
taken seriously. They are not to taken for real, it is suggested by the visuals.
The effect is similar to the posturing of Right Said Fred on the video for
that group's recording of 'I'm Too Sexy'.

(Nevertheless, Marks & Spencer may use the male body to sell such
unlikely-seeming items as socks. Once again, though, the model looks
'naughtily' daring, as if he is aware of playing a game, even as he allows
concentration on the curve of his left thigh where it meets his under-
pants. The image suggests that at any moment he will sober up and
reassert a more fitting relation with camera and viewer, so that the eroti-
cisation could be read as just a fantasy moment out of time.)

The semi-nudity that underwear advertising appears to authorise by
the nature of the product is extended into a less compromising male
nudity in advertisements for other products as wide-ranging as furniture
and motor oil. Adidas has eleven American soccer players grinning at the
camera, dressed in nothing but its athletic shoes. The power of nudity to

sell not only easily recognised products but pornography, or theatre and film entertainments since the 1960s (*Hair* on stage, *Women In Love* on screen), shows that it still represents a taboo. Nevertheless, the extension of the breach to encompass the male may not be as automatically liberatory in its potential as it could appear. The emphasis on beefcake in advertising works partly to alibi interest in male erotic objects by an appeal to sport and health, but it also has been argued to furnish clothing of sorts for the ostensibly naked. Thus, males "show their muscularity, like a coat of armour made by their own flesh".[11]

The humour that a New Fab detergent television commercial incorporates, acknowledging the male model's reverse striptease by music associated with (hitherto female) stripping on the soundtrack,[12] arguably helps to broaden the appeal of the eroticised male body to wives and mothers,[13] and not necessarily in terms of its libidinous appeal to these women.[14]

Macho images play an important part in advertising. In one Davidoff image, the eye is drawn, by means of its lighting in particular, to the developed pectorals and thighs, and the flattened abdomen, of the male model. The woman acts to legitimise the look at the male, who is, in this configuration, coded as hers. His heterosexual credentials seem to be in order, in other words. Yet, she offers no resistance to the viewer's contemplation of his bodily allure. Unusually, perhaps, not only are his eyes closed in dreamy contemplation of his physical accomplishments but so are hers. The female's head is raised to look upwards, not only away from the viewer but from the male. It is as if she shares his dream of himself.

The female's legs look well-exercised and sinewy, bringing a kind of ideal of masculinity even more centre-stage although in the guise of female corporeality. By exercise, he becomes fleshier and more voluptuous, while her body (small breasts, neatly turned buttocks, those athletic legs) offers another version of a trimmer but still masculine image. The viewer is not so much welcomed into the availability of masculine imagery here as granted the privilege of admiring it. The exhibition is spared the need to acknowledge that that is what it is.

Machismo is both reaffirmed and mocked in one of the Valentino advertisements, through its play with what could be understood as Italianicity in terms of its male and female stereotypes. The nakedness of the clinging female seems to be more insistent than that of the male, though

more square inches of his body may be on view. His hard stare into the camera refuses to acknowledge his object status. If this woman so help-lessly desires him, that is not his problem, he seems to say. Again, he is both on display and clearly not responsible for that display. It is, if anything, a favour to the ravenous female—less a favour granted than a favour not withheld. This ambivalence is reflected in the placing of his hands on her wrists; the pressure could be to encourage her exploration of his torso but could as readily be a warning to her that he will not let her go farther than he wants.

The emphasis on breadth of appeal in advertising images helps to explain the often-remarked passivity of the male model. Perhaps Hom's president, James Devens, does not have to be taken seriously when he claims that Hom will sell to "men, women, children, and animals",[15] particularly when he later admits that his company's advertising mainly has women in mind.[16] Whatever the targeted consumers, there is a noticeable passivity in current advertising images of men.[17] Their gaze is perceived as unthreatening, if it engages with the viewer's at all. The frequent use of black and white, and of softer lighting, may be to distance the viewer from the imaged male, by reminding the former that the latter *is* an image, the payoff being that the male is made more available thereby for erotic fantasising.[18] The feminisation consequent on being imaged at all is proven, perhaps paradoxically, by the "Beware a Wolf in Sheep's Clothing" advertisement, with its aggressive title and snarling model.[19]

Passivity and feminisation may be the consequences of male erotic imaging, but they are clearly useful in a postfeminist epoch when critiques (in 'gay' contexts too) of dominant versions of masculinity have rendered machismo vulnerable to ridicule or disbelief. Terence Conran makes use in 1987 of the new range of masculinities to feature a male nurturer in one of the Mothercare catalogues. The model is eroticised by being bare-chested, but rendered non-threatening by holding babies. The possibilities of representing the New Man of the image-makers extend to the creation and consolidation of such youthful, passive stereotypes as the toyboy.[20]

Male passivity, the cool, detached awareness of being a sex object, is easily readable in terms of narcissism. Andrew Wernick uses a Braggi aftershave advertisement which appeared in *Penthouse* to argue that

male narcissism is fully exposed in the photograph by the model's atten-
tion to himself as he stands before a mirror. However, the homoerotic
implications of such narcissism are kept at bay by the presence of a
woman who stares out at the viewer.[21] Whether or not the presence of the
woman provides cover here, women's presence, actual or implied, is used
perpetually by newspaper and magazine editors to rid viewers and
models alike of fears of homoeroticism by the imagined alibi that
connoted female desire is taken to furnish.

The grudging but inevitable place given to male narcissism by male
objectification in advertising has been taken as progressive in terms of
sexual politics. Rowena Chapman finds something charming in the
model's "wholehearted acceptance of himself as a sexual object,
embracing narcissism with open arms, and just a touch of aftershave".[22]
Frank Mort feels particularly encouraged by the absence of suggestions
of naturalness or unchangeability in relation to male sexuality/identity.
He values positively the self-consciousness encouraged by looks into the
mirror.[23]

Historically, looking at males by males has been coded as homoerotic.
Perhaps one of the reasons that such looking has had to enter the main-
stream and to be recuperated in terms other than gayness is that the
negative associations of HIV infection and AIDS with homosexuality,
actively encouraged by the media, make the open acknowledgment of
homoeroticism improbable for the advertising industry. If not acknowl-
edged, the use of so-called gay imagery in mainstream advertising is
nonetheless prevalent from as early as the mid-1970s and the creation of
the Marlboro Man, drawing on visual codes of machismo prevalent in
homoerotic contexts.

The masculine depicted in advertisements as free of such social
context as nuclear-family role-playing succeeds by neither addressing
nor yet excluding homosexual males. A masculinity which defines itself in
a free-floating context must, though, have an effect on the social percep-
tion of masculinity and femininity. The political evaluation of the slack-
ening of prohibitions on representations of male narcissism in terms of
progressivity for males in society cannot be applied with equal optimism
to women in society. As Judith Wlliamson stresses, "Taking on the clothes
or shape[24] of the opposite sex may be individually liberating for anyone
who wants to play with stereotype and 'escape' their conventional gender

image: yet as long as the value of male/female is imbalanced, even those 'transgressions' remain within a convention of a different kind. To play with the language of gender is not to escape it, merely to detach it from the sex of the 'wearer'".[25]

The evolution of the New Man may be a tactic by which male supremacy may be retained, not relinquished. Even the tacit acceptance of female desire in the representations of eroticised male passivity is tied in with its commercial exploitation. The imagined interchangeability of male and female models can be evidence not of sexual equality so much as the official ascendancy of that equality as a value, so that the conviction with which real-seeming representations are invested serves to mask inequity.[26] Advertisements try to create an image of actuality for the viewer, which it is essential for those decoding advertisements to recognise as a wishful state, which may serve the interests of a power group precisely by disguising inequality in a utopian image of equality.

Although the model in another ad for Levi's is specifically identified as a welder, the print offering the identification is so small that we may lose it altogether in our receptiveness to echoes of Jim Morrison imagery and of American photographs of the 1960s (perhaps Warhol's in particular). The handwriting may in context presumably be taken as that of the welder, Erik Rodenbeck. Yet, the whole image seems to be in quotation marks. Rodenbeck is both brazenly displaying his pubic hair and belly and yet doing so only because another time is being invoked—thus, not quite doing so for himself or for viewers of the 1990s.

Gap's use of Henry Rollins as erotic image in 1991 is particularly astute, since Rollins has already 'made an exhibition of himself' in the context of music; the connotations are exploited, not created, by the ad. Moreover, his glower into the lens, while expressing submission to its image-making, also asserts resistance and suggests that Rollins is, immediate appearances to the contrary, his own man. The abundance of tattoos gives more dramatic expression to this aspect of his persona.

In the unexpected quarter of ice-cream marketing, for Häagen-Dazs, the black male, presented without a face or even head, is fragmented and erotically objectified. His shining black skin is the surface which a hand has touched and on which the ice-cream melts. Like several other contemporary advertising images, the eroticism is rendered less immediate by being placed in quotation marks, as it were. This time, the quotation seems

to be from Robert Mapplethorpe, and the potential controversiality of the image could well be sidelined to Mapplethorpe and to the furore around such believed jokes as his 'Man in a Polyester Suit'. Eroticism of the 1950s extends into modern times in another ad. A near documentary image of James Dean—already an object of the gaze in his own period—on a city street is offered as a device to sell clothes by the discreet addition of the legend, "James Dean wore khakis" (see figure 1).

It might need more argument to establish that Hollywood genre films have a determining relationship, not just the determined relationship of reflectionist theory, with social actuality. However, it is almost self-evident that (successful) advertising must aim to have an effect in (and therefore on?) that actuality. The relationship between the femininity/masculinity of the advertising world and that obtaining in the world beyond it must be unusually intimate.[27]

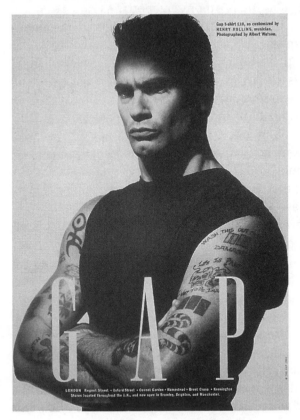

Fig. 9. Henry Rollins: his own man, yet modelling for Gap (1991)

One of the fundamental differences in the imaging of male and female figures in advertisements is the promotion of the area of leisure as proper for the active male; the appropriateness of the playboy image even to the passive male underlines the point. If this was observable in gendered ads. well before the mid-1980s, when eroticisation of the male gave a new, narcissistic meaning to those that featured apparently 'irresponsible' males on display, then we have to draw back from too uncritically inter-preting family-context-free depictions of the male as *only* narcissistic/solipsistic. It might be safer to suggest that eroticisation gives a new twist to the formerly obtaining representations of the male osten-sibly at home in the world of leisure. While the effect of the work done by women's and gay movements might be in the mid-1980s to suggest that there could be mileage in representing men as more like women, able to occupy similar social and sexual positions,[28] it is important not to over-play the idea of radical break in male representation.[29] As early as 1978, it was possible to decode a beer advertisement to foreground the woman's appreciation of the swimming-pool man's luxury and independence. His masculinity is tied in with his isolation. Most significantly, the look from the independent male is read in 1978 as follows: "He is not looking out of the ad. He does not have to seek out, to please; he will fasten his gaze on whatever interests him and at the moment it is his beer. We are sold the product by looking *with* him, not *at* him (as with women)".[30] Perhaps today we would be encouraged to look at, rather than with, the male, but much of what today would be read as pandering to male narcissism is less problematically read at that time as indications of a man's proper isola-tion in enjoyment of masculine power.

Late capitalism's creation of new marketing opportunities by extending commodificatory opportunities to male bodies augments the possibilities within pre-existing advertising. It is not difficult to see why men's bodies become commodities. What is more challenging is the question of the target audience/consumer. It surely can be claimed, whatever coyness there may be in advertisers' discussions of the matter, that it is men who are addressed, men in their sexual diversity, with care taken by the advertisers not to exclude certain constituencies. If so, then another question remains, one that concerns the process by which men buy men's products sold by appeal to men as sex objects. Whether or not there is, as has been claimed,[31] a particular appeal despite the retro

imagery to young men, the wider question of self-defining heterosexual males' openness to such advertising, or to the attractions of male eroticisation in general, is a challenging one. It will be taken up more fully in chapter 7.

MAGAZINE MARKETING FOR AND OF MALES

In 1986, about the same time as the Nick Kamen launderette advertisement was setting a trend for male images within commercials, *The Face*, a magazine without (easily recognisable) pornographic content aimed at men, was launched. This joined *Arena*, another magazine which was particularly geared to the exploration and encouragement of men's interest in male fashion. As with the advertising images discussed above, the male models of *Arena* are feminised not only in their exposure to the camera, but in their youthfulness and the connotations of passivity. Contradicting the surface impression of a new notion of masculinity catered to by these images is a far more traditional view of it in the verbal text of articles in which, for example, wealthy, powerful men are interviewed. Both elements, one promising a more New Man version of virility while the other retains male dominance, evince a shared concern with the consumer ethic of the 1980s.

These magazines suggest that male consumers are being fed images of themselves which ensure that their interest in fashion leads to purchases. Together with *Cosmo Man*, produced for men by *Cosmopolitan*, with the men's sections of *Options* and *Elle*, they can be taken at the time of their greatest popularity as "hooking into the new narcissism of men".[32] The sorts of male fashion photographs purveyed by Bruce Weber spawn styles associated with photographers linked to individual magazines—for example, Jamie Morgan of *The Face*. Stylists such as Ray Petri, who sometimes worked for *The Face*, created a visual language for men of the latter 1980s.[33]

Earlier than the magazines aimed at men and designed to sell a certain new version of masculinity as well as the fashion items catering to that conception was another sort of men's magazine, *Achilles Heel*, which attempted the dissemination of a personal politics designed to go some way to meeting feminist critiques of traditional masculinity. It stopped publication in 1982 after five years.[34]

The switch in the last decade's mediation of official masculinities

involves a dramatic shift from concerned libertarian–socialist postures to a newly sanctioned male narcissism. This shift creates a masculinity which may be described as aspirational,[35] which has partly dissolved the linkage between masculinities and class identities, and whose embrace of narcissism permeates the pages of the *Sun* newspaper in its 'Page Seven Fella' photo feature.

Is the intensity of the male look at male spectacle in these magazines an indication of the greater visibility and social tolerance of homoeroticism? After all, the sorts of sexualised representation that the magazine spreads feature do draw heavily on the representations of the masculine that have been historically marked out as gay. The determining factor is surely the context. The representation might have been deviant when it was circulated outside the mainstream, but the men's fashion magazines exploit, but also recuperate and reinterpret, male homoerotic imagery. As indicated above, the verbal texts of the magazines and newspapers focus on more traditional masculinities which—to identify but two tactics—tend to alibi by means of the notion of an (ultimate) female viewer or else to promote a lightened-up version of masculinity which feels no need to cloak its narcissism but which still tries to take the 'homo' out of its eroticism.

MEN AND FASHION

In talking about such magazines as *Arena*, we are already talking of fashion and the men who work in the fashion industry or who support it by fashion consumerism. In discussing such stylists as Ray Petri, we are already exploring the range of representations of masculinity available by 1987/8.[36]

A new sort of model is created in the middle and late 1980s. Eamonn J. McCabe, a photographer for *The Face* and *Interview* magazines among others, claims that the "tall, well built, lantern jawed hunk" no longer has a monopoly in modelling. "Slim is in, so too are interesting facial features ... A man can easily work into his 50s. If he gets wrinkles he has character ... "[37] Another interviewee says that the Macho Jock and Hunk types are on the way out, "almost too camp to be taken seriously any more".[38]

Although Gregory Ross suggests that black models are much less numerous than their white counterparts,[39] the coding of blackness in terms of darkness and lightness that is grafted on to the use of these

models is explicable as hypermasculine and sensuous in relation to dark black and light black respectively.[40]

Photographers such as Bruce Weber and stylists such as Ray Petri help to create a cult of the male model. Nick Kamen and Brad Pitt are known by name for their appearances in commercials, not only as a result of their careers in, respectively, music and film. Cameron, reported to earn £3,000 for his appearance in a single fashion show,[41] gained additional celebrity from being cast as Madonna's male plaything in her 'Express Yourself' video.[42] If the model were not open to individuation, if he were not marketable as a personality, there would be little point to Calvin Klein's decision to replace the politically reactionary image of Marky Mark with Michael Bergin's for the 1994 round of Klein television ads.

Perhaps the model can be both only a body at work in the fashion industry and yet available in terms of personality to media events, such as the chat show, because the body in some fashion contexts is regarded and sold as a surface on which images and objects can be hung or attached.[43] The personality is in this sense detachable and may become a matter of media interest beyond the photography or catwalk session. Stuart Hall finds that male willingness to use things to indicate who they are (this could be adapted, in fashion terms, to thinking of men's use of the body as a surface to create the personality) represents a remarkable shift in masculinities. Hitherto, he argues, men tended "to have themselves 'reproduced' . . . at arm's length from the grubby processes of shopping and buying and getting and spending". Now, they have formed habits of thought similar to women's historically traditional attitudes. Hall takes this to be a harbinger of greater social status for women through recognition of their experience.[44]

In that sense, male fashion draws attention to, even teaches, the artifactual nature of masculinity. It offers a variety of looks, each with a different relationship to an overall concept of it; since the looks may be tried on and discarded, versions of masculinity certainly, maybe even the central conception of masculinity, are destabilised and relativised in the process.[45] Thus, the apparent toughness of machismo may be a matter of pose, and of a self-aware pose, when translated into fashion terms. The man who dresses macho need not be advertising himself as truly macho.[46]

Presumably, then, if notions of play are relevant to men's fashion, there

has to be caution about too realist a reading of the narcissistic conventions of modelling, which embrace features such as the pout and an introspection which could indicate deep thought or, more credibly, self-absorption.[47] These conventions may invite a complicity between model and observer/consumer, but the invitation could be to try on the narcissistic look than more straightforwardly to be a narcissist.[48]

The achievement of recent trends in male fashion has been, whether this be read as politically progressive or reactionary, to allow men into a more 'feminine' relationship with themselves and their adornment while carefully sidestepping the implication that men, by being feminised, are lured into homosexual identifications. (Male homosexuality has been saddled culturally for much of the twentieth century with the most intense prejudice, misogynistic as much as homophobic, against effeminacy.) This is effected not so much by an explicit disavowal of homosexuality. Rather, it is by permitting no demystification of the secrets of male sexuality in general. Brakes need to be applied, in any case, to over-excited claims about fashion's encouragement to a revolutionary version of masculinity. For one thing, it is far easier to construct a thesis of this sort in terms of upmarket images than in general. Sean Nixon claims, too, that stylist self-consciousness is not new. "It is emblematic of all the spectacular male working-class subcultures of the post-war period, as well as, through different inflections, being present in the discursive baggage of middle-class masculinities".[49] If it is not new, it is, rather, intensified from the mid-1980s.

MEN AND COSMETICS

The renewed emphasis on clothes involves a foregrounding of the male body and face as a crucial part of the overall male image. It is largely bodies and faces that are used to appeal to a variety of consumers in advertising. Male bodies in the City are subject, according to Frank Mort, to the trend toward "hyper-cultivation".[50] Men who attended the City Lit's[51] course 'Men Caring for Themselves' claimed to want flatter abdomens.[52] This sort of desire in men is further attested by information from the London Hospital of Aesthetic Plastic Surgery concerning its male clientele, reckoned to be 40 per cent of the total, that, while more men in their late thirties choose facelifts, men between twenty-five and thirty years of age opt for liposuction.[53]

Gillette reckoned in 1993 that men in the UK spend an average of twenty-three minutes per day grooming themselves.[54] Since 1985, the 'male grooming market' has been calculated to be worth 26 per cent more than it was in 1985, and was believed to be about to grow by another 7 per cent.[55] A new range of Gillette skincare products for men was launched on 1 March 1993 with a £15 million advertising campaign.[56] The advertising image of the New Man may have been created in the 1980s, but it has become redundant in the 1990s, since, Gillette claims, all men have absorbed its messages.[57] Even when there are no applications of skincare products to the male face, it may well be cared for by aromatherapy and facial massage.

The main lesson here may simply be that there has been a marked growth in the belief of both genders of at least the entrepreneurial middle class that it is acceptable for men to pamper themselves and to expend time and effort on keeping up their appearance.

RECENT TRENDS IN THE MEDIA

While in 1969 male writers were happy to place on record their concerns about and recipes for the retention or creation of 'masculinity' in ballet, Judith Lynne Hanna in 1988 instead draws attention to the opportunities for male exhibitionism afforded by dance. She draws attention to the equation of masculinity with strength, directness and 'weight' as stereotypical, and notes new opportunities for demonstration of the male ability to ripple torsos and shift ribcages. While the context for men's dancing together was traditionally scenes of battle, work or competition, male dancers can today, she claims, relate as lovers.[58] The display that is an inevitable component of ballet but which could be thought to raise what to some are the dangers of male dancers' feminisation can be the very subject of a modern ballet. The lack of embarrassment in wider society about the exhibition of the male body beautiful permeates dance, so that a different conception of what is and is not proper to the masculine is mediated through ballet.[59]

Mark Finch notices how, in one popular American soap of the 1980s, *Dynasty*, the men are treated as *Playgirl* pin-ups, many of the younger male characters not only being in a state of undress in some scenes but remarked on for their attractiveness in such a state by what is connoted as a strong woman character of the Alexis Carrington variety.[60] In the

1990s, the most popular British soaps frequently offer shots of the younger male characters in their boxer shorts.[61]

American newscasting was examined as early as 1979 in the light of the to-be-looked-at-ness of certain male newscasters.[62] According to the report of that examination, television readers and reporters were believed to be employed on the basis of a version of Hollywood type-casting, so that the newscaster's face had to be strong and supple enough to advertise the most expensive cologne,[63] while the anchorman could be hip, more acerbic, young and sexy.[64] There have to be limitations to erotic appeal in television news, on the other hand. The study says in relation to Chuck Scarborough, "He's handsome enough so that, when he's reading a story, you do look at him; but his open, pleasing face isn't so distracting that he draws all your attention away from the news".[65]

MALE IMAGERY IN COMICS

Hypermasculine comic-book heroes can be found aplenty in the 1950s, when science-fiction comics offered heroes of seemingly impossible muscularity.[66] After considering the hypermasculine in them, Peter Middleton concludes that "the comics show what was possible for men".[67] Noticing that the commonest form of representation of the heroic male figure depends on an exaggerated male physique and the wearing of clothes that reveal as much of the body as possible, he points out that the heroes were displayed. Yet, this display bypassed the ego's censorship because of a fetishistic glance that allowed readers to see these pictures "only out of the corners of their eyes".[68] Because the muscular bodies, although apparently unconscious of sexual potential, summoned up homoerotic desire, violence kept the too explicit outcome of that desire at bay. "These heroes can't keep their hands off one another, but when they touch their desire turns to blows".[69] This analysis bears obvious similarities to that of Neale in relation to the male action genre.[70] Once again, the perceived threat of male display summons up violence. "These are bodies ill at ease with themselves, whether in the middle of some violent action or ready to perform one. Above all they are bodies to be looked at".[71]

Thus, in the 1992 Brian Lumley comic *Necroscope*, a magnificent-looking male, after stripping naked, approaches a prone naked male body. He thereupon steals the corpse's heart, smearing blood on his body as he bestrides the dead body.[72] Two men watching the screen on which

this activity appears are repelled by it, but are rebuked for their weakness by a third man, who looks older than they. At another point in *Necroscope*, the hero is asked why he always returns to his home in Romania.[73] "Is there some pretty girl?" He replies in the negative, and says, punningly, "Something in the *soil*,[74] I suppose". On both occasions, the erotic perceptions of diegetic viewer are superseded by actual or suggested violence.

In *Accident Man* (1991), the murderous villain of the comic is drawn as tall, lean, muscular, with short dark hair, and as wearing skintight leotards.[75] After his violent murder of a wimp type and his physical attack on some Northerner louts (the comic's identification) who have insulted a woman, he refers to the tension in him as PMT—Post Murder Tension. In this way, the erotic display that he first offers is bypassed by an emphasis on extreme violence, which is both glorified as highly male and critiqued (but by a female character) within the story. His resentment appears to be aroused by a nagging girlfriend[76] and by the lesbianism of his previous girlfriend.[77] The contradiction in presenting him as a splendid figure of a man whose male chauvinism is made ridiculous in the tale is not fully resolved. Then, too, *Accident Man* shows that it is not only the hero of comics, but the villain or at least anti-hero, who is supermuscular and hypermasculine.

Sometimes, the highly phallic men of the modern comic are endowed with a penis of heroic dimensions; more generally, the obscuring of their genital areas paradoxically suggests greater power, a power desired by women.[78]

The to-be-looked-at-ness of comics' heroic males identified by Peter Middleton is evidenced in *Digitek* (1992), but so is awareness of the potential discomfort that male exhibitionism can produce for the reader. When Jonathan Bryant transmogrifies into Digitek and declares, ". . . there's work to be done", he is dressed in a helmet, shoulder pads, boots and a loincloth of sorts. Jonathan's wife later turns on him and says, "Look, before you start posing again . . ."[79] Elsewhere, the ease and speed with which the hero strips is noteworthy. In a 1991 issue of *Detective Comics*, playboy Bruce arrives home, strips off his wet clothes in front of his English butler and then showers naked, with steam obscuring his midsection. Young Tim appears in tennis clothes. Bruce believes now that he is Batman, although Tim denies being the Boy Wonder.[80]

The homoeroticism of the visuals and the camp knowingness of the

narrative and dialogue at this point bring into play the homoeroticism that Middleton finds closest to thematisation in the Batman comics. "Batman wears a cape that falls almost to the ground, but, like a flasher, wears only trunks underneath. His large muscular body strains and stretches as he fights the villains".[81]

Modern comics are not more potentially homoerotic in their portraiture of male heroes and villains than those of several decades before. The difference is in their self-conscious awareness of potential eroticism, partly a result of their having as their target audience a more sophisticated, adult readership, and in the foregrounding of that awareness as well as the inclusion of such deflating devices as humorous comment on the unremarked erotic potential of the earlier artwork.

VI · male object—but which subject? (i): 'women'?

WOMEN AND THE PORNOGRAPHY DEBATE

Apart from the vexed, and highly relevant, question[1] of the definition of pornography, it would be conceded readily by the many sides in the pornography debate that some of the media contexts in which male erotic objects appear are unlikely to be identified as pornographic by any existing definition. Tarzan movies are not normally classified as porn, even if Johnny Weissmuller and, later, Lex Barker or Mike Henry can be appropriately discussed in terms of erotic object. However, the question of women as possible or intended subjects in the process of erotic objectification raises so many issues which occur within the pornography debate that it ought to avoid later redundancies of argument if this debate is now foregrounded at the start of this chapter.

Pornography is written about sometimes as if it were only heterosexual, or violent, or perverse.[2] More importantly, it is often written about as if the only possible position for women in heterosexual pornography were as diegetic objects. This effects the excision of women from pornography's spectators; according to this view, women are silenced in social actuality by their objectification in pornography, so that one of pornography's palpable harms is the obliteration of women and women's interests from the patriarchal map. But, even should that account be persuasive, what happens when women are diegetic subjects or socially constructed subjects (as at least appears to be the case in women-only audiences for so-called male striptease ladies' nights)? In such instances, is the alleged objectificatory harm of pornography lessened or intensified since this sort of erotic experience reinforces object-subject/female-male axes even if it switches the usual gender relations?

The debate may be familiar, indeed over-familiar, to some, but the central issues at least need to be rehearsed if the reader is to have access to other issues that follow in the wake of even the *apparent* creation of a social space, however narrow or covert, for the female subject.[3] The plurality of feminism, so that several feminisms rather than a monolith suggest themselves, has become more evident recently, particularly as a

result of splits engendered by attitudes to pornography and to legislation, actual or potential, concerning its suppression. The issues around which apparently polarised attitudes seem to occur within feminism include women's object status in pornography identified as male. They also include any suggestion that women could, or should, enjoy pornography which, while it is recognisably heterosexual in narrative terms, seems to offer a subjectivity that could well testify to a triumph of capitalism over patriarchy when the two collide.[4]

In 1990, it was noted by *Adult Video News* that a surprising share of sales and rentals of erotic films was cornered by videos featuring what it termed "men alone". The explanation for this[5] was found in "the growth in the male stripper-type video category".[6] The implication would appear to be, though it is not made explicit and is not necessarily the case, that female customers are involved, to a greater extent than hitherto realised, in such transactions.

It has been argued that the best way for American X-rated films to reach a female audience is via cable television. In 1987, it was reckoned that twenty-two million American households were wired for cable and that two hundred self-styled adult entertainment stations were located in different parts of the country.[7] One source claimed in 1985 that 60 per cent of the urban viewers of cable porn were women.[8] *Time* (30 March 1987) stated that, of the estimated one hundred million rentals of X-rated tapes per year, 40 per cent could be attributed to women. *Redbook* in the same year surveyed twenty-six thousand women: of these, nearly half claimed regularly to watch pornographic films, while 85 per cent claimed that they had seen at least one such film.[9] In the light of the statistics,[10] and of the existence of Candida Royalle's self-advertisingly different hardcore heterosexual video (with women as the alleged target audience), as well as of lesbian sadomasochistic fantasy pornography, it is far more difficult today to maintain the distinctions between male-oriented pornography and female-oriented erotica, the latter being, to quote Linda Williams, "soft, tender, nonexplicit".[11] Even away from the area of video and cable television, it has been affirmed that 40 per cent of the readership of the Scandinavian sex magazine *Cupido* is female and that the same statistic applies to the readership of the British *Forum*, that women's love of bodice rippers suggests an interest in female subjugation as a staple of romance in a way that is denied in women's name for more overtly pornographic contexts.[12]

The apparent growth of female interest in pornography throughout the 1980s, whether specifically created with women spectators in mind or not, has been argued to be not merely a sign of women's successful masculinisation but also a mark of the success of the women's movement.[13] Those women who combat the line on pornography associated primarily with Andrea Dworkin and Catharine MacKinnon—that pornographic images of women are responsible for women's subordination in social actuality—rest their case on two arguments. The first is that fantasy is related to reality, but that a relation which can be extremely complex is poorly explicated by an appeal to behaviourist psychology. The second is that the male audience that pornography is taken by its opponents to address encompasses a wide variety of individuals with differing attitudes to sex, including the desire to be passive, rather than a uniform universality. (The universalising tendency that has been descried in anti-pornographers extends to discussions of women, in that they purport to speak on behalf of all women, regardless of class, ethnicity and sexual orientation.)[14]

It could be commented that the insistence on exploration of the relation of fantasy to reality, of the representation of sexual performance to actual sexual conduct, is a retreat into an area where academics feel more at home, away from the conditions under which pornography is actually produced and consumed, an area where they can patronise the opinions of female sex workers and male truck drivers or invoke notions of false consciousness.[15] All the same, if a principal objection to pornographic fantasy is that it unleashes dangerous social effects, the debate has to be entered into, elitist-seeming or not.[16]

The feminist opposition to anti-pornography feminists tends to stress that the real is "a variable construction which is always and only determined in relation to its constitutive outside: fantasy, the unthinkable, the unreal".[17] Those who favour censorship can be understood to conflate the signified with its referent; in their view, fantasy "makes possible and enacts precisely the referent of that representation".[18] What pose as liberatory arguments around porn can be equally prone to assume actual identifications on naturalised gender lines. Thus, porn claimed to be from a woman's point of view or to offer more equality is taken to be automatically in women's interests, the assumption being that it is read on predictable male/female lines. "A very different reading," according

to Liz Kotz, "primarily derived from lesbian and gay cultural practices, would emphasise the possibility for multiple and contradictory gender identifications which shift and disperse within the scene, so that the woman viewer, in effect, can be anywhere".[19]

A question which plagues feminist objections to pornographic (and other?) representations of heterosexual activities is whether it is the representation only or the activities too which are objectionable. Anti-pornography arguments are largely silent on issues of sex, but their implication is that women feel no strong sexual desires, certainly no lust. The desexualised woman engendered by this discourse must be victimised not only by pornography oriented towards male pleasure but, presumably, by heterosexual coitus, which is implicitly geared towards male pleasure, a pleasure that is bound up with domination and aggression, placing the desexualised woman in the role of victim. Against this, some feminists would argue that to desexualise woman is to do the work of patriarchy, and that earlier strands of feminism sought to wrest definitions of female sexuality from patriarchal strictures. Most seriously, it can be claimed that this particular feminism acquiesces in general society's stereotyping and objectifying of women and even reinforces that objectification by characterising women, if desexualised, as inevitably the victims of male aggressors' lust. "To tell what is wrong with rape, explain what is right about sex", urges Catharine MacKinnon.[20] This can be taken, out of context, innocently enough, as counselling the promotion of consensual sex. It might well be taken to imply something quite different, that heterosexual acts cannot be simply thought of as right, because they represent a subjugation of women within the allegedly natural sexuality so beloved of the fundamentalist Right.

Not so long ago, it was possible to claim without apparently the need for argument that it was well known that women are not aroused by pornography.[21] This once unchallengeable opinion was based on observation, but needs further examination so that the value of the observation in, for instance, arguments about an essentially female sexuality may be gauged. One explanation for the lack of female interest might be that pornography seemed to be about sexual imagery made public and women have been taught that public displays of sexuality are negatively valued in social terms.[22] If so, the removal of pornography to areas of private consumption by the relatively new technologies of cable and of

video rental becomes of obvious relevance to considerations of women's attitudes to the pornographic. Another explanation is that women do like pornography, but that women's pornography is not recognised as such by male commentators. If Mills and Boon paperback romances present the subjugation of women by handsome, potent men, then one claimed message of at least heterosexual pornography is readily received by women readers. (A related point is made by Barbara Rogers, editor of *Everywoman*: "All the information we have shows that women don't like porn, but I don't categorise what the women's glossies are doing as porn").[23]

Alan Soble looks to labour relations under capitalism for an explanation of the claimed differences in male and female sexuality. A sine qua non of pornography categorised as male is the fetishisation and fragmentation of body parts. Soble argue that there is little female partialism of male bodies, because the traditional division of labour has restricted women to reproduction, nurturing and service industries; these realms generate "a more holistic than atomistic view of persons and bodies".[24] He also cites Marcuse in saying that, while vision is the most important sense in the (male) labourer, he is desensitised as to touch and smell, while women are not. "It follows", Soble argues, "that if men were brought into the realm of reproduction (with the collapse of the sexual division of labor), they would better be able to appreciate sexually the odours of women's bodies".[25] The corollary to this is not suggested by Soble, but may be more interesting for this chapter: that women brought into the realm of male labour are enabled to appreciate sexually the spectacle of men's bodies.[26]

Whatever the reasons, there is evidence, in the growth of women-oriented porn, the male strip show, specialist male stripograms, and erotic-fantasy phone lines for women, to suggest that sexually explicit and largely visual stimulation may not be as off-putting for women as it seems to have been prior to the 1970s at least. In any case, women may not be as excluded from hardcore porn not specifically geared to women as is often assumed. If phallic power is everywhere eroticised in our culture, then surely women's sexuality is learned partly through that eroticisation.[27]

The augmentation of women's pleasure in the sexually explicit is viewed by Sheila Jeffreys as a development to be deeply distrusted, although her argument is a curious one. This is that the connections

between sex, power and aggression have been explained as "immutable and harmless", so that the "libertarians" (among whom she places Michel Foucault and Jeffrey Weeks!) are enabled to treat sexuality "as a garden of delights in which the very connections which trouble the prudes and puritans can be mined for the pleasures they can provide".[28]

Despite evidence of change in women's attitudes to pornography there has recently been a history of more or less successful inroads into public opinion, such that it may be taken as axiomatic in some quarters that pornography must be injurious to women or to women's interests.[29]

In 1984, the Minneapolis Ordinance drafted by Andrea Dworkin and Catharine MacKinnon for a time permitted women to take civil action against the producers, distributors or sellers of pornography on the grounds that they, as women, had suffered harm by reason of its image of them. Despite the vetoing of the ordinance by the mayor, the Indianapolis City Council passed a revised version of it. Similar legislation was attempted the following year by Los Angeles and Cambridge, Massachusetts, while the Feminist Anti-Censorship Taskforce (FACT) battled against these attempts. The Supreme Court finally declared the Indianapolis ordinance unconstitutional, recognising that under the First Amendment to the American Constitution freedom of speech is guaranteed.

In Britain, the Campaign Against Pornography and Censorship attempted to repeat the temporary success of the Dworkin and MacKinnon–drafted legislation. Elements of both the Conservative and Labour Parties have in the 1980s and 1990s united with certain anti-pornography feminists to organise a campaign against the alleged exploitation of women. The Labour MP Dawn Primarolo, for example, in 1990 essayed legislation seeking to restrict the availability of sexually explicit material by her Location of Pornographic Materials Bill, using the Minneapolis Ordinance as her model. The main law on pornography continues, however, to be the Obscene Publications Act, which, in 1964, included photographic images within its ambit. The recommendations of the Williams Committee on Obscenity and Film Censorship in 1979 were that the possible offence created by the wide visibility of certain materials should be removed by the blacking out of sex-shop windows, for example. The spirit of these recommendations seems to have been ignored in the gathering urge in some political quarters to increase

control by restrictions on representations not only through such legisla-
tion as the Indecent Displays (Control) Act of 1981 but the Local Govern-
ment (Miscellaneous Provisions) Act of 1982 whereby local authorities
have the power to grant or withhold licences from sex establishments.
The Video Recordings Act of 1984 offered a laundry list of visual images
which required classification before they could be distributed. The
British Board of Film Classification thus took up the role of censor.
Importation of allegedly indecent articles is a matter for HM Customs
and Excise, with the onus to challenge placed on the importer from
whom goods are seized.[30]

Feminists who seek to make sexually explicit representation vulnerable
to prosecution appear to believe that censorship can remain within their
control. Some feminist (and other) opponents of censorship accept much
of what is argued regarding pornography and its reinforcement of patriar-
chal norms (even if there are counter-readings that focus on the unreli-
ability of fantasy as an indicator of real-life behaviour and attitudes). What
most concerns them is that legislation of this sort is often turned on
minorities, particularly in the field of indecent representations sexual mi-
norities, and may easily be used against, for example, lesbian-feminists.
That this is not a paranoid fear could be demonstrated by certain exam-
ples of recent intervention by state agencies of control. Among these
might be the ban on *Taxi Zum Klo* and on the "pro-lesbian" *Born in Flames*
by the Ontario Board of Censors, or the denial of state funding to exhibi-
tions of Robert Mapplethorpe's work on grounds that practically quote the
MacKinnon/Dworkin bill.[31]

Pornography's insistence on women's enjoyment, even if it be to reas-
sure men of the male power to grant that enjoyment, still more women's
own insistence on their ability to enjoy pornography, *can* be taken as
liberatory. Tania Modleski says pertinently, " . . . it is certainly true that for
women to insist on sexuality and on their right to enjoy pornography
may be a liberating release from a socialisation process that denies these
rights".[32] Such enjoyment runs the risk of being dismissed as male-iden-
tified, though.[33] Is there such a thing as feminine desire? On the one
hand, we have the idea from psychoanalysis that femininity, like
masculinity, is produced by the Oedipus complex, so that it is not essen-
tially or biologically female. On the other, we have Kathy Myers's notion
that the idea of desire "defined by drive and not by object" provides a

means of "challenging patriarchy's naturalisation of the sexual status quo", the patriarchal version of women's desire involving heterosexuality, passivity, domesticity.[34] This version informs the pleasures served up by heterosexual porn, in that the women of the diegesis usually exist for male pleasure, or receive pleasure precisely at the moment the men enjoying them achieve climax.[35] Yet, the view that the fantasy can be read only in two, socially gendered, ways by women so that they either identify masochistically with the woman of the diegesis or identify sadistically in transvestite manner with its man surely runs counter to what is suggested of fantasy by Freud—that identifications are multiple, fractured and unpredictable on gender lines. The most depressing sentence in Linda Williams's investigation of hardcore is her appeal to common sense when she refuses to consider gay or lesbian porn on the grounds that it could not appeal to her.[36] It can be compared with Rosie Gunn's rejection of heterosexual porn on the grounds that she is not addressed as a woman, because it has been produced for heterosexual men,[37] but can be contrasted with Gunn's frank enjoyment of gay porn which produces in her "a feeling of pure lust which I don't usually recognise when a woman is in the scene".[38] It may be precisely the absence of commonsense possibilities of identification that facilitates her pleasure; the exhibitionism of the male performers appeals to the secret voyeur in her, so that she takes "a certain pleasure in the naughtiness of seeing what I'm not meant to see".[39]

What would a pornographic address to women be like? Linda Williams seems already to feel addressed by heterosexual porn, perhaps because 'heterosexual' carries more meaning for her in this context than 'woman'; Rosie Gunn feels that she is not. The evidence from magazines such as *Playgirl* and the British *For Women*, which believe that they are addressing women, is not so helpful here, since they seem to reverse male sexism so that women learn to see as men have done. Margaret Walters may well object, "Struggling against their traditional passivity does not mean women becoming imitation men: which is the assumption made by magazines like *Playgirl* trying to sell nude pin-ups to women. Such magazines are trying to reduce a woman's feelings to a formula even before she knows what they really are or might be".[40] The assumption here pinpointed seems to be shared by pornographic narratives which make concessions to a previously ignored female spectator;

for example, they make voyeurism serve the interests of an improved sex life for a male–female couple or offer higher production values and better-looking male porn actors,[41] or create an illusion of greater equality by having the woman sex partner on top! The clue to a new potential of address may lie in Walters's suggestion that a woman's feelings (in the context of active desire and erotic fantasy) are not known, even if they are readily assumed to be a man's in reverse. Sara Diamond argues for an exploration of assumptions within porn, including a challenge to the stereotype of what a sexually active woman looks like.[42] The address would by this sort of reckoning be less content-based or even expressed in terms of identificatory positions. Rather, it would be an openness to alternative versions and visions,[43] exploring but not limiting itself to greater passivity in men: ". . . we can blur sexually explicit images, create an ambience of desire . . ."[44]

One way of looking at pornography with assumed appeal to women would be to consider the variety produced by women with women's pleasure in mind. Films made by Femme Productions (the most cele-brated director being Candida Royalle) and the Star Director Series (where famous women porn stars become directors) seem to pride themselves on a version of good taste and spend far more narrative time on foreplay than on hardcore sexual activity, this proportion appearing to reverse that associated with heterosexual pornography aimed at men. *Christine's Secret*, made by women for Femme Productions in 1984, is claimed to be "organised in a non-phallocentric way".[45] It is set in the countryside. The sunniness of the setting extends to the depiction of pleasure, so that mutuality and wholesomeness are emphasised, cum shots are absent, genital fragmentation is downplayed in favour of pans over bodies. To a masculinised viewer used to quite another variety of heterosexual porn, this seems like the closest to respectability that pornography can get.

Women who were once assumed to be outside the range of potential customers have in the 1970s but particularly the 1980s been taken as a vast new target group for pornography. That pornography, while largely categorisable as heterosexual, proclaims its differences from the customary male-oriented sort by some of the devices just outlined in the Candida Royalle context.

The greater control which the activities of female directors and

distributors suggest can certainly be used as a counter to the more sweeping claims of the anti-pornographers: such as, that women are always victimised and exploited by porn; that women who believe their autonomy is proved by their choosing to work in the sex industry within conditions decided by themselves are really dupes and have been colonised by patriarchy. On the other hand, it may be too sanguine altogether to suggest that an actress's control over her image is guaranteed by her conscious choices and her working conditions. Madonna's increasingly explicit erotic videos turn upon the star's awareness of the dangers of women's objectification as well as of the need to take control of that process herself, sometimes using laughter, rather than outrage, as a weapon. Sometimes, too, she wants to indicate her pleasure in the erotic use made of her by men whose attentions she welcomes. Despite her image of strength and the reality of her commercial power, she recognises limits to her independence.[46] "No matter how in control you think you are of sexuality and relationships there is always a certain amount of compromise".[47]

THE DOMINANCE OF MALE SEXUALITY IN PORNOGRAPHY

The fact that there is currently a type of pornography marketed for women is an insufficient answer to questions concerning the possibility or nature of female spectatorship in pornographic or erotic representations. The anti-pornography thinking that clusters around the Dworkin–MacKinnon views of female sexuality may not be cogent, in that it seems to demand an essential woman of pure female sexuality which has been repressed by patriarchy and which is opposed to an essential male of universally aggressive, demeaning and equally essential sexuality. However, it is just as unimpressive to leave the debate at the point of noting the creation of a female spectator by pornographic texts.

The historical subject, the woman who reads the texts, must relate to that hypothetical spectator, but exactly how? It has been claimed that there is no sexuality outside fantasy, that representation is vital to sexuality, that there are grounds for going so far as to claim that sexuality is nothing but representation. If we accept some or all of these claims, then we need to recognise that changed representations indicate change in at least the pornographic articulation of female desire. This change must have some bearing on the way that women in actuality experience

desire. If it should remain true, all the same, that the bulk of heterosexual pornography is for men, so that women's active desire is represented largely to reassure men that it is within their gift to satisfy it or to withhold satisfaction, then a different social picture could be painted—different from the one painted by attention only to the fact of an erotica for women (whether by women or not) or even to women's ability to read unpromising material in ways more appealing to their interests.

Also, there must be a possibility of understanding women's pain and anger in confronting pornographic images of women in ways which do not fall back on use of the "puritan", "frigid" or "prude" labels that are so vital to the workings of pornography itself. The appeal to the right of freedom of expression by those who enjoy heterosexual pornography rings hollow when it takes no account of many women's anguish and sense of betrayal. Possibly the best recruiting agent that the pro-censorship anti-pornographers have is the unregenerate prefeminist male user of pornography.[48]

An important end is served by the refusal to bring feminist positing of male power's reinforcement through pornography into the light of day. This is to prevent examination of male sexuality, which poses as natural and pre-given, just as heterosexuality poses as God-given and, again, natural. The particular, historical version of heterosexuality which not only assures male privilege but treats that privilege as unalterable (because natural) prefers to remain invisible so that its consequences may escape scrutiny or alteration. Hence, the easy use of insult in the attempt to silence dissent. Women who complain about male power or who believe that it is reinforced in pornographic representations can be safely ignored because they are in contention with Nature, it is confidently felt. Men are like that, it would seem. Can the leopard change its spots? Therefore, even if a male view of the world is not truth, it might as well be treated as such, since male dominance is assured by God and Nature. If indeed, as has been claimed, "the sexual pleasure of looking is central to male identification", then heterosexual pornography, when it is not straightforwardly marketing its appeal to the male customer, must be causing gender confusion in its female target.[49] (Or could it be counter-claimed that when the sexual pleasure of looking is publicly declared under capitalism to be proper to women too, this is a sign that historically shifting sexualities have begun to alter dramatically, albeit for commercial reasons?)

Is heterosexual pornography forever fixed as a relation between men? Certainly, that was the social message in the days of the stag-party one-reeler and in the running of porn-movie cinemas in the 1970s, where the presence of women in the audience was possible but uncomfortable.[50] That relation may still be assumed by certain men, but the new viewing conditions of the domestic environment for porn videos or of the ladies-only night out must suggest a major flaw in the edifice of male-only viewing.

Since John Berger's work on looking at fine-art depictions of the eroti-cised female, it has been accepted that that relation is between males, so that the male artist shows the attractive female possession to her owner, so to speak, and to the male spectator, another version of the propri-etor.[51] This carries over into heterosexual pornography, where the gender of the viewer, as male, can, apparently, be safely assumed. Some thinkers are not sufficiently impressed with this certainty. Judith Butler, for instance, feels that the pornographic text's allowance of a single in-terpretation (and thus, presumably, of a single gender of reader) is "itself a construction of the pornographic text as a site of unequivocal meaning". For her, the claim of an enforced closure of the text's possible readings "is itself the forcible act by which that foreclosure is effected".[52] The place open to women, of identification with the passive object posi-tion, requires the consolidation of rival sites of identification into this one. The obvious implication of Butler's analysis is that the text's foreclo-sure of other possibilities of female identification does not have to be allowed to operate. Only the claim of enforced closure effects that closure.

Women within the pornographic narrative may have the apparently important task of narrating. However, what they narrate is whether or not the men of the narrative have the capacity to do what is required of them by the women of the narrative—which is to overpower and subju-gate them to their will. Female desire in such scenarios is precisely to fulfil male desires. Put like this, the complementarity of male and female desire within heterosexuality is revealed as a peculiarly male construct, or rather an idea that is so remarkably convenient for male sexual privi-lege that it seems likely that it should be seen as a construct.

To read the pornographic narrative as it invites the reading to be done, as a triumphant assertion of male power, is curiously blinkered. Surely,

the importance of heterosexual pornography in male experience is testament to male insecurity and vulnerability. The power of the fantasy may be in its resolution of the feelings of inadequacy fostered by demonstrations of male impotence in the workplace as well as (therefore?) the home.[53] If pornography be read as a realist text in the manner of Dworkin–MacKinnon, then it can be taken as a demonstration of the real-life power (and brutal use of it) of man over woman. With its fantasy element to the fore, it suggests an awareness of diminishing power before, in particular, social advances made by women. The female spectator of heterosexual pornography, likewise, need not suggest so much a masculinisation of her essentially female sexuality as awareness of the greater power won for her in these advances.

There are signs even within the traditional pornographic narratives that the male is conscious of diminution in his traditional power, as in scenes where he enacts sexual slavery or degradation at the hands (or other body parts) of a dominating mistress.[54] In any case, as Scott MacDonald asks, if males dominate, "why would they pay to see sexual fantasies of male domination?"[55] If porn were the bible of male domination, why is the social experience of it so furtive and secretive for men?

There is a gulf between maleness and masculinity, between the penis and the phallus. One of pornography's most significant functions may be to suggest that the gap is bridged, that one is the other. The world in which we live is, according to Victor J. Seidler, "a social world of power and subordination in which men have been forced to compete if they are to benefit from their inherited masculinity".[56] In heterosexual pornography, men are always, by its understandings of the term, masculine, the penis always of generous size, and usually erect. It may be possible to go beyond this equation, and to suggest that the 'phallic penis' is beyond male control. The insatiable whores that represent women in heterosexual pornography will use men for their pleasure, in the sense that they use male organs for their pleasure, but will as readily use substitutes, dildos, vibrators, any penislike object. Pornography then offers a world that celebrates masculinity but a masculinity which transcends or threatens to transcend the virility of its males.

This may be one good reason, the loss of control by persons of *both* genders over the world of pornography, why the search for identification may be misleading as a way into pornographic texts. The Dworkin analy-

sis of pornography would lead us to expect male point-of-view shots to suture the spectator into the narrative, but the spectator's point-of-view is not aligned with either party to even a standard heterosexual encounter. Both bodies are fragmented and partialised. While there may be possibilities of piecemeal identification with the camera's look, there is no clear diegetic look of the male at the female to anchor the spectator in place, as in Mulvey's account of the gaze in narrative (Hollywood) cinema. Females in the narrative threaten constantly to exceed the position of spectacle, males threaten constantly to become spectacle.[57] For this reason, pornography is suprisingly difficult to read (in the interpretative sense), since the usual strategies by which spectators are drawn into complicity with certain characters and one gender are not easily discernible. Possibly the absence of compelling univocal evidence for the violence wrought by heterosexual pornography provides fertile ground for the tenacious growth of the urban myth of the snuff movie— in which everybody seems to believe as fact, but which nobody, not even a member of the police force, seems to have seen.[58]

One argument whereby pornography does not so much objectify women, does not so much force the female spectator into masculine seeing, is offered by E. Ann Kaplan, particularly when she says, "The open expression of women's often untramelled, limitless desire in some pornography may excite the female spectator, used only to the linking of female desire with evil in mainstream genres. It may be that the female spectator of pornography reaches her desire by a circuitous route (i.e. the representation only exists because of man's desire for her desire), but nevertheless she can reach it".[59]

PORNOGRAPHY AS FANTASY

Broad agreement seems to obtain that pornography is a form of fantasy. The great difference within feminism is that the fantasy translates almost inevitably into attitudes, acts and conduct by one reckoning, while Feminists Against Censorship, for example, claim forthrightly, "Sexual fantasies and sexual behaviour do not necessarily mirror attitudes and behaviour outside the context of sexual activity".[60] One group of analysts focuses on the intensification of real-life objectification of women. A different analysis would have it that in pornographic fantasy men dream of becoming more womanlike, more capable of being objectified.[61]

Rosemary Jackson's work on the literature of fantasy does not concern itself primarily with elements in pornography, but her characterisation of fantasy literature as subversive involves a study of the relation of fantasy to the real and to the social order.[62] Fantasy, in her account, "is a literature of desire, which seeks that which is experienced as absence and loss".[63] Again, fantasy "traces the unsaid and the unseen of culture: that which has been silenced, made invisible, covered over and made 'absent'".[64] The notion of culture in Jackson embraces the capitalist order and patriarchy. On this basis, applied to the present context, that which is fantasised, both male dominance and the granting of passive and objectified positions to male subjects, speaks to the silence, invisibility and absence of such possibilities within patriarchy. The real consequence of pornographic fantasising may be that it substitutes for action, rather than that it carries into effect its imaginary scenarios.[65]

One of the interesting results of consideration of Jackson's work is that a question could be raised about the moral outrage expressed against pornography: Is this outrage against its fantasy content? Fantasy has, after all, "persistently been silenced, or re-written, in transcendental rather than transgressive terms. Its threatened un-doing, or dissolution, of dominant structures, has been re-made, re-covered . . . ".[66] In Michel Foucault's words, it has been "either rejected altogether or polemically refuted . . . ".[67] The alleged violence of pornography, Sadean and otherwise, is explained also by fantasy's gnawing sense of frustration. Such fantasies are "driven by precisely this kind of restless dissatisfaction. They express a desire for the imaginary, for that which has not yet been caught and confined by a symbolic order". The self-mutilation, cruelty and horror employed in the tales of fantasy suggest the inaccessibility of the imaginary.[68]

According to Laplanche and Pontalis, identification within fantasy is "distributed among the various elements of the scene".[69] Thus, the subject is always present in the fantasy but "may be so in a desubjectivised form, that is to say, in the very syntax of the sequence in question".[70] Fantasy's fragmenting of identity makes its location highly problematic. An illustration of commonsensically impossible identifications in fantasy is offered by the statement that in fantasy "both sexes covertly seek that to which they are not overtly entitled".[71] When Bette Gordon made the film *Variety*, she wished to explore "the gap between

sexual fantasy and sexual identity" so that she could thereby explore issues at the intersection of feminism and film.[72] She believes that pornography is not a monolith, that it is open to intervention, that women are active agents, even within patriarchal culture, "who interpret and utilise cultural symbols on their own behalf".[73]

Brakes are applied to optimism consequent on conceptions of a subject's ability to occupy multiple positions by Kaja Silverman's emphasis on the importance of biological identity to the access one has to social positions, "even when one's identifications run completely counter to that 'recognition'". She adds, "The subject's pattern of identi- fication . . . assumes its meaning and political value in relation to his or her socially assigned gender".[74] Silverman, dealing with Freud on fantasy, focuses less on the fragmentation of the subject and more on the scenic organisation of the fantasies—"laid out, as it were for the gaze".[75] The gaze, she maintains, is crucial within the organisation of identity, so that woman cannot "escape specularity by slipping out of subjectivity and into sexuality".[76]

In any case, fantasy is not necessarily or inherently subversive, according to Rosemary Jackson. It is not the thematics only, but a struc- turalist reading of the texts, which uncovers its subversive potential. The fantastic "can be seen as an art of estrangement, resisting closure, opening structures which categorise experience in the name of a 'human reality'". She continues, "By drawing attention to the relative nature of these categories the fantastic moves towards a dismantling of the 'real' . . . ".[77]

With due caution about underestimation of the importance assign- able to the subject's biology or overestimation of fantasy's inbuilt subver- siveness, it is possible, surely, on the other hand, to wrest understanding of pornography from the predictability of a view that it can do no other than to reinforce male activity and female passivity.

WOMEN AND THE VISUAL

Historically, women were denied the medical and artistic gazes by being excluded so long from medical training and from life classes. In view of this history, belief in gender neutrality in, say, art is hard to maintain other than as myth. So, discussions of art as well as productions of art need to be carried on in awareness of gender values if that myth is to have

any hope of deconstruction. However, if historical conditions are subject to variability, cannot a female spectator be conceived? In any case, there has been continuous interest for the past twenty years at least in the possibilities suggested by a spectatorship, as in the conditions of the cinema, whose subjectivity challenges the imagined constancy and consistency of gender (and other) identity.

Kaja Silverman radically challenges the notion of a gaze that belongs to one gender (and not the other) by destabilising the anthropomorphisation of the gaze. She considers that the mirror stage is inconceivable without the presence of an other, standing in for the Other. Then, for the child "to continue to 'see' itself, it must continue to be (culturally) 'seen'".[78] The male subject is no different from the female subject in this regard. He is "as fundamentally exhibitionist" as the female. This exhibitionism has in more recent social history been disavowed. Male subjectivity has been identified with "a network of looks, including those of the designer, the photographer, the admirer, and the 'connoisseur'". By such means, the male subject sees himself (and is thus seen) as "the one who looks at women".[79] This account foregrounds the important conclusion that the gaze "proceeds from the place of the Other". (It is not, in other words, a male prerogative except in so far as this is seized on the male behalf in the symbolic order.)[80]

Perhaps, then, if Silverman's use of Lacan educates us as to the process that has operated in the symbolic order to make the gaze seem only masculine, and to disavow male exhibitionism along with female voyeurism,[81] our attention ought particularly to be directed to the construction (via patriarchal representations) of the spectator as male.[82]

Despite patriarchal prohibitions on female spectatorship, fan cults for stars of both sexes attest the possibility and the actuality.[83] In public situations where women have the chance to look but may be observed looking, it is presumably because of social prohibition that their looking is of a different character from men's. Thus, it has been observed of women on a nudist beach, "Women . . . do the nude voyeur thing, too, but more covertly, less intently, and generally with less willingness to talk about it".[84] This description approximates to Richard Dyer's belief that "women do not so much look at men as watch them".[85] This contrasts with male looking behaviour, where, when the object is a woman, staring seems a better description, this staring being closely related to dominance

display. When the situation is more protected and private, women may more openly declare an interest in the male as erotic object. Thus, for example, the American magazine *Glamour* claims that 86 per cent of women it questioned thought that there should be more male nudity in films.[86]

Patriarchal disapproval of the woman who looks is illustrated by the stereotype of the vamp who sizes up men in the Mae West style as castrating. It is an easy step from the social embargo on women's looking, with, as one powerful sanction, lost reputation, to suggesting that women's nature is not to feel pleasure in the visual. If the visual is not female territory, it is because the territory has been claimed by male imposture. Women's sojourn on the territory is made to feel like a gift from those who naturally inhabit it. Visual pleasure is crucial to that of pornography because it is linked with the pleasures of naturally possessing a right to gaze—or so it is all too often claimed. Pleasure in the visual is so tightly tied up with masculinity that pleasure from the visual can feel wrong for a woman in this society, since she is encouraged to feel that she is betraying her sex. After all, the visual field is that in which the female is objectified—both a part of and symbol of women's oppression.[87]

In view of the evidence of prohibition on female gazing, it is particularly interesting that Nancy M. Henley states that women engage in eye contact more than men, especially with other women.[88] She informs us that eye contact invites or indicates intimacy.[89] Thus, she draws attention to a look which is not covered by the fetishistic or voyeuristic gaze (at the cinema screen, especially)—the look of approval, indicating admiration or assent through visual attention. Since this is a look that is sought by women in particular from those with whom intimacy has been established or hoped for, it is difficult to call it an objectifying look, except in so far as approval may be based on positive assessment of the erotic attractions of the person looked at. The intimate look may have little relevance to the medium of cinema, whose erotic appeal, we have been accustomed to accept, depends on distance and on intensity of gaze; perhaps all that it permits is simply female voyeurism. What do we say, though, of female spectatorship in the context of video, television and magazines, where the distance is less and the intensity markedly less? With what confidence can we discuss female spectatorship on a cinema model, if the cinema spectator should be, as Hansen puts it, "an object of nostalgic contemplation"?[90]

Whatever the nature of the female look, the more social question insists itself: whether women have the power to act on a desiring look in the way that men in society are presumed to have—or, if men do not have, to have the brute strength to force their will. An answer of sorts is suggested by Pauline Brown, editor of *Ludus*: "Once women get behind the camera and choose how to photograph men, they don't feel nearly so threatened by them".[91] This answer, though, is more psychological than social, even if psychological change can produce social effects.

Given the prevailing and sometimes contradictory notions about the female gaze—that women don't like to look and that, if women do like to look, then they are castrating and following the habits of male subjects in objectifying (men)—what can we find new or different to say of the woman who chooses to view the nude male, for example? There may be a conspiracy to keep such viewing out of sight and thus out of reckoning. If so, the veil drawn over it has a similar effect (for similar reasons) to what results from the energies devoted to keeping male anatomy secret. As Peter Lehman puts it, "Traditional patriarchal constructions of masculinity benefit enormously by keeping the male body in the dark, out of the critical spotlight. Indeed, the mystique of the phallus is, in part, dependent on it".[92]

Mary Ann Doane, in attempting to describe the female spectator, proposes a Metzian opposition of proximity and distance. The woman, because she is unable fully to separate from the maternal body, cannot preserve a sufficient distance from her body to become a fetishist, but may rather overidentify masochistically with the image. Doane can conceptualise the diegetic female as using the notion of masquerade, whereby she dons the clothes of the "other". The female spectator sees through the diegetic masquerade and understands, thus, that femininity is performed rather than lived. Armed with this comprehension, she can stand back from the image and critique it.[93]

Another model for the female spectator is that of the nineteenth-century *flâneuse*, who was offered the new public spaces of the department store and amusement park for her gaze. (If she was thus empowered in visual terms by reason of an address to her as consumer, a similar address is surely not beyond imagination. That address would, though, be in the different context of erotic imagery.)

Whatever the theorisation of a female gaze, the attention devoted to

the narcissistic gaze (which is regularly accorded to women) helps to obliterate women's role in the creation of images. The female artist is expected by Rozsika Parker to confront the need to find a language "that will bring her own feelings into consciousness", though the artist in turn may expect her contributions to be viewed as "incorrect, deviant or flawed" because female interests and goals "will differ from the male tradition".[94] She will be placed, as a gazer, under the suspicion of what is highly tabooed, namely "female sexual aggression towards men".[95]

Della Grace argues that there is a power relationship in her photographs, but that the subject–object positions in her photography are not fixed. The power dynamics oscillate between the positions and between photographer and subject, according to her, in such a way that the spectator must question his or her positioning.[96]

The breaking down of the circumscribed masculine/feminine: subject/object picture is aided by Gaylyn Studlar's substitution of masochism for sadism as the principal visual pleasure of cinema, since exchanges of position "are part of the dynamic of pleasure in the masochistic play of pursuit and disappointment".[97]

FEMALE SEXUALITY/(VISUAL) PLEASURE

Over against essentialist notions of gender as biological and attributable to Nature is the thinking that would separate gender from biology and claim that it is learned and thus social, that the attribution of gender to Nature is a matter of ideology rather than a truth. Closely connected with gender, as socially constructed, is sexuality, also socially constructed within heterosexuality. One result of that construction is that our culture understands female sexual desire in terms of the eroticisation of female subordination. In this way, women's pleasure can seem "other, passive, dependent on the donor".[98] Catharine MacKinnon sees, for such reasons, that sexuality is to feminism what work is to Marxism—"that which is most one's own, yet most taken away".[99]

All the same, social constructions contain the potential for change, as society itself alters. There is a difference between, on the one hand, a view that sexual activity without repression automatically liberates and, on the other, a belief in the possibility of change in male and female plea-sure which recognises that such change is intertwined with social and economic changes. Female sexuality may be understood as being

loaded with, or even made equivalent to, eroticised subordination within our culture. This is different from confining the range of meanings to that which is dominant belief within that culture. As Carole Vance claims, "The hallmark of sexuality is its complexity: its multiple meanings, sensations, and connections. It is all too easy to cast sexual experience as either wholly pleasurable or dangerous; our culture encourages us to do so".[100] The danger is a blanket ignoring of individual dissent from prevailing views, a danger that may ensue from awareness that sexual individualism of the kind popularised in the 1960s leaves one gender in its active position (through which the other is denied activity) and the other to enjoy its subordination. Vance again: "To assume that symbols have a unitary meaning, the one dominant culture assigns them, is to fail to investigate the individuals' experience and cognition of symbols, as well as individual ability to transform and manipulate symbols in a complex way which draws on play, creativity, humour, and intelligence".[101] In other words, the personal may really be political. Mainstream culture's hegemony may be less seamlessly realisable than it cares to believe.

Attention needs to be paid in accounts of female spectatorship in cinema not just to identifications with the marginalised heroine of the male action film or to fantasies of activity by identification with an action man, but to pleasures linked with the male as visual, erotic object. The pleasurable positions offered to women may sustain male privilege, but this is not the whole story.

Ellen Willis believes that there is an element of surrender (loss of ego control, particularly) involved in giving oneself up to pleasure, but that there is also an element of empowerment "in the demand that one's needs be gratified, in directly seizing pleasure".[102] She believes that in a hierarchical society the two elements are split off from each other, that empowerment is confused with dominance, surrender with submission. She believes also that this account of duality in pleasure applies to both men's and women's pleasures, even if the acting out socially is differently determined for each gender.[103] Therefore, sex is not a monolith. Rather, "it's a minefield of all these contradictions; it's an area of struggle".[104]

Neither is pleasure eternal, unchanging, above history.[105] Accounts of female pleasure include those which refuse to play the wider culture's game and which discover possible pleasures in precisely those areas

where women are not addressed, where there is no "for women" label attached which tries to mould that pleasure in ways acceptable to a wider constituency. Thus, Sarah Kent claims that when a female presence is not expected or considered in erotic contexts, the woman is left free to indulge her voyeurism in a way that is severely impeded in the contemplation of those images where the female observer is envisaged; in these, her presence is a conscious element in the image's encoding.[106] If the increased visibility of the male nude is readable as not only "for women" but a possible tactic to expand masculine territory, Kent reminds us that patriarchal intentionality is as fallible and partial as other versions. Those feminists who are interested in exploring questions of female pleasure recognise that it involves not taking any one account as an orthodoxy but rather that there are spaces available— interstices between taking female sexuality as all danger or all pleasure, for example. These interstices are not self-evidently already in women's interests. They are available, nothing more. But to refuse to exploit availability could be mistaken.

A particular problem with female enjoyment in the visual field is that the male nude's fine-art meaning in patriarchy is entirely bound up with the phallic and therefore with public manifestations of power, while the female nude caters to the more private erotic fantasies of males in private. The phallic attributes of, say, Hercules in art are augmented by modern technology's electric drills and motorbikes and its wide array of sophisticated weaponry. Phallic power is, curiously, protected today by restrictions on direct representations of male genitalia and, especially in Britain, as a result of the police's understanding of obscenity laws, of the sexually excited male genitalia. Given these restrictions, the emphasis on indirect representation of male orgasm by splashing water, gushing champagne, and so on suggests that the phallic demands to be represented, all the more potently by the obliquity of phallic messages relating to the male body.[107]

Such insistence on the phallic in situations where the penis is veiled suggests that the problem with the phallus may actually be the penis, since the latter cannot live up to the former. Maxine Sheets-Johnstone puts the point thus: "As an object protected from public view and popular scientific investigation, it [the penis] is conceived not as the swag of flesh it normally is in all the humdrum acts and routines of everyday life but as

Phallus, an organ of unconditioned power".[108] Although many British male strippers go all the way, some of the most famous strippers, such as the Chippendales, never take off their pouches but instead display phallic power, even by the bulge in the pouch rather than the real thing, so to speak, or by doffing military or police uniforms.[109] The frontal nude male is almost never seen in American narrative cinema. In our culture, phallic symbolism, even if wielded by women, works to underline and mystify male power in a way that the penis only seldom can within safe representation.[110]

Tania Modleski argues that relatively recent films such as *Big* or *Twins* do attempt to reveal the penis behind the phallus, in their emphasis on the vulnerable, finite male behind the superhero image, but she feels that the films are as evasive as the phallic variety and as oppressive to women, "who are made to bear, as always, the burdens of masculine ambivalence about the body".[111] The tendency to dephallicise many new images of men is affirmed by Suzanne Moore, who believes that phallic presence is disavowed to give a place for the female spectator, the men being presented not "as all-powerful but as objects of pleasure and desire".[112]

WOMAN AS CONSUMER/MALE IMAGE AS COMMODITY

While normally excluded from production in patriarchal society so that her identity may be anchored to reproduction, woman is increasingly being addressed as a consumer. We may know little about the female consumer's perceptions of images, but she is bombarded with these, a significant number being eroticised male images. The one place where it seems certain today that there is male interest as to what and how women think is in the world of commerce, where advertisers feel an urgent need to read women in order to sell goods to them. Consumer culture in reaching out ever wider for new markets has commoditised sexual pleasure and must follow its usual imperative (the search for wider sales of its commodities) by attempting to open up the market in sex to female consumers. The result, capitalism's toying with the idea of—as it were—granting the active gaze to women, exemplifies the curious tension that exists between capitalism and patriarchy, by which groups disempowered by the latter may suddenly find themselves economically empowered and so addressed as consumers—although simultaneously commoditised themselves.

Consumer address to women may have increased greatly in the 1980s and 1990s, but it has been there since at least the aftermath of the First World War, judging by the way that Valentino was packaged and sold as an image. Perhaps narrative cinema has been constantly addressing women as consumers of male-image commodities since before that star. In the 1970s, women's ability to buy sex if their income amounted to enough is hinted at and very occasionally stated in women's magazines of the period. Before that, in *Midnight Cowboy* (1969), the "helluva stud" hero is rented for the night by a New York woman. When finally bedded by her, he is goaded into overcoming his impotence, reasserting sexual dominance, thanks to her innuendo that he could be homosexual. Next morning the restored stud has his name passed on by her to a female friend of presumably comparable income bracket.

Perhaps the most publicly-celebrated example of male commoditisation today is offered by the success of the Chippendales, who seem strictly for what has been socially defined as women's visual pleasure. The practice of commodifying the male with women's erotic interests allegedly in view is undisguised in contemporary society. The meaning of the commodity and the identity of the erotic interests imagined to be catered to are not so self-evident, however.

WOMEN AND THE MALE NUDE IN ART

If women are normally excluded from production within capitalism, there is evidence of an interest in the creation by women of images of men, largely in the latter half of this century. Women might finally have gained the right to enter art schools a hundred years previously, but, according to Frances Borzello, they "went into male structures and adopted male values and practices".[113]

One of the best-known female painters of males is Sylvia Sleigh. Her frequent use of Philip Golub and Paul Rosano over other models has been interpreted as a response to their grace and 'almost feminine' narcissism, as well as to their body hair.[114] The case for this alleged interest in the conjuncture of male models and the culturally constructed feminine is strengthened by the observation that she inverts famous examples of the female nude in gender terms to make witty commentary and to explore the limits on possibilities of reversibility within a male heterosexual tradition.

The aims of the exhibition 'What She Wants' help to spell out what female artists have to adopt a position on, especially if they are dealing with looking at the male as an erotic activity for women. These are "to present an experimental reversal of erotic traditions from women artists, to give a platform to women artists and photographers whose real work is, in theme or visual content, about the erotics of looking at men. This includes the process of actually taking the pictures as well as exploring the fears and taboos of showing explicit images of the male body".[115]

Judith Bernstein's interest in the phallic centres on what it says to women, and whether it can be appropriated by women. Her charcoal drawings of screws, huge enough to be phallic, sensual enough to the touch to be less obviously so, are interpreted as a resensualisation of the heroic image.[116] Colette Whiten not only creates images of men but uses men more directly in her work. The process whereby this Canadian artist makes casts of men requires the making of elaborate machinery to hold the men in place, so that the casting becomes a kind of performance. The males are feminised by having to become so passive in her hands and those of her assistants, by being depilated and vaselined.

There is a more obvious tradition of women photographers of the male. Thus, Immogen Cunningham created a scandal by, in 1915, publishing nude photographs of her husband in the Seattle *Town Crier*. One of the publications devoted to women's photographs of men has the appropriate title *Women Photograph Men* (1977).[117] The main impulse in these photographs appears to be the refusal by women to see men as men have seen women.[118] The female photographer Mellon, on the other hand, stresses the commonalities between the two, and above all the impression she has of being empowered by looking through the viewfinder. She talks freely of the voyeurism that she is enabled to enjoy, and the voyeurism which she creates in other persons by her photography. "I visualise when I look at a man. I undress him with my eyes. It's strange for a woman to say this . . . "[119] Another publication, *Women's Images of Men*, relates to an exhibition that was mounted at the ICA at the beginning of the 1980s, when women dealing with male images were still looked at askance.[120]

Women photographers of nude men have been rebuked for sexually objectifying men, as an apparent act of revenge. One strategy adopted by them has been a substitution of male nudes for traditional female nudes to point up the lack of symmetry between photographic objectification

of males and females. For example, Annette Leyener's *Sex Quartett* (1981) made four men pose exactly in the way that four women were posed on the backs of 'nudie' playing cards.[121]

Grace Lau, on the other hand, is concerned less with reversal and its limits than with celebrating musculature by softening it with elements of androgyny. Emmanuel Cooper writes of her work, "Aware of feminist objections to such representations, that they degrade and victimise and are further evidence of male power, Lau argues that these are controlled situations in which both partners are equal and willing participants".[122]

In less self-conscious circles, women are encouraged to look at men, whether to photograph them or to enjoy them, with the same appraising and judgmental eye that men have traditionally used. As long ago as 1897, the reviewers of the film, *The Corbett–Fitzsimmons Fight*, noted with surprise that women formed a significant fraction of the audience. One of the constructions (whatever the actuality) put on this observation was that these women were now afforded "the forbidden sight of male bodies in seminudity, engaged in intimate and intense physical action".[123]

MAGAZINES 'FOR WOMEN'

By mid-1993, there were on sale in Britain five magazines targeted at women: *Ludus, Playgirl, Women Only, Women On Top* and *For Women*. The total collective monthly distribution was reckoned to be in excess of 600,000, with the leader of these, *For Women*, at 250,000.[124] (The magazines' publishers may have overestimated demand, however, for most of the magazines were defunct by mid-1994. *For Women*, launched in March 1992, survives, though.) The advertising in these magazines professes an egalitarian ethos or is aimed at women, often by reinforcing thoroughly traditional anxieties about the reader's sexual attractiveness and, recently, safety from sexual (and other) attack. Indeed, the editor may not be female. The most successful of 1993's top-shelf contenders, *For Women*, has a male editor, for instance. Coincidentally or not, the magazine is claimed to take a strongly anti-feminist stance.[125]

These magazines appear to be 1990s, British, successors to *Viva* and *Cosmopolitan* which in the 1970s blazed a trail of sorts by presenting frontal nude males for the ostensible delight of women readers. *Playgirl* continues in largely unaltered form from that period, but *Cosmopolitan* decided to discontinue its publication of male nudes.

The nude male must conform to the literally unwritten law of no erections.[126] (Claimed disappointment about this on the part of readers may even account for the demise of some of these publications.)[127] There appears to be a general consensus that these magazines are not pornographic, but that judgment obviously turns on the definition of pornography. We might recall too that what would never be seen as pornography by males, since it is judged to be too lacking in hardcore excitement, could be taken to be highly stimulating by females, as with bodice ripper romances. The most that is claimed on these lines is that *Women On Top* is, in its editor's opinion, "a form of soft porn".[128]

The nude males are always bronzed and muscular, nude or in the process of stripping off military uniforms or work clothes, or else the models purport to be readers' husbands (although some of the same models appear in other magazines for gay consumption in the same poses but without the biographies furnished for the so-called hubbies). While female models in the magazines are defined as attractive by traditional masculinist criteria, male objects of the gaze incorporate stereotypical images, according to Elaine Colomberg, of "what they consider to be objects of desire for women, i.e. men who are bronzed, muscular and 'handsome'".[129] This may be the reason why those who find themselves resistant to magazines designed 'for women' feel particularly unimpressed: they see the same old image in the constructed female spectator of the helplessly adoring little woman admiring strength and business success, somebody who is taken to want as part of her fantasy the possibility of a caring relationship. Sarah Kent objects with particular energy, claiming that erotic fantasy works much the same for both sexes, and works only by bypassing personality (to present, in her view, the male as object).[130]

MALE PIN-UPS

When the naked male pin-up invades not only card and poster shops but page seven of the *Sun*, then there are good grounds for claiming that he is popular. Although there were clothed pin-ups of film and rock stars available for fans of both sexes, it was not until 1970 that there began to be nervous attempts to launch the male nude pin-up.[131] *Off Our Backs*, in April 1970, offered a feminist parody in which a bearded naked man divided his time between the typewriter, cooking in the kitchen and dreaming over a flower. In 1972, Burt Reynolds was presented 'tastefully'

and playfully nude in the pages of *Cosmopolitan*, his hairy chest exposed but his genitals concealed. This encouraged the launch of *Playgirl* and *Viva*, magazines that gave prominence to a more explicit, raunchier version of the nude male pin-up. Some of the tabloid newspapers of the same decade attempted briefly to introduce male pin-ups. If the time was not quite right then, it seems to be today.

The discomfort attendant on the notion of men being put on display for the erotic pleasure of women is well illustrated by a sequence from *Spartacus* in which the women who choose slaves to fight for them wearing "just enough for modesty" are portrayed in negative terms, because lascivious and untroubled about using their free-Roman power over male slaves.[132] Yet, there can be disavowal of the aggressive and apparently masculine powerfulness of the erotic gaze in the pin-up created for women. It would be useful to remember in this regard that the largest Athena seller of this sort in the 1980s is the poster entitled 'L'Enfant', Spencer Rowell's creation of a seated, bare-chested male cradling a baby. The display by women of the male pin-up in office space, for example, may be a form of revenge on men for the unthinking exhibition of fetishised women purely in the name of masculine pleasure (which apparently needs no defence other than itself), but the pin-up can still be to some extent dephallicised and feminised.

Discomfort at too explicit expression of passivity may be kept at bay, by, for instance, the model's performance of muscular masculinity and disavowal of narcissism. The hard work indicated by bulging muscles and by sweat helps to suggest male power by visual means, the power of "marshalling and controlling his bodily resources".[133] Other methods of disavowal of passivity may be by the look away from the viewer/camera upwards or the iron-jawed, castrating look boldly and directly at the viewer or again the suggestion of activity or potential for activity within the visuals of the pin-up.

Calendars offer a natural-seeming home for a whole sequence of male pin-ups on offer to women (as well as men?). In 1986, *Blues Boy* calendars by Neil Mackenzie Matthews were introduced, around the same time as *Select Men*, which favoured faceless torsos and male bottoms for an unspecified target consumer. The *Palmano Man* calendar for 1987 is described by Sean Nixon as producing "a particularly explicit example of . . . intertextuality".[134] There is allusion to the Ray Petri style in the black

and white men shown in three-quarter length shots exhibiting their muscular torsos and arms in vest tops. This style is anchored to a representation which is not defined by a particular sexuality. It does not pathologise gay sexuality while drawing on it; nor does it resolve "the tension set up in the ambiguity of the gay/straight image".[135] The vagueness and ambiguity of the targeting of male pin-up calendars make more sense when it is noted that "the gay tag" inevitably attaching to male pin-ups "hinders distribution".[136]

MALE STRIPPERS

In the USA, the male strip show became established in the mid 1970s as a girls'-night-out entertainment. It permeated not only the large metropolitan centres but city suburbs and small towns of the Middle West and the South. The superficial evidence suggests a complete role reversal, where the woman as consumer may freely objectify the male performers not only by gazing but by bawdy or even insulting remarks. The women-only rule ensures that no male in the audience inhibits the behaviour of the women, which *seems* spontaneous. The most famous of the American male stripper companies is the Chippendales, while in Britain such groups as the Dreamboys or the London Knights perform for women, the latter outdoing the Chippendales in their nudity. Specialist male stripograms are another sign of the popular market in exhibitions of male (partial or total) nudity aimed at women.

There is also the growing possibility of female watching, whether alone or in groups, of videos featuring male strippers. One of the London Knights tapes is subtitled *A Hen Night at Home*. Group viewing of the tape was made the subject of an *Independent* newspaper article in late 1991 under the heading of 'Girls' night in'.[137]

The male strippers often behave with bravado, revelling in their exhibitionism for the female customers, attempting apparently to provoke crowd ribaldry, to behave like strutting bantams in the expectation of arousing female response.[138] Costumes are various and can include ordinary street clothes, but there is an emphasis on what is conceived of as authority wear—Superman costumes, police or military uniforms, hardhat working gear—through which the strip is deemed more exciting. The men may wear face and/or body make-up, exhibit well-exercised bodies, and shave or trim body hair thought excessive. The American

format for the performances usually includes both group production numbers where three or four dance without removing their clothes and also eight or nine solo numbers in which dancers strip to G-strings. During the solo performances, customers are encouraged, sometimes vocally by the announcer, to tip the dancer by putting money in his G-string. In return, he will offer kisses and caresses to the tippers. The finale brings on all the dancers in the show.

Although it is not true that all male strip shows avoid complete frontal nudity, the most celebrated of the American variety keep G-strings in place even at the final stage of the strip. For this reason, the standard-format strip show can be thought phallic, rather than penile.[139] Companies such as the London Knights seem, on the evidence of their videos, to be both phallic and, since they strip to total nakedness, penile. The dancers seem to be chosen for their muscular and impressive physiques in some cases, for their awesome 'endowments' in others. A few display both. At this point, it is surely fair to observe that, while not many penises live up to the phallus, some do! And these few can ensure, given certain other attributes (youth, a reasonably well-shaped body, no outright ugliness) that the male exhibitor of this sort of phallic penis may pursue a career in stripping and/or pornography.

Female members of the audience at the American live shows appear to come from a wide variety of backgrounds, and differ widely in work, age, appearance and stated reasons for attendance. One common element attributed to them is that they are largely white women, just as the performers are largely white men.[140]

Women gazers put on the spot about their opinions of the men's exhibitionism in, for example, the *Independent* article on girls'-night-in watching of a London Knights video seem divided. One woman interviewed claimed, "Women are interested in the whole person", but she was immediately accused by another of coyness. Yet another expressed irritation that men stayed in control of the audience. One opinion was, "Maybe if erotica catered for women too, we wouldn't feel so exploited by it". The women's laughter was explained as a sign that they "didn't really mean it".[141] It could also indicate, surely, nervousness about excitement, a wish to retreat from the implications of female sexual aggressiveness displays, or at the very least a puzzlement about the meaning of the entertainment. If so, this puzzlement is shared by several commentators.

Female behaviour at live shows may be considerably less spontaneous than it appears to be on the evidence of male-stripper videos based on performances in show conditions. The announcers and DJs, often female but of either sex, inform women of the context of equal rights in which the show is to be placed.[142] Before the show, a slide show of the dancers and dancer–audience interaction both entertains and offers "anticipatory socialisation for the night's audience".[143] The ostensible foundation for the show, thus, is a popularised notion of equal rights for women, which is seen by two sociologist observers as "a seduction strategy to normalise the marginal aspects of the show for both the audience and the dancers".[144] To reinforce the preferred reading of the show, the announcer may promote scepticism about marriage and suggest toasts in honour of a freshly divorced member of the audience.

Working against this is the sense that the male dancers are more in control than they may on the evidence of the show appear, that they are not as available as objects as they appear to be, that women's subjectivity is severely compromised and limited. The initiation of kisses and caresses by female tippers may result in male welcoming of their approaches within the show format, but it is a matter of performance by the dancers and will almost certainly lead no further.[145]

It could be suggested that the brief socialisation of the preceding slide show and, especially, the verbal commentary and advice from the announcers are to ensure a sort of role reversal, in the name of equal rights for women, whereby women ogle and objectified men play to their gaze and for their (monetary) favours. The severe limitations placed on the credibility of this reversal by the genderised social world just beyond the nightclub or disco, the subtler ones within these areas so that males are not nearly as passive as they may play at being, have to be borne in mind. Remarkably different too, if there really is an attempt at reversing traditional roles, are the sheer noise and laughter from the audience. An all-male audience for a strip show is usually silent, with a sort of masturbatory quietude and sense of wishful isolation. It is also an anxious audience, as hostile to any sense of being overseen in its voyeurism as men in a sex shop browsing through erotically titillating items on sale. If there is anxiety in the female audience, it is expressed in helpless giggling and less helpless group laughter. The overwhelming impression of a girls'-night-out audience in videos of the events is that they react as members

of a homosocial group. Women who are singled out from the audience to assist the stripper keep looking back to the group from which they were chosen and seem to seek validation for any 'naughtiness' that they are encouraged to perform in the reactions of their friends.

It is noteworthy that an undercurrent of hysteria in the group laughter is detected by a shocked *male* observer who is further biased against the show by his avowal of healthful naturism.[146] All the same, the notion that an element of revenge informs the pleasure of the male strip show is credible. One male stripper believes that women audiences are telling him, "See what it's like!?"[147] The sociologist observers note frequent customer "excessiveness", involving verbal and physical aggression, denigration and name-calling, as well as scratches and bites.[148]

Although it is sometimes claimed that such behaviour proves women can be 'just as voracious, just as animal-like, as any man",[149] a different conclusion seems more persuasive. They are not so much behaving exactly as men do, but in a parody of male behaviour. They are encouraged specifically to ape male audiences for female strip shows, but they do not react with the solitary anxiety that men do. When they pull down a G-string to stuff a dollar bill into it, it is in awareness of the naughtiness involved in a woman doing that to a man, not with the male casualness of custom. The crucial difference may be in the group-experience aspect, in the sense that bonding with other women, the homosociality of the night out, is more important than the ostensible object of the entertainment. If this is so, then the male sex object helps to define difference for and from the women, not exactly in subject–object terms, but in terms of the gender solidarity enjoyed by them in distinction from men. This sense of distinction from the male is experienced not so much in terms of the male strippers as of the implied male audience which they definitely do not feel themselves to resemble. A male judge (literally a judge) may treat the male strip show for women as the end of civilisation.[150] Presumably, though, he makes the mistake of conceiving it as a simple reversal of the female strip show. Perhaps instead the male strip show constitutes an aberration which reinforces the dominant system.

The question remains, highlighted by the present section, but relevant to much of the chapter: is the commoditisation of the male object of the gaze really in the interests of the consumer (so that it leads to the appropriation of further subject positions by women in society) or does it

merely reinforce the more mainstream position of alignment of differentiated genders with subject–object status?

Peter Lyman supplies an account of a happening at an American university where half a dozen pledges as part of their initiation rites had to strip in front of a women students' residence and perform nude exercises on the lawn, while the women were lined up on the steps to watch. Any misogyny in the alleged joke was imagined to be defused by the women being invited, not forced, to watch. Also, male students stood alongside the women watching, which suggested that the pledges and not the women were butts of the joke. One woman reacted differently: "We were just supposed to watch, and the guys were watching us watch. The men set up the stage and the women are brought along to observe. They were the controlling force, then they jump into the car and take off".[151]

Is it straining this anecdote's applicability to suggest that the male-sanctioned joke, intended to defuse a sense of hostility, as well as the critical reaction of one woman, offer genuine insight into the phenomenon of male striptease 'for women'? And possibly of all such male-objectifying entertainments?

VII · male object–but which subject? (2): 'men'?

1. 'Gay' Men?

ONE VIEW OF THE RELATION OF GAY AND FEMINIST POLITICS

If the history of gay liberation is such that it can be claimed to have failed lesbians, the division between gay male interests and those of women in general can be expected to be all the more marked.[1] Catharine MacKinnon feels that even the affirmation of same-sex choice has very different meanings and results for men and women: "A choice to be a gay man can represent seeing through the way sex roles have made heterosexuality compulsory and thus be an affirmation of the feminist struggle. But it can also be an extension of the male bond, the ultimate conclusion of heterosexuality: men come first, men are better in every way, so why not also sexually?"[2]

The problem, actual or potential, in gay politics, and in any assumption that the interests of gay men and lesbians, for example, can simply be combined, is that gay men are men. Thus, whatever their subsequent history and claimed deviation from the sexual norm, they have undergone socialisation, including socialisation into sexuality, as males. If this is so, then that socialisation encourages, perhaps demands, the eroticisation of dominance and submission and, thereby, of subject/object sexual relations. In this way, sexual objectification, seen by some politicised women as the very fount of heterosexuality's ills, tends not to be viewed as a problem by homosexual men. They seem, on the contrary, largely to celebrate at least male objectification through the sort of pornography and erotica labelled gay, and through, for example, the rituals, or even just the significations of the costuming, of sadomasochism.[3]

It is easy, however, to overstate this point—to suggest that male-female relations in heterosexuality, let alone homosexuality, are ossified in eternal opposition, to treat masculinity and femininity as outside history. Both gay and feminist politics have profoundly altered pre-existing conceptions of the masculine and feminine. Concomitant with that alteration must surely be a questioning of the meaning and identity of

subject–object relations as operating within patriarchy, particularly within what has been called compulsory heterosexuality. Gay and feminist politics broadly share an anti-patriarchal stance, or else question and reinterpret the patriarchal. There is clear political danger in viewing differences between gay and feminist politics merely in terms, for example, of pornography and censorship, since this preoccupation and its encouragement to prioritise one over the other lets patriarchy off the hook. The alliances between Jesse Helms and anti-pornography feminists in the United States, between Mary Whitehouse and her ilk and the British counterparts of these American feminists, the way that anti-pornography feminism is valorised in the present-day Labour Party in the UK, illustrate the ease with which the implications of a right-wing agenda can be ignored. They are most easily ignored by pragmatic anti-pornographers who appear to feel that censorship's workings will remain within their control and to accept the particularly severe effects of these on sexual minorities.[4]

The most persistent and pernicious obstacle to any alliance between feminist and gay politics is the imputation of misogyny to homosexual men, what Craig Owens terms the "myth of homosexual gynophobia".[5] One obvious effect of the myth is that politicised gay males and politicised women are depicted as forever locked in opposition to each other. Another effect is less obvious and more damaging to the interests of these parties—that, while the connection of male homosexuality to heterosexuality (whose working is seen to benefit men only) is stressed, the patent link between misogyny and homophobia is passed over in silence. Eve Kosofsky Sedgwick characterises homophobia, including male fear of homosexual men, as misogynistic, justifying the characterisation in terms of fear of the feminine—a fear which must oppress women. She sees homophobia as regulatory of heterosexual as well as homosexual men, since every relationship with each other runs the risk of being identified and punished as homosexual.[6]

While pornography is seen as largely unproblematic within gay male culture, it has been seen as highly problematic within significant areas of feminism.[7] Perhaps this is because of the marked disparity in attitudes to pornography within gay and feminist politics, as well as within non-politicised homosexual men and women in general, that the myth of homosexual gynophobia has such apparently deep roots. Gay-male

pornography is analysed as oppressive in much the same way that heterosexual pornography historically geared to men's putative demands has been.[8] Little attention is paid to context, to the repeated claim that such pornography is important to gay culture.[9] Instead, a politically correct sexuality is invoked—or, what could be expected to be more difficult of achievement, a politically correct sexual fantasy.[10]

The insistence on the maleness, and therefore the presumed inbuilt misogyny, of homosexual males helps to mask their closeness in status to women. The social understanding of male homosexuality as diseased, an understanding born of legal and medical conceptions of what is regarded legally and medically as a condition, much abetted by the 1980s linkage of sexual deviation with AIDS, has clear affinities with societal conceptions of women as being castrated.[11] Women's right of self-defence against violence, sexual or otherwise, should surely be seen as part of minorities' rights to self-expression in terms sexual or otherwise. The choice to represent homosexual objectification of men's bodies as in opposition to women's rights seems a misreading and is part of a divide-and-rule strategy.

So far, this section has dealt with homosexual men's embrace of objectificatory practices in erotic contexts as if this had nothing to do with women's sexuality, or rather as if the connection between the two had to be in terms of whether or not the former threatened the latter. A controversy about erotic looking suggests greater alignment, rather. Against the view that a gay erotic gaze is enabled in the television show *Dynasty* "through the relay of the women's look",[12] Suzanne Moore argues the opposite, "that the codification of men via male gay discourse enables a female erotic gaze".[13] Why, within this dispute about the priority of the female or gay male gaze, the insistence on bifurcation? Surely there must be, at base, an implicit view that women and gay males have profoundly different experience or profoundly different social training and that the gaze is made available only to one by the privilege of the other. It may seem like a banal academic cop-out to suggest that both conclusions are correct, but this is resisted only if it be deemed that these categories, gay males and women, must be in opposition and that one must, as it were, triumph over the other. Could it not be that popular culture, say, for good or ill deems women's and gay-male erotic gazing as pretty well the same thing?[14]

THE INSTABILITY OF THE SEXUAL CATEGORY

For the sake of a convenient link between the previous chapter and this, a link unmuddied by questioning of the heterosexual/homosexual or gay/lesbian/straight categories, each of these terms has been deployed in this chapter as if it had the same unchallengeable meaning as it is taken to have in popular discourse. The notion, however, of a radical disjunction between heterosexuality and homosexuality may be an effect of compulsory heterosexuality. Judith Butler, for example, believes that heterosexuality "offers normative sexual positions that are intrinsically impossible to embody, and the persistent failure to identify fully and without incoherence within these positions reveals heterosexuality itself not only as a compulsory law, but as an inevitable comedy".[15] She goes so far as to think of the comedy of heterosexuality as "a constant parody of itself, as an alternative gay/lesbian perspective".[16]

By this reading, lesbianism or gayness is not a separate, identifiable sexuality so much as a "confusion and proliferation of categories".[17] For Brian Pronger, homosexuality is "a way of knowing, a special interpretation of the fundamental myths of our culture".[18] The so-called homosexual is thus not a discrete, coherent personality type, but is imagined to be so to shore up and balkanise the mythical parameters of heterosexuality, itself an imagined-to-be-discrete sexuality.

An entertaining illustration of the consequences of solemn belief in the separabiity and discreteness of the male heterosexual and homosexual is to be found in an experiment by K. Freund, reported in 1963 in *Behavior Research and Therapy*. The title reveals just about, but not quite, all—the article's assumptions as well as its 'scientific' methodology: 'A Laboratory Method for Diagnosing Predominance of Homo- or Hetero-erotic Interest in the Male'.[19] At least, it countenances predominance, rather than seeking exclusivity. On the other hand, it identifies fifty-eight of the 123 subjects as "exclusively or almost exclusively" homosexual.[20] The only interesting result of the experiment, which not surprisingly confirms the previously identified homosexuals as evidencing homosexual interest in the male, the previously identified heterosexuals as evidencing little or no erotic interest, is that in one case there was a discrepancy between the result of the laboratory examination and the case history "as far as the diagnosis of exclusive or almost exclusive homo- or heterosexuality is concerned".[21]

P. T. Brown takes up the puzzle in the following year's volume of the same periodical. The laboratory examination seems to have rested on the measurement of penile volume under various visual stimuli. Brown asserts that such volume change seems possibly to be under voluntary control. Still, he concludes, "knowing that faked responses are under voluntary control does not allow the deductive step that non-faked responses are not under voluntary control".[22]

Apart from the question of the absent criterion by which responses are to be deemed faked and non-faked, what is to be noted in both articles is the confidence in the relatively distinct categories of subject. When a tiny minority of the sample behaves in a way that runs counter to the diagnosis based on the case history, each researcher reports puzzlement and seeks the solution in the measure of voluntary control over the sample's penile behaviour. Neither even thinks of questioning the assumptions under which a case-history categorisation was made.

In the laboratory examination, trust is also placed in sexual *behaviour*. The sexual label follows entirely from case histories. Yet, to upset this confidence, there is the story of the man who had the occasional homosexual experience to prove to himself that he was not homosexual! The reasoning by which this extraordinary conclusion is reached seems to be illustrated in an observation by Morse Peckham: "I like an occasional experience of genital activity with a sexual object of the same sex to prove to myself that I can enjoy myself without having to categorise myself as a homosexual".[23] By this extraordinary logic, such homosexual behaviour actually *disproves* homosexual identification.[24] Another interpretation of the evidence is possible: homosexuality is the "necessary outside" of heterosexuality within the dominant discourse of sexual difference, but "the homo exerts . . . pressure on the hetero", or the outside stands in no "simple relation of exteriority to the inside".[25]

'GAY PORNOGRAPHY'

Allen Ellenzweig, in a book devoted to contemplation of photographic homoeroticism, offers a definition of what appears to be generally accepted as the pornographic: "that representation or discussion of sex, which by its literalness, its unmediated specificity, and its nonmetaphoric character, is denied access to the general consumer exchange of mass media images".[26] This claimed popular association of the pornographic

with the underground enables the writer to differentiate the homoerotic from the kind of emphasis placed by music videos on "beautiful bodies gyrating in orgasmic rhythm", or advertising's equation of consumer pleasure with erotic satisfaction.

It is doubtful, though, whether the videos marketed as gay porn in the USA and elsewhere would fit this definition of the homoerotic. Many, for example, stress consumer pleasures by locating their orgasmic bodies within private pools or outdoor jacuzzis or within ostentatious bedrooms and living rooms that seem to reek of expensive good taste, and also in shiny new cars or on the leather seats—and elsewhere—of shiny new motorcycles. Alternatively, or in addition, stress is placed on up-market locations, such as Aspen or Hawaii.

West Hollywood seems to be the centrepoint of the production of the 282 feature-length gay male tapes that were made in the 1990's.[27] The gay-male tape studios with the highest profiles in that year are reckoned to be Falcon, Catalina and Vivid.[28] The *Adult Video News* survey of the same year found that 68 per cent of video outlets in the USA carried "adult titles", an increase of 8 per cent since 1988.[29] While gay-male erotica was largely to be found on cinema screens of the 1970s, by the mid-1980s the popularity of the videocassette for gay erotica suggests predominantly home viewing, with tape rentals being a significant means of generating revenue.

One survey of popular gay-porn writing, not video work, recognises the value placed on 'masculinity' in this context, partly by reference to the most popular names given to erotic characters: Spike, Jock, Butch, for example; alternatively, it is noted that characters are named after tools or weapons, or even engine parts (Turbo, Crank); after states in the American West, or, more conventionally, after movie stars who were themselves gifted with such monosyllabic, apparently macho names as Tab, Rock or Troy.[30] Their hypermasculinity is expressed in the gay-erotic context also in their jobs—as cops, truck drivers, soldiers.[31]

The art of Tom of Finland takes hypermasculinity into new hyperboles, where every body is muscular, where cheerful macho faces are youthful but moustached, every penis so phallic that it defies credibility. This overt and undisguised eroticisation of masculine power can be interpreted, straight, as Fascist.[32] On the other hand, caution about the interpretation of such phallic imagery in its new context of same-sex relations is advisable.[33] As Thomas Yingling sees it, the problem to be

addressed in this case is "the relation between the phallus of male homo-sexual desire and the phallus of male heterosexual desire, where 'phallus' indicates both the power of the Symbolic order and the sexual organ associable with its articulation".[34] Phallic pleasure, he reminds us, in one economy is not equivalent to phallic pleasure in the other.

Tom's sketches, with their emphasis on bulging musculature and monumental endowment, on what has to be read as the raw animalism of black and working-class males, are recognisably parodic versions of the tendency towards the glorification of machismo in so much homo-erotic material. Rosalind Coward explains the attractiveness of "unchecked masculinity" in the male gay subculture, keeping in mind the sorts of caveat (against identifying phallic pleasures in different economies) on which Yingling insists, when she writes, "These charac-teristics are constructed as desirable in this context presumably as a sort of celebration of power which is safe as a game between people of the same sex, but entirely problematic between men and women".[35] The masculine associations of sports help to explain the fondness of much gay literary and visual material for featuring men in sports dress and undress within such areas as changing rooms and showers.[36]

While, then, gay porn traditionally seems to value 'masculinity' posi-tively, and to strive, as in male-targeted heterosexual porn, toward visu-ally proven orgasm,[37] it needs to be stressed that ambiguity has to be allowed into the relationship between gay porn's apparent values and male privilege, partly because the relationship between gayness and male power is highly contradictory. The excessive quality of the virile tips over into parody every so often, as in the Tom of Finland sketches, or in the magazine *Inches*' "Giants" sketch each month of a stud so hung as, on a more realist reading, to be grossly deformed.[38]

It would be an oversimplification of the history of gay porn imagery to suggest that only the hypermasculine, heavily muscled stud is valued, such as in Tom of Finland's artwork, in magazines such as *Drummer* or *Honcho* and in videos such as some of Jeff Stryker's vehicles. The prolif-eration of male types from the 1970s onwards includes a heavy emphasis on the ephebe, the young and the cute,[39] the preppie type; somewhere between the pretty youth and the hulking mature 'master' is the hand-some, streamlined athlete, usually younger and less bulky than the latter, but less insistently youthful and less unformed than the former.

There are particular inflections of these basic types in racial terms.
While white males can be found in each category of desirable image,
racial stereotypes tend to be docketed in one area only. The stereotypical
Oriental is pretty, smooth-skinned and figured as passive, to such an
extent that Richard Fung claims, on the evidence of the use of porn-actor
Sum Yung Mahn[40] in *Below the Belt*, that "Asian" and "anus" are confl-
ated.[41] He notes that profession is used for fantasy appeal in the case of
white actors, but "for the Asians, the sexual cachet of race is deemed
sufficient", the status of Asian being servant rather than master, in work
as in sex play.[42] Contrasting with the delicacy and prettiness of the
Oriental male in gay porn is the categorisation of blacks into sexual
animal or stud roles, of low caste in class terms but highly active and
dominant in those of sex. Tapes from Latino Fan Club centre on the
naked erotic charms of American Hispanics, heavily accented, usually
on the wrong side of the law, 'masculine' but compliant. Perhaps the
most popular tapes from Latino Fan Club belong to the three-part *Boys
Behind Bars* series. In the prison setting, prisoners and guards are
Hispanic, corrupt or easily corrupted, anti-social (one stud talks about
taking revenge when he gets out on the "old lady who turned him in").
Their objections to sexual abuse by the prison doctor alibi them initially
against the feminisation that the prisoners themselves associate with
homosexuality, although, in true pornographic manner, they exhibit
pleasure in same-sex intercourse once they are, in the tapes' terms,
broken in. The Puerto Rican stereotypes in these tapes and others from
the studio are untrustworthy, lazy, but definitely available, tricks to be
turned at remarkably little cost even outside the prison setting.

This sort of sex-role dichotomising on ethnic lines demonstrates once
again gay porn's fascination with the eroticisation of domination/
submission. The fascination is no surprise to scholars who have analy-
sed value systems in pornography in general, since it is discerned that all
pornography centres on just such eroticisation of differential power.[43]
This may be the time, however, to stress that power itself may be differ-
ently manifested and understood in a homosexual context and that
therefore the signification of dominance and submission, at least as these
are widely taken to be reflected in active and passive sex-act positions,
may not be so straightforwardly read as to render context irrelevant. As
Tom Waugh claims, "Gay porn in particular, and of course gay sexuality in

general, undermine the widespread assumption in the porn debate that penetration in itself is an act of political oppression. A sexual act or representation acquires ideological tenor only through its personal, social, narrative, iconographic, or larger political context".[44] It is difficult to claim that there are no connotations of dominance and submission within representations of anal penetration in gay porn, as Richard Fung's analysis alone suggests. What may clarify Waugh's point is that a penetrator in one sequence may just as easily become the penetrated, the male in the object position (if 'object' is, according to his argument, a fair term) in the very next sequence.[45]

The publicity surrounding the 'impenetrability' of Jeff Stryker suggests at first glance that it is of the essence that studs be active to retain their popularity within the acting of that stereotype.[46] Another possibility is suggested by the circulated gossip about Ryan Idol's willingness to consider representing the penetrated partner in a yet-to-be- made feature. The word seems to be that Idol has refused to countenance the possibility until a better commercial deal is offered to him to play the unaccustomed role. If this is so, then there is a suggestion of great erotic excitement being created in the target audience, *especially* when a star who has made his reputation for glamour on being slightly remote and always a penetrator relinquishes activity. That suggestion would in turn suggest that dominance/submission remains a vital part of the meaning of the pornographic representation of sex in the gay context, but that gay porn fosters a belief in the relative variability and relative unpredictability of dominance/submission partners.[47] If so, then gay porn offers an unexpected exemplar of the arguments about split subjectivity, which are sadly absent from analyses of pornography and its effects.[48]

It should be said, lest the claims become too sanguine, that strong expectations are set up both in visual and literary representations about which sort of partner will be active, which passive, and that these expectations are frequently fulfilled. Thus, men with super-macho names who are in early middle age and in what is imagined to be a virile profession can be relied on to be the seducers and penetrators of highly receptive (both psychologically and physically) younger males in late teens or early twenties, particularly if they are called Chip or Skipper or have for a name a diminutive ending in '-ie'. But the latter can occasionally cause mild surprise by topping the more experienced man.

Too great predictability results in judgments that commercial porn has degenerated into being boring.[49] In 1985, the editors of the gay-oriented magazine *Mandate* tried to understand the reasons for what they claimed as the low quality of porn writing. They blamed lack of talent, lack of payment, lack of publishers for more experimental fiction.[50] One writer concludes that "the fact that it's so bad simply confirms the deeply ingrained and ever-lingering suspicions of our largely Christian culture that sex is a sin and that thinking about it too much will drive you crazy".[51] The demand exemplified by all of these judgments for better writing, which is understood in terms of its decreasing predictability of generic characters, narrative and style, suggests a fundamental belief in the variability and unexpectedness of sexual roles and styles in the gay world, at least as that is mediated in porn.[52] Thus, Waugh's claim that the significance of penetration in dominance/submission terms should not easily be assumed is vindicated.

(A more thoughtful strain of commentary on generic gay porn calls, more critically, for a re-education of desire. Andrew Ross dismisses this, pointing up the far more urgent importance of promoting safe-sex techniques through visual porn, and highlighting what he takes to be already in existence—the unusual egalitarianism of a porn industry where there is "an equality of participation among producers, performers, and consumers that is still barely evident in the straight industry and market".)[53]

Laura Mulvey relates spectator positioning, in visual and psychological/social terms, in identification with the active male in dominant narrative cinema. This relation is less surely applicable to dominant cinema/video porn. It is particularly inapplicable to gay tapes, where the spectator's "identificatory entry into the narrative is not predetermined by gender divisions" and where "mise-en-scène does not privilege individual roles, top or bottom, inserter or insertee, in any systematic way".[54]

The significance of this mismatch is far greater than has been allowed to appear. Anti-pornography arguments tend to base themselves on assumptions about Mulveyite identifications with the doers, or 'masculine' active protagonists (almost exclusively male in the heterosexual field), so-called. Ignoring of gay-male porn by anti-porn theorists (as well as those, such as Linda Williams, claiming a less partial interest in porn analysis) is justified variously, on the grounds that it is not addressed to women, or that it is not central evidence of heterosexuality

and its institutions. Whatever the credibility of such justification, the effect of the decision is to make analysis of porn more confident than it ought to be. Laura Kipnis argues that the vast market share of the pornography of male bodies makes that sort of pornography central, not an anomaly. If that is so, then a theorisation of it "might throw . . . certainty about what pornography as a category is, and does, into question".[55] Her particular interest is in the study of 'she-male' fantasies, or transvestite porn. She concludes that, if such representation is not seen as exploitative or degrading to the male models or the cause of harm to men at large, then "it would seem to be due to a somewhat tautological line of reasoning" that "men as a class don't suffer ill effects from male pornographic images because porn victimises women".[56]

The significance of the mismatch between Mulvey's analysis and gay visual porn is lost, the doubts about pornography's nature sown by attention to that which is termed anomalous not even raised, in the decision to avoid serious consideration of what is presumed to be deviant material.[57] It is all the more galling, therefore, to have anti-pornographers coming out against gay porn because it preaches patriarchal oppression. According to Kathleen Barry, "homosexual pornography . . . acts out the same dominant and subordinate roles as heterosexual pornography", while Gloria Steinem claims that gay porn's violence resides in its putting a man "in the 'feminine' role of the victim".[58] Dawn Primarolo's 1990 bill, without debate on the particular nature of male-objectifying gay porn, simply states, after its definition of pornographic material in terms of humiliation and degradation of women, "The reference to women in subsection (1) above includes men".[59]

As for gay porn's alleged failure to address self-identifying heterosexual women such as Linda Williams, that, according to one analysis, may be precisely its appeal, since the viewer is spared identification with the characters and can enjoy the naughtiness of illicit viewing.[60] Conversely, for the gay male viewer addressed or even constructed by visual porn, identification can be just as probably with diegetic object as subject.[61]

In the context of pornography, as in the context of other sites of popular representation, it is important that the work of active reading be taken seriously in the place of the reading off of meaning, labelling, administering of social prescriptions. By consideration of the context,

Isaac Julien and Kobena Mercer are able to reconsider Mapplethorpe's black men as erotic objects. They remind the reader that preferred meanings are not fixed, that alternative readings may replace them "when different experiences are brought to bear on their interpretation". In fact, from the standpoint of gay politics, one of the most important functions of the Mapplethorpe black male nude could be the affirmation of gay black sexual identity.[62]

If meaning is not fixed, then claims about gay porn's social harm, or for that matter, about its social good cannot be universally valid. Whatever else gay porn does, it represents a statement (however regrettable or laudable depends on the politics of the receptor of the statement) that gay desire exists. That desire may be deemed to be limited or to be distorted in its pornographic representation. Yet, the legal suppression of that representation, which members of Parliament such as Dawn Primarolo wish to augment, inevitably becomes the denial of visibility and thus of existence to men who experience that desire, however differently Primarolo would seek to justify her amendment.[63]

THE 'CRACKDOWN' ON 'DEVIANT' PORN

While there is no definition of pornography in British law, the Obscene Publications Act of 1959 covers printed material, films and videos, Section 3 permitting police to seize and destroy obscene material, subject to a forfeiture hearing at a magistrates court.[64] The concept of obscenity is related in law to a tendency to deprave and corrupt those likely to view the material. The concept of indecency is less clear. Perhaps, for that reason, the courts, police, Customs or prosecuting authorities have a free rein to consider it in terms of what they would deem would offend or embarrass the "average person". This permitted, in 1988, for example, 24,000 items to be seized by Customs as indecent or obscene. According to Neil McKenna, the criterion appears to be what appears shocking or disgusting to the Customs officer(s) concerned.[65] In London, the act is enforced by the Obscene Publications and Public Morals squad of the Metropolitan Police. While the act has been interpreted as securing "a very large measure of freedom for the written word", it is the body of custom and practice which has grown up around the act that may be more worthy of consideration.[66] (Thus, for example, there is nothing on the statute books forbidding the representation of an

erect penis, but it is widely believed that there is such a law, because the police have taken this as one of their tests for offensiveness in published material.)

The Local Government (Miscellaneous Provisions) Act (1982) gives local authorities in England and Wales the power to control the siting and licensing of sex shops and cinemas. The Video Recordings Act (1984) demands that all videos offered for hire or sale for domestic use should be certificated by the British Board of Film Classification; videos given an 18R certificate may be sold only in licensed sex shops. Imported articles deemed indecent or obscene may be forfeited under the Customs and Excise Management Act (1979), although the EC Court of Justice in 1986 ruled that British customs could not apply more stringent tests to goods imported from EC countries than would be applied to domestically produced goods.

Within the context of these and related laws, it would appear that Customs has been especially vigilant against gay material, to judge by the raid on Gay's the Word bookshop in 1984 and the confiscation of some ninety titles, fifty of which were later returned since Customs did not find them indecent or obscene. Notably, lesbian publications have been targeted as well as gay-male material. Neil McKenna detects "some sort of cultural bias against homosexuals within the Customs service".[67] On the other hand, he has high praise for the civility and cordiality of Lorna Sinclair, head of information at Customs and Excise. She claims that Customs judge obscenity or indecency of gay material by exactly the same criteria as they judge that of heterosexual material. Thus, gay porn depicting "penetration, masturbation, buggery or bondage" would be liable to seizure. McKenna concludes, "Overall, Customs policy on the importation of gay pornography presents a bleak and depressing vista. Riddled with secrecy, inconsistency and, one suspects, homophobia, the odds seem weighted against the individual who wishes to import pornography for personal use".[68]

The generalised pious alarm publicly felt in Britain in the presence of alleged pornography is the keener when it is identified as gay. Lynne Segal points, for example, to Winston Churchill's 1986 bill aimed ostensibly at cleaning up television. Churchill's claim of concern about violence directed at women is belied by his particular anxiety to target Derek Jarman's *Sebastiane* and *Jubilee*.[69]

These examples bear out Varda Bustyn's belief, expressed in a Canadian publication, that, if smut is bad enough, "feminist" and "gay smut" is intolerable.[70] If since the 1980s feminists have joined with political conservatives in attacks on pornography in the belief that it is pornography's patriarchal bias that makes it such an enemy, they do not seem to have been sufficiently aware of the danger that it would be less obviously patriarchal porn that would be the chief object of legislators' disgust. The values to be upheld are those of what could be termed traditional heterosexuality, which must surely embody the most virulent exemplar of patriarchy's workings. It was in the name of embattled heterosexuality that films treating homosexuality as an acceptable aspect of social life received short shrift from the Ontario Board of Censors.[71] Heterosexual pornography has a much easier time with conservatives because it is deemed to reinforce what they take to be normal sexuality, and, with it, normal power divisions.

The traditional exempting of even the homoerotic under the protection of the title of art was abandoned in the USA during the right-wing attack on the exhibition of Robert Mapplethorpe's work. In 1990, the director of Cincinnati's Contemporary Arts Center was charged with obscenity and pandering and taken to court. Jesse Helms sought to narrow the congressional commission's guidelines on the sort of content that could attract National Endowment funding. Further, the Rev. Donald Wildman of the American Family Association, a major contributor to Paul Yule's film *Damned in the USA* (about the limits to artistic freedom with reference to Mapplethorpe's work), started legal proceedings, claiming $500,000 in damages because the film was shown at the Margaret Mead Film Festival in New York City. When it was in addition shown at the Edinburgh Festival and at Webster University, in Missouri, he increased the claim to $6 million. Wildman, an energetic campaigner against the portrayal of homosexuality on television, was deemed in 1992 to have gagged the film: "Preventing the transmission of this film in the United States will put back the right to freedom of expression in broadcasting by several years", as John Willis put it in the *Independent* newspaper.[72]

If pornographic and erotic imagery involve a strong fantasy element, the attacks on that imagery and that fantasy inevitably signal an attack on real-life homosexual experience. In this connection, Michael Bronski

says, "Gay life has always allowed and promoted fantasy because homo-
sexuality itself is such a forbidden fantasy . . . ".[73] The connection
between homosexuality and fantasy is viewed thereby as indissoluble.
Those who attack the sort of imagery which gay porn seems to promote,
albeit in the name of an anti-patriarchal zeal which seeks to outlaw
objectification on the grounds that it victimises, must also be at some
important level attacking homosexual self-perception and thus gay life
itself.

'GAY' PHOTOGRAPHS

The difficulty of categorising photographs celebrating male beauty or
desirability under the heading of gay porn is acknowledged here by this
separate section (although the permeability of the sections has already
been tacitly acknowledged, in that Mapplethorpe's work has been
alluded to in the previous section). This is more because Mapplethorpe's
representations have been labelled as pornographic by some spokesper-
sons for the Right in America than because there is any great confidence
felt in the porn heading. Similarly, the magazines and movies or videos
touched on in my discussion of 'gay pornography' belong there more
because they take that categorisation to themselves than because they
are self-evidently more pornographic, by whatever definition of the
term, than the photographs to be discussed here. Difficulties in sepa-
rating and categorising the representations discussed in this entire
chapter may confidently be anticipated in any case, because to some
ways of thinking all that is homoerotic is pornographic, and what may be
a sober record of male strength or beauty to one person could be taken as
wildly erotic and thus reprehensibly or laudably pornographic by
another.

 It is precisely this greyness around the borders of several concepts,
including 'homoerotic', 'documentarist' and 'athletic', that allows us,
with a sophistication (of hindsight) which it might have been risky to
exhibit in the period to see even the more circumspectly sober
photographs of near-nude men on sale from Athletic Model Guild in the
1940s and 1950s as potential erotic fare for gay men. The studio takes
pains in its publications of these decades to be seen to address a reader-
ship that seeks advice on exercising and on what is presented as the
inspiration of developed bodies. It offers a welter of physical statistics

and tantalising coded messages about its alleged athletes which either strengthen the impression that it is dedicated to documenting the hard work of what it sees as physical culture or else to rounding out the erotic spell of the photographs with real-life data that put the model within closer fantasy reach. The use of the posing pouch enables the idealised photographs and sketched illustrations of the male to evade charges of indecency, but also allows the baring of the buttocks, an area that is erotic in a male especially if an admission of the homoerotic element in viewing the male is made—which AMG's productions generally took care not to make. Nevertheless, these physique magazines did create a distinct iconography of erotic males—coded as cowboys, sailors, wrestlers, by, for example, the tiniest of vestimentary clues—and erotic settings, such as versions of ancient Greece and Rome or of the American West. Throughout the McCarthy period, homoerotic imagery was available, but always wearing the "alibi of camouflage".[74]

From the mid-1960s, the camouflage has been taken to be far less necessary. The paintings of David Hockney and the photographs of Robert Mapplethorpe depend to some extent for their reading on autobiographical elements, including their creators' fascination with the homoerotic. Mapplethorpe, together with Arthur Tress, even draws attention to links between his representations and those of what he sees as hardcore homosexuality. By 1980, four of New York City's art galleries specialised in exhibiting homoerotic work.

The notion and even the term of homoeroticism is explained by Ellenzweig in relation to its hostile use by, for example, Jesse Helms in his amendment, ostensibly occasioned by the public funding of a Mapplethorpe exhibition.[75] Thus, it is important to re-establish and dust off the term in the garnering of gay history. It is politically relevant to examine and deploy it in reaction to the political power used to silence it. After all, again, it is purely by reference to the presumed visual stimulus of the male nude that researchers published in the 1960s in *Behavior Research and Therapy* believe that they can distinguish the homosexual male.[76]

But what makes an image "homosexual" or "homoerotic"? Surely the label is given in relation to viewer response and must therefore depend for its validity to some extent on the gender and sexuality attributed or taken to him/herself by that viewer. To some extent this is fair; what cannot be

conceded is the apparent assumption of the Helms intervention in the controversy about federal funding of such photographers as Mapplethorpe—that the homoerotic is produced by the homosexual person, or even necessarily for the homosexual person.[77] This in turn casts some doubts on the appropriateness of the label "homoerotic", since at one level it is used merely when a male is made the object of erotic attention. (It might be helpful in this regard to turn to Mark Finch's distinction between radical gay culture, and a more mainstream version of gay culture which is not produced by or addressed to gay people although its identifications are with "the feminine".)[78]

However, just as gay culture, by one description, is exportable to people who would not conceive of themselves as gay, so mainstream imagery, by one understanding, is available for appropriation and even eroticisation by those who would self-identify as gay. Thus, Michelangelo's statuary clothed in the alibi of high art has an easily detected erotic appeal, to judge by the popularity of his David in gay households of the 1970s. The 1986 calendars of poses by non-aggressive eroticised males (*Blues Boy*, *Select Men* and Cindy Palamanos's men), like the male nudes of *Playgirl* and the earlier version of *Viva*, might have been marketed implicitly or explicitly as being for women, but they were readily available to men, and in that regard are easily describable as homoerotic at the same time as the term may in other circumstances seem inappropriate.[79]

MACHISMO – FOR 'GAYS'

The cult of hypermasculinity in the context of gay porn has been treated in some detail in an earlier section of the present chapter. The macho look has been of crucial importance in other, less obviously erotic, areas of gay life, such as the appearance and dress of gay men (and sometimes women) particularly out on the town in gay venues, or as cruising gear. The eroticisation of the 'masculine' elements of one's personality or appearance is, in an obvious sense, socially safer than the flaunting of what could be seen as the outrageous in dress or demeanour, since it does, after all, fit in with wider cultural habits.[80] On the other hand, the threat of parody, of going beyond the credible into excessiveness, speaks of the complicated relationship that homosexuality has with patriarchy in social actuality. This is why Martin Humphries talks of the myth of potency as one which is accepted by gay men even as its hollowness is

also known.[81] An example of the reframing of machismo in a gay setting is discoverable in the macho dancing of gay males, theatricalising and undermining the image even as that image is in another sense reinforced and reinvigorated.

Because in gay circles machismo is often reducible to a look, to be tried on and therefore with the potential of being discarded, it seems false to this recognition and leadenly prosaic to conclude that the double-edged celebration of 'masculinity' represents an assault on 'femininity' or *must* be read as, at heart, misogynistic. When Isaac Julien and Kobena Mercer describe Black Power as being at the expense of black women, gays and lesbians,[82] presumably they limit their understanding of its representation to the straight and, therefore, unironic. Some rap groups play up black hypermasculinity. This overplaying can be taken literally, or as an oblique comment on the stereotyping of black masculinity; it has also been explained as a non-violent charade of contained violence which compensates for *not* expressing violence in social actuality. There is one more layer to the conscious role-playing involved in the gay use of the macho look when the gay male is black. At the same time, black gay men are said by one observer to "assume deferential postures" in relation to white gay men[83] and to suffer possibly lower status in the gay world than the heterosexual. To that extent, there is a price to pay for the particular versions of masculinity available—whereby the black variety is "savage" and "animalistic stud" rather than "leader" or "policy maker". Black experience checks any facile interpretation of gay machismo as *only* play-acting. The role is one in which the actor must at some level and to some extent believe.

Gay machismo as a partly ironic stance in relation to but not simple identification with societal masculinity manages both to gnaw at the gender order but also to valorise it, because, as Brian Pronger puts it, "masculinity is the heart of homoerotic desire".[84] A consumerist culture uses the theatricalised version of masculinity both to sell its products (by means of the Marlboro Man, for example) but also to suggest a safe use by the middle-class consumer of gay-sensibility imagery, to grant, as Bronski puts it, "straight consumers a longed-for place outside of the humdrum mainstream".[85] The commercial interests working within the gay setting ensure, of course, that macho imagery is at least as much a selling pitch within gay circles. The look may be picked up and discarded, but it has

been kept alive, eroticised and elaborated on by commercial concerns, even if the process may not be recognised as such by its most enthusiastic beneficiaries.

2. 'real men'?

At first sight, the notion of a species of male erotic objectification 'for' even a category as heavily signposted by inverted commas as 'real men' seems an absurdity. If the reality of real men is culturally measured in large part by an absence of same-sex desire, how can there be an erotics of male objectification designed to appeal to self-identifying hetero-sexual men? The question is worth asking. There is no simple answer, but a combination of factors could be suggested. Prominent among these would be (1) the insecurity of real men's reality; and (2) the way that patri-archal culture does not readily admit certain aspects of its workings, particularly if these aspects undermine basic tenets of patriarchal belief.

In these regards, the reader is referred to chapter 2 and particularly to its sections on male narcissism and exhibitionism. In addition, Laura Mulvey's work, discussed in chapter 1, on the erotic objectification of the female could be helpful in the new context centring on male objectifica-tion. Her account of the (male) cinematic gaze centres not simply on voyeurism, but on a fetishistic gaze which "demands identification of the ego with the object on the screen".[86]

SPORT AND MALE OBJECTIFICATION

Sports have been coupled with movies as "the supreme escapist enter-tainments".[87] This coupling has in turn been explained as having a basis in nostalgia, the contemplation of sports bringing back to mind "child-hood, youth, prowess and power". There is, we are told, "no other occu-pation where the gap between desire and performance is so noticeable as people age".[88] The sorts of sport indicated here as escapist entertain-ment must surely be spectator sports. While women can and do partici-pate in sport as players, athletes and spectators, yet sport has been credibly claimed as a masculine preserve.[89] Sport's unabashed, because well-rationalised, obsession with the body is thus with the male or masculinised body.[90]

Within consumer culture, there is an easily detected tendency to

equate the body with the self. This tendency is nowhere clearer than in sport. When Chris Shilling writes, " . . . it is the exterior territories, or surfaces, of the body that symbolise the self at a time when unprecedented value is placed on the youthful, trim and sensual body", the reference is to the body in general within high modernity, but the applicability of the analysis to the context of sport and its valuation of the body is evident.[91]

The cruciality of sport to the question of looking at the male, and of his potential in terms of objectification, is clarified by awareness that, despite the strong social discouragement to male looking at the male, the setting of sport uniquely legitimises that gaze.[92] The gaze may be intensified through the technology of television, so that slow-motion techniques and manifold, multi-angled replays of winning performances are offered to the spectator, and sporting occasions may, especially in the case of track and field, assume the appearances of festivals of the body. The most intense and intimate spectatorship, however, is justified in non-sexual terms by the overall alibi for spectator sports, that of scientific inquiry.

The alibi's convenience and the sometimes passionate conviction with which it is held provide a helpful route to the legitimation of male pin-ups—both those of sportsmen in sporting activity, but also of other sorts of star making 'masculine' and socially approved use of their bodies, however exposed, within the context of sport.

Disavowed, but phantasmatic, images of men at the peak of physical perfection in the moment of power and ecstasy when victory is won are offered for the satisfaction of the male viewer. These images are then the means by which the television sponsor is able to make contact with the gratified viewer, since in the commercials the same sorts of images are employed to sell products, and the acquisition of masculinity through the purchase of certain sporting (and related) items seems guaranteed by the sponsors. These products are thus linked with and made dependent for their purchase on what has been termed by Morse "a limited and stereotypic view of masculinity".[93] The commercial importance of sport being explained in this way on American television, it is clear that spectacle must be maximised at the same time as disavowal is reinforced. The oneiric world of powerful males in beauteous motion created by slow motion and long lens is read as a mode of documentary realism, so that

the masculine perfection promised by the commercials seems to be actualised and to be within arm's reach in the televising of sport. The male, presented as erotic spectacle by sports television's techniques, is also by reason of the context and its concomitant potential for massive disavowal placed beyond any suspicion of eroticism.

Easthope usefully draws attention to the different reception of the Page Three Girl in the *Sun* as compared with the largely male sporting star photos in the back pages of the same newspaper. The girl is offered to arouse male desire but not identification. The bodies of partly clad young men on the sports pages are offered officially, it seems, for identification but not to incite male desire. While the sportsmen are pictured as active and their looks do not engage with or acknowledge the viewer's look, they are still "open to active scopophilic looking". Easthope concludes, "No matter how much it is disavowed, these photographs of handsome youths with flashing thighs must represent objects of desire for male readers of the *Sun*".[94] In this way, the alibi of the sporting context is invaluable, since it allows the offering of erotic images of the male to the self-identifying heterosexual male along with a near-total disavowal of eroticism.

The assumption of the sporting spectacle is that, with all eroticism disavowed, what would seem to be the rules of heterosexuality are in place. Brian Pronger points to the assumption "that no one involved is aware of the erotic potential of these phenomena [body contact, the attention of coach to athlete, the exposure of naked sportsmen in locker rooms and showers], that everyone is heterosexual", and then adds, " . . . *only* those involved know what erotic inspiration lurks for *them* behind the ostensible heterosexuality of these situations".[95] In making these observations, he equates erotic potential with undeclared or unacknowledged homosexuality. Nevertheless, the eroticism of sport may go well beyond such dichotomies as hetero- and homosexuality. The value of Easthope's illustration is that sport can unriskily be sold as a matter of highly erotic viewing to conventionally 'masculine' and self-identifying heterosexual males, precisely because of the effectiveness of disavowal mechanisms, voyeurism and fetishisation successfully sheltering beneath the umbrella of scientific inquiry.[96]

The danger of exposure, the unearthing of covert tensions which threaten the seamlessness of the disavowal by which the 'masculine' can

be consensually eroticised, is experienced occasionally and reacted to swiftly. This is demonstrated by *Sports Illustrated*'s refusal to print an Adidas advertisement which shows eleven soccer players grinning at the camera—and wearing nothing but their athletic shoes.[97] Another example of a refusal to countenance the erotic in sport is the disapproval expressed by the sociologist Gregory P. Stone for the predominance of female spectators, which he takes to signal sport's degradation into spectacle.[98] The female spectator is taken to have non-masculine and therefore socially dubious motives for watching sport. Presumably, these doubts apply whenever there is a significant number of spectators whose masculinity is taken to be other than conventional. One powerful reason for distrust of this sort of spectator is that she or he threatens to explode the accretions of mythology surrounding the spectacle of sport and to reintroduce erotic viewing into a context which has so successfully and for so long denied any such admixture into its spectacle.

One of the principal means of disavowal in the field of sporting representations appears to be 'laddish' facetiousness. (In advertising, the humour is still there, but, when it is, it seeks to be more sophisticated, more laid-back.)

Photographs of sportsmen are not only featured daily in most newspapers, but attention is drawn, especially in the more popular tabloids, to the potential eroticism of these photographs. Awareness of the sportsman as a source of visual pleasure is manifested not least by the energy with which such visual pleasure is masked or alibied, particularly in captions and other verbal text. The eroticised sportsman is, the writers would have it, only a joke or erotic only because of the presumed demands of the female fan, whose interest in sport is characterised more accurately, we are asked to believe, as interest in the bodies of sportsmen.

One female spectator who draws attention to the erotic spectacle provided by male athletes describes herself as a "reluctant voyeur" when she writes to the *Radio Times* of 14–20 January 1995. "I'd like to appeal", she claims, "to manufacturers of athletic supports to come forward and sponsor the male participants of the various field and track events that will take place in the months ahead". Why? To prevent "parts of the male anatomy flopping about my TV screen like demented elephants". The writer affects not to understand "why the cameramen (or is it women?) are so addicted to filming the lower part of the body, cutting off the legs

and the feet . . . ". She notices that male ballet dancers and Mr Motivator manage to control their "equipment", and concludes with the exhortation: "Come on sportsmen: . . . stop being exhibitionists, or is it a case of 'if you've got it, flaunt it'? "

MALE SPORTS STARS AS EROTIC MATERIAL

Paul Gascoigne

Even before, but certainly ever since, his tearful emotionalism at the 1990 World Cup was captured on the world's television screens, British footballer Paul Gascoigne, ubiquitously nicknamed Gazza, has received objectificatory treatment, especially by British tabloids. The tears of disappointment were first treated as a matter for sympathy. Soon, they were satirised—perhaps most memorably in the Comic Strip's *The Crying Game*, on television, where the Gazza-like footballer hero hides the secret of his being gay behind a cheerful façade. This could be taken to suggest a 'feminine' (because tearful and emotional) side to Gascoigne's public personality. If so, it made for easy exploitation in titillating press coverage, which disavowed its erotic potential by means of jokes which could credibly be claimed to suit the star's highly publicised daft-as-a-brush persona.

Thus, Vinny Jones's painful grasping of Gascoigne's crotch was given extensive tabloid exposure, for example. While the focus on Gascoigne's body in some pictures was frankly prurient, this relatively blatant eroticism is disavowed in the verbal text provided by *The People* (25 September 1994) as both a joke and a criticism of the player's alleged excess weight. Thus, to reinforce the headline "A Bit Slack at the Back, Gazza!" and to emphasise the caption beneath a bare-backside shot, "Gazza Can Bare-ly Contain Himself . . . ", the coverage begins, "What a bot he's got", and is followed up swiftly by what seems readable as the reassuring disavowal constituted by "—and it's not a pretty sight". If, the writer states, Gazza's bottom does not qualify for Rear of the Year, we are assured that the basis for this interest in his anatomy is purely concern with his fitness to play for Lazio: " . . . although he may be on thong in the comfort of his garden, he'll have to shape up a bit better than this if he expects to get into the Italian club's squad".

Nevertheless, it seems impossible to leave the naughtiness of the concern with his body exposure alone. At the very end, the writer says, "Oh well, it could have been worse. It could have been his tackle on view!"

We might note the disavowal evidenced by "worse", and the frequency of the exclamation mark, here and elsewhere in tabloid reports, whenever there seems to be acknowledgment of objectified body parts in this sort of writing.

The element of playfulness in Gascoigne's public persona not only permits the opportunity to journalists of denied or masked eroticisation but seems to have been inspired, in turn, by reporting of his own exposures of other sportsmen. He is, for example, labelled "joker Paul Gascoigne" by the *Daily Mirror* (21 October 1992) as he "lowers the tone at Tottenham to leave his Lazio skipper Claudio Schlosa ankle-deep in embarrassment".

On another occasion, captured by the *Daily Mirror* (27 March 1993), he pulls down the shorts of another British football star, Ian Wright, and proves to be "up to his old pranks again". Under the headline "Cheeky!", with its exclamation mark, Wright can be exposed incidentally within an anecdote whose overt point is to reveal Gazza's continuing daftness.

Reversing memories of his own crotch being grasped by Vinny Jones, he is photographed in the *Daily Mirror* (6 October 1992) caressing the groin of a Lazio player. Groper and gropee smile amiably. The interpretation of the event is offered in another punning headline, "NUTS! Gazza's Got it Cracked", and the opening paragraph of the story: "If you ever wanted proof that Gazza was nuts . . . well, here it is".

Andre Agassi
American tennis star Andre Agassi presents a potential problem, in that he is deemed erotically attractive by journalists—which apparently must raise questions about the seriousness of his tennis. One means of solving the tension is to foreground the apparently basic question of whether Agassi is only a pin-up (male eroticisation being thus innately unserious) or a true player. The other most popular method is to identify him as pin-up material—but strictly "for the ladies". Thus, viewing of Agassi's tennis matches is at a stroke released from suspicions of the homoerotic, despite his own occasional playing to the erotic; the apparent threat of his feminisation through his pin-up qualities is, in a sense, defused by considering that aspect of his persona in relation to those more trivial-minded of sports fans, 'the ladies'.

One article in *Today*, (6 June 1991), defines Agassi as "the new Ace of Hearts" and notes that he "flashes his stomach" as well as that he offers

the sight of "hairy thighs, tight shorts". However, this kind of eroticisation is deflected from his tennis by the article's stress on the fact that his play in this instance was merely part of a commercial for Nike. His erotic appeal is explained this time as being for teenagers, not women. Again, that category of fan, together with mention of his ambition to enter the world of rock and roll, saves sport from being too openly connected with the star's objectification.

What shows the fears raised by male eroticisation, especially the male sports star's, may be the words in this article: "And Andre is not one to spoil his carefully fostered image with the encumbrance of girlfriends. *Not that he doesn't have them*, [my emphasis] but in the past he has been accused of actually hiding them away so as not to put off the 'flirty-fifteens' . . . ". Agassi's erotic appeal is thus recognised, but the reader may be, apparently, reassured by the mention of his women fans.

The comparative smoothness of Agassi's chest becomes worthy of comment in the *Daily Mirror* (24 June 1993). Its smoothness demands a typically disavowing 'joke'—"Hair today, gone tomorrow"—and an apparently reassuring explanation in women's demands: "Andre Agassi thrilled his many female fans on No. 1 Court by revealing his bare torso at Wimbledon yesterday". Agassi himself is reported in the story to have said, "The girls like me better with short hair", but then reveals its relation to his game—that he is thereby made, he claims, more aerodynamic.

The verbal text accompanying a photograph (*Daily Mirror*, 23 June 1994) of Agassi's bare torso as he throws his shirt to the crowd for once does not explain the eroticism with reference to the imagined needs of his female fans, but to his "love affair with Wimbledon". Perhaps the relatively impassive ballgirls in the background of the photograph are taken to provide sufficient heterosexual cover for the tennis player's gesture.

Linford Christie

The myth of black men's genital prodigiousness has been explicitly revitalised with reference to the British runner Linford Christie. The prominence of Christie's "bulge" is emphasised by lycra. It is by no means lost on sports reporters. The tabloid fondness, inspired by the *Sun*, for reference to "Linford's lunchbox" is a sign of press awareness and yet another example of disavowal through apparent jocularity.

The news that Christie found sponsorship with Fyffes set off a

predictable series of 'jokes' in the *Sun* (26 May 1994) about bananas and their relation with his "lunchbox". Once again, intense erotic interest, this time in a sports star's genitals, is explained by reference to exclusively women's voyeurism: "Linford, famed for his power-packed lycra shorts, caught the eye of fruit firm Fyffes—as well as thousands of female fans". Christie's success is deemed likely to make a "big bulge in his pocket".

Allan Wells
An earlier example of interest in the bulge potential of close-fitting shorts is evidenced in media coverage of Scottish athlete Allan Wells. When women were asked in *Running* (no. 65) to "pen a sexist profile" of their favourite male athlete, Wells was the most popular choice. "The reason, of course, was Those Shorts". The apparent explicitness of some entries could, of course, be comfortingly explained as produced by the terms in which the assigment was set. While the innocence of Wells's motives for adopting lycra shorts is not doubted (to protect his thighs against injury), the readers of *Running* are thought to have been affected less innocently. Wells is often photographed in shorts which seem to draw attention to his genitals even as he himself shows no awareness of this aspect of his success.

Male sports stars in non-sports contexts
It is obviously helpful for disavowal in tabloid sports pages if the objecti-ficatory photographs of a male sports star are culled from elsewhere. Cricketer Chris Lewis, for example, was used as a nude model in *For Women*. Tennis star and former Wimbledon winner Pat Cash posed in undress to promote Green cleaning products for Ark. Both men were thus rendered available to daily tabloids' punsters. The eroticisation of Olympic speedskater Eric Heiden was also explicable with reference to the tastes of photographer Annie Leibowitz.

In *Today* (16 March 1994), the unusually frank nudity of French footballer Eric Cantona in the shower, acknowledging the presence of the camera with an unthreatening look into it, is, as it were, explained as belonging not to his Manchester United days but to "back home in France".

The use of female presence to alibi the eroticisation of male sports stars
Stars of the Rugby World Cup are photographed and discussed as erotic objects in the *Daily Mirror* (3 October 1991), but only because this is what

"the housewife" would appreciate in rugby. This staple of the tabloid worldview, the housewife, would find, we are told, that the rugby ball had "a silly shape" and that the rules were "impossibly complicated", but she could be expected to comprehend eventually that "beneath all the mud and the blood are some very hunky blokes".

In a statement reminiscent of the depiction of the housewife vis-à-vis rugby, 'Sunday Woman' Gill Martin assures the female readers of the *Sunday Mirror* (19 August 1990) that football is not just a man's game. "For women it's the sexiest show on the box". "Cute" Chris Woods is prominently featured in the glamour pose of unthreatening passivity familiar from women's magazines of the 1990s. His thighs are said to be "the limit". Woods himself is quoted on the subject: "I've got quite large thighs, and it's a bit of a struggle getting ordinary trousers over them".

The emphasis in a particular *Style & Travel* (23 May 1993) article on the attraction exerted by a shapely bottom, male as well as female, Pat Cash's as well as those of less celebrated sportsmen, is—apparently—naturalised by revelation of the gender of the writer—female.

'Neutral reporting' of bared bodies (1): those bared unintentionally
The fondness of British tabloids' 'candid cameras' for capturing those moments when, for instance, wear and tear on sports gear produces a moment of nakedness or near-nakedness is easily explicable if there is recognition of the proximity of sporting stardom to eroticisation. Because, nevertheless, there is no such tabloid recognition without ponderous alibi, the verbal text accompanying such sneak views has to make play with the notion that the camera's prying is merely to give the readers a laugh—as if that laugh had nothing to do with the shock of bodily revelation.

While the display of footballing thighs in one Ian Wright shot in the *Daily Mirror* (8 August 1994) is more generous than usual, it seems to be simply the lowering of shorts with its exposure of his white underpants that makes the photograph of the sight worth publishing. Chris Adams's bare bottom, in the *Sunday Mirror* (11 July 1993), evokes the old standby of "CHEEKY!" as headline for the photograph. "Adams nearly revealed all after having treatment".

Footballer Julio Salinas was named "bottom of the League" in the *Daily Mirror* (26 February 1993) for his exposure at the hands of a member of the opposing team. Football fans, it seems to be noted with

relief, "saw the funny side". The incident "gave a whole new meaning to a soccer strip". (For once, no exclamation mark signposts the attempt at humour.) Cricketers Chris Broad and Mike Atherton, and footballer Niall Quinn, received similar tabloid treatment.

'Neutral reporting' of bared bodies (2): those bared intentionally
Daley Thompson's pose, holding his shorts up to expose his own buttocks at the 1988 Olympic Games, was widely reproduced in both tabloid and more prestigious contexts.

Robbie Fowler is said, in another example of public self-revelation photographed in *Goals* (27 December 1994), to be "strutting his stuff". The meaning given to the strut is that of "the bum's rush".

A traditional 'laddish', sporting method of deflating the apparent pomposity of posing for a team photograph is the baring of the buttocks. In one such incident, captured by the *Sun* (21 October, 1994), the buttocks bared are Paul Harragon's. He is, as so often in tabloid reportage of such incidents, "a cheeky boy" and is said to look "over the moon".

An entire lineup of Wimbledon players was photographed baring their buttocks. Unusually, the *Daily Mirror* (18 May 1988) boasted that "the cheekiest pictures are always in your *Mirror*" and goes so far as to invite the viewer to "spot the ball". As if that were not enough, it pinpoints the testicle in question, referring to the readers scanning the photograph for it as "you dirty lot", and inviting them to enter the 'Name That Moon' competition.

Exploitation of unguarded moments for 'humour'
Of Neil Ruddock, when caught with hand to crotch by a "candid camera", it was said by *Goals* (28 November 1994) that he "keeps things in hand". In another such photograph (*Goals*, 8 February 1993), Les Ferdinand's hand on his groin occasions a double 'joke' by the caption writer. He is "really on the ball" and apparently scratching an "itch in time".

Vinny Jones's glance into his shorts (*Goals*, 22 November 1993) released a number of ribald remarks. He had "lost his tackle". "It was there a moment ago". Or else, he is checking that "everything is in working order". "No one likes you if you are too cocky", and so on. Footballers Teddy Sheringham and Darren Anderton are told, with traditional heavy punning, in the *News of the World* (4 September 1994), to "get your leg over lads" because of the position in which they are caught by the camera.

(Very occasional) absence of disavowal

Sometimes, but rarely, sports photographs seem unable to deflect objec-
tificatory potentiality with alibis that explain away that potential.

A photograph of the four runners in the 4 x 400 metres British relay
team shows the athletes' delighted awareness of their physical appeal,
albeit manifested by spoof body-builder poses and jocular exhibi-
tionism. The only runner observing, rather than participating in, the
masquerade is Roger Black, who has been given the appellation, "sex on
legs", in more than one context.

The Manchester United player Ryan Giggs is at present difficult to
photograph in a "neutrally sporting" manner. His customary "sensitive"
look, the hairy legs, the expanse of upper thigh, the ignoring of the
camera, combine to suggest pin-up rather than sports star in action.

MALE IMAGES FOR 'REAL-MAN' ENJOYMENT

Greco-Roman and Renaissance art ostensibly provide inspiration for
men in the 'masculinity' and muscularity of statuary, for instance. The
relegation of what can be read as the feminine to depictions of males
only in the case of ephebes can be taken by contemporary women
commentators to mean that high-art traditions of male representation
do not invite them into erotic experience.[99]

Narcissism is expected of the exposed female in art and other contexts,
while male narcissism is a cultural secret. Therefore, if the representation
of the magnificent male reveals him as too absorbed in his own self-plea-
sure through display, there is a threat to the male viewer in the public
revelation of his secret. For that reason, male display is often alibied by
the presence of a woman whose desiring gaze helps, it seems, to explain
his exposure. His exhibition is for her, it is suggested, not so much for
himself or for the male viewer.

In this regard, Andrew Wernick discusses a Braggi aftershave adver-
tisement which appeared in the September 1975 issue of *Penthouse*. The
naked man in the advertisement, lean, muscular and tanned, "stands
intently before a mirror, in whose reflection (which he is watching too)
we can see he is shaving". Wernick describes the drawing of the viewer's
eye down the model's back to the lighter shade of skin on his buttocks
"which are virtually at eye level in the middle of the page". Although the
caption reads, "Braggi: for the man who can take care of himself", which

seems to refer to the autoerotic narcissistic male, there is a woman in a kimono also in the advertisement who looks straight into our eyes. Thus, as Wernick puts it, "as our attention strays to inspect the man's fair ass, it is constantly interrupted by the eyes of the woman, who is herself always looking on. Those eyes judge and condone. But above all they also provide a crucial heterosexual cover, both for him and for us".[100]

This analysis is similar to Sean Nixon's discussion of another advertisement which seems to defuse the potential for a representation of the self-absorbed narcissistic male: "As if . . . to disperse the frisson of its sexual connotations for the imagined male viewer, a well-hung photograph of a woman (perhaps the subject of his 'sweet dreams'?) mediates between the reader and the model . . . the picture stitches the look invited at his bare thighs into a display that is primarily directed at the woman".[101] Yet, because the imagined male viewer's attention is not principally directed at the photographed woman, the effect is ambiguous. It may, thus, be fairer to say that more contemporary advertising representations of the exhibitionist male allow the possibility of an alibi, rather than take automatic shelter in the disavowal possibilities set up by a desiring female gaze.[102]

'Inspirational' photographs of body-builders in near nudity may look at times hardly distinguishable from the sorts of male posing that magazines allegedly targeted at women carry. Yet, the context is vital. Since the promotion at the end of the last century of Eugene Sandow through near-nude poses to Arnold Schwarzenegger as muscleman of the 1970s or as muscular active hero of the 1980s and 1990s, shots of male bodies have been aimed at men, and not necessarily homosexual men, through the possibilities offered by the conception of body-building as sport or at the very least suitably masculine pursuit.

Rock music has maintained another tradition by which male contemplation of the male body receives validation, a tradition much augmented by MTV with its constant supply of often erotic videos of male stars and boy bands. The attention for much heavy metal performance, particularly on video, is directed to the crotch. Such bands seem thus to be capitalising on a tradition of aggressive exhibitionism that reaches its 1950s apotheosis in Elvis Presley. It may be the phallic assertiveness of the posturing that spares the male viewer the implication of erotic looking, since such phallic power-displays, together with attention to the sounds

and sight of screaming, fainting women fans, encourage an explanation for apparent male narcissism in the alleged satisfaction of imagined demands from over-excited female fans.

Cinema history is probably the most fruitful area of all for research into male objects apparently made acceptable for unacknowledged fetishistic viewing by 'real-men' fans.

Tarzan's near nudity in certain star embodiments of the hero makes him a nearly self-evident object of the erotic gaze, but male looking is given reassurance in the manliness of Tarzan's achievements and the assertion of familialism in his jungle version of the nuclear family with Jane and Boy.[103]

Tarzan's erotic objectification is thus kept secret. Nevertheless, it threatens to break free in the 1981 portrayal of Tarzan by Miles O'Keefe, mentioned in chapter 4. As Walt Morton rightly states, the gaze (of spectator and of Jane) "keeps returning to the near-nude Tarzan as object of beauty".[104] When Tarzan is rendered unconscious at one point, "Jane comes to his side and takes advantage of the opportunity to caress and examine Tarzan's body in a series of closeups. The viewer, positioned as Jane, cannot avoid eroticising the male body".[105] This seems to suggest that the cultural secret of male eroticisation of Tarzan must surely be out. However, the alignment with Jane offers the possibility of escape from the obvious implications. O'Keefe, by being unconscious, cannot at this point be suspected of exhibitionism. He is made into an exhibition by the desiring female. If the viewer eroticises Tarzan at this point, it is only through an identification with Jane, who provides an explanatory cover for the objectification. Any eroticisation of this Tarzan has to do with female desire, much as the erotic look of the male at the model in the Braggi advertisement referred to a few paragraphs previously is secondary in that photograph to the desiring look of the female. As such, male eroticisation is not 'for' the man in the audience, but demanded as satisfaction of female erotic need.

An example of a quite different sort of fetishised male star is Humphrey Bogart, whose appeal in films is not at all based on muscularity or near nudity. Instead, he incorporates, especially in his film noir private-eye performances, a power over women and a susceptibility to them from which he still retains the 'male' power to withdraw when they are revealed as lethal mantraps. The delight of Woody Allen's *Play It Again, Sam* for

Joan Mellen is that it openly acknowledges "that most men are secretly tortured by not being Bogart", by not "measuring up" to his embodiment of 'masculinity'.[106]

Yet, accounts of masculinity and therefore of male erotic gazing at fetishised male stars may fall into the trap of taking cultural renderings of the masculine as truth. It is often suggested or implied by commentators on male cinematic experience that masculine libido is stirred only by depictions of masculinity as controlling and powerful (like Bogart at the end of his private-eye movies) or as at least powerfully built (Tarzan, or the heroes of the peplum genre). It may largely be fair to suggest that the *acknowledged* erotics of male–male viewing include references to admiration for power and effectuality. Still, Ian Green, for instance, believes that elements of passivity in cult male heroes explain part of the 'masculine' identification with them. (Moreover, he suggests that such identification, far from excluding it, may well permit the existence of a critique. Thus, with reference to *Le Samourai*, he claims that the viewer's identification permits the Alain Delon character to be critiqued.)[107] Cult status is taken by Green as "a sure sign of narcissistic involvement", but that involvement may be with "little men" who experience self-pity in their loss or failure. Thus, he believes self-pity to be an underrated element of male fantasy.[108] Further, identification may be with the physically inactive hero, who, by virtue of this physical inactivity, becomes an active looker.[109] He claims that what makes the male characters interesting is precisely contradictions about the active/passive axes, and thus shows that passivity is not excluded from the male image in certain key movies.[110]

Probably the chief area in cinema for the male body as spectacle is what has been termed the "male epic",[111] an area covering the Italian peplum movies, Hollywood epics or the 1960s offshoots of the latter tradition, filmed in Spain or Italy as co-productions. There is little doubt that the stars are chosen for their physical appeal. Indeed, the peplum makes so little secret of this aspect of its workings that former Mr Universes, such as Steve Reeves, go straight into starring roles on the basis of their build and the awareness acquired in their competition days of the techniques required for treating themselves as spectacle. In one way, the easily anticipated emphasis on muscularity, activity, physical achievement, sadism, is discovered in these movies. Yet, if there is

sadism, there is a concomitant (perhaps necessarily concomitant) masochism, several key moments of heroic passivity which appear to invite 'real-man' identification.

Leon Hunt notes, in this regard, that the first section of *Hercules Conquers Atlantis* has a remarkably passive hero, played by Reg Park. He, for example, "would rather lie in the sun than help his friends, although the very lying and the play of the sun on his body allow the camera to objectify him".[112] Gladiators, too, are "trained specifically to be looked at" even if that visual objectification entails death for the one looked at or else the killing of his friends.[113] An integral part of the male epic's project, it is argued by Hunt, is "to address male narcissism".[114] Passivity is clearly addressed too, in visual terms, in that one of the generic set pieces is crucifixion.

Therefore, a principal pleasure of the male epic is the male body as spectacle, and its phantasmic satisfactions involve an account of masculinity which allows for passivity as well as activity, self-pity as well as assertiveness. In this way, the male epic coasts so close to an open acknowledgment of the male spectator's eroticisation of the male that its tactics for avoidance of that open acknowledgment are worth consideration. The peplum genre has been claimed, after all, by Paul Roen as made up of movies "specifically tailored to suit the demands of a male homosexual audience".[115]

One of these tactics must surely be the suggestion so common in sports-viewing and allied contexts—that these built bodies are not merely spectacle but engage in heroic activities that suggest a triumphant masculinity, so that contemplation of them may not be exactly a matter of scientific inquiry but can be explained (as it was in the verbal text of 1940s and 1950s physique magazines) as inspirational. The peplum personifications of Maciste, Ursus, Goliath, Samson, in the wake of the commercial success of *Hercules* (1958) and *Hercules Unchained* (1959), were not of pretty-boy types. These names have mythological associations which conjure up brute strength and the image of physiques unconcerned with the onlooker's admiration. Moreover, muscularity connotes performativity. It is this performative aspect of the body-builder physique of so many male epic stars that helps to legitimise the camera's fascination with them.[116]

The observation that the male epic marginalises 'feminine interest'

could be expected to increase the edginess with which it might be viewed.[117] In her study of the action movie, however, Yvonne Tasker suggests that love interest is unwelcome because the action movie "often operates as an exclusively male space, in which issues to do with sexuality and gendered identity can be worked out over the male body".[118] The muscular male body is seen by her less as erotic spectacle than as "a sort of armour".[119] Ginette Vincendeau detects a comparable marginalisation of women in *Pepe le Moko*, where the women attached to Pepe's gang are treated as appendages or brutalised.[120] Similarly, Jean Gabin in the role of Pepe is intensely fetishised "in his centrality as object of the look and in the representation of his body as (erotic) spectacle" which "is often in excess of the requirements of classic narrative cinema".[121] She believes that Pepe's masculinity is tested against its own excesses, the paradigm being male/excess male rather than male/female or male/non-male. In this way, she confirms Tasker's generalisation about the consequences of "exclusively male space" for a film.[122]

In any case, even easily decoded erotic looks between men are read too simplistically as homoerotic, rather than erotic in a less specific sense, which needs to be differentiated from "some kind of gay eroticism".[123] Green's reminder that Freudian psychoanalysis gives wide-ranging and all-pervasive definitions of the sexual so that "we should be very cautious about what the 'norm' might be in cinema (and anywhere else)" is timely.[124] He notes that looks between male characters in Peckinpah's movies are often marked as erotic, but comments: "The issue is that this eroticism is bound up in a heterosexual male scenario whereby mutual gunplay, rivalry, admiration, sartorial elegance *are erotic* [Green's emphasis] (or can be), not a displacement of it, as people readily acknowledge about westerns". He then asks, "Is this not one reason why many heterosexual men find the western 'exciting', a genre noted for its relative absence of women who otherwise might bear the active male look?"[125]

Another tactic is to bracket the most intensely voyeuristic moments of the male epic, to hedge them about with the suggestion that the male heroes are in that position because they have been temporarily unmanned and placed in a (culturally feminine) object position. Within the narrative, those who have eroticised the male body can be depicted as unnatural and are set up for punishment once the hero has been restored to activity.[126]

Women and 'feminine interest' may be given little screen time in the male epic or the action movie, but a crucial function which explains the presence of women at all in certain movies is that they keep at bay what would otherwise be taken as the ever-present threat of homoeroticism. Angela Dalle Vacche claims that the heterosexual, homosocial order usually found in such movies "needs a woman to insert a discontinuity, so to speak, between two men, often a father and son, thus keeping the threat of homosexuality at bay".[127]

Again, homoerotic potential may be kept in check by insistence on familialism, with a father–son relationship being stressed, for example, where two men unrelated by blood seem to feel attraction for one another.[128] Or by the hero's aestheticisation, so that he looks less an objectified male than a beautiful consumer object alongside other beautiful consumer objects (clothes, cars).[129] Or by means of the objectifed hero's punishment so that the balance is, as it were, righted.[130]

The compensatory devices of an eventual redress of the balance in favour of male sadism, or of explaining male spectacle as temporary fault in the hero's masculine activity, for example, can be taken as an indication that, deceptive appearances to the contrary, action movies reinforce the norm. This judgment seems inescapable if attention is focused on the closures of these movies, but may be too sweeping if the pleasures encountered on the way to closure are given serious consideration. Paul Smith accepts that pleasure "is produced in these films through a specific mode of objectifying and eroticising the male body". He thinks of such operations as having "the trappings of a resistance to the phallic law" but believes that they in fact are "designed to lead the male subject through a proving ground toward the empowered position that is represented in the Name of the Father".[131]

The question remains, of whether the journey (through disempowering objectification and eroticisation) or the destination (empowerment) is the more interesting.

conclusion

AFTER A REVIEW OF THE EVIDENCE, LAURA MULVEY'S SUGGESTION THAT only females can be objectified (in narrative cinema) seems to be wrong. The falsity of that belief may have been harder to spot some twenty years ago. True, there was a male-nude tradition of great longevity in Greco-Roman statuary and in Renaissance art; there was a strong interest in photographing and selling the nude male almost from the year of photography's invention; and above all there was narrative cinema, with its glamorous male stars by the hundreds which Hollywood itself rejoiced in showing as swooned over by smitten female fans.[1]

Perhaps the summary dismissing of her suggestion is unfair, though. What Mulvey seems to be asking herself in 1973 is whether, if power and superior strength are vested in representations of even the naked male, the term "objectification" can fairly be applied to these. If male privilege, as undoubtedly guaranteed within patriarchy, is apparently retained by the phallic male nude, what is the point in claiming that the represented male becomes an object?

It is a question worth asking, but another insists itself, too: Can a represented male remain, when he invites a gaze which appears to have *something* to do with the erotic, a subject? Alternatively, if the erotic representation of the male does not render him an object, should not further questions be directed at the rest of Mulvey's thesis, whereby voyeuristic and fetishistic gazing produces only female, never male, objects?

The eroticised male seems in patriarchy to require secrecy, disguise, disavowal. That is to say, a nude Hercules needs his high-art and mythological context to suggest that frank appreciation of his musculature is for the prurient who fail to comprehend that high art and classical reference transform the nude into an aesthetic (rather than an erotic) object of contemplation.[2] Art representations based on narratives or teachings of Old and New Testaments may be even more strenuous in distancing appreciation of its naked males from erotics, by adding religious awe and respectful reverence to its array of preventive means. Photography has an obvious possible relevance to science, as Muybridge's nude studies of

male and female (and animal) clarify. It also has the traditions of high art to re-employ in the new context.

Hollywood narratives stress the activity of the male hero. Even when he is pinioned and tortured, the generic hero of the action movie is ultimately reinvigorated and turns the tables on his torturers, restoring himself to what the patriarchal film world would have as proper dominance of both unwilling villains and willing heroine. Yet, it may be too facile to believe that the closure of Hollywood narrative tells the whole story. In a literal sense, it clearly does not. The recuperative closure may be yet another alibi for straying into deviant territory, where the hero of our identification, according to Mulvey's thinking, is racked and broken—too passive and helpless to be a fit character to secure identification by one account, or helpless enough to be a fit magnet for male masochistic identification by another.[3]

An analysis of the glamour and identificatory range of male movie stars, along with the movie vehicles in which that glamour is narrativised, has the evidence of the overt stories to work on; but an account of identifications which allows only the possibility of sadism, emotional investment with the active elements (when, that is, these elements are allowed to be active) seems partial. Greco-Roman statues and those of Michelangelo, nineteenth-century studio portraits of classical or biblical heroes, Errol Flynn or Tyrone Power movies, may indeed insist on the properly virile potency and inspirational quality of their represented males. Yet, the act of looking itself involves a form of objectification. It is only by denying the erotic element of the look at the male that the implications of that banal observation can be avoided. All these examples at one level acknowledge and play to the look. How else could statues, paintings, photographs or movies exist? But, since the object position is in patriarchy the non-male position—that of females or homosexual males—that truth must be disavowed.

If such male representation is phallic, inviting the fetishising spectator's look, another kind of fetishistic thinking is involved in the difficult job of putting the male on show, without appearing to do so. This sort of thinking can be summed up in "I know it is so, but still . . . "[4] It is highly important in our culture, since it not only allows little girls to believe, at some level, that they are feeding their dolls,[5] but can play a significant role in adult life—in coping with grief, say, where the unbeliever can assuage

his or her sense of loss with the thought that "maybe" there is an afterlife, rational beliefs to the contrary. In the context of male representation, the erotic male both denies his own existence and yet embodies that existence.

To help fetishistic thinking on the spectator's part, there must be strongly credible, or at least strongly credited, alibis. Thus, the hero of the western tears his shirt off only because he is wounded in the chest. What could be more rational? The hero turns his back to the camera and climbs into bed naked. Why? Because he is going to bed and he sleeps in the nude, of course. When the rationale for the body exposure is more difficult to accept, there can be discomfort in the audience, a sense that they are caught looking.[6]

If Laura Mulvey allows herself to believe what she is told by Hollywood movies, that real men don't allow themselves to be objectified, she accepts only what Kenneth Clark accepts in the area of millennia of art. Had Mulvey's 'Visual Pleasure and Narrative Cinema' appeared in 1993, rather than in 1973, the judgment that males cannot be objectified in popular media would have been extraordinary, since what was cloaked in evasive half-truths seemed by then to be declared on billboards, television and cinema screens, glossy magazines marketed for men or, even by title, for women. What is declared in this decade is, apparently, that men can easily be objects of the gaze, and that objectified men are erotic.

The pleasures of male objectification have been known for much longer than the past decade within male homosexual experience, but that may be a good part of the trouble with male objectification. How can it be erotic, if it means looking through 'gay' male eyes, since, as everybody in patriarchy knows, heterosexual males have no admixture of the homosexual in them and enjoy a discrete sexuality in which their attraction is to women?—preferably to women whose objectification is pleasurably open to them. Yet, if men's fashion magazines coast in dangerous waters when they purvey fashion in the abstract, how much more dangerous are these waters when male models both in and out of their clothes are used to sell the fashion and the lifestyle that goes with it. The difficulty is to have 'real men' gazing with desire at other 'real men' without undermining belief, vital to patriarchy, in the reality of their masculinity. Solutions have been found, each partial, each raising possibilities that may work in unintended ways, but the balancing act of

walking safely through threats to 'masculinity' is presumably accomplished by ordinary men each day.

One of these tactics, possibly the most crucial, is to insist on a desiring female gaze. The effect is curiously similar to (other) parts of the influential Mulvey argument which, not perhaps incidentally, denied the possibility of a female gaze, insisting instead on the masculinised gaze, regardless of the biological gender of the spectator. Thus, the desiring male spectator is discouraged from self-consciousness about his gaze or his desire. He is instead looking *with* the desiring female.[7]

This attribution of the active look to the female and the male spectator's psychological alignment with her has its own difficulties, since that alignment may involve too frank an admission of, in this regard, the spectator's castration and thus femininity. Perhaps, instead, the concentration can be on the joys of heterosexual complementarity. By paying attention to what is apparently the newly desiring female, the male spectator can imagine that it is demanded of him in the egalitarian New Man ethos often promoted by current advertising that he allow himself to be objectified for her pleasure. The cultural secret of male masochism, of the quite male pleasures of exhibitionism and narcissism, is thus not quite out, for it is protected by the attribution of a demand for active viewing pleasure to the female, whom the 'real man' is bound within patriarchy to please sexually. In other words, it would seem to be perfectly alright for men to be on show because this is what women want.[8]

Not all eroticised males in advertising play within the scene to a female gazer. It may be too literal-minded to demand of every invocation of the female gaze that there be depicted a female gazing. After a while, the public has absorbed the idea, surely. On the other hand, it could be suggested that there has been a change in the public face of male narcissism—or, rather, that there is now acknowledged public male narcissism. It is differentiable from what would be read as the blatantly homosexual variety by the lack of libidinous drive, the very passivity of the male object. This passivity gives him the appearance of being available as an image without the responsibility (of sexual choice) which the attribution of a more obviously active aspect to him might entail.[9]

If the strong encouragement to a female gaze and the creation of a space for male narcissism are possibly the principal methods by which the male erotic object exists today in advertising and entertainment,

there are others. Richard Dyer's stress on potential subjectivity in the poses, Steve Neale's emphasis on the sadism of the (constructed) spectator and the concomitant masochism of the male spectacle, remain valuable insights.[10] There is also, as ever, disavowal of the most breathtaking sort.

The strength of resistance to the very notion that sportsmen are even capable of being eroticised in any normal circumstances, as described in the introduction, testifies, unless the resistance is persuasive, to the cultural habit of refusing to see the admiration of youth, strength and fitness as in any way erotic. Given the ubiquity of that cultural habit, sporting accoutrements and settings are an obviously attractive way of eroticising the male, since it spares the viewer the need for further disavowal.

One obvious question has not been voiced in the discussion so far, which has concerned itself with gender, patriarchal psychology and the patriarchal conception of the erotic. If we are at present able to countenance a female gaze because this gives a freer rein to the thoroughly male, but secret, pleasures of the object position, why should it be now? What are the special circumstances?

If our culture is patriarchal, we also live in a stage of consumer capitalism whose imperative is expansion. Women's bodies have long been commoditised, both to sell other commodities and to sell women's bodies *as* commodities. The patriarchal logic that would deny similar commodification to the male body comes up against a marketing sophistication which can roll back the notions of proper male positioning within patriarchy. It does this by exploitation of feminist and gay politics, to come up with an equal-opportunities policy as regards the commodification of the sexes, while evading a clash with the fundamentals of patriarchy. After all, male privilege may be retained, the dominance of one sex over the other in social actuality kept in place, even facilitated, by the creation of spaces in which that dominance is masked. If masochism is temporary in the 'male' action movie, so may be male objectification and eroticisation.

The male strip show provides a striking exemplar of the way that all this could work. Women are persuaded that, if they don't already want to see men strip, and to pay for the privilege both in terms of entrance fee and tips, their learning to want to is liberatory. The male appears available to

what may be a newly-fostered desire. He is there to excite—whether it be female libido, derision, desire, contempt. Within the space of the club or pub, or for as long as the videocassette is played, women have relatively handsome males at their service and may be encouraged to think that the service could continue elsewhere. When the show is over, the women customers return to their social place, the male performers to theirs. The latter can shake off their objecthood—or hold it, if it was pleasurably experienced, as a happy memory. The former may feel once again that it is their biological destiny to be objects of male desire. It isn't, but they may be encouraged to think of it that way. The strip show becomes time out, not just a night out.

This is not the whole story, though. It would be foolish to take contemporary popular culture's claims for the loosening up of sexual dichotomising at face value, and not to detect the inexorable workings of consumerism behind the advertisers' energetic discovery of male objects and female subjects. Yet, on the other hand, the amorality and directionlessness of consumerism opens up a space within patriarchy.[11]

The female gaze may at some level be a fiction, but it has by dint of repetition alone to become fact. If the gaze is credibly linked with social power and gender privilege, then the creation of a space for female spectatorship has unpredictable consequences. Male erotic objectification, however disavowed or alibied, is exposed as never before. Whatever safety nets have been set up by the culture, cultural understanding of sexuality must be affected, there has to be a denting of the more certain sense of masculinity as excluding passivity, there has to be a curb on the relegation of anything but compulsory heterosexuality to alien territory.

If the precise effects are unpredictable, then this book should stop short of offering predictions. The male erotic object may be recuperated soon or eventually or not at all. He has existed unacknowledged for many centuries. He now appears by common consent to exist, for good or for ill. There must be consequences.

notes

introduction

1. See Laura Mulvey, *Visual and Other Pleasures* (London: Macmillan, 1989), pp. 14–26, 29–38.

2. Mulvey, *Visual and Other Pleasures*, p. 20.

3. Students have as part of their assessment to be evaluated in terms of their seminar work, both as participants in seminars organised by others and as joint organisers of one of the seminar series per unit.

4. See Steve Neale, '*Chariots of Fire*, Images of Men', *Screen*, vol. 23, no. 3–4 (1982).

5. Seminar students generally request and appreciate staff involvement, sometimes assigning particular tasks to staff.

6. Emotional situations are particularly difficult to read in terms of the so-called correctness, political or otherwise, of responses.

7. This is probably why some of the silent class felt that they had been identified as these others, the minority, who were contaminating the experience of sporting spectacle.

8. Later, some members of the class expressed surprise that a Take That video would ever be considered as suitable material for academic study.

9. It was at the number-one spot during summer 1993.

10. In Channel 4's *Passengers* programme (12 August 1994), members of Take That themselves recognised that they had gained a reputation for probable gayness from the media because they did not distance themselves from their substantial gay following or express revulsion at the receipt of letters from male fans. Oddly, their self-stated ease in matters of their gay fans was belied by the inability of one of the group to finish a sentence in which he claimed that they had no difficulty, when in gay venues, in discussing–er–and then inarticulacy of utterance ' . . . gay issues,' another unseen member of the group suggested. 'Yeah, gay issues,' the spokesman continued, thanking his colleague for the help given at a difficult moment.

11. It is well-nigh impossible for me to write that appellation without inverted commas!

12. See Gloria Steinem, 'Erotica and Pornography: A Clear and Present Difference', in Laura Lederer, ed., *Take Back the Night: Women on Pornography* (London: Bantam, 1982).

13. Andrea Dworkin, *Pornography: Men Possessing Women* (London: The Women's Press, 1981), pp. 9–10.

14. Ellen Willis, 'Feminism, Moralism and Pornography', in Ann Snitow et al., *Desire: The Politics of Sexuality* (London: Virago, 1984), p. 84. Her emphasis.

chapter I

1. Laura Mulvey, *Visual and Other Pleasures* (London: Macmillan, 1989), pp. 14–26.

2. It can, of course, be claimed that narrative cinema props up patriarchal

thought's alignment of femaleness with 'femininity' (passivity, exhibitionism) and of maleness with 'masculinity' (activity, voyeurism) as somehow proper or natural. However, it may allow the argument to be too easily achieved if the distinction is allowed to be forgotten.

3. Mulvey, *Visual and Other Pleasures,* pp. 29–38.

4. Ibid., 30.

5. Part of Thatcherism's attempt to clarify the proper division of activity and passivity within service as well as more conventional industries was to establish the superior rights of the so-called customer.

6. It could be hazarded that the glance seems to be downwards from subject to object in sadistic voyeurism, upwards in fetishisation.

7. Mary Ann Doane, et al., *Re-Vision: Essays in Feminist Film Criticism* (Frederick, Md.: University Publications of America/The American Film Institute, 1984), p. 74.

8. See Steve Neale, '*Halloween*: Suspense, Aggression and the Look', *Framework* 14 (1981).

9. Ibid., p. 28.

10. This article's signal contribution to shaking the confidence with which narrative cinema's 'masculine' spectatorship is credited is matched by Neale's insistence on the possibility of male spectacle in another context. He might, however, want to reconsider one claim in his article on *Halloween*. He states, " . . . although suffering persecution and attack, the spectating subject does not turn *its* aggression against the film as such. On the contrary, the film is enjoyed, and this seems to involve the representation of violence and aggression in the film itself." (p. 28) Not all potential or actual spectators do enjoy the film's represented violence and aggression, though. I would hazard the opinion that the combative moralism of certain campaigns against what have been popularly termed video nasties or any suggestion that the BBFC might relax its vigilance against the violence of, say, *Reservoir Dogs* is explicable at one level as an act of aggression against the film in revenge for its own aggression on the spectator.

11. Thrillers which clearly work by the disorientation of the viewer and the destabilising of the spectator's 'masculine' control would surely include most of Hitchcock, but especially *Rear Window, Vertigo* and most obviously *Psycho*, and work by Brian De Palma, such as *Dressed to Kill*. It is odd to find that Mulvey's interest in Hitchcock does not open the door to her consideration of the *already* castrated James Stewart character as spectator of *Rear Window*, for example, who is (if this makes sense) further castrated by the end of the film.

12. Kaja Silverman, 'Masochism and Male Subjectivity', in Constance Penley and Sharon Willis, eds., 'Male Trouble' special issue, *Camera Obscura* 17 (1988).

13. Subjectivity involves, she reminds us with reference to Lacan's mirror stage, the subject's learning to see the self from the place of the Other.

14. Lorraine Gamman and Margaret Marshment, eds., *The Female Gaze: Women as Viewers of Popular Culture* (London: The Women's Press, 1988).

15. Suzanne Moore, 'Here's Looking at You, Kid!', in Gamman and Marshment, eds., *The Female Gaze*.

16. E. Ann Kaplan's question 'Is the Gaze Male?' (the heading of chapter 1 of E. Ann Kaplan, *Women and Film: Both Sides of the Camera* [London: Methuen, 1983]) is

perfectly justified in the light of Mulvey's collapsing of the distinction between 'masculine' and 'male'.

17. Mulvey, *Visual and Other Pleasures*, p. 20.

18. Ibid.

19. Steve Neale, 'Masculinity as Spectacle: Reflections on Men and Mainstream Cinema', *Screen*, vol. 24, no. 6 (1983).

20. The disavowal involved is remarkably similar to the hackneyed response trotted out in television chat shows of the 1960s, wherein actresses, on being asked why they had agreed to do a nude scene on stage or on film, would say, "I felt the nudity was integral to the plot".

21. When Australian Rules football was discussed on television in October 1994, it was noted that the players wore singlets and very high, tight shorts. The commentator said, "Well, now we know what's in it for 50% of the Australian population. But what do the men get from it?"

22. Richard Dyer, 'Don't Look Now: The Male Pin-Up', in *Screen*, eds., *The Sexual Subject: A* Screen *Reader in Sexuality* (London: Routledge, 1992).

chapter 2

1. Awareness of social censure usually means, of course, that for socialised beings there may be an admixture of shame or embarrassment about admitting, even to themselves, that what is taboo to their gender, say, is *felt* as natural. This must have an effect on that experience so that it begins to feel less natural.

2. Michael Kaufman, 'The Construction of Masculinity and the Triad of Men's Violence', in Michael Kaufman, ed., *Beyond Patriarchy: Essays by Men on Pleasure, Power, and Change* (Don Mills, Ontario: Oxford University Press, 1987), p.14.

3. It would seem that the infant–mother relationship is one better described in terms of identification than of love. See Mary Ingham, *Men: 'The Male Myth Exposed* (London: Century Publishing, 1984), p. 108.

4. Constance Penley and Sharon Willis, eds., 'Male Trouble' special issue, *Camera Obscura* 17 (1988), p. 5.

5. It has to be recalled that in her 'Afterthoughts' article, when Mulvey attempts to account for (biologically) female pleasure in dominant cinema, she opens the door to at least trans-gender identifications at fantasy level. (See Mulvey, *Visual and Other Pleasure*, pp. 29–38, and particularly the essay's final words, on p. 37, where she describes the "female spectator's fantasy of masculinisation" as "restless in its transvestite clothes".)

6. See Joseph Bristow, 'How Men Are: Speaking of Masculinity', *New Formations* 6 (1988), p. 121.

7. Yvonne Tasker, *Spectacular Bodies: Gender, Genre and the Action Cinema* (London: Routledge, 1993), p. 110.

8. Sandy Flitterman, 'Thighs and Whiskers: The Fascination of "Magnum, P.I."', *Screen*, vol. 26, no. 2 (1985), p. 43.

9. Bryan S. Turner, *The Body and Society: Explorations in Social Theory* (Oxford: Blackwell, 1984), p. 29.

10. Lynne Joyrich, 'Critical and Textual Hypermasculinity', in Patricia Mellencamp,

ed., *Logics of Television: Essays in Cultural Criticism* (Bloomington and London: Indiana University Press/NBFI Publishing, 1990), p. 168.

11. Joyrich, 'Critical and Textual Hypermasculinity', p. 169.

12. Sigmund Freud, quoted in David D. Gilmore, *Manhood in the Making: Cultural Concepts of Masculinity* (New Haven: Yale University Press, 1990), prior to the preface.

13. It seems surely to be in the spirit of Freud that we attempt to investigate the 'slippage' here.

14. Kaja Silverman, 'Masochism and Male Subjectivity', in Constance Penley and Sharon Willis, eds., 'Male Trouble' special issue, *Camera Obscura* 17 (1988), p. 149.

15. Mary Ingham writes in this regard, " . . . men . . . are often reluctant to tolerate anything which they feel to be non-masculine . . . They are shoring up their identity by so doing, because they feel threatened by that which remains at the core of their being.' (Ingham, *Men*, p. 107). Jessica Benjamin and Anson Rabinbach, in their foreword to the second volume of Klaus Theweleit's *Male Fantasies*, suggest that Fascism, in Theweleit's view, "is an extreme example of the political polarisation of gender". They continue, " . . . for the male it is the woman within that constitutes the most radical threat to his own integrityOn the one side there is the soft, fluid, and ultimately liquid female body which is a quintessentially negative 'Other' lurking inside the male body. It is the subversive source of pleasure or pain which must be expurgated or sealed off. On the other there is the hard, organised, phallic body devoid of all internal viscera which finds its apotheosis in the machine." (Jessica Benjamin and Anson Rabinbach, 'Foreword', in Klaus Theweleit, *Male Fantasies II (Male Bodies: Psychoanalyzing the White Terror*, tr. Chris Turner et al., [Cambridge and Oxford: Polity Press with Basil Blackwell, 1989], p. xix.)

16. Marilyn French, *Beyond Power: On Women, Men, and Morals* (London: Jonathan Cape, 1985), p. 501. She goes on to say, "Ignoring the far greater similarities than differences among humans, patriarchy divides and conquers." Graham McCann explains the appeal of Clift, Brando and Dean in the 1950s partly on the grounds of their self-acknowledged 'bisexuality', so that they were suited to roles "which expressed an erotic quality bereft of rigid gender identity". (Graham McCann, *Rebel Males: Clift, Brando and Dean* [New Brunswick, N.J.: Rutgers University Press, 1993] p. 3.) McCann believes that they invited audiences to recognise that their own identities were not as inevitable as they had thought. Despite the striving to fix 'masculinity' and 'femininity', these were precarious and provisional ideas. (McCann, *Rebel Males*, p. 4.)

17. Richard Dyer sees this explanation as fitting Sylvester Stallone films and some heavy metal band performances. (Suzanne Moore, 'Here's Looking at You, Kid!', in Lorraine Gamman and Margaret Marshment, eds., *The Female Gaze: Women as Viewers of Popular Culture* [London: The Women's Press, 1988], p. 53.)

18. This helps to explain not only the frenzy of violence that is sometimes reported as accompanying attacks on homosexual men who have picked up their assailants on what the latter claim to be the mistaken belief that they were homosexual too. It also helps to clarify the reasons behind the otherwise astonishing acceptance by their judges of their claimed disgust as excuse for assaults that are so vicious as to be sometimes lethal. A simple 'no' would surely have been enough. Yet, the powerful and pervasive myths of 'masculinity' would not be satisfied with such quiet insistence on male consent.

19. Scott MacDonald writes of this in connection with porn-watching, " . . . one of the primary functions of the female presence is to serve as a sign—to others and to oneself—that looking at erections, even finding them sexy, does not mean that the viewer defines himself as a homosexual". (Scott MacDonald , 'Confessions of a Feminist Porn Watcher', *Film Quarterly*, vol. 36, no. 3 [1983], p. 14.)

20. Susan Jeffords, 'Can Masculinity be Terminated?', in Steven Cohan and Ina Rae Hark, eds., *Screening the Male: Exploring Masculinities in Hollywood Cinema* (London: Routledge,1989) p. 15. She reminds the reader that display of the male object of homoerotic desire is "castrating" outside power and technological display.

21. Jonathan Rutherford, 'Who's That Man?', in Rowena Chapman and Jonathan Rutherford, eds., *Male Order: Unwrapping Masculinity* (London: Lawrence and Wishart,1992) p. 66.

22. See Laura Mulvey, *Visual and Other Pleasures*, pp. 29–38.

23. Mary Daly, *Pure Lust: Elemental Feminist Philosophy* (London: The Women's Press, 1984), p. 382.

24. Gary Day and Clive Bloom, *Perspectives on Pornography: Sexuality in Film and Literature* (London: Macmillan, 1988), p. 5.

25. Helen Chappell, 'Girl's Night In: "Ooo-er! Gross! Amazing!"', *Independent*, 3 December 1991, n.p.

26. See Jodi Duckett, 'The Flip Side: When Men are Sexually Harassed, All Things May Not Be Equal', *Morning Call*, 10 March 1994, p. D3.

27. Tom Ryan, 'Roots of Masculinity', in Andy Metcalf and Martin Humphries, *The Sexuality of Men* (London: Pluto, 1985), p. 16.

28. Mary Daly comments of Hoffman's Dorothy, " . . . the movie viewer is invited to swallow the message that a male in drag is better at behaving as a feminist and as a friend than are real women. All of the unmemorable wimpy women in the film illustrate this point." (Daly, *Pure Lust*, p. 208.)

29. Judith Williamson, *Consuming Passions: The Dynamics of Popular Culture* (London: Marion Boyars, 1986) p. 49.

30. Eve Sedgwick, in Christopher Newfield, 'The Politics of Male Suffering: Masochism and Hegemony in the American Renaissance', *differences: A Journal of Feminist Cultural Studies*, vol. 1, no. 3 (1989), p. 79.

31. Barbara Creed, 'From Here to Modernity: Feminism and Postmodernism', *Screen* vol. 28, no. 2 (1987), pp. 65–66.

32. Richard Dyer finds evidence for male jealousy of women in the pantomime of *Cinderella*, with its ugly sister characters: "We can turn this comedy inside out and see that it expresses male resentment at finding women sexually arousing, male jealousy that it is women who are allowed to present themselves with such allure. Yet this tradition of humour never says as much. We have to bring such a view from outside the humour." (Richard Dyer, 'Male Sexuality in the Media', in Metcalf and Humphries, eds., *The Sexuality of Men*, p. 35.)

33. "Sadistic" here is not necessarily given its full Sadean sense. It is, rather, used in the sense of taking control of the erotic scenario, making things happen, choosing and in other ways exercising subjectivity.

34. "No pain, no gain" is a slogan that encapsulates the place of physical suffering in

the triumph of body-beautiful acquisition.

35. Antony Easthope puts the relation between this sort of masochism and masculinity-as-dominance thus: "If I can hurt my body freely, by an act of my own will, then my mind is proved to be master of my body." (Antony Easthope, *What a Man's Gotta Do: The Masculine Myth in Popular Culture* [London: Paladin Books, 1986], p. 53.)

36. Phyllis Chesler, *About Men* (London: The Women's Press, 1978), p. 230.

37. Gaylyn Studlar, 'Masochism and the Perverse Pleasures of the Cinema', in Bill Nichols, ed., *Movies and Methods*, vol. 2 (Berkely and Los Angeles: University of California Press, 1985), p. 606.

38. Kaja Silverman, 'Masochism and Male Subjectivity', p. 41.

39. In 'The Economic Problem in Masochism', Freud allows a primary masochism to exist alongside primary sadism. (Christine Holmlund, 'Sexuality and Power in Male Doppelganger Cinema: The Case of Clint Eastwood's *Tightrope*', *Cinema Journal*, vol. 26, no. 1 [1986], p. 34.)

40. French, *Beyond Power*, pp. 522, 525.

41. See Silverman, 'Masochism and Male Subjectivity', p. 55.

42. Paul Smith, *Clint Eastwood: A Cultural Production* (London: UCL Press, 1993), p. 165.

43. The word is used here in the film studies sense rather than in the broad sense that the film industry gave to the term (for just about any straight-faced movie drama).

44. Studlar takes masochism as originating within the pre-Oedipal phase whose goal is union with the mother, while sadism's origins for her are Oedipal. She explains the female in the masochistic aesthetic as "a figure of identification, the mother of plenitude whose gaze meets the infant's as it asserts her presence and power". (Studlar, 'Masochism and the Perverse Pleasures of the Cinema', p. 610.)

45. Theodore Reik, quoted in Silverman, 'Masochism and Male Subjectivity', p. 43.

46. Kaja Silverman, 'Fragments of a Fashionable Discourse', in Tania Modleski, ed., *Studies in Entertainment: Critical Approaches to Mass Culture* (Bloomington and Indianapolis: Indiana University Press, 1986), p. 143.

47. Ibid.

48. See Silverman, 'Fragments of a Fashionable Discourse', pp. 141–2.

49. See Joyce McDougall, *Plea for a Measure of Abnormality* (London: Free Association Books, 1990) p. 302.

50. Jonathan Rutherford writes in this connection, "If this place remains unresolved, if the mother is experienced as lost through her psychic absence, there is little room for introjecting new objects. Sexual love becomes a precarious and dangerous undertaking for it threatens to displace the internal object of the bereaved mother." (Jonathan Rutherford, *Men's Silences: Predicaments in Masculinity* [London: Routledge, 1992], p. 192.)

51. Charles Henri Ford, 'Narcissism as Voyeurism as Narcissism', in Gerard Malanga, ed., *Scopophilia: The Love of Looking* (New York: Alfred Van Der Marck Editions, 1985), p. 46.

52. See Silverman, 'Fragments of a Faschionable Discourse', p. 139.

53. The uneasiness with which certain career choices made by men are viewed in wider culture leavens any over-positive accounts of the opportunities opened by these for the expression of male narcissism. This uneasiness is explained precisely by social disapproval of too direct expression by males of their exhibitionism and narcissism.

54. Judith Lynne Hanna, *Dance, Sex, and Gender: Signs of Identity, Dominance, Defiance, and Desire* (Chicago: University of Chicago Press, 1988), pp. 120–21.

55. Marcia Siegel, quoted in Hanna, *Dance, Sex, and Gender*, p. 194.

56. Elliott Erwitt says that people go to St Tropez to display themselves. "So to be a voyeur in St Tropez is no big deal; it's expected of you." (Elliott Erwitt, in Malanga, ed., *Scopophilia*, p. 40.)

57. Sean Nixon, 'Have You Got The Look? Masculinities and Shopping Spectacle', in Rob Shields, ed., *Lifestyle Shopping: The Subject of Consumption* (London: Routledge, 1992), p. 164. He is notably cautious, all the same, as to the extent to which he would read off messages about alterations in masculinities from "changing visual texts".

58. Suzanne Moore identifies the Levi 501s commercials as adding to the long history of male pin-ups a new acknowledgement of the 'to-be-looked-at' nature of the male body. (Moore, 'Here's Looking At You, Kid!', p. 47)

59. Philip Schlesinger et al. claim, "Many, if not most, women and girls have been flashed at, and all are made aware of its likelihood. One study of flashing found that 63 per cent of women had been flashed at." (Philip Schlesinger, et al., *Women Viewing Violence* [London: British Film Institute, 1992], p. 11.)

60. James K. Skipper, Jr and Charles H. McCaghy report that strippers were continually "treated to acts rivalling their own performance: male exhibitionism and masturbation" from the first five rows of spectators. (James K. Skipper, Jr. and Charles H. McCaghy, 'Teasing, Flashing and Visual Sex: Stripping for a Living', in James M. Henslin and Edward Sagarin, eds., *The Sociology of Sex: An Introductory Reader* [New York: Schocken Books, 1987], p. 180.)

61. Jacques Lacan, quoted in Mary Ann Doane, 'Masquerade Reconsidered: Further Thoughts on the Female Spectator', *Discourse*, vol. 11, no. 1 (1988–89), pp. 43–44.

62. This point is stressed in Cohan and Hark, *Screening the Male*, p. 3.

63. Miriam Hansen, *Babel and Babylon: Spectatorship in American Silent Film* (Cambridge, Mass.: Harvard University Press, 1991), p. 266.

64. George Zavitzianos, 'The Object in Fetishism, Homeovestism and Transvestism', *International Journal of Psychoanalysis* 58 (1977), p. 493.

65. Gary Day, 'Pose for Thought: Body-Building and Other Matters', in Gary Day, ed., *Readings in Popular Culture: Trivial Pursuits?* (London: Macmillan, 1990) pp. 51–52.

66. See Raymond Durgnat, *Eros in the Cinema* (London: Calder and Boyars, 1966), pp. 14–15.

67. Easthope, *What a Man's Gotta Do*, p. 15. There is a possible implication here, however, that the sexual involves activity and intersubjectivity. Narcissism is deemed not sexual only when such definitions of sexuality underlie conceptions of the sexual.

68. Alan Hollinghurst, *The Swimming-Pool Library* (Harmondsworth: Penguin, 1988), p. 15.

69. Jack D. Douglas, and Paul K. Rasmussen with Carol Ann Flanagan, *The Nude Beach* (Beverly Hills: Sage,. 1977), p. 24.

70. "Outrageous male exhibitionism has been perfectly permissible . . . for two generations of rock stars. The freedom to stand outside conventional masculinity is very often a freedom symbolising confidence and power—a freedom society tolerates easily in men but punishes in women." (Frank Mort, 'Images Change: High Street Style and the New Man', *New Socialist*, November 1986, n.p.)

71. Contradictions in the official Nazi attitude become apparent in the appropriation of images of rude health, athletic nakedness and near nakedness within the work of Leni Riefenstahl. Sequences of her *Triumph of the Will* (1935) involving the hearty outdoors-loving male camaraderie of the young Party faithful are possibly more interesting in this regard than even *Berlin Olympiad* (1938), with its early 'ancient-Greek' sequences and its fetishising of the divers' bodies: the latter film is, after all, alibied by the occasion of the Olympics, which is in turn alibied by being a celebration of sport and athletic competition.

72. Dr Maurice Parmelee, quoted by Emmanuel Cooper, *Fully Exposed: The Male Nude in Photography* (London: Unwin Hyman, 1990), p. 86, who supports this view by adding, "For women curious about the male body there were few, if any, places to go where their interest could be satisfied, other than nudist camps."

73. The address of most nudist films is to the as yet unconverted.

74. Alasdair Foster, 'Men in Print: Images of the Male Body in the 20th Century part three: Getting Phyiscal', *Gay Scotland*, vol. 33, no. 3 (1987), p. 8.

75. By, for example, William Leith, 'Of Muscles and Men', *Independent on Sunday*, 13 December 1992, p. 22.

76. Peter Baker, 'Exposing the Shapes of Things to Come', *Guardian*, 26 May 1992.

77. See Michael S. Kimmel, 'Rethinking "Masculinity": New Directions in Research', in Michael S. Kimmel, *Changing Men: New Directions in Research on Men and Masculinity* (Newbury Park, Cal.: Sage, 1987) pp. 37–39.

78. Day, 'Pose for Thought', p. 49.

79. See Rutherford, *Men's Silences*, p. 188.

80. Research work by Dr Sarah Grogan of Manchester Metropolitan University's psychology department found that men had even more difficulty than women in attaining the 'ideal' shape. She has predicted that more men than women may be expected in the future to suffer such eating disorders as anorexia and bulimia. Her findings were that men in her experiment had higher self-esteem and a better body image than women in her experiment, but that after seeing pictures of male models in such magazines as *For Women* self-esteem and body image plummeted. (Celia Hall, 'Chippendales' Image "Puts Pressure on Men"', *Independent*, 6 April 1993, p. 5.) Perhaps, though, her conclusions on this basis are too confident. Surely the importance of body image remains far more crucial in female than male experience, at least within the imagined norms of heterosexuality. Thus, the plummeting concerned with body image could be anticipated to reach far greater depths in female than male experience, given society's continuing concern to link femininity with corporeal desirability. Men can always, whatever their body image, take refuge in competing, and more conservative, accounts of masculinity, after all.

81. See Brian Pronger, *The Arena of Masculinity: Sports, Homosexuality, and the Meaning of Sex* (New York: St. Martin's Press, 1990), p. 170.

82. Tasker, *Spectacular Bodies*, p. 109.

83. Alasdair Foster, *Behold the Man: The Male Nude in Photography* (Edinburgh: Stills Gallery, 1988), p. 28.

84. Rosalind Coward, *Female Desire* (London: Paladin, 1984), p. 227.

85. Easthope, quoted in Gamman and Marshment, eds., *The Female Gaze*, p. 46.

86. This reasoning is, though, altogether too neat, not least because it seeks to over-simplify the homosexual/-erotic and to drive a wedge between it and the hetero-sexual/-erotic.

87. As Margaret Walters suggests, "The young boy may focus a man's dream of himself *incorporating* femininity, rediscovering in himself those qualities prohibited to him as a grown man." (Margaret Walters, *The Nude Male: A New Perspective* [Harmondsworth: Penguin, 1979], p. 15.)

88. Hansen, *Babel and Babylon*, p. 267.

chapter 3

1. Note, for example, Laura Mulvey's final 'Visual Pleasure' judgment: "Women . . . cannot view the decline of the traditional film form with anything much more than sentimental regret" (Laura Mulvey, *Visual and Other Pleasures*, p. 26).

2. Annette Kuhn, *Women's Pictures: Feminism and Cinema* (London: Routledge and Kegan Paul), 1982.

3. See Mary Ann Doane et al., *Re-Vision: Essays in Feminist Film Criticism* (Frederick, Md.: University Publications of America/The American Film Institute, 1984).

4. Hal Foster, ed., *Postmodern Culture* (London: Pluto, 1985), p. ix.

5. Gaylyn Studlar claims that Nijinsky was derided on these grounds (Gaylyn Studlar, 'Valentino, "Optic Intoxication," and Dance Madness', in Steven Cohan and Ina Rae Hark, eds., *Screening the Male: Exploring Masculinities in Hollywood Cinema* [London: Routledge, 1993], p. 24).

6. Igor Youskevitch et al., *The Male Image* (New York: Dance Perspectives 40, 1969).

7. Ibid., p. 11.

8. Ibid., p. 13. Why the downplaying of gender differences must produce effemi-nacy in the male dancer remains to be explained.

9. Ibid., p. 23. What is it for a woman—an irrational challenge?

10. Ibid.

11. Ibid., p. 25.

12. Ibid., pp. 31, 33.

13. Ibid., p. 36.

14. Ibid., p. 39.

15. All genres feature male actors who are in an obvious sense to-be-looked-at, but this fact is more easily disguised in some genres than others.

16. Steven Cohan, '"Feminizing" the Song-and Dance Man: Fred Astaire and the Spectacle of Masculinity in the Hollywood Musical', in Cohan and Hark, eds., *Screening the Male*, pp. 63–64.

17. The writers do, to be fair, imply that the societally masculine has to be rendered

in balletic terms, but in their writing tend to leave this aspect relatively unexplored, discerning the so-called problem and its solution in ways that fail to take account of the reception, the reading, of dance as (literally) theatrical performance.

18. Cohan, '"Feminizing" the Song-and-Dance Man', pp. 63–64.

19. Ibid., p. 47.

20. Ibid., pp. 60, 61.

21. Margaret Walters states (Margaret Walters, *The Nude Male: A New Perspective* [Harmondsworth: Penguin, 1979], p. 7) that female figures might well be rendered by Renaissance artists from male models.

22. Phyllis Chesler explains her ability to stare at what she calls perfect penises without any lustful stirrings, as well as her consequent attribution of the status of great art to such representations of the nude male, by her realisation that high art, like pornography, was designed to appeal to male interest, not to the imagined prurience of female interest (Phyllis Chesler, *About Men* [London: The Women's Press, 1978], p. 104).

23. See, for example, Norma Broude and Mary D. Garrard, *Feminism and Art History: Questioning the Litany* (New York: Harper and Row, 1982), p. 15.

24. Richard Dyer explains as follows: "This appeal [to the idea of timeless, immemorial ideals enshrined in our classics] can . . . be used to defend the practice of representing the naked human body in a period when such representation is widely deemed lewd or immoral . . . art practice had to produce a discourse that denied the erotic dimension of such images, that insisted classical style nudes transcended sexuality . . . it is . . . a way of producing potentially erotic images while denying that that is what is being done . . . " (Richard Dyer, *Heavenly Bodies: Film Stars and Society* [London: British Film Institute/Macmillan, 1987], p. 121).

25. Kenneth Clark, *The Nude: A Study of Ideal Art* (London: John Murray, 1956), p. 1.

26. Angela Carter remarks of this tendency: "It is almost as though, in order to excuse themselves for painting a beautiful male body, the artists had to deprive it of serenity and turn it into an image of horror and despair" (Angela Carter, 'A Well-Hung Hang-Up', in Paul Barker, ed., *Arts in Society* [London: Fontana, 1977], p. 77). This is a point taken up by Steve Neale (Steve Neale, 'Masculinity as Spectacle: Reflections on Men and Mainstream Cinema', *Screen*, vol. 20, no. 6 [1983]) in relation to mainstream cinema's less explored tendency to treat the male body as spectacle, where mutilation of the male body provides an alibi for what would otherwise be the more overt eroticisation of it.

27. See, for example, Mandy Merck, *Perversions: Deviant Readings* (London: Virago, 1993), p. 230.

28. Leo Steinberg, *The Sexuality of Christ in Renaissance Art and in Modern Oblivion* (London: Faber and Faber, 1984), p. 1.

29. " . . . the evidence of Christ's sexual member serves as the pledge of God's humanation . . . " (Steinberg, *The Sexuality of Christ*, p. 13).

30. See Leon Hunt, 'What Are Big Boys Made Of? *Spartacus, El Cid* and the Male Epic', in Pat Kirkham and Janet Thumim, eds., *You Tarzan: Masculinity, Movies and Men* (London: Lawrence and Wishart, 1993), p. 73.

31. Angela Carter believes that the paucity of what she calls lovely boys means that

a tradition cannot be claimed (Carter, 'A Well-Hung Hang-Up', p. 75). More interestingly, she draws attention to the way that, whether a tradition or not, the high-art "lovely boy" is popularly attributed to a homoerotic tradition, as, for example, "a masterpiece of homosexual art", this description warding off the possibility of female delectation.

32. Clark, *The Nude*, p. 343.

33. Ibid.

34. Freud himself, for all his concern to claim that the labeling of active/passive as masculine/feminine was provisional, partial and metaphorical, falls quickly into the habit of moving between the terms as if the distinction, having been addressed, could then be ignored. Yet, his account of the workings of fantasy, such as in the 'Child is being Beaten' scenario, permits no confidence in the stability or predictability of the subject's identification points on, say, gender lines.

35. It is in recognition of the potential which this difficulty engenders that Kay Larson argues, of Robert Mapplethorpe, that the photographer's psychological investment in his black models undermines a straightforward judgment that he objectifies them in a more pernicious sense. "By merging the viewing 'I' . . . with the otherness of the object . . . he converts the object into a subject. That is, he invests this beautiful thing-in-the-world with an erotic charge that transforms it and ennobles it by the passionate entwining of its nature with the artist's" (Kay Larson, 'Robert Mapplethorpe', in Janet Kardon, *Robert Mapplethorpe: The Perfect Moment* [Philadelphia: Institute of Contemporary Art, 1988], p. 16).

36. Anne Friedberg, *Window Shopping: Cinema and the Postmodern* (Berkely and Los Angeles: University of California Press, 1993).

37. We have to ask, of course, whether a multiplex offers a different set of spectatorships or remains important more for the economics of exhibition than for the viewing of a person who has paid for a single ticket granting admission to one of the many cinemas in the multiplex.

38. "Cinema spectatorship in the 1990s has been transformed by the time-shifting changes in spectatorship produced by the multiplex cinema and the VCR. Time-shifting removes the ontology of 'live' television and aligns televisual reception with the elsewhere and elsewhen that has always characterised cinematic spectatorship" (Friedberg, *Window Shopping*, p. 132).

39. Friedberg , *Window Shopping*, p. 139.

40. Mark R. Levy and Barrie Gunter, *Home Video and the Changing Nature of the Television Audience* (London: John Libbey, 1988), pp. 5, 1.

41. Friedberg, *Window Shopping*, p. 141.

42. Ibid., p. 142.

43. Ibid., pp. 184–5.

44. Ibid., p. 37.

45. Ibid., p. 90.

46. See Lynne Joyrich, 'Critical and Textual Hypermasculinity', in Patricia Mellancamp, ed., *Logics of Television: Essays in Cultural Criticism* (Bloomington and London: Indiana University Press/NBFI Publishing, 1990), p. 159.

47. Joyrich, 'Critical and Textual Hypermasculinity', p. 160.

48. Kathy Myers, 'Towards a Feminist Erotica', in Rosemary Betteron, ed., *Looking On: Images of Femininity in the Visual Arts and Media* (London: Pandora, 1987), p. 198.

49. Myers, 'Towards a Feminist Erotica', p. 199.

50. Ibid.

51. "There is . . . a specific and even ritualised form of male objectification and eroticisation in Hollywood cinema" (Paul Smith, *Clint Eastwood: A Cultural Production* [London: UCL Press, 1993[, p. 159).

52. Smith, *Clint Eastwood*, p. 160.

53. Richard Ballardo, 'Strip Joker', *Playgirl*, vol. 20, no. 8 (1992), p. 59.

54. This is not intended, of course, to suggest that no differentiation is possible *between* men in terms of access to power.

55. Steele details differences in effect as follows: "The strived-for similarity between these two images is obvious: the differences are telling. The young man is quite muscular: the young woman . . . is very thin. He is at ease, but powerful in his pose, and photographed frontally; he is erect in his posture. She seems less relaxed, photographed from her side, her reclining figure positioned diagonally in the frame; her spine arched . . . " (Lisa Steele, 'A Capital Idea: Gendering in the Mass Media', in Varda Burstyn, ed., *Women Against Censorship* [Vancouver: Douglas and McIntyre, 1985], p. 66).

56. " . . . it is common for oppressed groups to be represented in dominant discourses as non-active. It suits dominance that way . . . [Their] passivity permits the fantasy of power over them to be exercised, all the more powerful for being a confirmation of actual power; their passivity justifies their subordination ideologically . . ." (Dyer, *Heavenly Bodies*, p. 116).

57. "Having been objectified as sexual beings while stigmatised as ruled by subjective passions, women reject the distinction between knowing subject and known object—, the division between subjective and objective postures—as the means to comprehend social life . . . women's interest lies in overthrowing the distinction itself" (Catharine MacKinnon, 'Feminism, Marxism, Method, and the State: An Agenda for Theory', *Signs*, vol. 7, no. 3 [1982], p. 536).

58. Jennifer Wicke, 'Through a Gaze Darkly: Pornography's Academic Market', in Pamela Church Gibson and Roma Gibson, eds., *Dirty Looks: Women, Pornography, Power* (London: British Film Institute, 1993), p. 79.

59. Robyn Wiegman, 'Feminism, "The Boyz" and Other Matters Regarding the Male", in Cohan and Hark, eds., *Screening the Male*, p. 320.

60. Wiegman, 'Feminism', p. 322.

61. Ibid., p. 324.

62. "Robeson was taken to embody a set of specifically black qualities—naturalness, primitiveness, simplicity and others—that were equally valued and similarly evoked, but for different reasons, by whites and blacks" (Dyer, *Heavenly Bdies*, p. 70).

63. See Sean Nixon, 'Distinguishing Looks: Masculinities, the Visual and Men's Magazines', in Victoria Harwood et al., eds., *Pleasure Principles: Politics, Sexuality and Ethics* (London: Lawrence and Wishart, 1993), p. 58.

64. The highly controversial electioneering leaflets distributed in 1993 by Liberal Democrats in the London Borough of Tower Hamlets featured prominently an illus-

tration of a young black male alongside the verbal text concerning lawbreaking. The apologists for the leaflets are at the very least ingenuous if they imagine that this black male can be taken as threatened, rather than threatening, within dominant discourse, given the history of the black male stereotype in this country.

65. Admiration for Christie does not preclude tabloid interest in his genital size—under the euphemism "Linford's lunchbox".

66. Christie wins for Britain, even if he is popularly reported as temperamental. Hypersensitivity is commonly attributed to blacks in sporting contexts, as when their negative attitude to racial taunts from the football stands is criticised by white colleagues, who opine that they have a chip on their shoulders.

67. See Richard Dyer, 'Don't Look Now: The Male Pin-Up', in *Screen*, eds., *The Sexual Subject: A* Screen *Reader in Sexuality* (London: Routledge, 1992), p. 271.

68. This rule may be broken, to the extent that Danny Glover plays the more socially integrated cop in *Lethal Weapon* and is less of a sidekick than ever in *Predator 2*.

69. Richard Dyer points out the dilemma faced by the Harlem Renaissance, regarding the question of the political effects of playing up black sensuality; this could have been guilty of "playing into the hands of white culture, where such sensuality could be labelled as a sign of irrational inferiority and more grossly read as genital eroticism, as 'sexuality'" (Dyer, *Heavenly Bodies*, p. 111).

70. Beverley Skeggs's defence of Madonna against possible charges of racism rests on knowledge of her private attitudes and activity. "This might be seen as racist if one does not have prior knowledge of her commitment to anti-racism . . ." (Beverley Skeggs, 'Challenging Masculinity and Using Sexuality', *British Journal of Sociology of Education*, vol. 12, no. 2 [1991], p. 30).

71. Then, too, the examination of gender has been conducted in a manner that deserves the description of "heterosexual presumption".

72. Joseph Bristow, 'How Men Are Speaking of Masculinity', *New Formations* 6 (1988), pp. 120–21.

73. Richard Fung, 'Looking for My Penis: The Eroticized Asian in Gay Video Porn', in Bad Object-Choices, ed., *How Do I Look? Queer Film and Video*, Seattle, Wash.: Bay Press, 1991), p.162.

74. This strategy breaks down eventually under the vocal objection of spokesmen for American manhood to his imputed effeminacy.

75. This appears to be the case in, for example, *The Son of the Sheik* (1926).

76. Kaja Silverman, *Male Subjectivity at the Margins* (London: Routledge, 1992), p. 140. Her more detailed discussion of the second sequence may be worth quoting: "The second scene which works both to specularise and to sexualise Ali occurs after he and Emmi [Brigitte Mira] return from their vacation, and in it the desiring look is complexly imbricated with the gaze. Emmi invites two of her co-workers up to her apartment, and introduces them to her husband. The women circle around Ali, touching his biceps while murmuring, "Terrific . . . and such nice, soft skin"It is not only the attention which they lavish on the black man's body which dephallicises him . . . but the way they exchange him amongst themselves" (pp. 140–41).

77. A particularly useful account of the omission of racial difference (and sexuality)

in spectator–text theorisations may be found in Jane Gaines, 'White Privilege and Looking Relations: Race and Gender in Feminist Film Theory', *Screen*, vol. 29, no. 4 (1988).

78. Alile Sharon Larkin says, "Feminism succumbs to racism when it segregates Black women from Black men and dismisses our history. The assumption that Black women and white women share identical or similar histories presents an important problem" (Alile Sharon Larkin, 'Black Women Film-Makers Defining Ourselves: Feminism in Our Own Voice', in E. Deidre Pribram, ed., *Female Spectators: Looking at Film and Television* [London: Verso, 1988], p. 158–9).

79. Gaines, 'White Privilege and Looking Relations', p. 24.

80. Ibid., p. 22.

81. See Lynne Segal, *Slow Motion: Changing Masculinities, Changing Men* (London: Virago, 1990), p. 181.

82. See Dyer, *Heavenly Bodies*, p. 124.

83. Ibid., p. 115.

84. The hardcore use of the penis and penile imagery makes sense as phallic, precisely because it is *hard*core.

85. Punning in this regard may be unintentional, but almost unavoidable.

86. One solution to the problem is "maximum tumescence in repose" (Peter Schwenger, *Phallic Critiques: Masculinity and Twentieth-Century Literature* [London: Routledge, and Kegan Paul,1984], p. 71).

87. "Women don't go nuts over penis size . . . though a healthy bulge never hurts (Ballardo, 'Strip Joker', p. 59).

88. Barbara Creed, 'Dark Desires: Male Masochism in the Horror Film', in Cohan and Hark, eds., *Screening the Male*, p. 118.

89. Klaus Theweleit, *Male Fantasies II (Male Bodies: Psychoanalyzing the White Terror)*, tr. Chris Turner et al. (Cambridge and Oxford: Polity Press with Basil Blackwell, 1989), p. 313.

90. " . . . it is the view of psychoanalysis that while men seek to separate the genital from the anal and maintain an opposition between them, women are much less concerned to draw a firm line." (Antony Easthope, *What a Man's Gotta Do: The Masculine Myth in Popular Culture* [London: Paladin Grafton Books, 1986], p. 97.)

91. Ballardo, 'Strip Joker', p. 59.

92. Jenny Whitby, quoted in Lisa Brinkworth, 'Bringing up the Rear', *Style and Travel*, 23 May 1993, p. 11.

93. Neil Norman, 'Raw Deal', *For Women*, April 1994, p. 25.

94. Coward, *Female Desire*, p. 231.

95. Sarah Kent, 'The Erotic Male Nude', in Sarah Kent and Jacqueline Morreau, eds., *Women's Images of Men* (London: Pandora, 1990), pp. 79–80.

96. This reaction is surprising, since she seems to suggest here that the response to fantasy can be unproblematically what has been, apparently, dictated by the artist. Elsewhere in her essay, she finds a place for herself in fantasy precisely where she is not addressed as a woman, with the imagined desires of a woman.

97. See Rowena Chapman and Jonathan Rutherford, *Male Order: Unwrapping Masculinity* (London: Lawrence and Wishart, 1988), p. 238.

chapter 4

1. On the other hand, "lifelikeness", like "realism", is a convention which may alter in time. We have to hold back from easy assumptions that what is read as unlifelike today would have been so read in the 1840s.

2. See Phil Flasche, 'Introduction', in Ricardo Juan-Carlos, *Photographing the Male* (London: QED Publishing, 1983), pp. 10–12.

3. Alasdair Foster, *Behold the Man: The Male Nude in Photography* (Edinburgh: Stills Gallery, 1988), pp. 9–10.

4. Pesmé photographed the aerialist Léotard.

5. Juan-Carlos, *Photographing the Male*, p. 124.

6. Ibid., p. 132.

7. Ibid., p. 112.

8. Ibid., p. 102.

9. Ibid., opposite p. 102.

10. Peter Weiermair, *The Hidden Image: Photographs of the Male Nude in the Nineteenth and Twentieth Centuries*, tr. Claus Nielander.(Cambridge, Mass.: MIT Press, 1988).

11. Ibid., p. 10.

12. See, for example, Allen Ellenzweig, *The Homoerotic Photograph: Male Images from Durieu/Delacroix to Mapplethorpe* (New York: Columbia University Press, 1992), p. xvi.

13. Unless, that is, the neoclassicism and his apparent invocation of, say, the Hellenistic pastoral indicate something akin to apology.

14. By, for example, Flasche, 'Introduction', p. 13.

15. Ellenzweig, *The Homoerotic Photograph*, p. 121.

16. Ibid.

17. Ibid., p. 113.

18. Ellenzweig quotes White's words in this regard: "Is it you or I who says/out of my love for you/I will give you back to yourself?" (Ellenzweig, *The Homoerotic Photograph*, p. 113.)

19. Tony Benn, 'Perfect Body: Perfect Production', *Camerawork*, November 1982, p. 4.

20. Tony Benn says of this, "The pictorial bodies perform in the open theatre of New York where everything is part of the spectacle of competing signs." (Benn, 'Perfect Body', p. 4.)

21. Ibid.

22. For Allen Ellenzweig, the pleasure to be derived from an image may often be enhanced by knowledge of the power exercised against it. (Ellenzweig, *The Homoerotic Photograph*, p. xviii.)

23. " . . . the physical attractiveness of men and boys was offered up as a concomitant to the luxury of goods, the frank pleasures of fabrics and scents, and as the proper seasoning for any social encounter," (Ellenzweig, *The Homoerotic Photograph*, p. 163.)

24. Andrew Sullivan, 'Flogging Underwear: The New Raunchiness of American Advertising', *New Republic*, 18 January 1988, p. 23.

25. Thomas Yingling, 'How the Eye is Caste: Robert Mapplethorpe and the Limits of Controversy', *Discourse*, vol. 12, no. 2 (1990), p. 17.

26. Janet Kardon, *Robert Mapplethorpe: The Perfect Moment* (Philadelphia: Institute of Contemporary Art, University of Pennsylvania, 1988), p. 10.

27. Ellenzweig, *The Homoerotic Photograph*, p. 129.

28. For example, the Mapplethorpe retrospective expected to take place at the Corcoran Gallery in Washington, D.C. was cancelled. Senator Jesse Helms of North Carolina was particularly stimulated to action by what he regarded as the threat of public exhibition of Mapplethorpe's work when he steered through an amendment to existing guidelines for funding from the National Endowment for the Arts, forbidding it to fund "obscene or indecent" material, and thus, it appears, any project depicting homoeroticism.

29. Benn, 'Perfect Body', p. 5.

30. Larson writes, "In Freudian terms, the 'civilized' mind feels a danger in coming too close to the mental furnace, where the primordial heat of raw desire threatens to scorch the sublimated ego." (Kardon, *Robert Mapplethorpe*, p. 15.)

31. Kardon, *Robert Mapplethorpe*, p. 10.

32. Ibid., p. 21.

33. Ellenzweig, *The Homoerotic Photograph*, p. 132.

34. The greater ease of objectification and feminisation of racially other models has already been addressed in chapter 3.

35. Benn, 'Perfect Body', p. 5.

36. Kardon, *Robert Mapplethorpe*, p. 16.

37. As Sarah Kent puts it, Mapplethorpe's nudes affirm that "the perfectly potent male specimen can be found here on earth". (Sarah Kent, 'The Erotic Male Nude', in Sarah Kent and Jacqueline Morreau, eds., *Women's Images of Men* [London: Pandora, 1990], p. 86.)

38. Kobena Mercer, for example, asks whether the fetishism discernible in these images is necessarily a bad thing, since the articulation of ambivalence in his work "can be seen as a subversive deconstruction of the hidden racial and gendered axioms of the nude in dominant traditions of representation" (Kobena Mercer, 'Skin Head Sex Thing: Racial Difference and the Homoerotic Imaginary', in *Competing Glances (New Formations: A Journal of Culture/Theory/Politics)* 16 [1992], p. 7.)

39. An excellent example is provided by the notorious 1980 photograph 'Man in Polyester Suit' (Robert Mapplethorpe, *Black Book* [New York: St. Martin's Press, 1986], p. 55), where a huge uncircumcised black dick—the vernacular seems far more appropriate than "penis"—sticks out from the open fly of a three-piece suit. The model is photographed from the top button of his waistcoat to mid-thigh. The punning reduction of the black man, even in business attire, to his sex depends on knowledge of racist stereotypage, as does what in the photograph appears to be confirmation of the myth of size. If this is so, the photograph is at some level a joke, or satirical comment. But it is also more than that; its "placement in the book encourages us to read that as an interrogated practice . . . " (Yingling, 'How the Eye is Caste', pp. 21–2.)

40. Mercer refers to the mutual identification between artist and models when he concludes, " . . . it becomes possible to reverse the reading of racial fetishism in Mapplethorpe's work not as a repetition of racist fantasies but as a deconstructive

strategy which lays bare psychic and social relations of ambivalence in the representation of race and sexuality." (Mercer, 'Skin Head Sex Thing', pp. 10–11.)

41. Jane M. Gaines states, " . . . I don't see that Mapplethorpe's images have anything to do with miscegenation, with black seed spilling in white wombs. But I do think that they have already had to do with arousal, awakening, and yearning, even for women who would not know what to do with these bodies if they had them." (Jane M. Gaines, 'Competing Glances: Who Is Reading Robert Mapplethorpe's *Black Book*', *Competing Glances [New Formations: A Journal of Culture/Theory/Politics]* 16 [1992], p. 39.)

42. Mapplethorpe's *Black Book* abounds with photographs which fragment body parts. Derrick Cross (p. 2) becomes only buttocks and thighs. Charles Bowman (p. 3) is pictured from just above his nipples down to his pubic hair and upper thighs. Dan (p. 14) is a rear view from just behind the ears down close to his knee, his buttocks offering a glimpse of scrotum between his parted thighs. Only the hands and cock of the Man in Polyester Suit (p. 55) are visible.

43. Thus, Isaiah (p. 23) has the look that betokens 'savage', or, more generously, 'noble savage', thanks partly to the leopard skin over his right shoulder and his holding what looks like a bamboo spear. Ron Simms (p. 25) displays what seem like impressive genitals, albeit in repose; as do Jimmy Freeman (p. 27) and Tom (pp. 82–3). One of his untitled photographs (p. 54) features what looks like a KKK-type victim, wearing a hood to his neck, and then frontally nude to mid thigh.

44. Kobena Mercer puts the case thus: "[Mapplethorpe] appropriates elements of commonplace racial stereotypes to prop-up, regulate, organise and *fix* the aesthetic reduction of the black man's flesh to a visual surface charged and burdened with the task of servicing a white male desire to look and, more importantly, assert mastery and power over the looked-at." (Kobena Mercer, 'Imaging the Black Man's Sex', in Rowena Chapman and Jonathan Rutherford, *Male Order: Unwrapping Masculinity* [London: Lawrence and Wishart, 1988], p. 145.) Evidence of the claimed burden could be found in Bob Love's (pp. 12–13) apparently guarded look into the camera, Gregg Cauley's (p. 21) seemingly shy look, Dennis Speight's (pp. 40–41) submissive look. It might also be suggested as an explanation for the way that a number of models do not quite offer a direct look at the lens but slightly to one side of it; thus, Jeff Gray's eyes (p. 16) focus just to the right of the photographer, it seems, while Donald Cann (p. 28) and Michael Hall (p. 32) again look slightly to his right. Dennis Morgan (p. 17) looks downwards, as if relegated to silence, despite the left hand held up as though he were making a conversational point. Milton Moore (p. 48), in sailor uniform, keeps his eyes front but does not engage with the look of the camera. Terrence Mason (p. 63) has his right profile to the camera, but his eye moves suspiciously, it seems, round to attempt a look into the lens. Rory Bernal's (p. 31) eyes are closed.

45. Much has been made of Mapplethorpe's achievement of high-art status in the matter of whether or not he is vulnerable to a charge of racism.

46. See Gaines, 'Competing Glances', p. 26.

47. Mulvey, *Visual and Other Pleasures*, pp. 14–26.

48. This argument has been coupled with the evidence of male hostility to him during his lifetime.

49. Miriam Hansen asks, "How could millions of women have indulged in such

specifically male perversions?" and concludes, "Such exhibitionism, given the mechanisms of the apparatus, cannot escape fetishisation: the male body, in its entire beauty, assumes the function of a phallic substitute." (Miriam Hansen, 'Pleasure, Ambivalence, Identification: Valentino and Female Spectatorship', in Christine Gledhill, ed., *Stardom: Industry of Desire* [London: Routledge, 1991], pp. 276–77.) Gaylyn Studlar's contention that Valentino was merely a successor to such arousers of women as Francis X. Bushman, Lou Tellegen and Maurice Costello serves to augment the strong prima facie case for the recognition of a specifically female pleasure in voyeurism and fetishisation of male stars (Gaylyn Studlar, 'Discourses of Gender and Ethnicity: The Construction and De(con)struction of Rudolph Valentino as Other', *Film Criticism*, vol. 3, no. 2 [1989], p. 21.)

50. Richard Dyer, '*The Son of the Sheik*', *The Movie* 126, p. 2512 (his emphasis). The same writer alerts us to the possibility of the introduction of a representation of female desire by the convention of the iris, so that the desire is made more spiritual and distant (Dyer, *Heavenly Bodies*, p. 114).

51. Valentino's alleged encouragement to effeminacy was blamed for the installation of a pink powder machine in a men's lavatory on Chicago's North side.

52. See Studlar, 'Discourses of Gender and Ethnicity', p. 21.

53. Ibid., p. 23. An example, more than a description, of the operations of the alibiing of the erotic by exploitation of the exotic is discoverable in Donald Spoto: "Rudolph Valentino's intense attitudinising wasn't really an appeal of any kind at all; it was a *demand*, an emotional if not actual rape that only florid exoticism kept from appearing as ridiculous as it actually was" (Donald Spoto, *Camerado: Hollywood and the American Man* [New York: Plume, 1978], p. 50).

54. "Valentino not only inaugurated an explicitly sexual discourse on male beauty, but he also undercut standards of instrumental rationality that were culturally associated with masculine behaviour; his resistance to expectations of everyday pragmatism, his swerving from the matter-of-fact and reasonable, may after all account for his subterranean popularity with male movie-goers, whether homosexual or heterosexual." (Hansen, 'Pleasure, Ambivalence, Identification', p. 275)

55. Studlar, 'Valentino, "Optic Intoxication," and Dance Madness', p. 27.

56. He had most appeal, presumably, to those who "were caught between the hopes fanned by the phantasmagoria of consumption and an awareness of the impossibility of realising them within existing social and sexual structures" (Hansen, *Babel and Babylon*, p. 268).

57. Hansen describes the ambivalence of the look at and from Valentino well. "The power of Valentino's gaze depends upon its weakness—enhanced by the fact that he was actually nearsighted and cross-eyed—upon its oscillating between active and passive, between object and ego libido. The erotic appeal of the Valentinian gaze, staged as a look within a look, is one of reciprocity and ambivalence, rather than mastery and objectification" (Hansen, 'Pleasure, Ambivalence, Identification', p. 265).

58. Ibid.

59. Gabe Essoe, *Tarzan of the Movies: A Pictorial History of More than Fifty Years of Edgar Rice Burroughs' Legendary Hero* (Secaucus, N.J.: Citadel, 1968), p. 74.

60. Pat Kirkham and Janet Thumim write of it that it "is slit to the waist at the side

thus elongating his already long legs and further objectifying them, and him" (Pat Kirkham and Janet Thumim, eds., *You Tarzan: Masculinity, Movies and Men* [London: Lawrence and Wishart, 1993], p. 130).

61. See Essoe, *Tarzan of the Movies*, p. 68.

62. One enthusiast said of him, "With his flowing hair, his magnificently proportioned body, his catlike walk, and his virtuosity in the water, you could hardly ask anything more in the way of perfection" (Essoe, *Tarzan of the Movies*, p. 73).

63. "The male physique, displayed to its full classical perfection in the bodies of swimmers such as Johnny Weissmuller, was now [in the 1930s] thought worthy of celebration" (Roger Tredre, 'The Great Smell of Marketing', *Independent* 1 March 1993, p. 14).

64. Yvonne Tasker, *Spectacular Bodies: Gender, Genre and the Action Cinema* (London, Routledge, 1993), p. 2.

65. Gabe Essoe records his disappointment that Frank Merrill's "superb physique"— he was the second runner-up for the title of 'World's Most Perfectly Developed Man'— was covered more than adequately by leopard skins; since it was more impressive than any of the other Tarzans in silent movies, it "should have been" displayed (Essoe, *Tarzan of the Movies*, p. 61). William S. Van Dyke stated that the most important requirement of a Tarzan was "a good physique" (Essoe, *Tarzan of the Movies*, p. 67). Margaret Hartford of the *Los Angeles Times* wrote of Mike Henry that he made a "handsome, rather humourless Tarzan who looks fine in a loincloth. Muscular as all get-out" (Essoe, *Tarzan of the Movies*, p. 186).

66. Lex Barker said, "If my muscles hold up and my waistline keeps down, I can play Tarzan till I'm fifty." (Essoe, *Tarzan of the Movies*, p. 130) He is reported to have been offered the role entirely on his physical attributes, the director exlaiming, "Well, where have you been hiding?" (Essoe, *Tarzan of the Movies*, p. 127).

67. Dyer, *Heavenly Bodies*, p. 118.

68. Perhaps these conventions are what encourage Ellenzweig to claim the Weissmuller portrait as part of a "homoerotic" tradition. (Ellenzweig, *The Homoerotic Photograph*, p. 92)

69. Dyer, *Heavenly Bodies*, p. 113.

70. Ibid., p. 118.

71. This claimed tendency is even more marked in Marlon Brando's 1950s persona. When he plays the no-hope boxer of *On the Waterfront*, he constantly surprises (and eventually seduces) the Eva Marie Saint character by unexpectedly 'feminine' uncertainty and shyness. The sequence of that film where, while he talks with her in the park, he plays with and then tries on her glove, illuminates the tough-but-tender aspects of his conception of his character. Terry is one of the most remarkably eroticised heroes of 1950s Hollywood, especially in a narrative and setting which do not obviously allow for the possibility of feminisation.

72. *Rebel Without a Cause* promises a better version of adulthood for him and for the Natalie Wood character now that they have played the part of more loving, nurturing parents to him than the Sal Mineo character's actual mother.

73. See, for example, Ellenzweig, *The Homoerotic Photograph*, p. 123.

74. See the discussion of star and biographical work on him in Kenneth MacKinnon,

The Politics of Popular Representation: Reagan, Thatcher, AIDS, and the Movies (Cranbury, N.J., and London: Associated University Presses, 1992), pp.180–86.

75. Richard Meyer, 'Rock Hudson's Body', in Diana Fuss, ed., *Inside/Out: Lesbian Theories, Gay Theories* (London: Routledge, 1991).

76. Meyer's emphasis.

77. Meyer, 'Rock Hudson's Body', p. 261.

78. Meyer's emphasis.

79. This parallels a point that the present writer has tried to argue in the unpublished area of letters to 'experts' on Hudson—that it is not *in spite of* but *because of* his refusal to deliver what could be seen as the masculine goods which he gives every appearance of possessing, that it is because he looks the part of masculine lover but does not deliver proof, that he is such an excellent romantic figure, the essence of romance being, arguably, in the deferment of realisation.

80. The several rear-nude scenes in which Alan Bates has appeared—in, for example, *Georgy Girl* and *The Fixer*—suggest that this might be a productive undertaking where Bates at least is concerned.

81. That the outcome is not so clearcut in the event does not invalidate the point.

82. The female gaze of *American Gigolo* is less literally impossible than that of *Magnificent Obsession*, all the same.

83. Judith Williamson, *Deadline at Dawn: Film Criticism 1980-1990* (London: Marion Boyars, 1993), p. 280.

84. When his grandmother is confronted with him and he exhibits himself to her mock-erotically, she retreats in confusion.

85. Quentin Tarantino's recent insistence on taking Travolta seriously is not particularly daring, since Travolta was given a manifestly serious part by Brian De Palma in *Blow Out*. Perhaps, though, Tarantino's faith is worthy of declaration in light of the *Look Who's Talking* series.

86. Clever use is made of that aspect in *Deliverance*. The Boorman film's daring does not extend to making the Reynolds character one of the victims of rape, though.

87. Or perhaps the joke claim is yet another form of alibi for male eroticisation, a fallback position from which the editors can claim, in the face of outrage or disgust, that they never expected to be taken seriously. The unlikely juxtaposition of 'masculine' hairy-chested male and 'naughty' pose underlines the culturally demanded feminisation of the eroticised male.

88. Sean Connery continues to be a sex symbol—whose buttocks were (not incongruously) bared in *Robin and Marian* and *The Man Who Would Be King*—but embodies a very different version of it today from that of the James Bond epoch.

89. Ellenzweig, *The Homoerotic Photograph*, p. 138.

90. Barbara Creed, 'From Here to Modernity: Feminism and Postmodernism', *Screen*, vol. 28, no. 2 (1987), p. 65.

91. His ostensible attempt, in 1993's *Last Action Hero*, to uncouple himself from the generic trappings through which he arrived at and maintained star status seems less sure-footed in career terms.

92. He is naked in the nocturnal streets of Los Angeles. The teenagers who first see him ridicule him and see him as a potential victim, unimpressed as yet with the power

that his muscles might be expected to announce.

93. Tasker, *Spectacular Bodies*, p. 1.

94. In this connection, 1993's *Cliffhanger* looks like a reaffirmation of Stallone's virility, but its self-consciousness as genre piece is indicated by the title alone.

95. Paul Smith, *Clint Eastwood: A Cultural Production* (London: UCL Press, 1993), pp. 151, 153.

96. Smith, *Clint Eastwood*, p. 160.

97. As with many television personalities, it seems difficult for fans to draw a distinct line between successful series characters and the actors who play them. This is particularly true of actors who gain popularity in television soaps which may run for decades. One of the reasons why actor William Roache had difficulty in combating through the courts suggestions of dullness must be that he has played schoolteacher Ken Barlow (he has not always remained a teacher during the series' run, though) since *Coronation Street*'s early days. The vicissitudes of his love life may have been written into the script more recently as the soap's own attempt to keep at bay any associations of Ken with dull dependability, and he has now been retired from the teaching profession.

98. Sandy Flitterman, 'Thighs and Whiskers: The Fascination of "Magnum, P.I."', *Screen*, vol. 26, no. 2 (1985), p. 43. Further citations from this source are noted parenthetically in this paragraph and the two that follow.

99. This is not to argue that the claims involved with Selleck's outing are true. Rather, the stance is to hold back from judgement on the matter and to note simply that questions have been raised, which in turn suggests that reading Selleck is not the simple matter that Sandy Flitterman would have it. Apart from the question of the facts, it is entirely possible that the unproblematic-seeming feminisation of Magnum has had unforeseen effects on Selleck's image. Secondly, this is not to argue that the erotic pleasures offered by Hudson or Selleck are jeopardised by imagined knowledge or rumours about what are taken to be the stars' actual sexualities. It has been argued in this chapter that the potency of Hudson's romantic-hero qualities has much to do with deferment of any kind of performance. Unlike Schwarzenegger or Stallone, Hudson's Sirk characters and Selleck's Magnum have never felt the need to "perform the masculine".

100. Scott Benjamin King, 'Sonny's Virtues: The Gender Negotiations of *Miami Vice*', *Screen*, vol. 31, no. 3 (1990), p. 286. Further citations from this source are noted parenthetically in the two paragraphs that follow.

101. A succinct illustration of the process is afforded by King's suggestion that the heterosexual male viewer says "nice shot" instead of "cute guy" (p. 285).

102. But is "designer stubble" read straightforwardly as masculine or as a sign of masculinity and therefore easily available to a deconstruction which may provide a different reading of it?

103. At this point, it is tempting to ask of Sandy Flitterman whether Magnum's prohibited romances with female characters are entirely consistent with what she takes to be his untroubled masculinity, or whether masochism is not a concept that may be invoked in that context too.

104. It is interesting to compare King's article with Lynne Joyrich's essay entitled 'Critical and Textual Hypermasculinity'. She sees the once female power over the

masquerade as being given to Crockett and Tubbs in that they "display themselves as criminals in order to lure their prey into captivity"; again, through their advertising and fashion images, it is the males who masquerade rather than the female characters (p. 167). Joyrich sees the conventional terms of sexual difference as displaced on to racial difference in this partnership (p. 168). She concludes challengingly, "In a medium in which the familial is the dominant theme as well as mode of address, this is the final irony that cannot yet be explained by current theories of sexual and textual difference—the masculine threat that lurks 'within the gates' of a medium deemed feminine." (p. 169)

105. See Barbara Ehrenreich et al., *Re-Making Love: The Feminization of Sex* (London: Fontana, 1987), pp. 11–12.

106. Ehrenreich et al , *Re-Making Love*, pp. 18–19.

107. Fabian later modelled nude for *Playgirl*, making his association with a brand of wholesome, country-boy eroticism more explicit.

108. Avalon's highly parodic performance of 'Beauty School Dropout' in the film of *Grease* makes him a very evident object of the diegetic female gaze. This encourages a retroactive reading in eroticised terms of his performances in the days in which *Grease* is set.

109. Rydell's attributes of sweet passivity and youthfulness are important ingredients for his success. His small-town boyish innocence is sharply contrasted with the overtly sexual, big-city posturing of the fictitious pop star Conrad Birdie in the 1963 musical *Bye Bye Birdie*.

110. Another factor contributing to this disguise may be the association of rhythm and blues itself with 'Blackness'.

111. In middle age, Richard is still sold as eternally youthful by reference to his allegedly Peter Pan qualities. His association with Mary Whitehouse and the Festival of Light, with their emphasis on purity, together with his highly public declaration of religious conviction, makes his image more similar to Pat Boone's than may at first appear. Given his long history, it may be interesting to recall that he was first marketed as a highly sexy British version of Presley. In one 1950s film, *Expresso Bongo*, his singing of 'The Shrine on the Second Floor' flanked by choirboys was a wickedly satirical exposure of the cynical manipulation of his active/passive rock image of raw sex within the diegesis. In his first film, the non-musical *Serious Charge*, assertively young and working-class Richard is taken to have inspired homosexual lust in the local vicar.

112. Suzanne Moore, 'Here's Looking at You, Kid!', in Lorraine Gamman and Margaret Marshment, eds., *The Female Gaze: Women as Viewers of Popular Culture* (London: The Women's Press, 1988), p. 55.

113. Joseph Bristow, 'How Men Are Speaking of Masculinity', *New Formations* 6 (1988), p. 120.

114. Ibid.

115. Ibid.

116. The lyrics of rap have been explored in the 1990s for their allegedly strongly misogynist and homophobic content. Rap, whatever the lyrics, tends to be popularly associated with an aggressive and therefore 'masculine' posture, whatever the actual gender of the rapper.

117. Hence, his reported distaste, very much in the Samantha Fox manner, to be known merely for having a great body (William Leith, 'Of Mucles and Men', *Independent on Sunday*, 13 December 1992, p. 22).

118. In 1994, an apparently illicit and unreleased photograph of the frontally naked Marky Mark was reportedly circulated in the United States via fax machines. Information about the star's anger at this unlicensed use of his body as homoerotic stimulus were also circulated in the gay press. Similar objection to his being seen as just a body was voiced by Marky Mark on Channel 4's *The Word*.

chapter 5

1. It may not be coincidental that, when advertising is the subject, the words "probably the most . . . " should so quickly suggest themselves!

2. Jonathan Rutherford says of it, "It's an image that reflects a culture of sexual diversity, one that traditional masculinities have vehemently denied. But because heterosexual men repress our own homoerotic desires we fetishise gay men" (Jonathan Rutherford, 'Who's That Man?', in Rowena Chapman and Jonathan Rutherford, *Male Order: Unwrapping Masculinity* [London: Lawrence and Wishart, 1988], p. 59).

3. Frank Mort says of the close-up "on bum, torso, crotch and thighs" that it "follows standard techniques of the sexual display of women in advertising over the last forty years" (Frank Mort, 'Boy's Own? Masculinity, Style and Popular Culture', in Chapman and Rutherford, *Male Order*, p. 201).

4. It is still true in 1994. That year, a Levi 501s commercial had the young daughters of a Puritan family slipping away from the communal meal in what appears to be the American wilderness to spy on a young man bathing in the river, apparently but not actually naked. His stride past them without awareness, or at least acknowledgment, of their nervous but curious looks augments a tradition whereby the male object does not assent to objectification. Another tradition, whereby it is the youthful male who is most available for eroticisation, is confirmed here by the viewers' disappointment that the man who has shucked off his jeans at the riverside is older than the hunk first sighted by them.

5. " . . . Weber's sybaritic idylls involving men and women of heroic Greek proportions are denatured to such an extent that their pornographic potential is largely neutralised . . . We are . . . invited to participate in a magnetic dance, in which our attraction to the images' physical density reciprocates with a repulsion brought on by their hyperreality" (Andy Grundberg, *Images of Desire: Portrayals in Recent Advertising Photography* [Philadelphia: Goldie Paley Gallery, Moore College of Art and Design, 1989], p. 9).

6. Judith Gaines, 'The "Beefcake Years": More and More Ads Are Baring Men's Bodies', *Philadelphia Inquirer*, 17 October 1993, p. K5.

7. He publicly agreed with Shabba Ranks on Channel 4's *The Word* that homosexual men should be crucified. He also appears to have a police record for harassing black schoolchildren and to have served a prison term for assaulting a Vietnamese American ('Calvin Clean', *Independent on Sunday*, 13 March 1994, p. 34).

8. Lisa Steele doubts, however, whether the sexual objectification of male models

represents the sort of equality that feminists might have wanted. Also, her examination of the so-called mirror advertisements suggests that there is a quite asymmetrical effect relating to gender. Gender difference is highlighted so as to "reinforce the very traditions of male dominance" (Lisa Steele, 'A Capital Idea: Gendering in the Mass Media', in Varda Burstyn, ed., *Women Against Censorship* [Vancouver: Douglas and McIntyre, 1985], p. 66).

9. Allen Ellenzweig, *The Homoerotic Photograph: Male Images from Durieu/Delacroix to Mapplethorpe* (New York: Columbia University Press, 1992), p. 163.

10. Richard Dyer thinks of the new underwear as "playfully sexy" in that when humour and irony are employed they are adjuncts to, not the traditional deflaters of, sexiness (Richard Dyer, *The Matter of Images: Essays on Representations* [London: Routledge, 1993], p. 125).

11. Adam Thorburn, quoted in Judith Gaines, 'The "Beefcake Years": More and More Ads Are Baring Men's Bodies', *Philadelphia Inquirer*, 17 October 1993, p. K5. Gary Day interprets the use of muscularity in advertising differently, believing that consumer society's concern with surface rather than depth requires more of appearance, so that there has to be compensation—just as the texture of certain products, so the richness, roundness and completeness of muscular curvature provide that compensation. (Gary Day, 'Pose for Thought: Body-Building and Other Matters', in Gary Day, ed., *Readings in Popular Culture: Trivial Pursuits?* [London: Macmillan, 1990], pp. 49–50)

12. "In a parody of a stripper sequence, the camera follows the belt-line up the legs, moves round to the back as he buckles his crotch, and then circles toward the abdomen as he pulls on a snug white T-shirt. The stripper music heats up until, suddenly, a cascade of liquid softener gushes into a Fab detergent container. The guy finishes his routine with a quick pelvic thrust to the music" (Andrew Sullivan, 'Flogging Underwear: The New Raunchiness of American Advertising', *New Republic*, 18 January 1988, p. 20).

13. This is certainly Sullivan's belief (ibid.).

14. Barbara Lippert, advertising critic for *Adweek*, believes that there is an element of revenge, which she calls "post-feminist fallout", in the reduction of men to bimbos. (ibid.).

15. Sullivan, 'Flogging Underwear', p. 22.

16. Andrew Sullivan refuses to credit this. He believes that the advertisements are gay in appeal—"the marketing that dare not speak its name". (Sullivan, 'Flogging Underwear', p. 20.)

17. Paul Rodriguez, art director of the Athena chain, says, "The public want pictures of half-naked men—but all done in the best possible taste! We've played down the macho thing, the men are more passive, there's nothing aggressive" (Brian Kennedy and John Lyttle, 'Wolf in Chic Clothing', *City Limits*, 4–11 December 1986, p. 16).

18. "This distance provides the space for the spectator to insert her/himself into the fantasy scenario evoked by many of these representations as the male is marked out as an erotic object" (Suzanne Moore, 'Here's Looking at You, Kid!', in Lorraine Gamman and Margaret Marshment, eds., *The Female Gaze: Women as Viewers of Popular Culture* [London: The Women's Press, 1988], p.54).

19. "The model disavows his passivity through his aggressive look, through demonstrating that he still has control over definitions of who he is" (Rutherford, 'Who's That Man?', p. 32).

20. Kennedy and Lyttle add to this explanation the suggestion that the social changes encouraged under Thatcherism produced an upwardly mobile middle class which adopted New Manism from an American yuppie seedbed (Kennedy and Lyttle, 'Wolf in Chic Clothing', p. 17).

21. "Those eyes at once judge and condone. But above all they also provide a crucial heterosexual cover, both for him and for us" (Andrew Wernick, 'From Voyeur to Narcissist: Imaging Men in Contemporary Advertising', in Michael Kaufman, ed., *Beyond Patriarchy: Essays by Men on Pleasure, Power, and Change* [Don Mills, Ontario: Oxford University Press, 1987], p. 292).

22. Rowena Chapman, 'The Great Pretender: Variations on the New Man Theme', in Chapman and Rutherford, *Male Order*, p. 228.

23. "The freedom to stand outside conventional masculinity is very often a freedom symbolising confidence and power—a freedom society tolerates easily in men but punishes in women." He believes that a precondition for men's changing of themselves is "some space to debate the issue themselves, rather than insisting they conform to a pre-timetabled feminist agenda" (Frank Mort, 'Images Change: High Street Style and the New Man', *New Socialist*, November 1986).

24. We might add, " . . . or positionality in specular relations".

25. Judith Williamson, *Consuming Passions: The Dynamics of Popular Culture* (London: Marion Boyars, 1986), pp. 53–54.

26. Andrew Wernick puts this as follows: "Besides the persistence of inequalities between the sexes themselves, class differences and the status hierarchies based on them crucially mediate the search for personal satisfaction and ties, so that the whole process becomes (or remains) deeply enmeshed in the more general scramble for wealth, power, and status" (Wernick, 'From Voyeur to Narcissist', p. 295).

27. "Even when it appears that ads are producing a *new* representation . . . not merely reproducing an idea of femininity found elsewhere, the signification is not completely autonomous but anchored by the patriarchal and capitalist relations in which we as individuals already have a history and which we already know about" (Janice Winship, 'Sexuality for Sale', in Stuart Hall et al., eds., *Culture, Media, Language* [London: University of Birmingham, 1980], p. 218).

28. For the present, there is no attempt to interpret whether or not it is paranoid to deem one effect of this to be a threat to women's social place by means of fantasies of displacing them altogether.

29. Indeed, the 1950s songs that accompany some of the Levi 501s advertisements would tend to suggest that the eroticised male is meant to be taken as harking back to a simpler time, rather than pointing forward to a period of sexual equality.

30. Judith Williamson, *Decoding Advertisements: Ideology and Meaning in Advertising* (London: Marion Boyars, 1978), p. 81.

31. By Frank Mort, for example (Mort, 'Boy's Own?').

32. Rutherford, 'Who's That Man?', p. 38.

33. Sean Nixon describes Petri's fashion and its assertion of muscular toughess in

terms partly of its connection with 1950s body-building and boxing portraits (Sean Nixon, 'Distinguishing Looks: Masculinities, the Visual and Men's Magazines', in Victoria Harwood et al., eds., *Pleasure Principles: Politics, Sexuality and Ethics* [London: Lawrence and Wishart, 1993], p. 58). This helps to make further sense of the harking-back messages of the retro soundtracks in some of the most famous commercials of the period, alluded to in the previous section.

34. Jonathan Rutherford remarks, "Men's anti-sexist politics was superseded by a more personalised, depoliticised concern with men's roles and emotions" (Rutherford, 'Who's That Man?', p. 41).

35. Rutherford's term, in Rutherford, 'Who's That Man?', p. 39.

36. For fuller discussion of Petri, the Buffalo trademark with which he was associated and the masculine vocabulary which it established, see Nixon, 'Distinguishing Looks'.

37. Eamonn J. McCabe, quoted in Martin Raymond, 'Boys on Film', *Girl About Town*, 16 February 1987, n.p. Bruce Hulse was reported as "over 40" in 1992 (Anita Chaudhuri, 'Homme Sweet Homme', *Time Out*, 11–18 March 1992, p. 28).

38. Raymond, 'Boys on Film', n.p.

39. Ibid. Ross claims that many magazines simply will not use black models.

40. Nixon, 'Distinguishing Looks', p. 58.

41. Chaudhuri, 'Homme Sweet Homme', p. 28.

42. Right Said Fred's song 'I'm Too Sexy', in its allusions to the catwalk, comments satirically on the sort of narcissism promoted and celebrated by the male model cult.

43. "This styling draws attention to the construction of a 'look', to the process of 'bricolage'" (Nixon , 'Distinguishing Looks', p. 60).

44. Stuart Hall and Martin Jacques, *New Times: The Changing Face of Politics in the 1990s* (London: Lawrence and Wishart, 1989), p. 131. Lynne Joyrich is less sanguine, since the tactic of the masquerade has thereby been wrested from women and made available to men (Lynne Joyrich, 'Critical and Textual Hypermasculinity', in Patricia Mellencamp, ed., *Logics of Television: Essays in Cultural Criticism* [Bloomington and London: Indiana University Press, NBFI Publishing, 1990], pp. 166–67).

45. "At its most interesting, what came out of these [1980s men's] stylings was less of an assertion of an 'essential', true masculinity than acts of play with the signs of maleness" (Sean Nixon, 'Have You Got The Look? Masculinities and Shopping Spectacle', in Rob Shields, ed., *Lifestyle Shopping: The Subject of Consumption* [London: Routledge, 1992], p. 162).

46. This has been known in 'gay' dress codes for far longer than the 1980s.

47. "Posed usually alone, their gaze is often focused downwards or side-ways out of the frame, registering self-reflection and . . . a hint of melancholy" (Nixon , 'Distinguishing Looks', p. 61). Importantly, these poses are not directed to an imagined female spectator, not alibied by this means in the way that so much male erotica could be argued to be.

48. To complicate this even further, it then has to be asked, presumably, why that look and not another appeals to the particular individual who, although he has a range of identities to try on, goes for that particular kind.

49. Nixon, 'Have You Got The Look?', p.: 164.

50. Mort, 'Boy's Own?', p. 204.

51. Despite the reappearance of 'City' in the institution's name, there is no intention here to suggest that its students are men and women of the City.

52. See Peter Baker, 'Exposing the Shape of Things to Come', *Guardian*, 26 May 1992.

53. Ibid.

54. This, of course, raises questions about the exact definition of 'grooming'.

55. The figure quoted for 1993 is £469 million.

56. All statistics in this paragraph come from Roger Tredre, 'The Great Smell of Marketing', *Independent*, 1 March 1993, p. 14.

57. "In the Nineties, *every* man is a New Man, ready to pamper himself with new shaving gels, aftershave gels, and clear gel anti-perspirants . . . " (ibid.).

58. Judith Lynne Hanna, *Dance, Sex, and Gender: Signs of Identity, Dominance, Defiance, and Desire* (Chicago: University of Chicago Press, 1988), p. 217.

59. Marcia Siegel says of Eliot Field's *The Gods Amused*: 'these gods disport themselves by running and leaping back and forth, and impersonally admiring each other" (Hanna, *Dance, Sex, and Gender*, p. 194).

60. Mark Finch, 'Sex and Address in *Dynasty*', *Screen*, vol. 27, no. 6 (1986), p. 27.

61. Thus, for example, in BBC1's *EastEnders* Grant, Phil, Mark, Ricky and Sanjay have been recently offered to the viewing public in undergear appropriate to first-thing-in-the-morning scenes. If there is any reaction to the undress from the other (often female) characters in the scene, it is usually one of scornful laughter. Ambivalence about male objectification has a long tradition in British popular culture.

62. See Richard Corliss, 'Sex Stars of the 70s', *Film Comment*, vol. 15, no. 4 (1979). The title of this article, whatever its irony, 'Sex Stars of the 70s', indicates its awareness of dealing in a species of the erotic.

63. Ibid., p. 27.

64. Corliss, 'Sex Stars of the 70s', p. 28.

65. Ibid., p. 29.

66. Alasdair Foster sees the medium of the comic as one of those which offers naive reaffirmation of phallic masculinity. (Alasdair Foster, 'Men in Print: Popular Images of the Male Body in the 20th Century part three: Getting Physical', *Gay Scotland*, vol. 33, no.3 [1987], p. 9)

67. Peter Middleton, *The Inward Gaze: Masculinity and Subjectivity in Modern Culture* (London and New York: Routledge, 1992), p. 34.

68. Middleton, *The Inward Gaze*, p. 32.

69. Ibid., p.: 34.

70. Steve Neale, 'Masculinity as Spectacle: Reflections on Men and Mainstream Cinema', *Screen*, vol. 24, no. 6 (1983).

71. Middleton, *The Inward Gaze*, p. 32.

72. Brian Lumley, *Necroscope* (Westlake Village, Cal.: Malibu Comics, 1992), pp. 5, 7.

73. Lumley, *Necroscope*, p. 13.

74. Original emphasis.

75. Pat Mills and Tony Skinner, *Accident Man* (Leicester: Apocalypse, 1991).

76. "She's really pretty. Pretty stupid," he remarks of her to the reader.

77. "The women's *Green Movement* . . . that's what split us up. When she met *Hilary*"

(Both emphases original).

78. When a couple are drawn in *Necroscope* as 'making out', the female has her hand down the front of the male's jeans.

79. Andy Lanning et al., *Digitek* (London: Marvel Comics, 1992).

80. Peter Milligan and Tom Mandrake, *Detective Comics* (New York: DC Comics, 1991).

81. Middleton, *The Inward Gaze*, p. 31. Public censoriousness in the 1960s seemed more concerned about Robin's penile bulge than Batman's in American TV's Batman series. That focus would be unlikely if there were not a (scarcely acknowledged) awareness of the eroticism in visuals and situations of Batman.

chapter 6

1. Impatience is expressed in some of the anti-pornography writing with what is termed academic insistence on a workable definition, as if objections to the vagueness of the term 'pornography' constituted an unreasonable block on the necessary work of anti-pornography legislation, as if academics must always be fellow-travellers with the pornography industry, whether so-called or self-styled. Female academics seeking a definition are sometimes viewed as having taken on a male set of values in even raising the question. "We know it when we see it", on the other hand, is hardly safe grounds for serious discussion, let alone legislation.

2. There might be more mileage in arguing that voyeurism—all examples of it—is, by some psychoanalytic criteria, perverse. But, if so, it is still a majority perversion!

3. The gaze is usually written about as male, but it is clear that biologically female spectators of Hollywood narrative cinema may be taken to gaze in a male way, and to have learned masculinisation as a social habit (Mulvey, *Visual and Other Pleasures*, pp. 29–38). If there is any such thing as a female gaze, the question is prompted whether that gaze is open to male-gendered spectators too.

4. I have already attempted an overview of debates—Right, liberal and feminist—concerning pornography, but this hardly touched on the attempt to create female subjectivities (Kenneth MacKinnon, *Misogyny in the Movies: The De Palma Question* [Cranbury, N.J. and London: Associated University Presses, 1990], pp. 76–102).

5. 'Men-alone' video sales and rentals amounted to 40 per cent of the totality of erotic films; this percentage should be set beside 29 per cent for male/female couples, 13 per cent for male/male, 3 per cent for female/female and 15 per cent for 'women-alone' videos (statistics from John Patrick, ed., *The Best of the Superstars 1992: The Year in Sex* [Sarasota, Fl.: STARbooks Press, 1992], p. 97).

6. Patrick, ed., *The Best of the Superstars*, p. 97.

7. Barbara Ehrenreich et al., *Re-Making Love: The Feminization of Sex* (London: Fontana, 1987), p. 115.

8. See Myrna Kostash, 'Second Thoughts', in Varda Burstyn, ed., *Women Against Censorship* (Vancouver: Douglas and McIntyre, 1985), p. 36. Andrew Ross adds the information, "Cable programmers . . . report that most single women choose to pay extra for the adult entertainment option in a cable package" (Andrew Ross, *No Respect: Intellectuals and Popular Culture* [London: Routledge, 1989], p. 173).

9. Linda Williams, *Hard Core: Power, Pleasure and the 'Frenzy of the Visible'* (London: Pandora, 1990), p. 231.

10. The interpretation of the data may not be as straightforward as it appears. Women could rent porn as a favour to male partners, for instance; the 85 per cent who had seen at least one porn film might not have particularly liked it. Nevertheless, it is difficult to argue away the percentages in their entireties as distortions and exaggerations of what is basically being claimed.

11. Williams, *Hard Core*, p. 6.

12. Alison Assiter and Avedon Carol, eds., *Bad Girls and Dirty Pictures: The Challenge to Reclaim Feminism* (London: Pluto, 1993), p. 15.

13. Thus, Sara Diamond suggests that "the greater general visibility and acceptability of sexual imagery reflects not only the backlash against women but also real gains by the women's and gay movements in making sexuality an area of more open and explicit discussion and depiction" (Sara Diamond, 'Pornography: Image and Reality', in Varda Burstyn, ed., *Women Against Censorship* [Vancouver: Douglas and McIntyre, 1985], p. 48).

14. This is based on an identification of pornography with the dominant culture. However, the relation of pornography, which in many ways is kept out of sight, with dominance needs to be addressed more rigorously.

15. See Ross, *No Respect*, p. 175.

16. The exposure which the arguments have received on television, for example, would suggest that the assumptions about the direct and predictable relation of fantasy to actuality are accepted by many non-academics and that the arguments against the more popularised notion of pornography's harms need therefore to be heard as widely, if there is to be a democratisation of the debate. Andrew Ross makes a highly interesting point when he draws attention to the similarities between Cold War liberal critiques of mass culture and anti-pornography arguments from some quarters of feminism: "Both share a picture of a monolithic culture of standardised production and standardised effects, and of normalised brutality, whether within the mind or against the body"; then again, "The charge of propagandism is repeated, and the renewed use of the rhetoric of protection and reform has sustained the privilege of intellectuals to 'know what's good' for others" (Ross, *No Respect*, p. 176).

17. Judith Butler, 'The Force of Fantasy: Feminism, Mapplethorpe, and Discursive Excess', *differences: A Journal of Feminist Cultural Studies*, vol. 2, no. 2 (1990), p. 106.

18. Ibid. Even if fantasy adjudged politically incorrect did produce, was not merely produced by, some of the incorrectness of patriarchy, another problem would be that fantasy cannot simply be corrected, as if it were amenable to conscious control and not rooted in subconscious patterns originating in childhood.

19. Liz Kotz, 'Complicity: Women Artists Investigating Masculinity', in Pamela Church Gibson and Roma Gibson, eds., *Dirty Looks: Women, Pornography, Power* (London: British Film Institute, 1993) p. 104.

20. Catharine MacKinnon, 'Feminism, Marxism, Method, and the State: Toward Feminist Jurisprudence', *Signs*, vol. 8, no. 4 (1983), p. 647.

21. See Angela Carter, 'A Well-Hung Hang-Up', in Paul Barker, ed., *Arts in Society* (London: Fontana, 1977), p. 75.

22. Thus, Sara Diamond states, " . . . we have learned that to engage in public displays of sexuality is to be defined as a slut. Where boys learn that sex makes them

powerful, we learn that it makes us powerless and bad" (Diamond, 'Pornography', p. 50).

23. 'Speak Out Sister', *For Women*, November 1993, p. 86.

24. Alan Soble, *Pornography, Marxism, Feminism, and the Future of Sexuality* (New Haven: Yale University Press, 1986), p. 65.

25. Soble, *Pornography*, p. 69.

26. This is surely implied in any case by Soble's belief that "we should expect to find some convergence between women's and men's sexuality" as a result of the demise of the sexual division of labour, so that, as male sexuality may become more holistic, female sexuality becomes more atomistic (Soble, *Pornography*, p. 74).

27. Susan Bordo, 'Reading the Male Body', *Michigan Quarterly Review*, vol. 21, no.4 (1993), p. 705. On the other hand, "it is no longer for men alone to decide what is, or is not, exciting in pornography". New Femme pornography may seem too "safe" and "legitimate" to male eyes, but "it could be that this legitimacy is needed to enable women to create for themselves the safe place in which they can engage in sex without guilt or fear . . . " (Williams, *Hard Core*, p. 264).

28. Sheila Jeffreys, *Anticlimax: A Feminist Perspective on the Sexual Revolution* (London: The Women's Press, 1990), p. 286. Jeffreys seems to have created a special category of 'libertarians' largely from antitheses to radical-feminist positions. My own reading of Foucault and Weeks would lead me to conclude that both of them teach mutability, rather, if not indeed actual change in the field of sexuality within different social conditions.

29. The debt which the following potted history of anti-pornography activities in the USA and UK owes to the study by FAC (Feminists Against Censorship 1991) ought to be gratefully acknowledged.

30. One celebrated example of intervention by Customs and Excise was the 1985 raid on the Gay's The Word bookshop. Charges were dropped the following year because British law was found to be out of step with European Community law in this area.

31. Judith Butler comments, "The effort to limit representations of homoeroticism within the federally funded art world—an effort to censor the phantasmatic—allows and only leads to its production; and the effort to produce and regulate it in politically sanctioned forms ends up effecting certain forms of exclusion that return, like insistent ghosts, to undermine those very efforts" (Butler, 'The Force of Fantasy', p. 108). Perhaps unexpectedly, Catharine MacKinnon echoes this conclusion when she says, "If part of the kick of pornography involves eroticising the putatively prohibited, obscenity law will putatively prohibit pornography enough to maintain its desirability without ever making it unavailable or truly illegitimate" (MacKinnon, 'Toward Feminist Jurisprudence', p. 644).

32. Tania Modleski, *Feminism without Women: Culture and Criticism in a 'Postfeminist' Age* (London: Routledge, 1991), p. 159.

33. The risk is shared by, for example, female sex-workers who claim certainty that they are not exploited in the sex industry.

34. Kathy Myers, 'Pasting over the Cracks', in Lisa Appignanesi, ed., *Desire* (London: Institute of Contemporary Arts, 1984), p. 36.

35. Linda Williams draws attention to the way that the male ejaculation triggers

orgasmic bliss in the female whose face or breasts may be the recipient of seminal fluid. (Williams, *Hard Core*, p. 101)

36. " . . . lesbian and gay pornography do not address me personally . . . " (Williams, *Hard Core*, p. 7) Are we to assume, then, that fantasy is limited to what is sanctioned by a specific address to the fantasiser in terms of 'real' gender and sexuality?

37. Rosie Gunn, 'On/Scenities', *Body Politic* 4 (1993), p. 38.

38. Ibid.

39. Ibid.

40. Margaret Walters, *The Nude Male: A New Perspective* (Harmondsworth: Penguin, 1979), p. 18.

41. See Williams, *Hard Core*, pp. 234, 232.

42. Diamond, 'Pornography', p. 55.

43. A particularly important attribute of phallocentricism is a claim to univocality, which forces out into marginality alternative readings of phallic texts.

44. Diamond, 'Pornography', p. 55. As soon as particulars of this nature are offered, the project looks doomed (perhaps inevitably when desire is admitted only in patriarchal terms) to having patriarchy set the agenda. Women were passive in men's porn—let's see what happens when men are. And the distrust of explicitness sounds as if it could have been voiced by a Dworkinite anti-pornographer.

45. Ross, *No Respect*, p. 171.

46. This is surely one meaning suggested by her armour-plated costumes.

47. Madonna, quoted in Beverley Skeggs, 'A Spanking', *Magazine of Cultural Studies* 3 (1991), p. 31.

48. On the other hand, those who want to open up a debate, or who, as in the present instance, want to weigh claims for female enjoyment of pornography, can be summarily dismissed as naive or insensitive.

49. Patricia Holland et al., eds., *Photography/Politics: Two* (London: Comedia, 1986), p. 5.

50. The discomfort of female presence in an area of sexually pleasurable looking is taken to be their own by male customers, so that those women who feel confident enough to penetrate male territory usually make men uncomfortable. Unsupervised and free looking assumed to operate when there is a men-only environment seems suddenly watched over and disapproved by the presence of a single female in a sex shop.

51. John Berger et al., *Ways of Seeing* (London and Harmondsworth: BBC and Penguin, 1972).

52. Butler, 'The Force of Fantasy', p. 114.

53. Paul Hoch makes an important point when he writes, "If sexual repression is indeed such a persistent element of our civilisation [as Freud believes], might we not flip Hegel on his head and ask whether most men's attempts at domination are not the result of being so dominated and repressed themselves? Freud . . . had only scorn for the often repeated view—then associated with his former colleague, Alfred Adler— that such strivings after a dominative masculinity were biologically innate" (Paul Hoch, *White Hero, Black Beast: Racism, Sexism and the Mask of Masculinity* [London: Pluto, 1979], p. 19).

54. This object status for men is, of course, eroticised within the pornographic scenario; thus, the painful effects of real-life subjection could be argued to be 'bound' by means of the roleplay of sexual subjection. Carol J. Clover states that sex workers claim that men predominantly pay to play the subservient 'feminine' role in sadomasichistic transactions (Carol J. Clover, 'Introduction', in Pamela Church Gibson and Roma Gibson, *Dirty Looks*, p. 2).

55. Scott MacDonald, 'Confessions of a Feminist Porn Watcher', *Film Quarterly*, vol. 36, no. 3 (1983), p. 11.

56. Victor J.Seidler, *Rediscovering Masculinity: Reason, Language and Sexuality* (London: Routledge, 1989), p. 21.

57. "Pornographic images produce exactly an instability of identificatory positioning in the male spectator. One function of porn video is to produce and reproduce that instability, along with the fundamental hystericisation of sexual identity that it entails." (Paul Smith, 'Vas', in Constance Penley and Sharon Willis, eds., 'Male Trouble' special issue, *Camera Obscura*, 17 May 1988, p. 106)

58. For a brief account of the background to, and genesis of, the myth of the snuff movie, see MacKinnon, *Misogyny in the Movies*, p. 85 and Gerald Peary, 'Woman in Porn', *Take One*, 6 September 1978.

59. E. Ann Kaplan, 'Pornography and/as Representation', *Enclitic*, vol. 17/18, no. 1–2 (1987), p. 17.

60. Feminists Against Censorship, *Pornography and Feminism: The Case Against Censorship*, ed. Gillian Rodgerson and Elizabeth Wilson (London: Lawrence and Wishart, 1991), p. 59.

61. " . . . men seek to shed their identity in pornography to achieve a state of selflessness or 'objectification', and this is borne out . . . by analyses of pornographic material which show that it is ultimately concerned with phantasy." (Gary Day and Clive Bloom, *Perspectives on Pornography: Sexuality in Film and Literature* [London: Macmillan, 1988], pp. 4–5)

62. Rosemary Jackson, *Fantasy: The Literature of Subversion* (London: Methuen, 1981).

63. Jackson, *Fantasy*, p. 3.

64. Ibid., p. 4.

65. See Butler, 'The Force of Fantasy', p. 111.

66. Jackson, *Fantasy*, p. 173.

67. Foucault, in Jackson, *Fantasy*, p. 173.

68. Jackson, *Fantasy*, p. 91.

69. Butler, 'The Force of Fantasy', p. 109.

70. Ibid., p. 110.

71. Catharine MacKinnon, 'Desire and Power: A Feminist Perspective', in Cary Nelson and Lawrence Grossberg, eds., *Marxism and the Interpretation of Culture* (Urbana and Chicago: University of Illinois Press, 1988), p. 119.

72. Bette Gordon, '*Variety*: The Pleasure in Looking', in Carole S. Vance, ed., *Pleasure and Danger: Exploring Female Sexuality* (London: Routledge & Kegan Paul, 1984), p. 191.

73. Gordon, '*Variety*', pp. 194, 196.

74. Kaja Silverman, *The Acoustic Mirror: The Female Voice in Psychoanalysis and Cinema* (Bloomington and Indianapolis: Indiana University Press, 1988), p. 148.

75. Silverman, *The Acoustic Mirror*, p. 161

76. Ibid.

77. Jackson, *Fantasy*, p. 175.

78. Kaja Silverman, 'Fragments of a Fashionable Discourse', in Tania Modleski, ed., *Studies in Entertainment: Critical Approaches to Mass Culture* (Bloomington and Indianapolis: Indiana University Press, 1986), p. 143.

79. Ibid.

80. Silverman, 'Fragments of a Fashionable Discourse', p. 145.

81. The slippage here between 'male/female' and 'masculine/feminine' is conscious, since Laura Mulvey's claim that women become active spectators by submitting to temporary transvestism in effect leaves masculine viewing naturalised as male activity (Mulvey, *Visual and Other Pleasures*, p. 37).

82. The alleged differences in male and female spectatorship come under attack from another quarter when Gaylyn Studlar argues that identificatory pleasure (in cinema and elsewhere) has been disavowed as primarily masochistic (Gaylyn Studlar, *In the Realm of Pleasure: Von Sternberg, Dietrich, and the Masochist Aesthetic* [New York: Columbia University Press, 1988]). In Laura Mulvey's account, male sadism is alone stressed while even female masochism is kept in silence. There seems to be no possibility in her work that male visual pleasure could depend on, albeit disavowed, masochistic identification with the diegetic female position (Mulvey, *Visual and Other Pleasures*, pp. 14–26).

83. Writing of fan cults, Miriam Hansen observes, "... women not only experienced the misfit of the female spectator in relation to patriarchal positions of subjectivity but also developed imaginative strategies in response to it" (Miriam Hansen, *Babel and Babylon: Spectatorship in American Silent Film* [Cambridge, Mass.: Harvard University Press, 1991], p. 125).

84. Jack D. Douglas, and Paul K. Rasmussen with Carol Ann Flanagan, *The Nude Beach* (Beverly Hills: Sage, 1977), p. 137.

85. Richard Dyer, 'Don't Look Now: The Male Pin-Up', in *Screen*, eds., *The Sexual Subject:. Screen Reader in Sexuality* (London: Routledge, 1992), p. 267.

86. Neil Norman, 'Raw Deal', *For Women*, April 1994, p. 23.

87. Sheila Jeffreys extends this notion to argue that the erotic objectification of the male cannot be sexy for women. "In heterosexuality the attractiveness of men is based upon their power and status. Naked beef is not a turn-on for women because objectification subordinates the object group" (Jeffreys, *Anticlimax*, p. 254). While the analysis of objectification in heterosexuality is persuasive, the prescription is less so. Is feminism impossible within heterosexuality? If it is not—and Jeffreys may be claiming that it is—why should male attractiveness remain outside historical change, so that it is forever predicated on power and status?

88. Nancy M. Henley, *Body Politics: Power, Sex, and Nonverbal Communication* (Englewood Cliffs, N.J.: Prentice-Hall, 1977), p. 160.

89. Henley, *Body Politics*, p.152.

90. Hansen, *Babel and Babylon*, p. 3.

91. Pauline Brown, in Peter Baker, 'Exposing the Shape of Things to Come', *Guardian*, 26 May 1992.

92. Peter Lehman, '*In the Realm of the Senses*: Desire, Power, and the Representation of the Male Body', *Genders* 2 (1988), p. 105.

93. See *Screen*, eds., *The Sexual Subject: A* Screen *Reader in Sexuality* (London: Routledge, 1992), pp. 224–45.

94. Rozsika Parker, 'Images of Men', in Sarah Kent and Jacqueline Morreau, eds., *Women's Images of Men* (London: Pandora, 1990), p. 64.

95. Phyllis Chesler's term, in Sarah Kent, in Kent and Morreau, eds., *Women's Images of Men*, p. 76. There is evidence of a new public interest in the possibility of female sexual harassment of a male in, for example, Michael Crichton's commercially successful novel, *Disclosure*, where a woman seduces a man whose superior she has become at work. American men's claims of sexual harassment by women amount to almost 9 per cent of the complaints filed with the federal Equal Opportunity Commission in 1993. One commentator on this does not believe that growth in women's power in the workplace must result in women behaving with sexual aggression towards male employees, however: "Culture has been such that it has given men positive feedback when they get uninvited sexual attention, where women are more likely to get negative reactions when they get uninvited sexual attention. So, men are more likely, if they are going to abuse power, to abuse power in a sexual way than women are." (Ellen Bravo, executive director of 9–5, National Association for Working Women, in Jodi Duckett, 'The Flip Side: When Men are Sexually Harassed, All Things May Not Be Equal', *Morning Call*, 10 March 1994, p. D3)

96. Della Grace, 'Dynamics of Desire', in Victoria Harwood et al., *Pleasure Principles: Politics, Sexuality and Ethics* (London: Lawrence and Wishart, 1993), pp. 93–94, 90.

97. Studlar, *In the Realm of Pleasure*, 35.

98. Eileen Phillips, ed., *The Left and the Erotic* (London: Lawrence and Wishart, 1983), p. 33.

99. Catharine MacKinnon, 'Feminism, Marxism, Method, and the State: An Agenda for Theory', *Signs*, vol. 7, no. 3 (1982), p. 515.

100. Vance, ed., *Pleasure and Danger*, p. 5.

101. Ibid., p. 15.

102. Ellen Willis, in MacKinnon, 'Desire and Power', p. 118.

103. Even then, women's demonstrable power in personal relationships, for example, is often as underplayed in feminist analyses as it is by the wider culture. See Wendy Hollway, 'Women's Power in Heterosexual Sex', *Women's Studies International Forum*, vol. 7, no. 1 (1984) for an interesting foregrounding of female power within heterosexuality.

104. Ellen Willis, in MacKinnon, 'Desire and Power', p. 119.

105. Rosalind Coward observes in relation to this: "Pleasure can be created, and stage-managed ... The pleasures offered, the solutions held out, neither exhaust what there is to be said about female desire, nor do they actually offer any solution." (Rosalind Coward, *Female Desire* [London: Paladin, 1984], pp. 14, 15–16)

106. Sarah Kent, in Kent and Morreau, eds., *Women's Images of Men*, pp. 82, 87.

107. The importance, to men particularly, of indirect phallic representation seems to be illustrated by George Zavitzianos's investigation of the social meaning of homoeovestism (where, for example, an athletic or militaristic item of clothing is worn during

sexual activity). Thus, one case described by Zavitzianos in 1972 is explained as follows: the jock-strap was chosen "to deny castration; but the castration of the patient and not that of the woman, as is the case in fetishism" (George Zavitzianos, 'The Object in Fetishism, Homeovestism and Transvestism', *International Journal of Psychoanalysis* 58 [1977], p. 490).

108. Maxine Sheets–Johnstone, in Bordo, 'Reading the Male Body', p. 698.

109. Christine Anne Holmlund draws attention, on the other hand, to the *Pumping Iron* camera's refusal to focus on the bulge in Schwarzenegger's or Lou Ferrigno's trunks, concluding, "to look might reveal too much or too little, threatening the tenuous equation established between masculinity, muscularity, and men" (Christine Holmlund, 'Visible Difference and Flex Appeal: The Body, Sex, Sexuality, and Race in the *Pumping Iron* films', *Cinema Journal*, vol. 28, no. 4 [1989], p 45).

110. Richard Dyer illustrates the point about the penis's revelation being a matter of embarrassment rather than pride with reference to a seaside postcard which shows an unhappy muscleman with barbell aloft and trunks accidentally slipped down his thighs (Richard Dyer, 'Male Sexuality in the Media', in Andy Metcalf and Martin Humphries, eds., *The Sexuality of Men* [London: Pluto, 1985], p. 33). A succinct illustration of the anxiety shown about penile display on such a public medium as television may be found in the impossibility of showing Jo Menell's *Dick* even in Channel 4's retrospective on censored films. (For a fuller discussion, see Lynne Segal and Mary McIntosh, eds., *Sex Exposed: Sexuality and the Pornography Debate* [London: Virago, 1992], pp. 83–4.) Another is the furore about a *possibly* glimpsed erection in Derek Jarman's *Sebastiane*, shown on Channel 4, which was much criticised for the decision to show the film.

111. Tania Modleski, *Feminism without Women: Culture and Criticism in a 'Postfeminist' Age* (London, Routledge, 1991), p. 109.

112. Suzanne Moore, 'Here's Looking At You, Kid!', in Lorraine Gamman and Margaret Marshment, eds., *The Female Gaze: Women as Viewers of Popular Culture* (London: The Women's Press, 1988), p. 56.

113. Frances Borzello, *The Artist's Model* (London: Junction Books, 1982), p. 8.

114. Walters, *The Nude Male*, p. 317.

115. Naomi Salaman, 'Women's Art Practice/Man's Sex ... and Now for Something Completely Different', in Victoria Harwood et al., eds., *Pleasure Principles: Politics, Sexuality and Ethics* (London: Lawrence and Wishart, 1993), p. 41.

116. Lisa Tickner writes, "They are metaphors for women ready to acknowledge the masculine elements in themselves and who are 'ready to admit things hidden for a long time—that they have the same drive, the same aggressions, the same feeling as men'" (Lisa Tickner, 'The Body Politic: Female Sexuality and Women Artists Since 1970', in Rosemary Betterton, ed., *Looking On: Images of Femininity in the Visual Arts and Media* [London: Pandora, 1987], p. 242—the words in single inverted commas come from Cindy Nemser).

117. Danielle B. Hayes, ed., *Women Photograph Men* (New York: William Morrow, 1977).

118. Molly Haskell, in Hayes, *Women Photography Men*, 'Introduction' (n.p.).

119. Mellon, quoted by Charles Henri Ford, 'Narcissism as Voyeurism as Narcissism',

in Gerard Malanga, ed., *Scopophilia: The Love of Looking* (New York: Alfred Van Der Marck Editions, 1985), p. 68.

120. Kent and Morreau, eds., *Women's Images of Men*.

121. Claire Bonney says of this, "The ridiculousness of the male images makes it apparent that Leyener is not interested in merely exchanging traditional sex roles" (Claire Bonnney, 'The Nude Photograph: Some Female Perspectives', *Women's Art Journal* Fall 1985, p. 13).

122. Emmanuel Cooper, *Fully Exposed: The Male Nude in Photography* (London: Unwin Hyman, 1990), p. 204.

123. Hansen, *Babel and Babylon*, p. 1.

124. Elaine Colomberg, 'Fore Women? Sex, Myths and Vibrations Rising in the 90s!' (London: University of North London [unpubished final-year Women's Studies project], 1993), p. 2. She adds the caveat that these may in fact be launch figures.

125. Colomberg, 'Fore Women', p. 20. 'Anti-feminist', like 'feminist', has validity only in relation to a particular understanding of feminism. What is most ridiculed in these magazines is a stereotype of the radical feminist, cast as prude, intent on shutting down possibilities of pleasure, her attitudes implicitly or explicitly often explained as founded on a lesbian personality, whatever that is exactly. At other points, some of the magazines claim to be promoting the interests of women in empowering them through the chance to exercise choice to view objects kept out of their sight for decades.

126. British police seem to have decided to enforce a no-erections line when the letter of the law makes no mention of this as "likely to deprave or corrupt".

127. See, for example, Suzanne Woollard in Abby Edwards, 'Are Sexy Mags Really Just For Men?', *Woman's Own*, 29 March 1993, p. 10.

128. Sharon Longford, quoted in Edwards, 'Are Sexy Mags Really Just For Men?', p. 11.

129. Colomberg, 'Fore Women', p. 26.

130. Kent, 'The Erotic Male Nude', p. 92.

131. The imagined jokes of putting nude males in the object position in pinup poses surely indicate uncertainty and nervousness on the part of the publishers.

132. Leon Hunt describes the sequence in more detail: "The men are paraded for them to look at, and it becomes increasingly clear that the decisions are being made on the basis of physical attractiveness . . . [They] ogle each of the men in turn, whisper and giggle about an Ethiopian fighter (their gazes indicate where they are looking), choose Spartacus because he looks 'impertinent' . . . " (Leon Hunt, 'What Are Big Boys Made Of? *Spartacus, El Cid* and the Male Epic', in Pat Kirkham and Janet Thumim, eds., *You Tarzan: Masculinity, Movies and Men* [London: Lawrence and Wishart, 1993], p. 72).

133. Kirkham and Thumim, *You Tarzan*, p. 13. On the same page, these writers describe the bead of sweat, in this context, as "representative of bodily fluids" and indicate their belief that sweat may "allude to *both* vulnerability *and* power".

134. Sean Nixon, 'Distinguishing Looks: Masculinities, the Visual and Men's Magazines', in Harwood et al., eds., *Pleasure Principles*, p. 62.

135. Nixon, 'Distinguishing Looks', p. 63.

136. Brian Kennedy and John Lyttle, 'Wolf in Chic Clothing', *City Limits*, 4–11 December 1986, p. 17.

137. Helen Chappell, 'Girls' Night In: "Ooo-er! Gross! Amazing!"', *Independent*, 3 December 1991.

138. When the tension was broken in one performance by one stripper's bouncing pectorals, the aftermath is described as follows: "Everybody took it from there, every movement a scream of laughter, every jerk of the buttocks a shock of recognition, every thrust a gasp of helpless incredulity." The brutal power attributed by the writer to "Shane" "had the women in shouting rapture, every shout a bump" (George Target, 'Cocks and Hens', *International H&E Monthly*, vol. 94, no. 6 [1994], p. 55).

139. Susan Bordo says of it, "What is eroticised in the male stripper routines is not the strip, not the exposure of nakedness, but the teasing display of phallic power, concentrated in the hard, pumped-up armour of muscles and the covered frontal bulge, straining against its confinements. Their penises they keep to themselves." (Bordo, 'Reading the Male Body', p. 700)

140. See Paula L. Dressel and David M. Petersen, 'Gender Roles, Sexuality, and the Male Strip Show: The Structuring of Sexual Opportunity', *Sociological Focus*, vol. 15, no. 2 (1982), p. 153.

141. Chappell, 'Girls' Night In'.

142. Judith Lynne Hanna reports that at one club the female announcer stated, "It's equal rights, Ladies: we're gonna let the guys work for us for a change," while at a discotheque featuring a male strip show the disc jockey urged, "The more you scream, the more you see" (Judith Lynne Hanna, *Dance, Sex, and Gender: Signs of Identity, Dominance, Defiance, and Desire* [Chicago: University of Chicago Press, 1988], pp. 225–26).

143. David M. Petersen and Paula M. Dressel, 'Equal Time for Women: Special Notes on the Male Strip Show', *Urban Life*, vol. 11, no. 2 (1982), p. 189.

144. Dressel and Petersen, 'Gender Roles', p. 154.

145. Dressel and Petersen add, " . . . although many strippers report accepting gifts or favours from female customers, they appear to have substantial control regarding what they exchange in return" (Dressel and Petersen, 'Gender Roles', p. 158).

146. He says, "Laughing, they were, except that it wasn't happy laughter, too shrill, too loud, too close to hysteria . . . egging each other, getting nasty, cruel, perhaps desperate, unaware of their own ferocity" (Target, 'Cocks and Hens', p. 55).

147. Richard Ballardo, 'Strip Joker', *Playgirl*, vol. 20, no. 8 (1992), p. 58.

148. Dressel and Petersen, 'Gender Roles', p. 157.

149. Ballardo, 'Strip Joker', 59.

150. See Walters, *The Nude Male*, p. 17.

151. Peter Lyman, 'The Fraternal Bond as a Joking Relationship: A Case Study of the Role of Sexist Jokes in Male Group Bonding', in Michael S. Kimmel, *Changing Men: New Directions in Research on Men and Masculinity* (Newbury Park, Cal.: Sage, 1987), p. 152.

chapter 7

1. Sheila Jeffreys, for one, makes precisely this claim (Sheila Jeffreys, *Anticlimax: A Feminist Perspective on the Sexual Revolution* [London: The Women's Press, 1990], p. 145).

2. Catharine MacKinnon, 'Desire and Power: A Feminist Perspective', in Cary Nelson and Lawrence Grossberg, eds., *Marxism and the Interpretation of Culture* (Urbana and Chicago: University of Illinois Press, 1988), p. 121. She puts the matter fairly carefully, and does concede that gay male choice may be made because of a wish to avoid oppressing women. There is a danger, all the same, of reaching the same sort of fatuous conclusion as Jane Gallop does in saying, "I distrust male homosexuals because they choose men over women just as do our social and political institutions . . . " (Jane Gallop, *Thinking Through the Body* [New York: Columbia University Press, 1988], p. 113). Is sexual choice entirely equitable with social and political choice, then? The unacceptability of this sort of telescoped thinking would be obvious if heterosexual males were praised—and trusted—by the same writer for choosing women over men, as if they were thereby feminist in sympathy. While it is undeniable that men, as a category, are given social and political privilege, and that some homosexual, as well as heterosexual, men justify what might be termed their choice in terms of bitter misogyny and implicit or explicit assent to male privilege, it is reductionist to saddle gay politics, let alone the generality of homosexual males, with the blame for this. Because there are misogynistic women, feminism is no less valid. If there are misogynistic homosexual men, should not the temptation to universalise from this observation be strongly resisted?

3. After risking this much generalisation, from albeit partial empirical evidence, it is only fair to stress that many women, including many who would consider themselves feminist, would not see erotic objectification of men (or even of women) as automatically injurious to women's interests or consider sadomasochism to be. When Sheila Jeffreys claims that her view, that sexual minorities are simply exaggerated versions of the deleterious facets of male sexuality, is feminist analysis, she speaks for one version of feminism only (Jeffreys, *Anticlimax*, p. 167).

4. It has of course been counter-claimed by anti-pornography feminists that sexual minorities, by reinforcing the male bias of patriarchal exploitative dominance/submission relations, need to be curbed in women's interest.

5. Craig Owens, 'Outlaws: Gay Men in Feminism', in Alice Jardine and Paul Smith, *Men in Feminism* (New York and London: Methuen, 1987), p. 219.

6. Eve Kosofsky Sedgwick, in Owens, 'Outlaws', pp. 220–21.

7. This is not to say that gay politics has not detected and explored problems in the erotic objectification which pornography appears to demand. Awareness of feminist image analysis probably explains the distrust of the icon of the 'hot jock' in the early days of gay lib. It is not to suggest either that there are not significant areas of feminism which contest the simple and single reading of pornography as injurious to women's interests.

8. The more mainstream version of men's pornography is seldom analysed, except with the supposition that representation can be read unhesitatingly as realist in the most naive terms. Sheila Jeffreys asks, "Why is pornography seen as a privileged category of representation?" (Jeffreys, *Anticlimax*, p. 253). She makes the inquiry because she feels that pornography's defenders claim that it is "a privileged exception to other media in that it had no effect on the way its users felt about the world" (Jeffreys, *Anticlimax*, p. 252). In this statement, she weights the debate unfairly in her own favour. There is a marked difference between a claim that it has no effect and a claim that its

effects are not as predictable and easily read as anti-pornographers maintain. Rather than trying to treat pornography as a privileged exception, investigators of pornography (not so easily to be depicted as defenders of it) would like it to be investigated as a genre (not, as Jeffreys seems to believe, a medium), in the terms in which other genres have been investigated.

9. Lynne Segal explains the importance of the sexual/erotic in homosexuality helpfully: "Because the affirmation of homosexuality is the affirmation of sexual desire, it inevitably symbolises opposition to repressive sexual norms." Homosexuality's affirmation of the pleasures of the body is deemed by her to have its most enduring effect on concepts of masculinity. A negative view of sex being basic to patriarchal psychology and being linked always with a fear of women, "the historic harnessing of sexuality to the social creation of gender . . . is challenged . . . by the visibility of both lesbian and gay sexuality" (Lynne Segal, *Slow Motion: Changing Masculinities, Changing Men* [London: Virago, 1990], p. 156).

10. One result of insistence on straight understanding of deviant fantasy was a split in the early 1970s between heterosexual and lesbian feminists, thanks to the latter's refusal to be silenced in the face of a supposed norm of women's sexuality.

11. See Kenneth MacKinnon, *The Politics of Popular Representation: Reagan, Thatcher, AIDS, and the Movies* (Cranbury, N.J. and London: Associated University Presses, 1992) *passim*.

12. Mark Finch, in Suzanne Moore, 'Here's Looking At You, Kid!', in Lorraine Gamman and Margaret Marshment, eds., *The Female Gaze: Women as Viewers of Popular Culture* (London: The Women's Press, 1988), p. 53.

13. Ibid.

14. On the other hand, popular culture, to judge by current male-eroticising advertisements, does seem to find female gazing more acceptable, in the sense that it is at least representable, than male–male erotic gazing. This suggests that gay-male erotic gazing is alibied by diegetic female gazing, and would suggest that Finch's claim is the more credible. The crucial aspect may rather be that both kinds of gazing are granted some sort of social permission through the alibi, and that they are allied in their being problematic, though not equally problematic. And this level of elaboration does begin to suggest academic copout!

15. Judith Butler, *Gender Trouble: Feminism and the Subversion of Identity* (London: Routledge, 1990), p. 122.

16. Ibid.

17. Ibid.

18. Brian Pronger, *The Arena of Masculinity: Sports, Homosexuality, and the Meaning of Sex* (New York: St. Martin's Press, 1990) p. x.

19. K. Freund, 'A Laboratory Method for Diagnosing Predominance of Homo- or Hetero-erotic Interest in the Male', *Behavior Research and Therapy* 1(1963). The title seemed to promise much more than it delivered. I wrongly took it to mean, at first sight, that the method would differentiate (male) interest in the male (another male) as either homo- or hetero-erotic.

20. Of the patients labelled heterosexual, twenty-four are said to be capable of being regarded as sexually normal.

21. Freund, 'A Laboratory Method', p. 88.

22. P. T. Brown, 'On the Differentiation of Homo- or Hetero-erotic Interest in the Male: An Operant Technique Illustrated in a Case of a Moto-Cycle Fetishist', *Behavior Research and Therapy* 2 (1964), p. 31.

23. Morse Peckham, *Art and Pornography: An Experiment in Explanation* (New York: Basic Books, 1969), p. 196.

24. Perhaps this is less weird than it appears. Exactly the same explanation is offered for same-sex physical relations in prisons or single-sex boarding schools. The males 'enjoy themselves' with their own sex in the absence of females, thus proving, because they are 'not homosexual', that their virile nature demands sexual relief (the sex of the object not counting for anything). Obviously homosexual behaviour has no automatic bearing on whether the men indulging in it are categorised as homosexual or not. In some parts of the Mediterranean, those males believed to favour passive sexual positions are labelled homosexual and thus despised, while active partners are thought to be 'men', to be admirable, and therefore not possibly homosexual.

25. Diana Fuss, 'Inside/Out', in Diana Fuss, ed., *Inside/Out: Lesbian Theories, Gay Theories* (London: Routledge, 1991), p. 5. This is why Claire Pajaczkowska calls for the acknowledgement of the psychoanalytic premises of primary bisexuality within analyses of the sexual processes at work in representation (Claire Pajaczkowska, 'The Heterosexual Presumption', in *Screen*, eds., *The Sexual Subject: A Screen Reader in Sexuality* [London: Routledge, 1992], p. 193). Her wish is not to confirm "the heterosexual presumption", by which the positions of man and woman, not to mention heterosexual and homosexual, are taken as given.

26. Allen Ellenzweig, *The Homoerotic Photograph: Male Images from Durieu/Delacroix to Mapplethorpe* (New York: Columbia University Press, 1992), p. 205.

27. 'Gay' (like 'homosexual') may require to be cautiously used, but marketing strategies for mainstream video pornography confidently indicate their intended market—as 'gay' and 'straight', 'kinky' and 'vanilla', etc.

28. See Mandy Merck, *Perversions: Deviant Readings* (London: Virago, 1993), p. 223.

29. John Patrick, ed., *The Best of the Superstars 1992: The Year in Sex* (Sarasota, Fl.: STARbooks Press, 1992), p. 97.

30. Leigh W. Rutledge, 'Why is Gay Pornography So Bad? Or, How *Not* to Write an Erotic Story', *Mandate*, vol. 11, no. 2 (1985), p. 27.

31. "Everything about them is bulging . . . " (Rutledge, 'Why is Gay Pornography So Bad?', p. 28).

32. Margaret Walters claims that the ideal man lurking behind the leather boys is a Nazi storm trooper (Margaret Walters, *The Nude Male: A New Perspective* [Harmondsworth: Penguin, 1979], p. 297).

33. Not always same-sex. One of Tom's Kake series focuses on a sailor who is seduced away from his girlfriend/whore by the hero's attention to his exposed backside as he copulates with her, and Tom also fulfils a shared-girl scenario. There is, notably, an apparently sizeable target gay audience for male porn stars engaged in heterosexual activity—particularly if they demonstrate the versatility about object choices that 'bisexual porn' usually exhibits.

34. Thomas Yingling, 'How the Eye is Caste: Robert Mapplethorpe and the Limits of Controversy', *Discourse*, vol. 12, no. 2 (1990), p. 7.

35. Rosalind Coward, *Female Desire* (London: Paladin, 1984), p. 231.

36. Brian Pronger claims that probably the first homoerotic film, in 1949, took the 'athletic' title, *The Cyclist*. (Pronger, *The Arena of Masculinity*, p. 126)

37. This generalisation is more difficult to maintain in the context of Kristen Bjorn's highly individualistic and instantly recognisable productions—Bjorn being the most obvious example of auteur in the commercial gay-porn circuit. In these, orgasm is made painstakingly visible, but the predominantly gentle foreplay of muscular, often 'Latin', men suggests pleasure in bodily contact and physical tenderness. As if to unseat orgasm as dramatic or sexual climax, a 'money shot' is often followed by further sexual activity on the part of the actor concerned, frottage being as likely as the more forceful varieties of intercourse.

38. 'Over-the-top' phalluses regularly appear on (presumably) amateur sketches on lavatory walls. These at once speak of male homoerotic desire but also suggest mockery of its attainment. Occasionally, a wry comment, such as 'A likely story!', or 'Dream on', suggests that the incredibility of these penile dimensions produces sneering incredulity rather than awe-struck wonder.

39. As well as *The Young and the Hung*, to quote a famous William Higgins video title.

40. The lip-smacking connotations of the name are clear if the three syllables are pronounced aloud.

41. Richard Fung, 'Looking for My Penis: The Eroticized Asian in Gay Video Porn', in Bad Object-Choices, ed., *How Do I Look? Queer Film and Video* (Seattle: Bay Press, 1991), p. 158.

42. Fung, 'Looking for My Penis', p. 162.

43. And pornography targeted at heterosexual males is sometimes treated as if it were the key to the understanding of all varieties of porn/erotica.

44. Tom Waugh, 'Men's Pornography: Gay vs. Straight', *Jump Cut* 30 (1981), p. 31.

45. Indeed, the mild suspense generated about just who is being penetrated—since any actor, however 'masculine', may be in gay porn—probably explains the fondness of many gay-porn videos for the slow reverse zoom away from the anal and genital detail at the start of certain representations of homosexual liaison to clarify to the viewer which actor's anus and which actor's genitals are being shown. Kristen Bjorn's fondness for confusing the viewer about whom to expect in the 'passive' position becomes readable as a form of humour, perhaps. His productions normally confound any comfortable assumptions about the relevance of 'masculinity' to dominance in the sex act.

46. At least by human agency. Dildos offer a halfway house for this sort of hyper-masculine sex-star.

47. 'Relative' because there are some porn stars who have built their careers on always being 'top' or 'bottom'.

48. Moralising analyses tend to envisage a unified subject as viewer or—more pejoratively—user of pornography. The user is imagined to carry out in social actuality (since pornographic scenarios themselves are taken to be the very crystallisation of

social actuality's sexual relations) with extreme literal-mindedness the presumed simple message of pornography.

49. Value judgments about porn's quality in terms other than moral are seldom offered by the more academic analyses of porn and its effects. It is most often treated as a monolith, its devotees as aesthetically uncritical as they are morally degenerate.

50. Rutledge, 'Why is Gay Pornography So Bad?', p. 88.

51. Ibid., p. 90.

52. It also suggests a hostility widely shared within Western culture to the formulaic and truly generic, so that detection of these in cultural production veto that production's entry into the field of high art. The analysis of porn-movie style by the end of 1990 also indicates an awareness of what is termed the limited repertoire of televisual techniques, these traditionally including mid-shots, flat lighting, interior settings. See Merck, *Perversions*, p. 223.

53. Andrew Ross, *No Respect: Intellectuals and Popular Culture* (London: Routledge, 1989), p. 198.

54. Waugh, 'Men's Pornography', p. 32. Waugh's entirely credible analysis of the multiplicity of identificatory positions in gay porn is not matched in his listing of taboos, which include male-female sex, effeminacy, age, obesity and drag (ibid.). All or most of these tastes are catered for in specialist publications or by studios specialising in 'bisexual' tapes, men of 'bulk' or 'maturity'. The fact that these aspects are thus recognised as not mainstream does not surely translate into their being taboo.

55. Laura Kipnis, 'She-Male Fantasies and the Aesthetics of Pornography', in Pamela Church Gibson and Roma Gibson, eds., *Dirty Looks: Women, Pornography, Power* (London: British Film Institute, 1993), p. 125.

56. Kipnis, 'She-Male Fantasies', p. 128.

57. We seem once again to be in the presence of 'the heterosexual presumption'.

58. Kathleen Barry and Gloria Steinem, in Michael Bronski, *Culture Clash: The Making of Gay Sensibility* (Boston: South End Press, 1984), p. 164.

59. See Feminists Against Censorship, *Pornography and Feminism: The Case Against Censorship*, ed. Gillian Rodgerson and Elizabeth Wilson (London: Lawrence and Wishart, 1991), pp. 27–28.

60. See Rosie Gunn, 'On/Scenities', *Body Politic*, 4 October (1993), p. 38.

61. Michael Bronski writes, "While it is true that the viewer, sexually aroused, lusts after the object, it is equally true that he may also want to *be* [author's emphases throughout this quotation] that object. This element of identification *with* as well as desire *for* the sexual object distinguishes gay and straight porn ... [T]he fact that identification exists simultaneously with objectification transforms the power relationships which some have presumed to be inherent in the viewing of sexual images." (Bronski, *Culture Clash*, p. 165)

62. Isaac Julien and Kobena Mercer, 'True Confessions: A Discourse on Images of Black Male Sexuality', *Ten*, vol. 8, no. 22, p. 6.

This particular example illustrates Thomas Yingling's wider claim, that "a sign originating in a repressive practice . . . may be dislocated from its initial site and installed in one subversive to the system in which it took its original meaning" (Yingling, 'How the Eye is Caste, p. 8).

63. A wider objection is that the impulse to suppress the pornographic is doomed, since the pornographic is not limited to that which wears the label. Fredric Jameson believes that "The visual is *essentially* [his emphasis] pornographic, which is to say that it has its end in rapt, mindless fascinationPornographic films are thus only the potential of films in general, which ask us to stare at the world as though it were a naked body" (Fredric Jameson, *Signatures of the Visible* [London: Routledge, 1992], p. 1). Yet another objection is that *any* image of homosexuality has been thought by many to be "inherently pornographic" (Bad Object-Choices, ed., *How Do I Look?*, p. 27).

64. Much of the data on law and custom in this section is based on documentation compiled by the ICA for its one-day conference of May 1992 entitled 'We Should Be Seeing Things: Screen Censorship and Sexuality'.

65. Neil McKenna, 'Nothing to Declare?', *Gay Times*, September (1990), p. 16.

66. Geoffrey Robertson, QC, in Colin Richardson 1992, 'The Porn Laws', in ICA, 'We Should Be Seeing Things: Screen Censorship and Sexuality', 25 April 1992, p. 2.

67. McKenna, 'Nothing to Declare?', p. 17.

68. Ibid.

69. Lynne Segal, *Is the Future Female? Troubled Thoughts on Contemporary Feminism* (London: Virago, 1987), p. 112.

70. Varda Burstyn, ed., *Women Against Censorship* (Vancouver: Douglas and McIntyre, 1985), p. 18

71. *Taxi zum Klo* was banned outright by it, while *Born In Flames* had cuts ordered in it.

72. John Willis, 'Banned and Damned in the USA', *Independent*, 5 August 1992, p. 15.

73. Bronski, *Culture Clash*, p. 173.

74. The term is used in Peter Weiermair, *The Hidden Image: Photographs of the Male Nude in the Nineteenth and Twentieth Centuries*, tr. Claus Nielander (Cambridge, Mass.: MIT Press, 1988), p. 15.

75. See Ellenzweig, *The Homoerotic Photograph*, p. xv.

76. "The sexual orientation indicated by the test [the measurement of 'penile volume' in relation to moving pictures of male and female nudes] was . . . homosexual for fourteen of the subjects conscious of homosexual feeling, the total of subjects so conscious being put at twenty-two." (N. McConaghy, 'Penile Volume Change to Moving Pictures of Male and Female Nudes in Heterosexual and Homosexual Males', *Behavior Research and Therapy* 5 [1967], p. 43) The account of this experiment, like the others concerned with the determination of sexuality in this journal, has a macabre fascination. There is a brief reference, for example, to all twenty-two "homosexual subjects" being referred for aversion therapy. (McConaghy, 'Penile Volume Change', p. 45.)

77. Ellenzweig writes in this regard, "Significantly, pictures in which men are objects of erotic attention are not the exclusive province of photographers who address a gay audience" (Ellenzweig, *The Homoerotic Photograph*, p. 168).

78. Mark Finch, 'Sex and Address in *Dynasty*', *Screen*, vol. 27, no. 6 (1986), p. 24.

79. The demonstrability of homoerotic *potential* but not necessarily 'fact' in many publicly exhibited male nudes seems not to harmonise with Sarah Kent's claim that,

for example, Damiano Mazza's *Ganymede* presents a round-buttocked submissive figure which suggests buggery as well as spanking and thus too specific and exclusive an audience. Also, when the male nude is more active and muscular, Kent dislikes his "overbearing presence", which creates the only female viewer function as "to admire and be conquered" (Sarah Kent, 'The Erotic Male Nude', in Sarah Kent and Jacqueline Morreau, eds., *Women's Images of Men* [London: Pandora, 1990], pp. 79-80). Her implied assumption of a homogenised homosexual gaze is interesting. Kent writes as if this audience's response would be uniform and predictable, when it might be more credible to suggest that the male homosexual gazer is used to inserting himself where such a gaze is not invited or specifically catered to. She continues: "As an exultation of power and its uses, they ['active' male nudes] offer women only negative identification." Familiar territory since Mulvey, but is submission necessarily negative in fantasy, and is it not possible, as in homosexual fantasising and presumably other forms of it, to read images against the grain?

 Present-day boy bands again raise questions about their target audience, since official publicity stresses their appeal to (female) teenyboppers. Nevertheless, Take That and Bad Boys, Inc. not only have demonstrable homoerotic appeal but this is acknowledged in not just the underground press. Thus, Joseph Gallivan, writing for the *Independent*, claims that the groups are "banking on two strong forces in the chart market: teenage girls and gay men" (Joseph Gallivan, 'Ooo, I wanna Be Like You', *Independent*, 19 August 1993, p. 12).

 80. Thus, according to Graham McCann, Tennessee Williams's heroes were sexually potent males who satisfied, soothed and "saved" women, while "their obvious appeal to homosexuals (their creation, in fact, by a homosexual writer) was discreetly overlooked. The 1950s were not ready to consider what Marlon Brando, stripped to the waist . . . might have been able (and even willing) to do for some of the frustrated men of that small, tight town in New Orleans" (Graham McCann, *Rebel Males: Clift, Brando and Dean* [New Brunswick, N.J.: Rutgers University Press, 1993], pp. 20–21).

 81. Martin Humphries, 'Gay Machismo', in Andy Metcalf and Martin Humphries, eds., *The Sexuality of Men* (London: Pluto, 1985), p. 84. He adds, "The real danger for us is in the macho image being promoted as the only permissible gay image by commercial forces operating within the gay culture."

 82. Julien and Mercer, 'True Confessions', p. 7.

 83. Clyde W. Franklin, II, *The Changing Definition of Masculinity* (New York: Plenum, 1984), p. 174.

 84. Pronger, *The Arena of Masculinity*, p. 2.

 85. Bronski, *Culture Clash*, p. 187

 86. Laura Mulvey, *Visual and Other Pleasures* (London: Macmillan, 1989), p. 18. If the gaze is 'male', then it is far simpler to see how "the spectator's fascination with and recognition of his like" would work with both subject and object male (ibid.). That said, biological gender should not be allowed, whatever the shortcomings of the original expression of ideas, to dominate understanding of either Mulvey's original position or of the new context of male fascination.

 87. Ronald Bergan, *Sports in the Movies* (London: Proteus, 1982), p. 4.

 88. Ibid.

89. See Margaret Morse, 'Sport on Television: Replay and Display', in E. Ann Kaplan, ed., *Regarding Television: Critical Approaches–An Anthology* (Los Angeles: American Film Institute, 1983), p. 44.

90. That rationalisation is achieved by the promotion of an ideal of "scientific inquiry into the limits of human performance", as Margaret Morse puts it. This can be thought of, therefore, as a "very effective mechanism for disavowal" (Morse, 'Sport on Television', p. 45).

91. Chris Shilling, *The Body and Social Theory* (London: Sage, 1993), p. 3.

92. Rosalind Coward thinks of health and strength as analogous to "barriers between the desire of men", although she also recognises that sport and fitness routines do enable men to share attention to their own and each other's bodies. By this means, she believes, which serve to maintain heterosexuality, there is introduced "a pocket of turbulence" (Coward, *Female Desire*, p. 231).

93. Morse, 'Sport on Television', p. 61.

94. Antony Easthope, *What a Man's Gotta Do: The Masculine Myth in Popular Culture* (London: Paladin Grafton Books, 1986), p. 139.

95. Pronger, *The Arena of Masculinity*, p. 9.

96. Pronger is aware, though, not only of the homoerotic appeal of muscularity in the gay context, but also of the fact that there is thus a paradox in sport's version of masculinity—that masculinity is thus promoted, even as it is subverted by its overt eroticisation (Pronger, *The Arena of Masculinity*, pp. 10, 11). This paradox may be at the very heart of gay experience, which embraces desire for 'masculinity' at the same time as it almost automatically dismantles its mythology, which generally equates it and heterosexuality.

97. See Judith Gaines, 'The "Beefcake Years": More and More Ads Are Baring Men's Bodies', *Philadelphia Inquirer*, 17 October 1993, p. K5.

98. See Morse, 'Sport on Television', p. 45.

99. Phyllis Chesler, for instance, is on record as declaring that "magnificent" Greek and Renaissance sculptures of nude men fail to arouse her sexual interest (Phyllis Chesler, *About Men* [London: The Women's Press, 1978], p. 104).

100. Andrew Wernick, 'From Voyeur to Narcissist, Imaging Men in Contemporary Advertising', in Michael Kaufman, ed., *Beyond Patriarchy: Essays by Men on Pleasure, Power, and Change* (Don Mills, Ontario: Oxford University Press, 1987), pp. 290, 292.

101. Nixon, 'Distinguishing Looks', p. 65.

102. A social situation which approximates to this legitimation of the male gaze is provided by Margaret Walters, when she notes that *Playgirl* is bought by many couples, so that men may look and yet be saved from the necessity to acknowledge any attraction to other men (Walters, *The Nude Male*, p. 305). There is an analogy here for, say, the male partner's excuse for the viewing of soap opera on television as, "It's only for her sake."

103. Johnny Weissmuller and the developing Johnny Sheffield may look in some of their later movies as if they are promoting male pederasty, but their spectacle together is heavily alibied by their father-son relationship in the narrative.

104. Walt Morton, 'Tracking the Sign of Tarzan: Trans-Media Representation of a Pop-Culture Icon', in Chapman and Rutherford, *Male Order*, p. 119.

105. Ibid.

106. Joan Mellen, *Big Bad Wolves: Masculinity in the American Film* (London: Elm Tree Books, 1978), p. 337.

107. Ian Green, 'Malefunction: A Contribution to the Debate on Masculinity in the Cinema', *Screen*, vol. 25, no. 4-5 (1984), p. 42.

108. Ibid., p. 43.

109. The examples cited by Green are the expected ones of Hitchcock's James Stewart in *Rear Window* and *Vertigo* (Green, 'Malefunction', p. 44).

110. Ibid., pp. 45, 46.

111. By, for example, Leon Hunt (Hunt, 'What Are Big Boys Made Of?', p. 66).

112. Hunt, 'What Are Big Boys Made Of?', p. 71. All the same, this choice is implicitly criticised by the rest of the film.

113. Ibid.

114. Ibid., 'What Are Big Boys Made Of?', p. 70.

115. Paul Roen, *High Camp: A Gay Guide to Camp and Cult Films*, vol. 1 (San Francisco: Leyland Publications, 1994), p. 12. He explains this claim as follows: "The dramatic emphasis was always on rippling muscles, masculine camaraderie, and killing the bad guy (often as well-built as the good guy, and just as scantily clad) . . . The sexual element was . . . so explicit and clearly premeditated that some of these movies go beyond gay camp, into the realm of softcore erotica" (Roen, *High Camp*, p. 13).

116. Richard Dyer points out an analogous use of muscles: "In nineteenth-century socialist and trade union art and in Soviet socialist realism the notions of the dignity and heroism of labour are expressed through dynamically muscular male bodies." (Richard Dyer, 'Don't Look Now: The Male Pin-Up', in *Screen*, eds., *The Sexual Subject: A* Screen *Reader in Sexuality* [London: Routledge, 1992], p. 271)

117. Derek Elley notes, for example, that in *Ben Hur* and *The Fall of the Roman Empire* the principal interest is reserved for male friendship rather than male-female erotic partnering. (Derek Elley, *The Epic Film: Myth and History* (London: Routledge and Kegan Paul, 1984), p. 109.

118. Yvonne Tasker, *Spectacular Bodies: Gender, Genre and the Action Cinema* (London: Routledge, 1993), p. 17.

119. Tasker, *Spectacular Bodies*, p. 18.

120. Ginette Vincendeau, 'Community, Nostalgia and the Spectacle of Masculinity', *Screen*, vol. 26, no. 6 (1985), p. 31.

121. Ibid., p. 30.

122. Ibid., p. 32. She also admits an element of passivity into the approved form of masculinity in this French classic, when she says that Gabin's ideal of masculinity includes values traditionally ascribed to femininity.

123. Green, 'Malefunction', p. 47.

124. Ibid.

125. Ibid.

126. Ina Rae Hark argues that "Males played by movie stars become spectacularised or commodified, these narratives assert, only because the rightful exercise of masculine power has been perverted by unmanly tyrants" (Ina Rae Hark, 'Animals or Romans: Looking at Masculinity in *Spartacus*', in Cohan and Hark, eds., *Screening the Male*, p. 152).

127. Angela DalleVacche, *The Body in the Mirror: Shapes of History in Italian Cinema* (Princeton, N.J.: Princeton University Press, 1992), p. 15. A similar, but more subtle, point is made by Yvonne Tasker with regard to *Death Warrant*, where the figure of woman is used as a space through which to locate displaced homoerotic desire (Tasker, *Spectacular Bodies*, p. 42).

128. Chris Holmlund's citation of *Tango and Cash* is particularly useful here. The exchange of long, hard looks between the two men, and especially the shower scene with its dialogue peppered with double entendres, could easily be read as homo-erotic. However, as Holmlund argues, this film (and *Lock Up*) "attempt to contain the homoeroticism generated by the display of male bodies and male bonding by posi-tioning Stallone and the clones as 'family' and by designating Stallone as the more 'mature' of the two, labelling him the dad and the older brother-in-law, respectively, of First Base and Cash" (Chris Holmlund, 'Masculinity as Multiple Masquerade: The "mature" Stallone and the Stallone Clone', in Cohan and Hark, eds., *Screening the Male*, p. 221).

129. This is how Scott Benjamin King argues that Don Johnson as Sonny in *Miami Vice* is spared the full implications of his erotic objectification (Scott Benjamin King, 'Sonny's virtues: The Gender Negotiations of *Miami Vice*', *Screen*, vol. 31, no. 3 [1990], p. 285). On the other hand, Susan Jeffords sees Rambo's body as "technologised": "By representing Rambo's body as performance, the otherwise erotically suggestive display of his bare chest throughout the film is diverted as an object of military training, 'a fighting machine'" (Susan Jeffords, *The Remasculinization of America: Gender and the Vietnam War* [Bloomington and Indianapolis: Indiana University Press, 1989], p. 13).

130. King argues that the viewer does not entirely share Sonny's pain when he expe-riences loss in the *Miami Vice* narratives, so that he is "spectacularly destroyed each week for our viewing pleasure" (King, 'Sonny's virtues', p. 292).

131. Paul Smith, *Clint Eastwood: A Cultural Production* (London: UCL Press, 1993), p. 170.

conclusion

1. If evidence is needed, we have only to think of the (diegetic) audience reactions to Don Lockwood, played by Gene Kelly, in *Singin' in the Rain*, or the dead faints into which the ladies of *Bye Bye Birdie*'s small town fall when the pop star sings 'You Gotta Be Sincere'.

2. Of course, the separation of aesthetics from erotics is a concomitant necessity. An analogous achievement is required in the context of sport, where admiration of the superbly developed male physique has to distance itself from erotics and cloak itself in the mantle of aesthetics, if not science.

3. Here, the work of Kaja Silverman and Gaylyn Studlar has especial relevance.

4. Or else, "I know it isn't so, but . . ."

5. This can be explained as mere play and harmless let's pretend fantasy, but that explanation would not account for the distress that can be caused to a child by an assault on or destruction of the doll.

6. An example is suggested by Rock Hudson's bare-chested scrub-up before surgery on Jane Wyman in *Magnificent Obsession*. Surgeons just don't do that.

7. Or else she, not he, is doing all the looking.

8. At last we know! Freud would no longer need to be baffled.

9. He is available as object for homosexual choice, but this particular choice does not have to be acknowledged within the image itself.

10. Paul Smith reminds us that the masochism is always temporary.

11. "Directionlessness" except, that is, in the direction of the expansion of old markets or tapping of new.

bibliography

Ableman, Paul. *The Banished Body*. London: Sphere, 1982.

Allen, David W., M.D. *The Fear of Looking or Scopophilic-Exhibitionistic Conflicts*. Charlottesville: University Press of Virginia, 1974.

Anger, Kenneth. *Hollywood Babylon*. London: Arrow Books, 1986.

Assiter, Alison. *Pornography, Feminism and the Individual*. London: Pluto, 1989.

Baker, Peter. 'Exposing the Shape of Things to Come'. *The Guardian,* 26 May, 1992.

Ballardo, Richard. 'Strip Joker'. *Playgirl,* vol. 20, no. 8, 1992.

Barthes, Roland. *Camera Lucida: Reflections on Photography*, tr. Richard Howard. London: Fontana, 1984.

———. *Mythologies*, tr. Annette Lavers. London: Paladin, 1973.

Baudrillard, Jean. 'The Ecstasy of Communication', tr. John Johnston. In Hal Foster, ed. *Postmodern Culture*. London: Pluto, 1985.

Benjamin, Jessica, and Anson Rabinbach. 'Foreword'. In Klaus Theweleit, *Male Fantasies II. Male Bodies: Psychoanalyzing the White Terror*), tr. Chris Turner et al. Cambridge and Oxford: Polity Press with Basil Blackwell, 1989.

Benn, Tony. 'Perfect Body: Perfect Production'. *Camerawork,* November, 1982.

Bergan, Ronald. *Sports in the Movies*. London: Proteus, 1982.

Berger, John, et al. *Ways of Seeing*. London and Harmondsworth: BBC and Penguin, 1972.

Bhabha, Homi K. 'The Other Question . . . ' *Screen* 24, November–December, 1983.

Bonney, Claire. 'The Nude Photograph: Some Female Perspectives'. *Women's Art Journal,* Fall, 1985.

Bordo, Susan. 'Reading the Male Body'. *Michigan Quarterly Review,* vol. 32, no. 4, 1993.

Borzello, Frances. *The Artist's Model*. London: Junction Books, 1982.

Brinkworth, Lisa. 'Bringing up the rear'. *Style and Travel,* 23 May, 1993.

Bristow, Joseph. 'How Men Are: Speaking of Masculinity'. *New Formations* 6, 1988.

Bronski, Michael. *Culture Clash: The Making of Gay Sensibility*. Boston: South End Press, 1984.

Broude, Norma, and Mary D. Garrard, *Feminism and Art History: Questioning the Litany*. New York: Harper and Row, 1982.

Brown, P. T. 'On the Differentiation of Homo- or Hetero-erotic Interest in the Male: An Operant Technique Illustrated in a Case of a Motor-Cycle Fetishist'. *Behavior Research and Therapy* 2, 1964.

Butler, Judith. 'The Force of Fantasy: Feminism, Mapplethorpe, and Discursive Excess'. *differences: A Journal of Feminist Cultural Studies,* vol. 2, no. 2, 1990.

———. *Gender Trouble: Feminism and the Subversion of Identity*. London: Routledge, 1990.

'Calvin Clean'. *Independent on Sunday,* 13 March 1994.

Campbell, Beatrix. 'A Feminist Sexual Politics: Now You See It, Now You Don't'. In *Feminist Review,* ed. *Sexuality: A Reader*. London: 1987. Virago, 1987.

Carol, Avedon, and Nettie Pollard. 'Changing Perceptions in the Feminist Debate'. In
 Alison Assiter and Avedon Carol, eds. *Bad Girls and Dirty Pictures: The Challenge
 to Reclaim Feminism.* London: Pluto, 1993.

Carter, Angela. 'A Well-Hung Hang-Up'. In Paul Barker, ed. *Arts in Society.* London:
 Fontana, 1977.

Chapman, Rowena. 'The Great Pretender: Variations on the New Man Theme'. In
 Rowena Chapman and Jonathan Rutherford, *Male Order: Unwrapping Mas-
 culinity.* London: Lawrence and Wishart, 1988.

Chappell, Helen. 'Girls' Night In: "Ooo-er! Gross! Amazing!"'. *Independent,* 3
 December 1991.

Chaudhuri, Anita. 'Homme Sweet Homme'. *Time Out,* 11–18 March, 1992.

Chesler, Phyllis. *About Men.* London: The Women's Press, 1978.

Clark, Kenneth. *The Nude: A Study of Ideal Art.* London: John Murray, 1956.

Clover, Carol J. 'Introduction'. In Pamela Church Gibson and Roma Gibson, eds. *Dirty
 Looks: Women, Pornography, Power.* London: British Film Institute, 1993.

Cohan, Steven. '"Feminizing" the Song-and-Dance man: Fred Astaire and the Spec-
 tacle of Masculinity in the Hollywood Musical'. In Steven Cohan and Ina Rae Hark,
 eds. *Screening the Male: Exploring Masculinities in Hollywood Cinema.* London:
 Routledge, 1993.

Cohen, David. *Being A Man.* London: Routledge, 1990.

Colomberg, Elaine. 'Fore Women? Sex, Myths and Vibrations Rising in the 90s!'.
 London: University of North London. Unpublished final-year Women's Studies
 project.) 1993.

Cooper, Emmanuel. *Fully Exposed: The Male Nude in Photography.* London: Unwin
 Hyman, 1990.

———. *The Sexual Perspective: Homosexuality and Art in the Last 100 Years in the
 West.* London: Routledge and Kegan Paul, 1986.

Corliss, Richard. 'Sex Stars of the 70s'. *Film Comment*, vol. 15, no. 4, 1979.

Coward, Rosalind. *Female Desire.* London: Paladin, 1984.

Creed, Barbara. 'Dark Desires: Male Masochism in the Horror Film'. In Steven Cohan
 and Ina Rae Hark, eds. *Screening the Male: Exploring Masculinities in Hollywood
 Cinema.* London: Routledge, 1993.

———. 'From Here to Modernity: Feminism and Postmodernism'. *Screen,* vol. 28, no.
 2, 1987.

Dalle Vacche, Angela. *The Body in the Mirror: Shapes of History in Italian Cinema.*
 Princeton, N.J.: Princeton University Press, 1992.

Daly, Mary. *Pure Lust: Elemental Feminist Philosophy.* London: The Women's Press, 1984.

Day, Gary. 'Pose for Thought: Body-Building and Other Matters'. In Gary Day, ed.
 Readings in Popular Culture: Trivial Pursuits? London: Macmillan, 1990.

Day, Gary and Clive Bloom. *Perspectives on Pornography: Sexuality in Film and Liter-
 ature.* London: Macmillan, 1988.

D'Emilio, John, and Estelle B. Freedman. *Intimate Matters: A History of Sexuality in
 America.* New York: Harper and Row, 1988.

Diamond, Sara. 'Pornography: Image and Reality'. In Varda Burstyn, ed. *Women
 Against Censorship.* Vancouver: Douglas and McIntyre, 1985.

Dimen, Muriel. 'Politically Correct? Politically Incorrect?' In Carole S. Vance, ed. *Pleasure and Danger: Exploring Female Sexuality*. London: Routledge and Kegan Paul, 1984.

Doane, Mary Ann. 'Masquerade Reconsidered: Further Thoughts on the Female Spectator'. *Discourse*, vol. 11, no. 1, 1988–89

Doane, Mary Ann, et al. *Re-Vision: Essays in Feminist Film Criticism*. Frederick, Md.: University Publications of America/The American Film Institute, 1984.

Douglas, Jack D. and Paul K. Rasmussen, with Carol Ann Flanagan. *The Nude Beach*. Beverly Hills: Sage, 1977.

Dressel, Paula L., and David M.Petersen. 'Gender Roles, Sexuality, and the Male Strip Show: The Structuring of Sexual Opportunity'. *Sociological Focus*, vol. 15, no. 2, 1982.

Duckett, Jodi. 'The Flip Side: When Men are Sexually Harassed, All Things May Not Be Equal'. *Morning Call*, 10 March, 1994.

Durgnat, Raymond. *Eros in the Cinema*. London: Calder and Boyars, 1966.

Dworkin, Andrea. *Pornography: Men Possessing Women*. London: The Women's Press, 1981.

Dyer, Richard. 'Don't Look Now: The Male Pin-Up'. In *Screen*, ed., *The Sexual Subject: A Screen Reader in Sexuality*. London: Routledge, 1992.

———. *Film Stars and Society*. London: British Film Institute/Macmillan, 1987.

———. 'Male Gay Porn: Coming to Terms'. *Jump Cut* 30, 1981.

———. 'Male sexuality in the media'. In Andy Metcalf and Martin Humphries, eds. *The Sexuality of Men*. London: Pluto, 1985.

———. *The Matter of Images: Essays on Representations*. London: Routledge, 1993.

———. '*The Son of the Sheik*'. *The Movie* 126.

Easthope, Antony. *What a Man's Gotta Do: The Masculine Myth in Popular Culture*. London: Paladin Grafton Books, 1986.

Edwards, Abby. 'Are Sexy Mags Really Just For Men?' *Woman's Own*, 29 March, 1993.

Ehrenreich, Barbara,. 'Foreword'. In Klaus Theweleit, *Male Fantasies*, vol. I: 'Women, Floods, Bodies, History', tr. Stephen Conway et al. Minneapolis: University of Minnesota Press, 1987.

Ehrenreich, Barbara et al. *Re-Making Love: The Feminisation of Sex*. London: Fontana, 1987.

Ellenzweig, Allen. *The Homoerotic Photograph: Male Images from Durieu/Delacroix to Mapplethorpe*. New York: Columbia University Press, 1992.

Elley, Derek. *The Epic Film: Myth and History*. London: Routledge and Kegan Paul, 1984.

English, Deirdre, et al. 'Talking Sex: A Conversation on Sexuality and Feminism'. In *Feminist Review*, ed. *Sexuality: A Reader, 1987*. London: Virago, 1987.

Epstein, Julia and Kristina Straub, eds. *Body Guards: The Cultural Politics of Gender Ambiguity*. London: Routledge, 1991.

Erens, Patricia, ed. *Issues in Feminist Film Criticism*. Bloomington and Indianapolis: Indiana University Press, 1990.

Essoe, Gabe. *Tarzan of the Movies: A Pictorial History of More than Fifty Years of Edgar Rice Burroughs' Legendary Hero*. Secaucus, N.J.: Citadel, 1968.

Feminists Against Censorship. *Pornography and Feminism: The Case Against Censorship*, ed. Gillian Rodgerson and Elizabeth Wilson. London: Lawrence and Wishart, 1991.

Finch, Mark. 'Sex and Address in *Dynasty*'. *Screen*, vol. 27, no.6, 1986.

Fischer, Lucy. 'Mama's Boy: Filial Hysteria in *White Heat*'. In Steven Cohan and Ina Rae Hark, eds. *Screening the Male: Exploring Masculinities in Hollywood Cinema*. London: Routledge, 1993.

Flasche, Phil. 'Introduction'. In Ricardo Juan-Carlos, *Photographing the Male*. London: QED Publishing, 1983.

Flitterman, Sandy. 'Thighs and Whiskers: The Fascination of "Magnum, p.i."'. *Screen*, vol. 26, no. 2, 1985.

Ford, Charles Henri. 'Narcissism as Voyeurism as Narcissism'. In Gerard Malanga, ed. *Scopophilia: The Love of Looking*. New York: Alfred Van Der Marck Editions, 1985.

Foster, Alasdair. *Behold the Man: The Male Nude in Photography*, Edinburgh: Stills Gallery, 1988.

———. 'Men in Print: Popular Images of the Male Body in the 20th Century part three: Getting Physical'. *Gay Scotland*, vol. 33, no. 3, 1987.

Foster, Hal, ed. *Postmodern Culture*. London: Pluto, 1985.

Franklin, Clyde W., II. *The Changing Definition of Masculinity*. New York: Plenum, 1984.

French, Marilyn. *Beyond Power: On Women, Men, and Morals*. London: Jonathan Cape, 1985.

Freund, K. 'A Laboratory Method for Diagnosing Predominance of Homo- or Hetero-erotic Interest in the Male'. *Behavior Research and Therapy* 1, 1963.

Friedberg, Anne. *Window Shopping: Cinema and the Postmodern*. Berkeley and Los Angeles: University of California Press, 1993.

Friedman, Lester B, ed. *Unspeakable Images: Ethnicity and the American Cinema*. Urbana and Chicago: University of Illinois Press, 1991.

Fuchs, Cynthia J. 'The Buddy Politic'. In Steven Cohan and Ina Rae Hark, eds. *Screening the Male: Exploring Masculinities in Hollywood Cinema*. London: Routledge, 1993.

Fung, Richard. 'Looking for My Penis: The Eroticized Asian in Gay Video Porn'. In Bad Object-Choices, ed. *How Do I Look?*, 1991. *Queer Film and Video*. Seattle: Bay Press, 1991.

Fuss, Diana. 'Inside/Out'. In Diana Fuss, ed. *Inside/Out: Lesbian Theories, Gay Theories*. London: Routledge, 1991.

Gaines, Jane. 'White Privilege and Looking Relations: Race and Gender in Feminist Film Theory'. *Screen*, vol. 29, no. 4, 1988.

———. 'Competing Glances: Who Is Reading Robert Mapplethorpe's *Black Book*?'. In *Competing Glances. New Formations: A Journal of Culture/Theory/Politic*,. 16, 1992.

Gaines, Judith. 'The "Beefcake Years": More and More Ads Are Baring Men's Bodies'. *Philadelphia Inquirer*, 17 October, 1993.

Gallivan, Joseph. 'Ooo, I Wanna Be Like You'. *Independent*, 19 August, 1993.

Gallop, Jane. *Thinking Through the Body*. New York: Columbia University Press, 1988.

Gerrard, Nicci. *Into the Mainstream*. London: Pandora, 1989.

Gilmore, David D. *Manhood in the Making: Cultural Concepts of Masculinity*. New Haven: Yale University Press, 1990.

Goffman, Erving. *Gender Advertisements*. New York: Harper and Row, 1987.

Gordon, Bette. '*Variety*: The Pleasure in Looking'. In Carole S.Vance, ed. *Pleasure and Danger: Exploring Female Sexuality*. London: Routledge and Kegan Paul, 1984.

Grace, Della. 'Dynamics of Desire'. In Victoria Harwood et al, eds. *Pleasure Principles: Politics, Sexuality and Ethics*. London: Lawrence and Wishart, 1993.

Green, Ian. 'Malefunction: A Contribution to the Debate on Masculinity in the Cinema'. *Screen*, vol. 25 no. 4–5, 1984.

Gross, Larry, et al, eds. *Image Ethics: The Moral Rights of Subjects in Photographs, Film, and Television*. New York: Oxford University Press, 1988.

Grundberg, Andy. *Images of Desire: Portrayals in Recent Advertising Photography*. Philadelphia: Goldie Paley Gallery, Moore College of Art and Design, 1989.

Gunn, Rosie. 'On/Scenities'. *Body Politic* 4, 1993.

Hall, Celia. 'Chippendales Image "Puts Pressure on Men"'. *Independent*, 6 April, 1993.

Hall, Stuart. 'The Meaning of New Times'. In Stuart Hall and Martin Jacques, *New Times: The Changing Face of Politics in the 1980s*. London: Lawrence and Wishart, 1989.

Hammond, Mike. 'The Historical and the Hysterical: Melodrama, War and Masculinity in *Dead Poets Society*'. In Pat Kirkham and Janet Thumim, eds. *You Tarzan: Masculinity, Movies and Men*. London: Lawrence and Wishart, 1993.

Hanna, Judith Lynne. *Dance, Sex, and Gender: Signs of Identity, Dominance, Defiance, and Desire*. Chicago: University of Chicago Press, 1988.

Hansen, Miriam. *Babel and Babylon: Spectatorship in American Silent Film*. Cambridge, Mass. and London: Harvard University Press, 1991.

———. 'Pleasure, Ambivalence, Identification: Valentino and Female Spectatorship'. In Christine Gledhill, ed. *Stardom: Industry of Desire*. London: Routledge, 1991.

Hark, Ina Rae. 'Animals or Romans: Looking at Masculinity in *Spartacus*'. In Steven Cohan and Ina Rae Hark, eds. *Screening the Male: Exploring Masculinities in Hollywood Cinema*. London: Routledge, 1993.

Haskell, Molly. 'Introduction'. In Danielle B.Hayes, ed. *Women Photograph Men*. New York: William Morrow, 1977.

Heath, Stephen. 'Male Feminism'. In Alice Jardine and Paul Smith, *Men in Feminism*. New York: Methuen, 1987.

Henley, Nancy M. *Body Politics: Power, Sex, and Nonverbal Communication*. Englewood Cliffs, N.J.: Prentice-Hall, 1977.

Hoch, Paul. *White Hero, Black Beast: Racism, Sexism and the Mask of Masculinity*. London: Pluto, 1979.

Holland, Patricia, et al, eds. *Photography/Politics: Two*. London: Comedia, 1986.

Hollinghurst, Alan. *The Swimming-Pool Library*. Harmondsworth: Penguin, 1988.

Hollway, Wendy. 'Women's Power in Heterosexual Sex'. *Women's Studies International Forum*, vol. 7, no. 1, 1984.

Holmlund, Chris. 'Masculinity as Multiple Masquerade: The "Mature" Stallone and the Stallone Clone'. In Steven Cohan and Ina Rae Hark, eds. *Screening the Male: Exploring Masculinities in Hollywood Cinema*. London: Routledge, 1993.

————. 'Sexuality and Power in Male Doppelganger Cinema: The Case of Clint Eastwood's *Tightrope*'. *Cinema Journal*, vol. 26, no. 1, 1986.

————. 'Visible Difference and Flex Appeal: The Body, Sex, Sexuality, and Race in the *Pumping Iron* Films'. *Cinema Journal*, vol. 28, no. 4, 1989.

Horowitz, Gad and Michael Kaufman, 'Male Sexuality: Toward a Theory of Liberation'. In Michael Kaufman, ed. *Beyond Patriarchy: Essays by Men on Pleasure, Power, and Change*. Don Mills, Ontario: Oxford University Press, 1987.

Humphries, Martin. 'Gay Machismo'. In Andy Metcalf and Martin Humphries, eds. *The Sexuality of Men*. London: Pluto, 1985.

Hunt, Leon. 'What Are Big Boys Made Of? *Spartacus, El Cid* and the Male Epic'. In Pat Kirkham and Janet Thumim, eds. *You Tarzan: Masculinity, Movies and Men*. London: Lawrence and Wishart, 1993.

Huyssen, Andreas. *After the Great Divide: Modernism, Mass Culture, Postmodernism*. London: Macmillan, 1986.

Ingham, Mary. *Men: 'The Male Myth Exposed'*. London: Century Publishing, 1984.

Jackson, Rosemary. *Fantasy: The Literature of Subversion*. London and New York: Methuen, 1981.

Jackson, Stevi. 'Femininity, Masculinity and Sexuality'. In Scarlet Friedman and Elizabeth Sarah, eds. *On the Problem of Men: Two Feminist Conferences*. London: The Women's Press, 1982.

Jameson, Fredric. *Signatures of the Visible*. London: Routledge, 1992.

Jeffords, Susan. 'Can Masculinity be Terminated?'. In Steven Cohan and Ina Rae Hark, eds. *Screening the Male: Exploring Masculinities in Hollywood Cinema*. London: Routledge, 1993.

————. *The Remasculinization of America: Gender and the Vietnam War*. Bloomington and Indianapolis: Indiana University Press, 1989.

Jeffreys, Sheila. *Anticlimax: A Feminist Perspective on the Sexual Revolution*. London: The Women's Press, 1990.

Joselit, David. 'Robert Mapplethorpe's Poses'. In Janet Kardon, *Robert Mapplethorpe: The Perfect Moment*. Philadelphia: Institute of Contemporary Art, University of Pennsylvania, 1988.

Joyrich, Lynne. 'Critical and Textual Hypermasculinity'. In Patricia Mellencamp, ed. *Logics of Television: Essays in Cultural Criticism*. Bloomington and London: Indiana University Press/NBFI Publishing, 1990.

Julien, Isaac, and Kobena Mercer, 'True Confessions: A Discourse on Images of Black Male Sexuality'. *Ten*, vol. 8, no. 22.

Kaplan, E. Ann. 'Pornography and/as Representation'. *Enclitic*, vol. 17/18, no. 1–2, 1987.

————. *Women and Film: Both Sides of the Camera*. London: Methuen, 1983.

Kaufman, Michael. 'The Construction of Masculinity and the Triad of Men's Violence'. In Michael Kaufman, ed. *Beyond Patriarchy: Essays by Men on Pleasure, Power, and Change*. Don Mills, Ontario: Oxford University Press, 1987.

Kelly, Mary. 'Woman—Desire—Image'. In Lisa Appignanesi, ed. *Desire*. London: Institute of Contemporary Arts, 1984.

Kennedy, Brian, and John Lyttle. 'Wolf in Chic Clothing'. *City Limits*, 4-11 December, 1986.

Kent, Sarah. 'The Erotic Male Nude'. In Sarah Kent and Jacqueline Morreau, eds. *Women's Images of Men*. London: Pandora, 1990.

Kimmel, Michael S. 'Rethinking "Masculinity": New Directions in Research'. In Michael S. Kimmel, *Changing Men: New Directions in Research on Men and Masculinity*. Newbury Park, Cal.: Sage, 1987.

King, Lynn. ' . . . Sex, Per Se, Is Not the Problem: Sexism Is'. In Varda Burstyn, ed. *Women Against Censorship*. Vancouver: Douglas and McIntyre, 1985.

King, Scott Benjamin. 'Sonny's Virtues: The Gender Negotiations of *Miami Vice*'. *Screen*, vol. 31, no. 3, 1990.

Kipnis, Laura. 'She-Male Fantasies and the Aesthetics of Pornography'. In Pamela Church Gibson and Roma Gibson, eds. *Dirty Looks: Women, Pornography, Power*. London: British Film Institute, 1993.

Kleinhans, Chuck, and Julia Lesage. 'The Politics of Sexual Representation'. *Jump Cut* 30, 1981.

Koch, Gertrud. 'Female Sensuality: Past Joys and Future Hopes', tr. Reinhart Sonneburg and Eric Rentschler. *Jump Cut* 30, 1981.

———. 'Why Women Go to Men's Films'. In Gisela Ecker, ed. *Feminist Aesthetics*, tr. Harriet Anderson. London: The Women's Press, 1985.

Kostash, Myrna. 'Second Thoughts'. In Varda Burstyn, ed. *Women Against Censorship*. Vancouver: Douglas and McIntyre, 1985.

Kotz, Liz. 'Complicity: Women Artists Investigating Masculinity'. In Pamela Church Gibson and Roma Gibson, eds. *Dirty Looks: Women, Pornography, Power*. London: British Film Institute, 1993.

Kruger, Barbara. 'No Progress in Pleasure'. In Carole S. Vance, ed. *Pleasure and Danger: Exploring Female Sexuality*. London: Routledge and Kegan Paul, 1984.

Kuhn, Annette. *Women's Pictures: Feminism and Cinema*. London: Routledge and Kegan Paul, 1982.

Lanning, Andy, et al. *Digitek*. London: Marvel Comics, 1992.

Larkin, Alile Sharon. 'Black Women Film-makers Defining Ourselves: Feminism in Our Own Voice'. In E. Deidre Pribram, ed. *Female Spectators: Looking at Film and Television*. London: Verso, 1988.

Larson, Kay. 'Robert Mapplethorpe'. In Janet Kardon, *Robert Mapplethorpe: The Perfect Moment*. Philadelphia: Institute of Contemporary Art, University of Pennsylvania, 1988.

Lehman, Peter. '*In the Realm of the Senses*: Desire, Power, and the Representation of the Male Body'. *Genders* 2, 1988.

Leith, William. 'Of Muscles and Men'. *Independent on Sunday*, 13 December, 1992.

Lesage, Julia. 'The Human Subject—You, He, or Me? Or, The Case of the Missing Penis)'. *Jump Cut* 4, 1974.

Levy, Mark R., and Barrie Gunter. *Home Video and the Changing Nature of the Television Audience*. London: John Libbey, 1988.

Linz, Daniel, and Neil Malamuth. *Communication Concepts 5: Pornography*. Newbury Park, Cal.: Sage, 1993.

Lucie-Smith, Edward. 'Robert Mapplethorpe'. *Art and Artists*, November, 1983.

Lumley, Brian. *Necroscope*. Westlake Village, Cal.: Malibu Comics, 1992.

Lyman, Peter. 'The Fraternal Bond as a Joking Relationship: A Case Study of the Role of Sexist Jokes in Male Group Bonding'. In Michael S. Kimmel, *Changing Men: New Directions in Research on Men and Masculinity*. Newbury Park, Cal.: Sage, 1987.

MacCarthy, Fiona. 'Naked Truths Laid Bare'. *Observer*, 27 December, 1992.

MacDonald, Scott. 'Confessions of a Feminist Porn Watcher'. *Film Quarterly*, vol. 36, no. 3, 1983.

MacKinnon, Catharine. 'Desire and Power: A Feminist Perspective'. In Cary Nelson and Lawrence Grossberg, eds. *Marxism and the Interpretation of Culture*. Urbana and Chicago: University of Illinois Press, 1988.

———. 'Feminism, Marxism, Method, and the State: An Agenda for Theory', *Signs*, vol. 7, no. 3, 1982.

———. 'Feminism, Marxism, Method, and the State: Toward Feminist Jurisprudence'. *Signs*, vol. 8, no. 4, 1983.

MacKinnon, Kenneth. *Misogyny in the Movies: The De Palma Question*. Cranbury, N.J. and London: Associated University Presses, 1990.

———. *The Politics of Popular Representation: Reagan, Thatcher, AIDS, and the Movies*. Cranbury, N.J. and London: Associated University Presses, 1992.

McCann, Graham. *Rebel Males: Clift, Brando and Dean*. New Brunswick, N.J.: Rutgers University Press, 1993.

McCannell, Juliet Flower, ed. *The Other Perspective in Gender and Culture: Rewriting Women and the Symbolic*. New York: Columbia University Press, 1990.

McConaghy, N. 'Penile Volume Change to Moving Pictures of Male and Female Nudes in Heterosexual and Homosexual Males'. *Behavior Research and Therapy* 5, 1967.

McDougall, Joyce. *Plea for a Measure of Abnormality*. London: Free Association Books, 1990.

McKenna, Neil. 'Nothing to Declare?'. *Gay Times*, September, 1990.

Mapplethorpe, Robert. *Black Book*. New York: St Martin's Press, 1986.

Marshall, John. 'Tories Promise Tough Controls on Pornography'. *Gay Times*, April, 1992.

Maynard, Mary. 'Privilege and Patriarchy: Feminist Thought in the Nineteenth Century'. In Susan Mendus and Jane Rendall, *Sexuality and Subordination: Interdisciplinary Studies of Gender in the Nineteenth Century*. London: Routledge, 1989.

Mayne, Judith. *Cinema and Spectatorship*. London: Routledge, 1993.

Mellen, Joan. *Big Bad Wolves: Masculinity in the American Film*. London: Elm Tree Books, 1978.

Mercer, Kobena. 'Imaging the Black Man's Sex'. In Rowena Chapman and Jonathan Rutherford, *Male Order: Unwrapping Masculinity*. London: Lawrence and Wishart, 1988.

———. 'Skin Head Sex Thing: Racial Difference and the Homoerotic Imaginary'. In *Competing Glances. New Formations: A Journal of Culture/Theory/Politics*. 16, 1992.

Merck, Mandy. *Perversions: Deviant Readings*. London: Virago, 1993.

Meyer, Richard. 'Rock Hudson's Body'. In Diana Fuss, ed. *Inside/Out: Lesbian Theories, Gay Theories*. London: Routledge, 1991.

Middleton, Peter. *The Inward Gaze: Masculinity and Subjectivity in Modern Culture*. London: Routledge, 1992.

Milligan, Peter, and Tom Mandrake. *Detective Comics*. New York: DC Comics, 1991.

Mills, Pat, and Tony Skinner. *Accident Man*. Leicester: Apocalypse, 1991.

Mishkind, Marc E., et al. 'The Embodiment of Masculinity: Cultural, Psychological, and Behavioral Dimensions'. In Michael S. Kimmel, *Changing Men: New Directions in Research on Men and Masculinity*. Newbury Park, Cal.: Sage, 1987.

Modleski, Tania. *Feminism without Women: Culture and Criticism in a 'Postfeminist' Age*. London: Routledge, 1991.

———.*Loving with a Vengeance: Mass-Produced Fantasies for Women*. London: Routledge, 1988.

———, ed. *Studies in Entertainment: Critical Approaches to Mass Culture*. Bloomington and Indianapolis: Indiana University Press, 1986.

Moore, Suzanne. 'Here's Looking at You, Kid!'. In Lorraine Gamman and Margaret Marshment, eds. *The Female Gaze: Women as Viewers of Popular Culture*. London: The Women's Press, 1988.

Morreau, Jacqueline, and Catherine Elwes. 'Lighting a Candle'. In Sarah Kent and Jacqueline Morreau, eds. *Women's Images of Men*. London: Pandora, 1990.

Morse, Margaret. 'Sport on Television: Replay and Display'. In E. Ann Kaplan, ed. *Regarding Television: Critical Approaches—An Anthology*. Los Angeles: American Film Institute, 1983.

Mort, Frank. 'Boy's Own? Masculinity, Style and Popular Culture'. In Rowena Chapman and Jonathan Rutherford, *Male Order: Unwrapping Masculinity*. London: Lawrence and Wishart, 1988.

———. 'Images Change: High Street Style and the New Man'. *New Socialist*, November, 1986.

Morton, Walt. 'Tracking the Sign of Tarzan: Trans-Media Representation of a Pop-Culture Icon'. In Pat Kirkham and Janet Thumim, eds. *You Tarzan: Masculinity, Movies and Men*. London: Lawrence and Wishart, 1993.

Moye, Andy. 'Pornography'. In Andy Metcalf and Martin Humphries, eds. *The Sexuality of Men*. London: Pluto, 1985.

Mulvey, Laura. 'The Image and Desire'. In Lisa Appignanesi, ed. *Desire*. London: Institute of Contemporary Arts, 1984.

———. *Visual and Other Pleasures*. London: Macmillan, 1989.

Myers, Kathy. 'Pasting over the Cracks'. In Lisa Appignanesi, ed. *Desire*. London: Institute of Contemporary Arts, 1984.

———. 'Towards a feminist erotica'. In Rosemary Betterton, ed. *Looking On: Images of Femininity in the Visual Arts and Media*. London: Pandora, 1987.

Neale, Steve. '*Chariots of Fire*, Images of Men'. *Screen*, vol. 23, no. 3–4, 1982.

———. '*Halloween*: Suspense, Aggression and the Look.' *Framework* 14, 1981.

———.'Masculinity as Spectacle: Reflections on Men and Mainstream Cinema'. *Screen*, vol 24, no. 6, 1983.

Newfield, Christopher. 'The Politics of Male Suffering: Masochism and Hegemony in the American Renaissance'. *differences: A Journal of Feminist Cultural Studies*, vol. 1, no. 3, 1989.

Nixon, Sean. 'Distinguishing Looks: Masculinities, the Visual and Men's Magazines'. In Victoria Harwood et al, eds. *Pleasure Principles: Politics, Sexuality and Ethics*. London: Lawrence and Wishart, 1993.

———. 'Have You Got The Look? Masculinities and Shopping Spectacle'. In Rob Shields, ed. *Lifestyle Shopping: The Subject of Consumption*. London: Routledge, 1992.

Norman, Neil. 'Raw Deal'. *For Women*, April, 1994.

Orbach, Susie, and Luise Eichenbaum. *What Do Women Want?* London: Fontana, 1984.

Owens, Craig. 'Outlaws: Gay Men in Feminism'. In Alice Jardine and Paul Smith, *Men in Feminism*. New York and London: Methuen, 1987.

Pajackowska, Claire. 'The Heterosexual Presumption'. In *The Sexual Subject: A Screen Reader in Sexuality*. London: Routledge, 1992.

Parker, Rozsika. 'Images of Men'. In Sarah Kent and Jacqueline Morreau, eds. *Women's Images of Men*. London: Pandora, 1990.

Patrick, John, ed. *The Best of the Superstars* 1992: *The Year in Sex*. Sarasota, Fl.: STARbooks Press, 1992.

Peary, Gerald. 'Woman in Porn'. *Take One* 6, 1978.

Peckham, Morse. *Art and Pornography: An Experiment in Explanation*. New York: Basic Books, 1969.

Petersen, David M., and Paula M.Dressel. 'Equal Time for Women: Special Notes on the Male Strip Show'. *Urban Life*, vol. 11, no. 2, 1982.

Phillips, Eileen, ed. *The Left and the Erotic*. London: Lawrence and Wishart, 1983.

Pollock, Griselda. *Vision and Difference: Femininity, Feminism and Histories of Art*. London: Routledge, 1988.

———. 'What's Wrong with Images of Women?' In Rosemary Betterton, ed. *Looking On: Images of Femininity in the Visual Arts and Media*. London: Pandora, 1987.

Pronger, Brian. *The Arena of Masculinity: Sports, Homosexuality, and the Meaning of Sex*. New York: St Martin's Press, 1990.

Raymond, Martin. 'Boys on Film'. *Girl About Town*, 16 February, 1987.

Richardson, Colin. 'The Porn Laws'. In ICA, 'We Should Be Seeing Things: Screen Censorship and Sexuality', 25 April, 1992.

Roen, Paul. *High Camp: A Gay Guide to Camp and Cult Films*, vol. 1. San Francisco: Leyland Publications, 1994.

Ross, Andrew. *No Respect: Intellectuals and Popular Culture*. London: Routledge, 1989.

Rubin, Gayle. 'Thinking Sex: Notes for a Radical Theory of the Politics of Sexuality'. In Carole S. Vance, ed. *Pleasure and Danger: Exploring Female Sexuality*. London: Routledge and Kegan Paul, 1984.

Russell, Lyndsay. 'Bring on the Dancing Boys'. *Independent*, 11 September, 1993.

Rutherford, Jonathan. *Men's Silences: Predicaments in Masculinity*. London: Routledge, 1992.

———. 'Who's That Man?' In Rowena Chapman and Jonathan Rutherford, *Male Order: Unwrapping Masculinity*. London: Lawrence and Wishart, 1988.

Rutledge, Leigh W. 'Why is Gay Pornography So Bad? Or, How *Not* to Write an Erotic Story'. *Mandate*, vol. 11, no. 2, 1985.

Ryan, Tom. 'Roots of masculinity'. In Andy Metcalf and Martin Humphries, eds. *The Sexuality of Men*. London: Pluto, 1985.

Rynning, Roald. 'Antonio Banderas'. *Time Out*, 9-16 March, 1994.

Salaman, Naomi. 'Women's Art Practice/ Man's Sex . . . and Now for Something Completely Different'. In Victoria Harwood et al, eds. *Pleasure Principles: Politics, Sexuality and Ethics*. London: Lawrence and Wishart, 1993.

Schlesinger, Philip, et al. *Women Viewing Violence*. London: British Film Institute, 1992.

Schwenger, Peter. *Phallic Critiques: Masculinity and Twentieth-Century Literature*. London: Routledge and Kegan Paul, 1984.

Segal, Lynne. *Is the Future Female? Troubled Thoughts on Contemporary Feminism*. London: Virago, 1987.

——. *Slow Motion: Changing Masculinities, Changing Men*. London: Virago, 1990.

Segal, Lynne, and Mary McIntosh, eds. *Sex Exposed: Sexuality and the Pornography Debate*. London: Virago, 1992.

Seidler, Victor J. *Recreating Sexual Politics: Men, Feminism and Politics*. London: Routledge, 1991.

——. *Rediscovering Masculinity: Reason, Language and Sexuality*. London: Routledge, 1989.

Sexton, Patricia Cayo. *The Feminized Male: Classrooms, White Collars and the Decline of Manliness*. London: Pitman Publishing, 1970.

Shilling, Chris. *The Body and Social Theory*. London: Sage, 1993.

Silverman, Kaja. *The Acoustic Mirror: The Female Voice in Psychoanalysis and Cinema*. Bloomington and Inadianapolis: Indiana University Press, 1988.

——. 'Fragments of a Fashionable Discourse'. In Tania Modleski, ed. *Studies in Entertainment: Critical Approaches to Mass Culture*. Bloomington and Indianapolis: Indiana University Press, 1986.

——. *Male Subjectivity at the Margins*. London: Routledge, 1992.

——. 'Masochism and Male Subjectivity'. In Constance Penley and Sharon Willis, eds. 'Male Trouble' special issue. *Camera Obscura* 17, 1988.

Skeggs, Beverley. 'Challenging Masculinity and Using Sexuality'. *British Journal of Sociology of Education*, vol. 12, no. 2, 1991.

——. 'A Spanking'. *Magazine of Cultural Studies* 3, 1991.

Skipper, James K., Jr., and Charles H.McCaghy. 'Teasing, Flashing and Visual Sex: Stripping for a Living'. In James M.Henslin and Edward Sagarin, eds. *The Sociology of Sex: An Introductory Reader*. New York: Schocken Books, 1978.

Smith, Anne Marie. 'Oulaws as Legislators: Feminist Anti-Censorship Politics and Queer Activism'. In Victoria Harwood et al, eds. *Pleasure Principles: Politics, Sexuality and Ethics*. London: Lawrence and Wishart, 1993.

Smith, Paul. *Clint Eastwood: A Cultural Production*. London: UCL Press, 1993.

——. 'Vas'. In Constance Penley and Sharon Willis, eds., 'Male Trouble' special issue. *Camera Obscura* 17, 1988.

Snitow, Ann. 'Retrenchment vs. Transformation'. In Caught Looking Inc., F.A.C.T. Book Committee, *Caught Looking: Feminism, Pornography and Censorship*. East Haven, Conn.: Long River Books, 1992.

——. 'The Front Line: Notes on Sex in Novels by Women 1969–1979'. In Catharine R. Stimpson and Ethel Spector Person, eds. *Women: Sex and Sexuality*. Chicago: University of Chicago Press, 1980.

Soble, Alan. *Pornography, Marxism, Feminism, and the Future of Sexuality*. New Haven: Yale University Press, 1986.

Sontag, Susan. *Under the Sign of Saturn*. London: Writers and Readers, 1983.

'Speak Out Sister'. *For Women*, November 1993.

Spoto, Donald. *Camerado: Hollywood and the American Man*. New York: Plume, 1978.

Squires, Judith. 'Editorial'. *Competing Glances. New Formations: A Journal of Culture/Theory/Politics*, 16, 1992.

Steele, Lisa. 'A Capital Idea: Gendering in the Mass Media'. In Varda Burstyn, ed. *Women Against Censorship*. Vancouver: Douglas and McIntyre, 1985.

Steinberg, Leo. *The Sexuality of Christ in Renaissance Art and in Modern Oblivion*. London: Faber and Faber, 1984.

Steinem, Gloria. 'Erotica and Pornography: A Clear and Present Difference'. In Laura Lederer, ed. *Take Back The Night: Women on Pornography*. London: Bantam, 1982.

Stoller, Robert J., M.D. *Perversion: The Erotic Form of Hatred*. London: H. Karnac, 1986.

Studlar, Gaylyn. 'Discourses of Gender and Ethnicity: The Construction and De(con)struction of Rudolph Valentino as Other'. *Film Criticism*, vol. 13, no. 2, 1989.

———. *In the Realm of Pleasure: Von Sternberg, Dietrich, and the Masochist Aesthetic*. New York: Columbia University Press, 1988.

———. 'Masochism and the Perverse Pleasures of the Cinema'. In Bill·Nichols, ed. *Movies and Methods*, vol. 2. Berkeley and Los Angeles: University of California Press, 1985.

———. 'Valentino, "Optic Intoxication," and Dance Madness'. In Steven Cohan and Ina Rae Hark, eds. *Screening the Male: Exploring Masculinities in Hollywood Cinema*. London: Routledge, 1993.

Sullivan, Andrew. 'Flogging Underwear: The New Raunchiness of American Advertising'. *New Republic*, 18 January, 1988.

Target, George. 'Cocks and Hens'. *International H&E Monthly*, vol. 94, no. 6, 1994.

Tasker, Yvonne. *Spectacular Bodies: Gender, Genre and the Action Cinema*. London: Routledge, 1993.

Tickner, Lisa. 'The Body Politic: Female Sexuality and Women Artists Since 1970'. In Rosemary Betterton, ed. *Looking On: Images of Femininity in the Visual Arts and Media*. London: Pandora, 1987.

Toolin, Cynthia. 'Attitudes Toward Pornography: What Have the Feminists Missed?' *Journal of Popular Culture*, vol. 17, no. 2, 1983.

Tredre, Roger. 'The Great Smell of Marketing'. *Independent*, 1 March, 1993.

———. 'Under Cover of Darkness (and Lycra)'. *Independent*, 10 June, 1993.

Turner, Bryan S. *The Body and Society: Explorations in Social Theory*. Oxford: Blackwell, 1984.

Vincendeau, Ginette. 'Community, Nostalgia and the Spectacle of Masculinity'. *Screen*, vol. 26, no. 6, 1985.

Waldman, Diane. 'Film Theory and the Gendered Spectator: The Female or the Feminist Reader?' *Camera Obscura* 18, 1988.

Walker, Janet. 'The Problem of Sexual Difference and Identity'. *Wide Angle*, vol. 6, no. 3, 1984.

Walters, Margaret. *The Nude Male: A New Perspective*. Harmondsworth: Penguin, 1979.

Waugh, Tom. 'Men's Pornography: Gay vs. Straight'. *Jump Cut* 30, 1981.

Webster, Paula. 'The Forbidden: Eroticism and Taboo'. In Carole S.Vance, ed. *Pleasure and Danger: Exploring Female Sexuality*. London: Routledge and Kegan Paul, 1984.

Weiermair, Peter. *The Hidden Image: Photographs of the Male Nude in the Nineteenth and Twentieth Centuries*, tr. Claus Nielander. Cambridge, Mass.: MIT Press, 1988.

Wernick, Andrew. 'From Voyeur to Narcissist: Imaging Men in Contemporary Advertising'. In Michael Kaufman, ed. *Beyond Patriarchy: Essays by Men on Pleasure, Power, and Change*. Don Mills, Ontario: Oxford University Press, 1987.

Wicke, Jennifer. 'Through a Gaze Darkly: Pornography's Academic Market'. In Pamela Church Gibson and Roma Gibson, eds. *Dirty Looks: Women, Pornography, Power*. London: British Film Institute, 1993.

Wiegman, Robyn. 'Feminism, "The Boyz," and Other Matters Regarding the Male'. In Steven Cohan and Ina Rae Hark, eds. *Screening the Male: Exploring Masculinities in Hollywood Cinema*. London: Routledge, 1993.

Williams, Linda. 'Film Body: An Implantation of Perversions'. *Cinetracts*, vol. 3, no. 4, 1981.

———. *Hard Core: Power, Pleasure and the 'Frenzy of the Visible'*. London: Pandora, 1990.

Williamson, Judith. *Consuming Passions: The Dynamics of Popular Culture*. London: Marion Boyars, 1986.

———. *Deadline at Dawn: Film Criticism 1980- 1990*. London: Marion Boyars, 1993.

———. *Decoding Advertisements: Ideology and Meaning in Advertising*. London: Marion Boyars, 1978.

Willis, Ellen. 'Feminism, Moralism and Pornography'. In Ann Snitow et al., *Desire: The Politics of Sexuality*. London: Virago, 1984.

Willis, John. 'Banned and Damned in the USA'. *Independent*, 5 August, 1992.

Winship, Janice. 'Handling Sex'. In Rosemary Betterton, ed. *Looking On: Images of Femininity in the Visual Arts and Media*. London: Pandora, 1987.

———. 'Sexuality for Sale'. In Stuart Hall et al, eds. *Culture, Media, Language*. London: University of Birmingham, 1980.

Yingling, Thomas. 'How the Eye is Caste: Robert Mapplethorpe and the Limits of Controversy'. *Discourse*, vol. 12, no. 2, 1990.

Youskevitch, Igor, et al. *The Male Image*. New York: Dance Perspectives 40, 1969.

Zavitzianos, George. 'The Object in Fetishism, Homeovestism and Transvestism'. *International Journal of Psychoanalysis* 58, 1977.

index